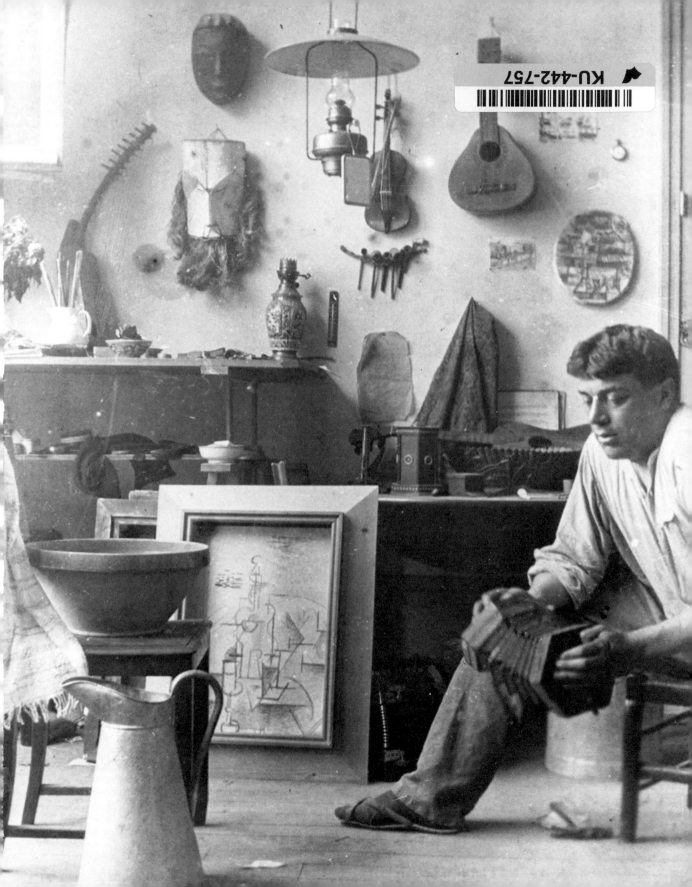

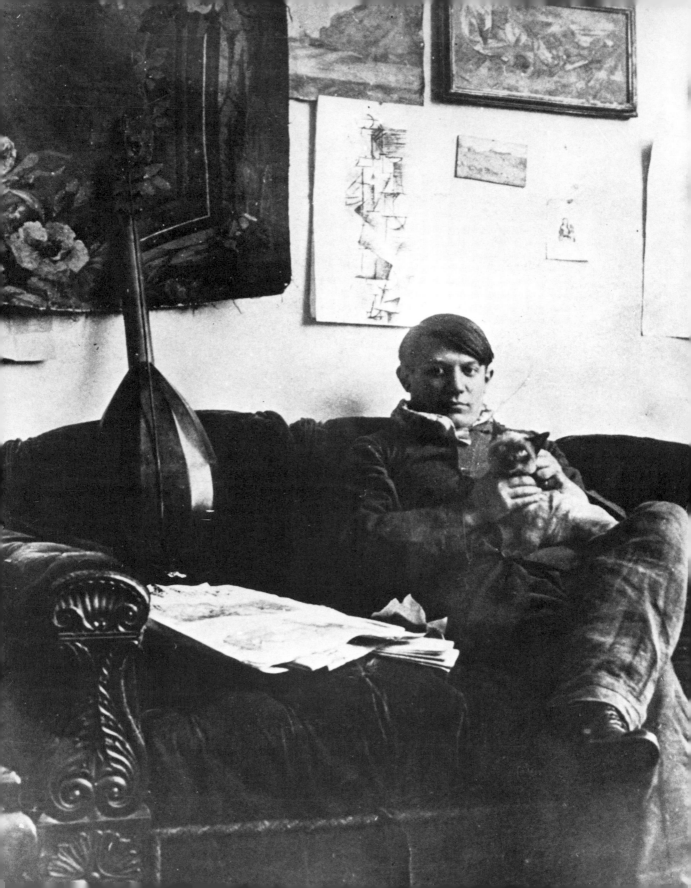

DOUGLAS COOPER AND GARY TINTEROW

THE ESSENTIAL CUBISM

Braque, Picasso & their friends

1907 - 1920

THE TATE GALLERY

ISBN 0 905005 24 4
Published by order of the Trustees 1983
for the exhibition of 27 April-10 July 1983
Copyright © 1983 The Tate Gallery/Douglas Cooper/Gary Tinterow

Published by the Tate Gallery Publications Department,
Millbank, London SW1P 4RG
Designed by Sue Fowler
Printed in Great Britain by Balding + Mansell Limited, Wisbech, Cambs

Cover
'Pierrot and Harlequin', 1920 (cat.no. 178)

Frontispiece page 1
Braque in his studio, Rue Caulaincourt, Paris, 1911
Archives Laurens

Frontispiece
Picasso in his studio, 11 Boulevard de Clichy, 1910-11
Musee Nationaux, Paris

Contents

Foreword

We were delighted when Douglas Cooper and Gary Tinterow accepted our invitation to select this exhibition and are most grateful to them for their tireless efforts in searching for and often themselves securing the loan of works of the highest quality for inclusion. They have researched into the provenance of all the loans and have collected a quantity of new material for the catalogue.

The exhibition has been designed to show the stylistic evolution of Cubism in the hands of the four Cubist masters, Braque, Picasso, Gris and Léger in the years 1907-1920. Also included are the two great cubist sculptors, Laurens and Lipchitz, together with a small group of work by some of the French artists who were associated with the Cubist Movement in its early years – Delaunay, Gleizes, Marcoussis, Metzinger and Villon.

Clearly such an undertaking would have been impossible without the co-operation and generosity of a large number of collectors, both private and public. To all of these we are deeply indebted. Their names can be found at the end of the catalogue.

Several museums and many private collectors have made very special exceptions to their normal policy and have lent works not usually available for exhibition, either because of their extreme importance in the collection or because of their fragility. Here I should like to single out for special mention and thanks the Kunstmuseum Basel, the Solomon R. Guggenheim Museum and the Museum of Modern Art, New York, the Musée Picasso and the Musée National d'Art Moderne, Paris, the Philadelphia Museum of Art and the Národní Galerie, Prague; Mr & Mrs Gelman, Mr & Mrs Jucker, Mr & Mrs Körfer, M. et Mme Laurens, Mme Leiris, M. Maguy, M. Prejger and Baron Thyssen and several other lenders who prefer to remain anonymous.

It is a curious fact that there has never before been a major Cubist exhibition in London. After waiting for so long, it is particularly gratifying for the Tate Gallery to be able to present an exhibition that will surely be seen as the definitive one.

Alan Bowness
Director

Acknowledgements

It was the Trustees and Director of The Tate Gallery who expressed their desire to present a large-scale exhibition of 'true' Cubist art – the first to be seen in England – and called on us as Guest Directors to plan and realise the project. From the first moment, our task has been enormously facilitated by the particular interest and active participation of Alan Bowness, the Director, as well as by the supportive co-operation and the calm, efficient execution of every move involved in the organisation of this complicated project by the professional staff of the Tate Gallery. They have spared no effort to achieve the perfect result, so for us it has been throughout a real pleasure to work with them. For this, we wish to express our deepest gratitude, and if we may single out two people who have brilliantly carried a major share of responsibility for the realisation of this exhibition, then it is to Ruth Rattenbury, Exhibition Curator, and to Iain Bain, Publications Manager, that we owe special thanks for the interest and care that they continually showed in trying to meet our wishes.

On a more personal plane, we are deeply indebted to numerous friends, museum personnel, art historians with special knowledge of the period and art dealers, not only for valuable assistance with the loan of major paintings which we particularly desired to include, but also for the trouble they have taken to answer our innumerable questions and to help us solve certain difficult problems. First and foremost among those whom we wish specially to thank is Heinz Berggruen. From the start, he enthusiastically supported our conception of this exhibition, as well as the historical approach adopted in the catalogue entries and proved his interest by the extraordinary generosity of his loans, by opening up his archives and by putting at our disposal many facts embedded in his remarkable memory. We are also specially indebted to Dr Christian Geelhaar, Director of the Kunstmuseum in Basel, and to Dr Werner Schmalenbach, Director of the Kunstsammlung Nordrhein-Westfalen, for their readiness to accede to our pressing request for the loan of some of the most significant works in the collections for which they are responsible. We have also acquired a great deal of essential and often unpublished information, as well as valuable loans, from conversations with Monsieur and Madame Claude Laurens, joint heirs of both Braque and Henri Laurens; from Herr Andreas Speiser of Basel; from Madame Louise Leiris and the staff of her gallery, who have been tireless in digging into their early records; from Mr Gustav Kahnweiler; from Monsieur Reuben Lipchitz; from Madame Isabelle Monod-Fontaine, Madame Nadine Pouillon, and Mlle Michèle Richet, curators of the Centre Georges Pompidou and of the Musée Picasso in Paris; from Mr Klaus Perls of New York; from Miss Claudia Neugebauer, secretary of the Galerie Beyeler in Basel; from Miss Patricia Tang, secretary to Mr Eugene Thaw; and from Herr Eberhard Kornfeld of Bern. To them, individually and as a group, we are very grateful indeed for patient researches on

our behalf, and for their repeated willingness to try to satisfy our unending curiosity. We are also most grateful to Mr David Somerset for his successful intervention with the owner, which enabled us to secure the loan of a Picasso masterpiece.

Lastly we owe a debt of gratitude to Mr Alvin Martin, who authorised us to read and to make use of any conclusions or other information contained in his unpublished doctoral thesis on Braque's early formative years (1905-10).

D.C./G.T.

CORRECTION
Cat. no. 24, Georges Braque, 'Guitar, Glass and Newspaper'. The reproduction of this work should be shown vertically. It has been printed with its top edge to the left.

Introduction

In the field of modern art, Cubism has become, during the past fifteen years, a major focus of interest. On both sides of the Atlantic, art historians have been busy researching into the history, the literature and the spread of Cubist influence before 1914. Cubist painting has been subjected to close and detailed study, while various attempts have been made to search out its origins and to discuss its stylistic development, to reveal the mysteries of its material content and to measure its significance both as an art form and as a pictorial re-creation of reality. Forgotten articles, documents of major importance and revealing photographs have been brought to light; concealed personal references and witticisms have been discovered and interpreted; while an intelligible chronology for the paintings (most of which are undated) has been established.

Survey exhibitions of Cubist painting have been shown in many major cities in Europe and America – though never before in London – as well as major retrospectives of the work of the leading artists concerned. As a result, the general public is now familiar with the appearance of Cubist paintings, even if it still has difficulty in 'reading' the subject matter represented and does not fully comprehend the style and its *raison d'être*.

These many exhibitions held elsewhere have tended, on the whole, to be of a generalising nature, and as a rule have revealed a confused and confusing conception of what constitutes Cubist art, to the extent even of losing sight of the nature of 'true' Cubism as created by its originators Braque, Picasso, Gris and Léger. In France, strangely enough since it was the country in which Cubism was created and developed, the word signifies almost exclusively the work of those minor and theoretically minded artists who constituted the Cubist Movement in Paris. Indeed, the only all-embracing exhibition in which the four original Cubist painters were at the centre of an overall conception, was 'The Cubist Epoch', organised in America in 1970-71, an occasion on which major groups of their works were displayed alongside representative groups of works by artists of the Cubist School in Paris, as well as by artists of countries other than France – Holland, Italy, Germany, Russia, Czechoslovakia and America – who had adopted and transformed different aspects of Cubism to suit their own conceptions. On this occasion, the widespread influence of Cubism in its own time was extensively illustrated and it was easy to compare the original idiom with its many offshoots.

It seemed, therefore, to us that this was an excellent occasion to present a narrow view of Cubism in its purest form and to try to analyse and define, more clearly than has yet been achieved, just what we mean by true Cubism – that is to say, the pictorial idiom created by Braque, Picasso, Gris and Léger – in order first of all to determine those essential features (if any) which make of it an independent, recognisable style, and then to indicate such elements as are peculiar to it.

To this end, we have tried to illustrate, with large groups of their finest and most significant works, the progressive achievements of the four masters and of two sculptors – Laurens and Lipchitz – who were later associated with them, in order to reveal the stylistic differences which divide them from the so-called Cubism associated with the artists of the Paris School and others.

This attitude on our part should therefore be regarded as the prime reason for our having chosen to give this exhibition the challenging title 'The Essential Cubism'.

And now, having assembled the special type of exhibition just defined, it behoves us to give meaning to the word 'essential' in this context and to attempt in this Catalogue to offer a valid definition of what constitutes true Cubism after studying the assembled evidence.

As we see it, the first factor to note is that the form of Cubism originally created and practised by Braque and Picasso, between 1908 and 1913, was their work alone. No school of like-minded artists was involved, nor did Braque and Picasso accept, at a later stage, a group of disciples who developed their own forms of Cubism independently. The Cubist idiom as we see it in the paintings of Braque and Picasso was evolved by and for themselves alone, working in accordance with their personal intuition and not concerned with any pre-established principles or theories. The painting of Cézanne (especially that of his later works) was a major source of inspiration, and Braque was the first, by rather more than a year, to understand and accept Cézanne's innovatory methods of representation, from which he drew certain conclusions (winter 1907-8) affecting the handling of forms in his own work. In 1907, Picasso, on the other hand, was struck by the conceptual treatment of objects which he found both in the paintings of Henri Rousseau and in African negro sculpture. So in 1908, that is to say at the moment when Cubism began to evolve in Braque's paintings, Picasso initially adopted this same conceptual treatment of figures and objects in his own work. Thus it is only at the beginning of 1909 that the treatment of forms and space in his own paintings reveals Picasso's new-found interest in the pictorial innovations of Cézanne.

Cubism as it was created from 1909 on by these two artists was never, in the conventional sense, a definable style of painting which other artists could adopt as it stood. The central episode in the evolutionary history of Cubism is entirely dominated by Braque and Picasso, who together progressively perfected and consolidated their new manner of pictorial representation, and eventually (1911) shifted from a perceptual to a conceptual approach to reality. The period of their closest and most intense cooperation runs from the autumn of 1909 – when Braque returned to Paris after a summer spent working around La Roche Guyon and Le Havre, and Picasso returned from Horta de Ebro – to the spring of 1913, after the invention of the technique of *papier collé*.

At that time, Juan Gris, who had evolved a Cubist idiom of his own, with roots in the painting of Cézanne as well as in the Cubist achievements of Braque and Picasso, with which he was familiar, was accepted by the two originators as a Cubist painter

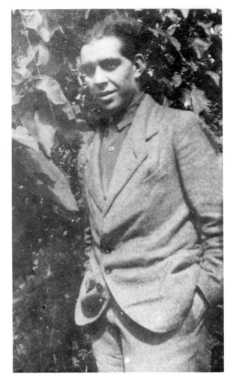

Léger at the Front, 1916
Photo Musée National Fernand Léger

Gris at Beaulieu, Touraine, 1916
Photo Josette Gris

in their own sense of the term. Now it is perhaps Gris, looking back in 1925 at the early phases of his own artistic evolution, who has evoked most clearly for posterity his understanding at the time of the aims and nature of authentic Cubism. At the start, says Gris, it was 'simply a new way of representing the world', a conscious reaction against the pursuit of those fugitive effects which had been a major concern of the Impressionists. Braque and Picasso were therefore involved, at all times, in a search for 'less unstable elements' in the objects which they chose to represent. The Cubists, Gris goes on, rejected 'momentary effects of light' and 'substituted what they believed to be the local colours of objects', while at the same time representing objects as the mind conceives them to be and not as they actually appear to the eye. But the most significant part of Gris's statement is perhaps his revelation that he 'never consciously and after mature reflection became a Cubist, but, by dint of working along certain lines', came to be accepted as such. And this statement is followed by the conclusion that 'Cubism is not a manner but an aesthetic: it is a state of mind.'

However, for all that Cubism was a reaction against the spirit of Impressionism, it is the story of the creation and development of Impressionism which provides the closest analogy with the story of Cubism. For instance, Impressionism as a manner

of painting was, in the strict sense, evolved by Monet and Renoir while working together between 1868 and 1874. In 1872, they were joined by Pissarro and Sisley, though this did not interrupt the continuity of their development. Nevertheless, by 1882 the original Impressionist manner of painting had been adopted by a number of other artists – for example, Manet, Berthe Morisot, Cézanne, Guillaumin and Gauguin – whose intervention had the effect of diluting and changing the essential technique of Impressionism. But by this time, the original Impressionist artists themselves, having realised the limitations of their initial pictorial record of reality, had moved on and begun to work individually in different, more precisely defined post-Impressionist manners.

Looking now at the development of Cubism, we find that in like manner it was Braque and Picasso, working alone in unison and enjoying a degree of seclusion comparable with that enjoyed by Monet and Renoir as they worked along the banks of the Seine, who by the end of 1909 had forged an early phase of Cubism. This is splendidly illustrated here in such outstanding paintings as 'Violin and Palette' by Braque (no. 9 of this Catalogue) and 'Seated Nude' by Picasso (no. 118 of this Catalogue). In these paintings, figures like objects are analysed into a succession of facetted shapes which, individually, serve no descriptive purpose, though when assembled in an organised manner they evoke a figure or an object seen from several points of view. Moreover, at this stage Braque and Picasso restricted their palette to a scale of neutral tones and treated light arbitrarily as an element which they could direct to any point where they felt a need for it. Such was the basis of the first representational phase of Cubism, whose inherent possibilities Braque and Picasso explored and tested for some three years (1909-12), that is to say, until the invention of the technique of *papier collé*. And by that time, already, the two artists had arrived at a bolder idiom based on large, flat forms set in a compressed pictorial space, which is evoked through a structure of planes laid one over another.

Following the invention of *papier collé* by Braque in September 1912, the two artists found, however, that they could invert the structural procedure which they had followed hitherto. This meant that, instead of breaking down a figure or an object into different fragments and facets, which when reassembled added up to a total image, they could begin with a range of purely pictorial elements – shaped forms and coloured planes, for instance – and endow them gradually, as the composition progressed, with an objective significance. In other terms, whereas in Cubist paintings of 1910-11 Braque and Picasso would signify the presence of a guitar not by a clearly defined, overall shape but as a series of insubstantial, shifting planes and facets on the canvas, by 1913 they could signify a guitar by means of an unmistakable double-curved plane, around which sometimes two views of the instrument – a side view and the surface across which the strings are stretched, for example – would be combined.

By the time Braque and Picasso had evolved to this phase of Cubism, however – and here once again one may note a parallel with latter-day Impressionism – many

other artists of varying talent and degree of comprehension had begun to try their hand at adapting earlier forms of Cubism for themselves. Generally speaking, the results, in terms of Cubism, were pathetic, whether one considers what was produced by those artists forming the Cubist Movement in Paris – Gleizes, Villon, Hayden, Marcoussis, Metzinger, Lhote and Le Fauconnier for example – or the pastiches of a de la Fresnaye, whose situation was not unlike that of Bastien-Lepage in relation to the Impressionists, or the misconstrued versions of Cubism taken over and used to other ends by artists of the Prague School, by the Italian Futurists, by the Vorticists and by Russians such as Malevich, Udaltsova, Popova and Exter.

Only one other artist, Fernand Léger – and he for only three years (1910-13) – can be said to have painted a series of truly Cubist works, the most authentic of which, the 'Woman in Blue' (1912; no. 97 of this Catalogue), is a Cubist masterpiece.

In the ultimate phase of Cubism between 1913 and 1919, Braque and Picasso, the original creators, moved on to produce, each in his own way – as had Monet and Renoir before them – a succession of great paintings in the so-called 'synthetic' form of Cubism. Gris, however, remained faithful to his original, strictly Cubist manner without attempting to keep up with the subsequent transformations by Braque and Picasso. His attitude is, in this respect, comparable with that of Sisley in relation to the later styles of Monet and Renoir.

At the end of this survey of Cubism as it was created and developed by Braque and Picasso, we are therefore led to the inescapable conclusion that it cannot be defined as a style any more than it can be identified by its subject-matter. Nor was it the expression in pictorial terms of any particular philosophy. By their very nature, as we have seen, Cubist paintings are essentially personal in character and bear the mark of an individual personality. They are, indeed, intimate records of a way of life and allow us an insight into the surroundings in which the original Cubist artists lived and worked. So, in conclusion, it seems appropriate to quote once again Juan Gris's enlightening comment that Cubism was 'not a manner' but 'a state of mind'.

Early Purchasers of True Cubist Art

No one has yet set out to ascertain the names of those people who purchased examples of true[1] Cubist art while it was evolving and in its climactic years, nor to establish the dates at which these purchases were made. But in this information lies the key to knowing about the sources of financial support available to these young, impoverished, revolutionary artists, Braque and Picasso,[2] while they were elaborating their new language of pictorial representation. This I have sought to record here. But I have also been interested in showing how it happened that Cubist art, scorned and mocked when it was first seen, rather quickly gained artistic prestige and came to enhance the original creators' reputations. For by 1920, Picasso and Braque were regarded by connoisseurs as masters to be reckoned with, whereas the stature of Gleizes, Metzinger and Delaunay, who had many supporters, was much less certain, and the same was also true of Gris and Léger. These interesting aspects of the history of Cubism challenged my curiosity, and I think it is appropriate that I should record my findings in a preface to the Catalogue of this historically-minded exhibition.

It will be more practical, as well as more desirable, to group and discuss the information in two parts: the first (1907-20) devoted to the activities of those whom one should collectively refer to as 'The Pioneers', while the second part (from 1921 onwards) will cover those I call 'Later Enthusiasts and Collectors'. But even the first and longer section needs to be dealt with in two parts, the first devoted to the role played by those courageous dealers who, from the start, bought 'true' Cubist paintings and sculpture from the artists themselves and continued buying new works regularly up until July 1914; the second part focussed on the first real collectors of Cubist art.

(i) The Pioneers: Dealers

A few dealers, whose activities I shall discuss below, had a virtual monopoly over the purchase and sale of 'true' Cubist art before 1914, because as a rule the artists did not sell to private purchasers. This arrangement might have worked against the buyer's interests, either by limiting the number of available works he had to choose from or by creating differences of price for the same work in different cities. But it did not, probably because Daniel-Henry Kahnweiler (the artists' principal dealer) kept the main and constantly growing stock of works together in Paris and himself controlled its international distribution. Also, no doubt, because the artists were

[1] As opposed to *derivative* (see the explanation in the Introduction).
[2] Gris and Léger did not join them until the end of 1912.

keen to sell all they could – they needed the money – and were ready to trust Kahnweiler to find buyers.

Braque had begun by showing paintings between 1905 and 1907 at the Indépendants and the Salon d'Automne, as did Léger and Gris in their turn: it was the best means of becoming known to the artistic public. Picasso, however, never exhibited there. By 1908, both Braque and Picasso were so disgusted by the unintelligent and unfriendly treatment they received from the ignorant critics that, with Kahnweiler's support, they gave up the practice of exhibiting at the annual Salons, and in due course Léger and Gris would follow their example. Kahnweiler did not, however, organise one-man shows of recent works in his gallery after an initial Braque exhibition in November 1908. Instead, he permanently kept a changing selection of paintings by his artists hanging on the walls of his gallery, where anyone interested could always ask to be shown more. In the course of time, various small private galleries – in Berlin, Düsseldorf, Munich and New York – established relations with the Galerie Kahnweiler, from whom they bought, until 1914, many Cubist paintings. Kahnweiler also sent as many as he could (on sale) to large exhibitions in other countries, for example to the Sonderbund show (organised by his friend Flechtheim) in Düsseldorf in July 1910 and to the Sezession in Berlin; he also participated in shows organised by Skupina (an artists' group) in Prague, in the second Post-Impressionist exhibition in London in 1912, and in the

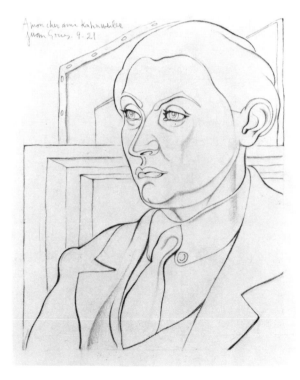

Gris
'Daniel-Henry Kahnweiler', 1921
Archives Galerie Louise Leiris

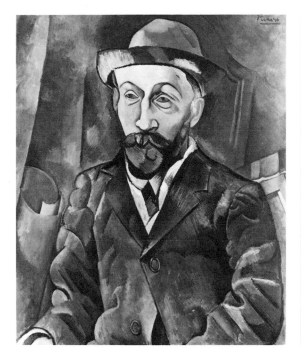

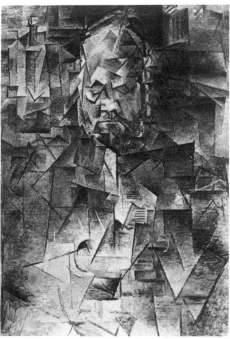

Picasso, 'Clovis Sagot', spring 1909
Hamburger Kunsthalle

Picasso, 'Ambroise Vollard', 1909-10
Pushkin Museum of Fine Art, Moscow

Armory Show in New York in 1913, which went also to Boston and Chicago. He was rewarded for this enterprise by several unexpected sales, but it also enabled him to familiarize the art-conscious public in several countries with the stylistic idiom of true Cubist painting and to make the names of these young artists more widely known.

The first two dealers who bought paintings from Picasso in the early analytical phase of Cubism were Clovis Sagot and Ambroise Vollard, both of whom had a gallery on the rue Laffitte in Paris. These men had been buying paintings, drawings and engravings from Picasso since 1901, when he was still unknown and lived in the *bateau-lavoir* in Montmartre.[3] Vollard continued buying large groups of paintings from Picasso until 1910, the year in which Picasso painted his portrait. Then Vollard decided that he could not accept the later development of Cubism, thought the artists were misguided in what they were doing, and two years later sold (1913) his portrait to Ivan Morosov. Sagot, on the other hand, whose portrait Picasso painted in the spring of 1909, had felt obliged to stop buying from him before this, because the artist's newly increased prices were beyond his means. Yet, Sagot could afford to buy from the young Juan Gris in 1911 a group of his early Cubist works, thus becoming his first supporter. Sagot had these paintings on his

[3]See Commentary to no. 111.

hands for less than three years, because in 1913-14 he sold them to Léonce Rosenberg, a young and rising collector-dealer.

The first major patron of the Cubist idiom created by both Braque and Picasso was the dealer Daniel-Henry Kahnweiler, a young German aesthete from Mannheim whose early training was that of a banker. By temperament, however, Kahnweiler was not interested in banking and set his heart instead on becoming an art-dealer. He convinced his rich uncles, who were also bankers, to back him in this enterprise with a considerable financial loan, after which Kahnweiler established himself in Paris and, in the spring of 1907, opened a gallery in the rue Vignon, close to the Madeleine.

When he started, Kahnweiler knew nothing about young artists in Paris, nor about recent stylistic developments in painting. So he had to look around and decide for himself what he liked and thought he could sell. His first purchases were paintings by Derain, Vlaminck and Braque – at the Indépendants of 1907 – and these constituted the basis of his original stock. Shortly afterwards, Kahnweiler came to know these three young *fauves* and, having decided to specialise in the most adventurous modern styles of painting, arranged to buy more works from them in the future. This was his first gamble. The second followed soon after when, unexpectedly, Vollard visited the gallery in the company of Picasso. This led, within a week, to Kahnweiler visiting Picasso in his studio in the *bateau-lavoir* in Montmartre. His main reason for going there was, ostensibly, to see a 'strange' painting – the 'Demoiselles d'Avignon', in fact – on which he had heard that Picasso was working. But, of course, he also hoped to buy some recent works by Picasso. In this, Kahnweiler succeeded, and thereby initiated what subsequently became a life-long (though occasionally frustrated) friendship. But it was in the autumn of 1908 that Kahnweiler made his first major coup, when he acquired a large group of early analytical Cubist paintings by Braque, which had been finished a few months earlier at L'Estaque. Braque had submitted these in September 1908 to the Salon d'Automne, where all but one were rejected by the jury. Braque thereupon withdrew the whole group and sold them to Kahnweiler who, within a few weeks, organised an exhibition in his gallery, secured a preface to the catalogue written by Guillaume Apollinaire and began to sell the paintings. It was on this occasion that the critic Louis Vauxcelles wrote in the newspaper *Gil Blas* that Braque's pictures were made up of 'little cubes'. After that, Kahnweiler continued to buy virtually all of Braque's production, and all that he could afford from Picasso, while waiting for collectors who appreciated the new style and were ready to acquire some of these paintings for themselves.

In the course of November and December 1912, Kahnweiler fulfilled a two-year-old ambition when he at last succeeded in getting both Braque and Picasso to sign a contract which gave him an exclusive right to purchase their entire output and specified the prices he would pay. At the same time, Kahnweiler signed a similar contract with Juan Gris, a young painter whom he had known for a few years. Gris

had only recently evolved a Cubist style of his own, influenced both by Picasso and Braque, as well as by the theoretically inclined artists of Puteaux, who formed the group known as the 'Section d'Or'.[4] Fernand Léger, one of whose paintings 'Woman Sewing' (Cat. no. 94), Kahnweiler had seen and bought at the Indépendants of 1910, was the last to be added to the small group, when he too signed an exclusive contract in October 1913. Thus, whereas Kahnweiler alone bought from Braque and was one of two or three dealers who bought from Picasso before November 1912, after that date and for the very brief period remaining before the declaration of war in August 1914, virtually every work produced by those four artists whom we now regard as the 'masters' of true Cubism, passed first through the Galerie Kahnweiler before it was offered to potential purchasers. In this way, there was no confusion – until Léonce Rosenberg opened the Galerie de L'Effort Moderne in 1918 – between 'true' Cubism and the work of those French artists who referred to themselves as Cubists,[5] and were thought of as such by the critics and public, who never saw works by the original creators of Cubism hanging in the annual public exhibitions in France. The French 'cubists' – Gleizes, Metzinger, Hayden, Villon, Marcoussis and de la Fresnaye – exhibited on their own, though their paintings were bought by many of the same collectors.

Such was the situation in mid-July 1914, when Kahnweiler left Paris for his annual holiday. Everyone realised, or at least sensed by then, that the outbreak of war could not be long delayed. Yet Kahnweiler who, like his friend Wilhelm Uhde, was a German national, took no precautions before leaving Paris to conceal the very large stock of Cubist paintings, drawings and prints which were either in his gallery, in storage or in his home. Did he believe that he was already French in every way except that of having changed his nationality? Or did he feel that a German running an art business in Paris, dealing in pictures by artists resident in France, would not be victimised? At all events, when all German nationals living in France were declared enemy aliens by the government, soon after the outbreak of war, Kahnweiler found that he was powerless to prevent the sequestration by the French of all his property and that he could not return to France. Uhde, naturally, received the same treatment.

In the summer of 1914, therefore, the four Cubist artists who had been supported by Kahnweiler found that the regular income to which they had become accustomed had disappeared, they no longer had a gallery in which to exhibit their works, while the buyers (mostly foreigners) of their paintings had left Paris. Kahnweiler, who was living in Switzerland, did nothing to help, and when Juan Gris, who was completely without financial resources, found some buyers for his paintings, he was threatened by Kahnweiler with a lawsuit after the war for alleged breach of contract. Picasso remained in Paris and continued painting: he did not suffer because he had saved money in the pre-war years, was paid by Diaghilev for

[4]Gleizes, Metzinger, Villon, Duchamp
[5]Listed in the Introduction.

executing the décor and costumes of the ballet *Parade* in 1917, and also received some contributions from friends. Braque and Léger, on the other hand, survived because both were mobilised and taken in hand by the army at the start of the war, but they could not, of course, continue painting. Moreover, both men were very seriously wounded early in 1916 and did not have any new paintings for sale before 1917-18. But at that moment they too had no longer a dealer to take care of them, no gallery in which to exhibit and apparently no one waiting to buy their paintings.

It was in these circumstances that, at the end of 1915, Léonce Rosenberg, the son of a dealer in antiquities and Impressionist paintings recently dead, found himself heir to a gallery in the Avenue de l'Opera and a small fortune. His younger brother Paul took over the interest in Impressionist paintings and opened a gallery of his own at 21 rue de la Boétie. But Léonce, who had bought some Cubist paintings by Braque and Picasso for himself before 1914, decided at the end of 1915 to give up dealing in antiquities and launch out into the modern field, when the war was over, through a new gallery of his own to be called the Galerie de L'Effort Moderne. It was established in the rue de la Baume, a narrow street running parallel to the rue de la Boétie. Rosenberg's war service was as an interpreter at the field headquarters of Allied Air Forces. He was therefore rarely in Paris, indeed only when he came on leave. But Rosenberg seized every chance that he could to visit the studios of the Cubist masters, as well as those of Laurens and Lipchitz, and of several of the secondary Cubists in order to buy paintings and sculpture. With some of the artists he signed contracts guaranteeing to buy their works up to a specific sum each year. Such was the case with Gris, Laurens, Léger and Lipchitz. Rosenberg was thus able, despite the war, to establish himself gradually as the only Cubist dealer and to assume something of Kahnweiler's role during the pre-war years. Then, at the end of the war, Rosenberg, who was more enterprising than Kahnweiler, decided to promote all the artists he represented, and in particular the recent work of the original Cubists, with a succession of major one-man exhibitions held in his own gallery. Thus, his opening show was of works by the sculptor Laurens, a friend of Braque, in May 1918 – Kahnweiler quickly took him away and signed his first exclusive contract with Laurens at the end of 1920 – followed by Braque in March 1919, by Gris in April, by Picasso in June and by Léger in October 1919.

However, Léonce's hold on the market for Cubist paintings was short-lived. After Kahnweiler's return to Paris in the second half of 1920, he intrigued with Gris to escape from his contract with Rosenberg and rejoin him in his new gallery, the Galerie Simon in the rue d'Astorg. Then, before long, Paul Rosenberg attracted Picasso, Braque and later on Léger away from his brother and Kahnweiler by offering them the backing of his own smart gallery and more tempting offers by contract of purchases. These arrangements survived throughout the 1920s, but at the end Paul Rosenberg dropped Léger, who returned to Kahnweiler, and subsequently (1935) had a joint contract with Louis Carré.

(ii) The Pioneers: Collectors

Against this background, it now becomes possible to discuss the people who frequented these galleries and exhibitions and purchased true Cubist paintings in the period between 1907 and 1920. The first fact to note, it seems to me, is how few of these purchasers were, in fact, French, and how few of the foreign purchasers actually lived in France. Kahnweiler's first client was Hermann Rupf, a tradesman from Berne and an old friend from his banking days. Rupf bought his first Cubist paintings by Picasso in 1907-08, added Braque in 1909, and came to Léger and Gris some five years later. Apart from some works by Kandinsky and Klee, bought

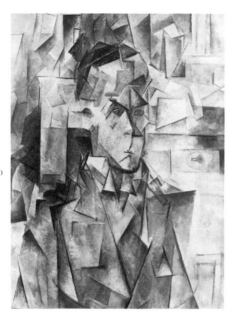 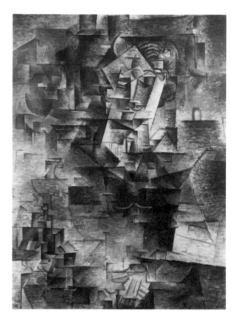

RIGHT
Picasso
'Wilhelm Uhde', spring 1910
Joseph Pulitzer Jr,
St Louis

FAR RIGHT
Picasso, 'Daniel-Henry
Kahnweiler', autumn 1910
The Art Institute of
Chicago, Gift of
Mrs Gilbert W. Chapman
in memory of Charles B.
Goodspeed

later, Rupf as a collector was faithful to Kahnweiler, from whom he continued to acquire one or two Cubist paintings, as well as works by Derain and Vlaminck, annually over a period of some forty years. Roger Dutilleul,[6] an active but discriminating French collector whose taste in modern French art was eclectic, bought his first Cubist paintings by Picasso and Braque from Kahnweiler early in 1908. Kahnweiler also got to know, at this time, the German collector–dealer Wilhelm Uhde, who lived in Paris, bought several Cubist paintings by Picasso from Kahnweiler, and especially a large number of Cubist works by Braque, beginning with some paintings at Kahnweiler's exhibition in 1908. During his few years of activity in Paris (1907-14), Uhde assembled a varied stock of modern paintings,

[6]This collection was inherited *c.* 1950 by his nephew Jean Masurel of Roubaix, who has added to it and recently given it to the town of Lille, where it becomes the nucleus of the new Musée d'Art Moderne du Nord.

beginning with Cubist works by Braque and Picasso, but also including works by Dufy, Herbin, Laurencin, Metzinger and Henri Rousseau. Uhde sold to friends, including some Germans: one such was the collector Edwin Suermondt, a well-to-do industrialist living in the Eifel, south of Düsseldorf, who bought from Uhde at the end of 1910 Braque's two still-lifes 'Violin and Palette' (no.9) and 'Piano and Mandola', which had been painted during the preceding winter. Kahnweiler and Uhde were the only dealers at this date who dealt in works by Braque, and we get a late glimpse of Uhde's commitment to true Cubist painting through the Catalogue of the sale in 1921 of his property sequestered in Paris, that is to say, the stock he had left behind in 1914. The lots offered at this sale included sixteen paintings by Braque, six by Picasso, and one each by Léger and Gris, which were in company with five by Henri Rousseau, five by Dufy, three by Metzinger, two by Herbin, one by Jean Puy, and five by Nils de Dardel.

Kahnweiler's major customers for Cubist paintings by Picasso in the pre-war years were, however, two Americans and two Russians: Leo and Gertrude Stein, prosperous bourgeois from San Francisco, who lived in Paris; also Sergeï Shchukin and to a much lesser extent Ivan Morosov, two rich merchants from Moscow. The two Steins, brother and sister, were not ambitious collectors – their financial resources were limited – but they were nonetheless selective. At the start, Leo, an unsuccessful painter with firm convictions in aesthetic matters, decided on what they should purchase, with the result that, in the winter of 1904-05, the Steins acquired – largely from Vollard – a group of paintings by Renoir, Cézanne and Gauguin. But at the Salon d'Automne of 1905, and during the two years following, Leo moved ahead and bought an impressive group of paintings by Matisse and Picasso, the latter from either Sagot or Vollard. Later, they bought directly from Picasso. However, in 1910 Leo refused to buy any more paintings by Picasso, because he had lost faith in the value of Cubism. On the other hand, Gertrude had identified herself by then with the Cubism of Picasso, and therefore sold off some of the nineteenth-century paintings in order to have some money to go on buying Cubist paintings by Picasso.

In 1913 Gertrude and Leo decided to separate and gave up living together in Paris. This meant that the paintings, which they regarded as joint property, had to be divided up between them. The outcome of this was that Gertrude retained several Cézannes, all the Picassos and a very few Matisses, while Leo contented himself with sixteen Renoirs, some Cézanne paintings and watercolours, and a few fine Matisses.

Gertrude Stein never bought any paintings by Braque or Léger, nor did she buy any works by any of the secondary Cubists. But in June–July 1914 she did buy from Kahnweiler three paintings of 1913 and 1914 by Juan Gris – perhaps because of her conviction that 'Cubism is a purely Spanish conception and only Spaniards can be Cubists'.

Shchukin, the more important of Kahnweiler's two Russian collectors, had been buying nineteenth-century French paintings – Courbet, Lucien Simon, Couture,

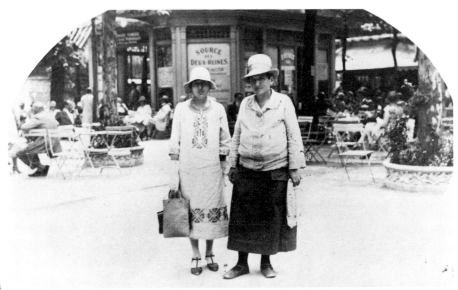

Alice B. Toklas and
Gertrude Stein in
Aix-les-Bains. 1920s

Puvis de Chavannes – since about 1895. However, soon after 1900, Shchukin's
taste evolved and he began to frequent the dealers Durand-Ruel, Cassirer, Bernheim
Jeune, Druet and most of all Vollard, from whom he went on acquiring – right up till
1914 – paintings by the Impressionists, by Cézanne and Gauguin, and later by
Bonnard. Shchukin also acquired some fine paintings by Gauguin directly from the
famous French collector Gustave Fayet. Beginning in 1909, that is to say,
simultaneously with his other line of purchases, Shchukin also began to buy, first of
all from Vollard, analytical Cubist paintings by Picasso. Already he owned several
major paintings by Matisse, whom he had met in 1907, and it seems to have been
Matisse who directed him to the Galerie Kahnweiler, where he could see more
Cubist Picassos. Shchukin already owned some Picassos of the years 1901-05,
which he had bought from Vollard, but between 1911 and 1914 he again bought
important paintings of this period from both Kahnweiler and Vollard, as well as
from the Steins, to balance his fine and still growing collection of Cubist paintings by
Picasso. In 1911, also, Shchukin acquired from Kahnweiler the only Cubist
painting by Braque ever to enter a Russian collection: one of the five versions of 'Le
Château de La Roche Guyon' of 1909 (see no. 8). It is not, therefore, surprising that
when he stopped buying in 1914 Shchukin owned the largest collection of works by
Picasso, particularly of Cubist works, in private hands, with a lot of other works by
Matisse, the Nabis, M. Denis, van Dongen, Marquet and Derain besides. Shchukin
possessed fifty important paintings by Picasso, all except twelve being later than
1907; one Cubist painting by Braque; thirty-seven paintings by Matisse, and some
forty more by other modern French artists. The second Russian collector, Ivan
Morosov, who bought much less at the Galerie Kahnweiler, had begun in the 1890s
by buying contemporary Russian art. But he had an elder brother, Mikhail, who

bought Impressionist paintings, and when he died in 1903 leaving his paintings to the Tretiakov Museum, Ivan decided to change and start assembling this type of collection for himself. Although Ivan Morosov's taste was not adventurous, he sought assistance from his more knowledgeable friend Shchukin and was soon buying, largely from Vollard, paintings by Van Gogh, Gauguin, Cézanne, Maurice Denis and Bonnard, as well as some early paintings by Picasso. Then in 1912 he bought major paintings by Matisse, and in 1913 acquired from its subject Picasso's cubist 'Portrait of Vollard' (1910).

Another European collector who bought, from Kahnweiler and Vollard, many fine Cubist paintings by Braque and Picasso from 1909 onwards was the Czech art historian Vicenč Kramař, who before 1913 spent a great deal of time in Paris, wrote extensively about Cubism and in 1919 was appointed Director of the National Gallery in Prague.

Nor must I forget to mention another group of dealers who bought Cubist paintings from Kahnweiler between 1910 and 1914. First there was Alfred Flechtheim, a former grain-merchant, who opened galleries in Berlin and Düsseldorf in 1912; Justin Thannhauser of Munich, who held a Picasso exhibition there early in 1913; Alfred Stieglitz of New York, who in March 1911 showed an important group of Picasso drawings that he had bought in Paris, and in December 1914 held a second exhibition of paintings by Braque and Picasso; and lastly Brenner and Coady of The Washington Square Gallery in New York, who in 1913 were the first Americans to buy paintings by Juan Gris.

These American dealers, in conjunction with a group of modern-minded young American artists, who hoped to break the hold of the National Academy of Design over aesthetic matters in America and establish the right of independent modernists to be included in official exhibitions, were active backers of and lenders to the famous Armory Show that opened in New York in February 1913. This privately sponsored exhibition, the first of its kind in America, contained a major European section in which were represented all the late nineteenth-century French masters down to van Gogh, Gauguin and Bonnard, followed by a large, contrasted and intentionally astounding group of twentieth-century artists, including Braque, Brancusi, Delaunay, Duchamp, Matisse, Kandinsky and Picasso. Not many true Cubist paintings were on view there (more due to chance than to prejudice) but these few were all sold. New York art circles received a major visual shake-up, and the show resulted in convincing important New York figures – for example, the painter Arthur B. Davies, John Quinn and Walter Arensberg in particular – to go and buy more contemporary works by European artists. These collectors, however, were not to be hurried, so it was some three years after the Armory Show had closed before a man like Quinn acquired any Cubist paintings. He was a major buyer of works of earlier date by Picasso, and also bought a large number of paintings by secondary Cubists. But Cubism proper did not appeal to him, any more than it did to such collectors as Albert Barnes and Lillie Bliss, who were actively buying modern

French paintings throughout the 1920s. Even Walter Arensberg, who was buying from about 1916 until the early 1930s and amassed a very fine group of Cubist works by Picasso, Braque, Gris and Léger, thought more highly of Marcel Duchamp and Picabia.

Some other European purchasers of true Cubist paintings after 1910 deserve mention here. Christian Tetzen-Lund of Copenhagen, who had already assembled a group of fine paintings by Matisse, the Fauves and the Nabis, added to his collection some Cubist works by Picasso in the years between 1912 and 1922; H.J.T. Norton of London, a friend of Clive Bell, acquired Picasso's 'Bottle and Books' (1910-11) at the Post-Impressionist Exhibition of 1912; Frau Ida Bienert of Dresden, who had bought her first Cézanne in 1911, already had a collection consisting mainly of works by Kandinsky, Feininger and Klee when, between 1914 and 1918, she bought from Flechtheim two 'Contrasts of Forms' (1913) by Léger and a splendid *papier collé* (1913) by Picasso. Nor should one forget Pierre Faure who, buying from Léonce Rosenberg, put together between 1915 and 1927 a large collection of twenty-six paintings by Juan Gris, executed between 1912 and 1919, the emphasis of which was on the period 1917-18. Lastly, it should not be forgotten that in 1919, at the height of his success with new ballets in décors by Picasso, Derain, Matisse and Braque, Leonid Massine, the dancer and choreographer, was taken to the gallery of Léonce Rosenberg by Diaghilev and persuaded to invest part of his salary in recent paintings by Braque, Gris and Picasso.

I think the moment has now come when we can ask ourselves what salient points emerge and create a pattern in the collecting of Cubist paintings before 1920. The secondary Cubists were undoubtedly more sought after than the original creators, and their works fetched high prices. But my purpose here is confined to discussing the purchasers and collectors of Cubism proper. And I would note right away the important role played by those dealers who, in the early years, believed in the pictorial significance of Cubist painting as it was evolved by Braque and Picasso, and who were not afraid to buy and exhibit this in considerable quantity, just as Kahnweiler did again a few years later for Léger and Gris. I am thinking here of the dealers Sagot, Vollard, Uhde, Kahnweiler, Léonce Rosenberg, Stieglitz, Flechtheim and Brenner and Coady. That the original Cubist artists preferred to sell their works through dealers, rather than have potential purchasers coming to their studios, can be accounted for as a defence against being distracted from their work, and as a way of safeguarding their frequent desire to leave Paris and yet not cut themselves off from their public of buyers. It is easy to overlook how, after 1908, both Braque and Picasso did much of their finest and most creative work in villages far away from Paris.

Secondly, it emerges that very few of the early purchasers of true Cubist painting were French: they were Russians, a few Germans, Gertrude and Leo Stein, and one Czech before 1914, with other Americans starting to buy in 1911.

This is not the picture that is usually presented of how things were at the start. Of

course, a complete change occurred after 1921. That is why I have chosen to make a break at this date. Moreover, with the Uhde and the first Kahnweiler sales occurring in the summer of 1921, and three more Kahnweiler sales being held at intervals over the next two years, such a break is justified historically. When these sales were over, it was apparent that nothing was the same as before. The Cubism of Braque and Picasso, of Gris and Léger, had entered the public domain and was coming to be seen as a stage in the modern development of pictorial art. Materially, these sales produced very little money, but afterwards the names of the masters were more familiar, while as a consequence of various successful bids (often by dealers) their paintings came to be redistributed throughout western Europe, and before long reached America too. Lastly, these sales stimulated the emergence of several new and alert collectors, who went on buying Cubist paintings for some years.

(iii) Later Enthusiasts and Collectors

Inevitably, since more than 600 works – paintings, drawings and prints – by the four Cubist masters and some 500 more, predominantly by Derain and Vlaminck, but also including others by Friesz, van Dongen, Metzinger and Guillaumin, were suddenly thrown on the open market in five forced sales, the art world of Paris was in a great state of agitation beforehand. There were those, the traditionally minded, who had always feared and resented true Cubist painting, which they could not understand, who now secretly hoped that many paintings would find no buyers, and that in consequence prices would be very low, thereby finishing off for ever the prestige of the style and the artists who had created it. For still others, who remembered the scandalous outburst against Cubism in the Chambre des Députés in December 1912,[7] this manner of painting had been created by Germans and then promoted by German dealers in Paris, so that they were happy to anticipate yet another form of German defeat. On the other hand, some genuine admirers of Cubism welcomed the sales in advance, because they hoped for a chance of acquiring some important paintings cheaply for themselves. Lastly, Kahnweiler's friends were outraged that Léonce Rosenberg had agreed to act as 'Expert' at these sales, which gave him a chance to liquidate the stock of his commercial rival at knock-down prices and take advantage of his privileged position to expand his own.

So far as the artists involved and Kahnweiler himself were concerned, their attitudes differed. Picasso, for example, paid no attention and did not protest, as he might have, that the sales would undermine his newly won prestige and upset his much higher scale of prices for recent work. Braque and Léger, on the other hand, were wholly opposed to the sales out of fear for their future; while Gris thought

[7]See P. Daix, *Picasso: The Cubist Years* (Boston and London, 1979), p. 285 (bottom right).

Rosenberg 'an ass' to want to liquidate so much stock at one time, because the unfavourable result of the sales would be as damaging to him as to Kahnweiler. But Gris made no open protest.

The Uhde and the first Kahnweiler sale in May and June 1921 went not too badly from the financial angle, but the prices at the last three Kahnweiler sales in 1922 and 1923 were very much lower. Important Cubist works by Braque went for between 250 and 550 frs. each; works by Gris fetched between 65 and 150 frs.; while those by Léger went for between 75 and 500 frs. These prices were well below those paid for works by Vlaminck, far less than those paid for paintings by Derain and barely half what had to be paid for recent works by the artists. Only Picasso, in a price range between some 200 and 1250 frs., with a few major works fetching more, could compete with Derain and Vlaminck, and when collective lots of anything between twelve and twenty-five mixed drawings, watercolours and *papiers collés*, all by any one of the four Cubist artists, were offered, the overall price generally dropped so low that individual sheets were fetching less than 5 frs. apiece. Thus the final result of these sales was the sort of disaster that had been foreseen, and it was not compensated for by an indemnity of DM. 20,000 paid to Kahnweiler by the German government.

A lot of interesting new names of purchasers can be found in the official records of these sales. Officialdom in France, England and elsewhere in Europe and America still had such a strong aversion to modernism that the museum of Oslo, which bought two Picasso paintings of 1912, was the only museum with courage. On the other hand, a group of far-seeing contemporary French artists, writers and Dadaist poets – for example, Ozenfant, Le Corbusier, Lipchitz, André Breton, Paul Eluard, Tristan Tzara and Maurice Raynal – appeared unexpectedly and bought in quantity. Many of these purchases were made for themselves, but sometimes they were bidding on behalf of new collectors like Raoul La Roche, a Basel banker living in Paris, who in 1923 moved into a house in Auteuil designed for him by Le Corbusier; Jacques Doucet, the Paris couturier, who in 1921 had appointed André Breton to be his artistic and literary adviser, also made several purchases and, in a private deal at this time, became the first owner of 'Les Demoiselles d'Avignon' by Picasso. Then there was Josef Müller of Solothurn, who had been much impressed when he saw the Armory Show in New York in 1913 and now bought paintings by Picasso and Léger; also the collector-dealer Alphonse Kann, an Austrian living in Paris who had been buying Impressionist and Post-Impressionist paintings since about 1907, now began to buy paintings by Braque and Picasso. Dr Albert Barnes of Philadelphia bought, through Durand-Ruel, some twelve paintings by Picasso and some Braques; the Comte Etienne de Beaumont, who in 1924 was to organise a ballet season for Massine under the title *Soirées de Paris*, for which Picasso and Braque (among others) provided décors, also bought through Durand-Ruel at the sales a beautiful cubist painting of 1913 by Braque; while Alfred Richet, who subsequently put together a modest collection of fine-quality paintings, made his

first purchases there too. Siegfried Rosengart, a German who had recently broken with his cousin Thannhauser and opened a gallery of his own in Lucerne, made various purchases; Jacques Zoubaloff, who bought Picasso, Braque, and Gris, went on to assemble within a few years a highly varied Cubist collection, including works by Valmier, Survage, Severini and Herbin, with sculpture by Laurens and Lipchitz; another major buyer of Braque and Picasso was the Russian sculptor Oscar Miestschaninoff, a close friend of Lipchitz – the two artists lived in adjoining studios designed by Le Corbusier – who bought extensively as a speculation for resale, as did Jean Crotti, brother-in-law of Marcel Duchamp, and also the dentist Tzanck. Lastly we come to two women, students of Gleizes, Evie Hone of Dublin and Sally Lewis from Portland, Oregon, who bought works of 1914 by Gris.

As was to be expected, Léonce Rosenberg, paying full sale-room prices, bought a very great deal, acquiring in particular many of the Légers.

Kahnweiler himself, who had returned to Paris in 1920, had opened a new gallery, the Galerie Simon in the rue d'Astorg, using the name of his French backer. He was disqualified by law from making any purchases at these sales under his own name, so instead he was represented by a syndicate of friends and relatives – his younger brother Gustav, his brother-in-law Herr Forchheimer, his sister-in-law Louise Godon, Hermann Rupf and Alfred Flechtheim – who bought shares in a speculative dealing operation and bid under the fictitious name of 'Grassat'. Their role was to try and acquire, for pre-determined values, the works on a list drawn up before each sale by Kahnweiler. At the end of each sale, any share-holder could either buy out the other partners at a profit and keep a specific work for himself, or else it was added to the growing stock of the Galerie Simon, which later distributed the money available to the share-holders when the work had been sold. By this means, Kahnweiler was able to buy back for his gallery the great majority of works by Gris in the Catalogues, as well as a considerable number of Braques, Légers, Derains and Vlamincks, the last two being regarded as a quick-selling, profitable investment. The syndicate did not, however, buy back a single work by Picasso – between 1920 and 1927 Picasso and Kahnweiler were temporarily not on good terms – not so much because Kahnweiler forbade them to do so, but because Rupf was opposed to it. The result of this operation with the 'Grassat' syndicate resulted in Kahnweiler reacquiring a good proportion of his pre-war stock, and when everything had been sold and the members of the syndicate paid out, everyone agreed that the gamble had been worthwhile.

By the time these sales were over, true Cubist painting was recognised by a small percentage of visually alert members of the art-conscious public to have been the beginning of a stylistic revolution which was inevitable. Such people could see and admire the fine quality of execution and feel in Cubist painting a new and serious approach to pictorial representation, determined by new conceptions of form, space and time characteristic of a twentieth-century outlook and which inevitably had to find expression in its art. In no other contemporary idiom could they find these

values. The non-figurative language of art, which grew out of one aspect of Cubism, presented no problems of interpretation, and offered little to stimulate the imagination. The imagery of Surrealism produced laughter but carried no convincing significance as art. Also people were beginning to see that the original Cubist artists, all of whom were alive and at work, had continued to pursue a development from their earlier, severely structured style towards a degree of humanisation. As a result, each had evolved a personal, colourful, 'readable' late Cubist idiom, the imaginative richness of which, added to the subtle interplay of forms, suggested the hand of a master at work.

It is in this context, remembering that the current trend in collecting then, especially in America, was towards Cézanne, Gauguin, Bonnard, Vuillard, Henri Rousseau, Matisse, Derain, Utrillo and Modigliani – remembering too the boom of the immediate post-war years in America and Europe which lasted until 1929 – that one must situate the formation of a certain number of collections which embraced several Cubist paintings, dated even as recently as 1919. Let us consider first of all some collections that were formed in Paris. I have mentioned Jacques Doucet. He had a large apartment, newly decorated in the *art deco* style, which housed a newly acquired collection of major Cubist works by Picasso, Braque and Laurens. Then there was Raoul La Roche, whom I have also mentioned, who assembled a very considerable number of Cubist paintings by Braque, Gris, Léger and Picasso, as well as by Ozenfant and Le Corbusier, many of them of major importance, and continued to add to his collection over the next few years. Jacques Zoubaloff, who bought throughout the 1920s, owned several fine Cubist works by Picasso, Braque, Gris, Laurens and Lipchitz. Another collector was Rolf de Maré from Stockholm, the founder in 1920 of the Ballets Suédois, for which Léger designed the décors and costumes of two major ballets: *Skating Rink* (1922) and *La Création du Monde* (1923). De Maré had been buying Cubist paintings since at least 1914, when he paid 3000 frs to Uhde for 'The Bowl of Fruit' by Braque (Cat. no. 5), while in 1915 he bought from Flechtheim in Düsseldorf for DM4000 Picasso's 'Man with a Mandoline' (Cat. no. 129). De Maré was not a purchaser at the Kahnweiler sales, but by 1922 he was the owner of three very fine Cubist paintings of 1912 and 1916 by Picasso, of four fine paintings by Braque executed between 1908 and 1911, as well as a fifth of 1919, of three major paintings by Léger dating between 1914 and 1917, and of two small works by Gris of 1913, as well as of later paintings by Léger, two paintings by Seurat and several other works. Then there was the Baron Gourgaud who, after marrying Eva Gebhardt, an American actress, began in the mid-1920s to assemble a group of fine modern paintings to add to the splendid collection of French nineteenth-century art which he had inherited. Gourgaud's purchases consisted of a group of major works by Picasso of the period 1917-19, several Légers of the period 1918-20, and five paintings by Gris executed between 1912 and 1925.

Looking now outside of Paris, we find René Gaffé of Brussels buying, in the first

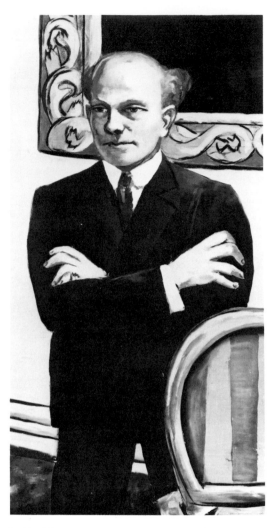

Max Beckmann
'Dr G.F. Reber', 1929

half of the 1920s, some fine early Cubist paintings by Picasso and Gris; also Mevr.
Krüller-Möller of The Hague adding, again in the first half of the 1920s, to her very
large and important collection of modern works some unusual Cubist paintings by
Picasso, Braque and Gris, which came from Léonce Rosenberg. Then there was the
German collector-dealer Dr G.F. Reber who, from 1921 onwards for almost ten
years, was exchanging his very considerable collection (made before 1914) of
works by Cézanne, Degas, Manet, Renoir and other nineteenth-century French
artists in order to assemble a major collection of very fine-quality early Cubist and
later works by Braque, Picasso, Gris and Léger, which he obtained from Vollard,
Paul Rosenberg, Léonce Rosenberg and the Galerie Simon. By 1930, indeed, Reber
possessed a private collection of outstanding and finely selected paintings by the
four Cubist masters which was unrivalled.

So far as America was concerned, John Quinn, who acquired a very large mixed collection of works by French artists, put together his never very large group of Cubist paintings by Picasso, Gris and Braque (one work) almost entirely in the years between 1915 and 1920. Then in 1922 Katharine Dreier, who had formed the Société Anonyme with Marcel Duchamp to acquire a museum type of collection in order 'to spread an understanding of the New Forms of Art which the coming era was creating', acquired from Léonce Rosenberg an excellent group of Cubist paintings by Picasso, Braque and Gris. In Germany, Italy and, of course, England, where Augustus John was still more highly valued than Matisse and Picasso, no collectors of true Cubist painting existed either before or after the war. Indeed, when Gustav Kahnweiler (aided by his brother in Paris) opened a gallery in Frankfurt with Flechtheim in 1922, and even as late as 1927, when they exhibited Cubist paintings by Picasso in Berlin, not a single work was sold. In Paris, on the other hand, in the early 1930s, a new collector, the banker André Lefèvre, a close friend of Alfred Richet, began to form a collection which eventually included several excellent Cubist paintings by Braque, Picasso, Gris and Léger as well as sculpture by Laurens. He bought mainly from the Galerie Simon, but by that time an interested collector could find in other galleries such as the Galerie Percier (André Level) important Cubist works, often coming from collections which had existed and had recently been dissolved. The Quinn collection, for example, was auctioned after his death (1924) in Paris in 1926 and in New York in 1927; the collection of Pierre Faure was acquired as a whole by the Galerie Simon in 1933; Dr Reber was obliged in the early 1930s to sell off a large number of his finest paintings by Braque and Picasso; and lastly the collection of Jacques Zoubaloff was sold at auction in Paris in 1935.

This was the situation at the beginning of the 1930s, as I discovered for myself when I first began to be deeply involved with twentieth-century art, and in particular with the painting of the true Cubists. It was a favourable moment for a collector to buy because the earlier boom had turned into a terrible and long-lasting slump, with the result that the prices for paintings by the four masters of Cubism had again fallen, having been pushed upwards in the later 1920s by a growing demand for the American market. I took advantage of the situation for myself as best I could and in 1932 began to buy true Cubist paintings with the intention of forming a substantial collection of my own. This pursuit became for me the adventure of a lifetime and led to my coming to know not only the artists concerned (apart from Gris, who was already dead) but also a great many of the dealers and collectors I have mentioned.

D.C.

Notes on the use of the Catalogue

For the convenience of readers, the works included in the exhibition are arranged in chronological order and organised in this catalogue in the following sections:

FOUR MASTERS

Georges Braque Paintings and *papiers-collés*
Drawings
Prints

Juan Gris Paintings and *papiers-collés*
Drawings and watercolours

Fernand Léger Paintings
Drawings and watercolours

Pablo Picasso Paintings and *papiers-collés*
Drawings and watercolours
Prints
Sculpture

TWO CUBIST SCULPTORS

Henri Laurens Sculpture and works on paper

Jacques Lipchitz Sculpture and works on paper

ASSOCIATED FRENCH ARTISTS

Robert Delaunay Paintings

Albert Gleizes Paintings and works on paper

Louis Marcoussis Prints

Jean Metzinger Paintings

Jacques Villon Painting and prints

The titles, dates and places of execution (where given) have been assigned by the authors, except in those instances where the artist has so inscribed the work in question.

Details regarding media, dimensions and inscriptions have been supplied by the owners of the works. Dimensions in inches precede those in centimetres, enclosed in parentheses: height precedes width.

The authors have restricted the literary references to *catalogues raisonnés*, museum and collection catalogues, and a few strictly relevant documentary sources (artist's letters, early monographs, etc.). The full citations for the references referred to in abbreviation will be found in the Bibliography; readers should consult these publications for further information regarding exhibition and bibliographic references, which are not included here.

The authors have taken special care to compile (often for the first time) as accurate and complete a provenance for each work as is possible. In this they have been aided by access to the archives of the Galerie Kahnweiler and new information regarding the purchasers at the four Kahnweiler sales in Paris, 1921-3. The details given in the provenance should be read in the light of the information in the essay 'Early Purchasers of True Cubist Art.'

Georges Braque 1882–1963

Georges Braque, 1910 *Archives Laurens*

1 Landscape at L'Estaque

Painted in late autumn 1907
Oil on canvas, $25\frac{5}{8} \times 31\frac{3}{4}(65 \times 81)$
Signed bottom left: 'G. Braque'; signed and dated on back: 'G. Braque 07'

Lit: I. no. 30; M. (1907-14) no. 1; Rubin 1977, p. 160; Museum inv. no. 82.22

Prov: the artist to Galerie Kahnweiler, Paris (photo no. 1177), 1908; unidentified private collection, Paris, 1908-79; on the market, Paris, 1979; Galerie Berggruen, Paris; E. V. Thaw & Co., New York, 1981-2; to the museum in 1982
Minneapolis Institute of Arts. John R. Derlip Fund, Fiduciary Fund and various Donors

At the end of September 1907, Braque returned from La Ciotat, where he had worked all summer, to Paris, where he expected a group of his recent works in a *fauve* style to be hung at the Salon d'Automne. In fact only one of them was accepted. But on this occasion Braque was able to study there at leisure a major retrospective of works by Cézanne, who had died a year previously.

Throughout the summer of 1907, Braque, wearying of the late Impressionist and decorative element of Fauvism, had been painting with more concern for structure in a Cézannian manner. He had seen a large exhibition of Cézanne's late watercolours at the Galerie Bernheim in Paris in 1906. Then in late autumn 1907, Braque substituted Cézanne as his mentor in place of his former friends Matisse and Derain.

This stylistic transformation began to occur at L'Estaque – a small town and port outside Marseille where Cézanne had worked, especially in the early 1880s – whither Braque moved at the beginning of September 1907 and to which he returned from Paris late in October. The present painting, executed presumably in October-November 1907, is an outstanding early example of the emerging new style of painting. The framing of the landscape between trees, the dual perspective down through and upward over the viaduct, the high horizon, the open featureless foreground, and the elementary geometrification of certain forms are all features derived from Cézanne's landscapes of the 1880s. But Braque is still indebted to Fauvism for his range and use of colour.

When Braque executed this painting, Picasso had completed the 'Demoiselles d'Avignon' some six months previously, and was then exploring the formal simplifications of primitive idioms, as in 'Standing Nude' of the summer and 'Three Figures under a Tree' of late autumn 1907 (nos. 112 and 113). It was fully a year later before Picasso began to investigate the stylistic innovations of Cézanne in works such as 'The Chocolate-Pot' (no. 159) and 'Landscape with a Bridge' of spring 1909.

The representation of space and form are the chief preoccupations of the artist here, and he has tried to make the eye experience these in as full a manner as possible. The conception of naturalistic imitation has been discarded. The artist has asserted his right to combine what we see and know of natural reality to make a pictorial representation of the scene without recourse to illusionism.

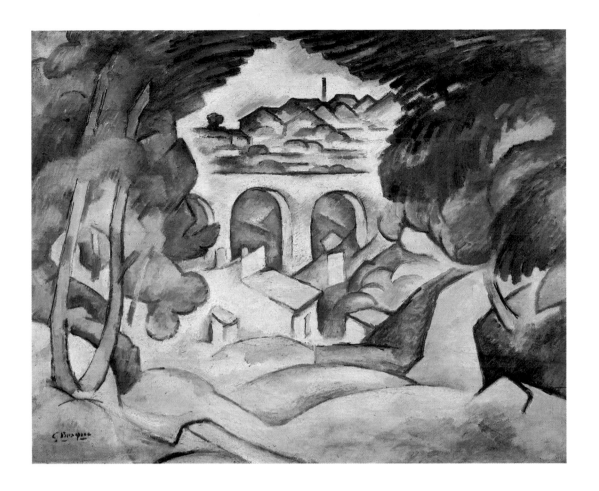

2 Standing Female Nude

Painted between December 1907 and June 1908
Oil on canvas, $55\frac{1}{4} \times 39\frac{1}{2}$ (140 × 100)
Signed bottom right: 'G. Braque'; signed and dated on back in blue pencil: 'Juin 1908 / Braque'

Lit: I. no. 31; M. (1907-14) no. 5

Prov: the artist to Galerie Kahnweiler, Paris (photo no. 1014), 1908-14; sequestered Kahnweiler stock, 1914-22; 3rd Kahnweiler sale, Hôtel Drouot, Paris, 4 July 1922, lot 39, sold for 240 frs. to André Breton, Paris, 1922-?; Marie Cuttoli, Paris, before 1936-7; to the present owner in 1972
Alex Maguy, Paris

When Braque had visited Picasso in his studio in late September 1907, he had reacted strongly against what he saw in the 'Demoiselles d'Avignon' of expressionistic violence and of crude, primitivising angularity in the treatment of forms. Yet, on reflection, he seems to have understood that Picasso, like himself, was seeking a new form of pictorial representation. Within a month of seeing the 'Demoiselles', Braque himself embarked on an ambitious and unexpected figure composition, the present 'Standing Female Nude', which he continued to work on until June 1908. There is tangible evidence in it of Picasso's influence on the conception of the figure, and no doubt Braque was partially motivated, when he started to paint this picture, by a desire to compete. However, the rounded forms, the twisted body, the lack of angularities, the use of modelling, the concern with volume and space, and the choice of colours reflect unmistakably the influence of Cézanne ('Bathers' of the 1880s), and of Matisse ('Blue Nude' of early 1907), as well as Braque's own recent pictorial experiences and steadily evolving new stylistic conceptions. What gives this painting a historical and stylistic importance, especially in regard to the evolution of Cubism, are the novelty and individuality of its conception as a painting, and the convention-defying innovations made by the artist. Here Braque worked from imagination and not from a model.

Compare this with the contemporaneous etching of a less contorted 'Standing Nude' (no. 49) which was probably executed at the end of 1907.

Following this a few months later, Braque made a drawing of three interlocked female figures which were intended to add up to a representation of a single 'Woman' (repr. M. (1907-14), p. 62). The figure on the left relates closely to the present 'Nude', but the forms are treated with a degree of primitivism which suggests the influence of memories of the 'Demoiselles d'Avignon'. This drawing, 'Woman', was given by Braque to the American journalist Gellett Burgess, apparently in April 1908. Alvin Martin has shown conclusively, on the basis of internal evidence, that Burgess's interview with the artist cannot have taken place at any later date. The drawing suggests, incidentally, that Braque was already aware of certain negroid figure compositions executed by Picasso after the 'Demoiselles', such as no. 113.

This painting, the engraved 'Nude' (1907) and the Burgess drawing (which may have corresponded to another painting now lost), in three differing styles, constitute the whole of Braque's involvement with the human figure until he executed two paintings of a 'Woman Playing a Mandolin' in an early analytical Cubist style in the spring of 1910 (see no. 13).

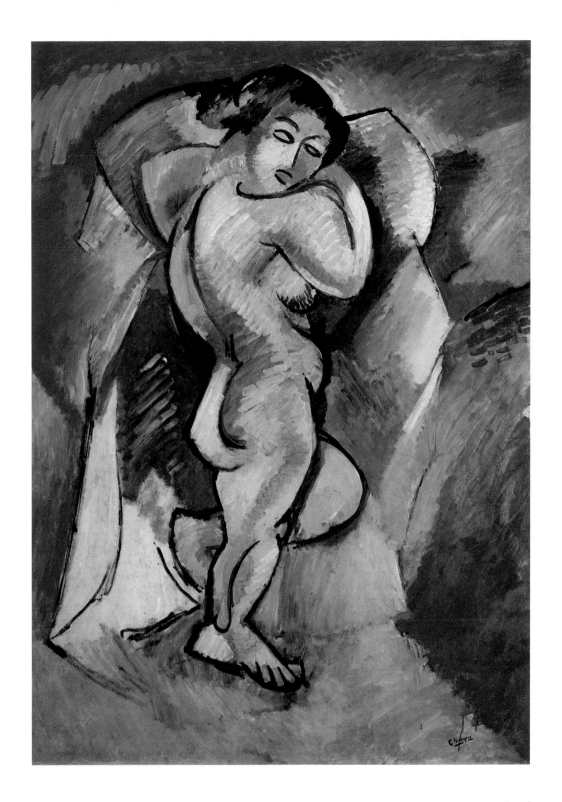

3 L'Estaque: Viaduct and Houses

Painted in early summer 1908
Oil on canvas, $28\frac{1}{2} \times 23\frac{1}{4}$ (72.5 × 59)
Neither signed nor dated

Lit: M.(1907-14) no. 12; Rubin 1977, pp. 175-6

Prov: the artist, Paris, 1908-63; bequeathed to M. and Mme Claude Laurens, Paris 1963-83;
to the present owners in 1983
Private collection, Paris

Braque has here chosen as his subject the central section of 'Landscape at L'Estaque' (no. 1) but has largely composed the scene from memory and imagination. Appearance is, as it were, amplified in this painting by knowledge. The influence of Cézanne persists here both in the composition, the limited range of colours and the parallel hatchings of the brush strokes. The viewpoint is varied and the eye is directed down and up by the lines of the rooftops. There is no vanishing-point in this painting, the depth of space being checked by the viaduct; thus the surface of the canvas takes on a new life and importance.

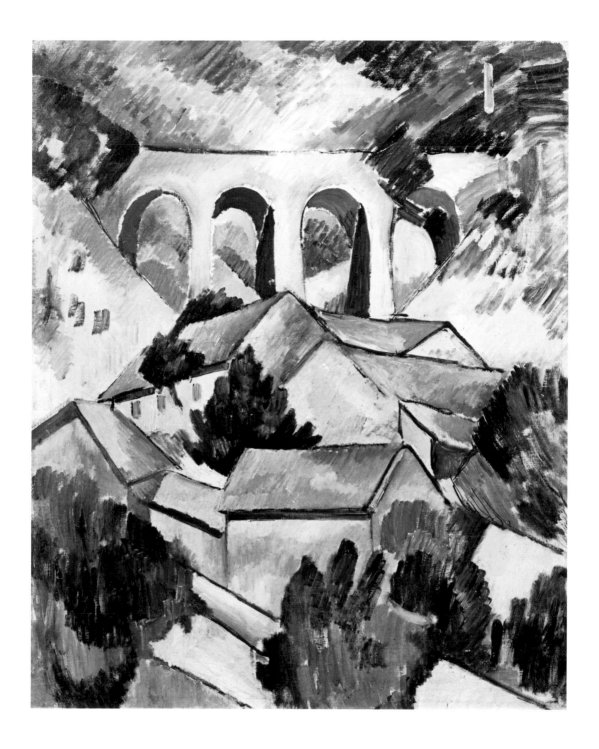

4 Big Trees at L'Estaque

Painted in summer 1908
Oil on canvas, $31\frac{1}{8} \times 23\frac{5}{8}$ (79 × 60)
Formerly signed on back (now relined): 'G. Braque'; not dated

Lit: I. no. 38; M. (1907-14) no. 18; Rubin 1977, pp. 175-80

Prov: early whereabouts unknown; Jan Heyligers, Paris; Dr G. F. Reber, Lausanne; Paul Adamidi
Frasheri Bey, Nice and later Geneva, by 1934 until 1945; to the present owner in 1945
Private collection

At the end of May or the beginning of June 1908, Braque left for L'Estaque. He remained there until the end of September, when he returned to Paris to present his latest works at the Salon d'Automne. Although they were all refused, they could be seen a few weeks later in a hastily arranged exhibition at the gallery of his new dealer, Henri Kahnweiler.

Braque was already set to pursue a stylistic development stemming from Cézanne and, in a matter of four months, produced a homogeneous and daringly innovative group of some thirty landscape and still-life compositions. He dispensed in these with the bright colours of Fauvism in favour of a palette of greens, ochres, black and grey used structurally rather than descriptively. Here Braque combines multiple viewpoints with an inconsistent use of light from different sources to define planes, and show more of an object than the eye normally sees. The denial of spatial depth is here more pronounced than in 'Viaduct and Houses' (no. 3).

Talking to Dora Vallier in 1954, Braque was to say of his change of attitude:

What impressed me about Fauve painting was its novelty ... It was painting full of fervour ... I was twenty-five ... I liked this physical painting ... then I realised that the paroxysm in it could not be sustained. Why? When I returned a third time to the south, I found that the exaltation which had overwhelmed me on my first visit, and which I put into my pictures, was no longer the same. I saw something else.

And in spring 1908, talking to the American reporter Gellett Burgess about the drawing showing three female figures entitled 'Woman', Braque explained that 'to portray every physical aspect of such a subject had required three figures, much as representation of a house requires a plan, an elevation and a section', Braque's handling of a landscape, as here, was consistent with his attitude to a figure.

Braque has here gone beyond Cézanne in disregarding natural appearances. The sky and natural light are excluded, recession is evoked by framing the landscape in an arch of interlocked trees, helped by a series of planes tilted at varying angles to the surface of the canvas. Within the central oval, formalised buildings and trees are piled upwards in a diminishing scale. This appears to be the definitive version of this subject and was probably executed in September 1908.

Reviewing the Braque exhibition at the Galerie Kahnweiler, where this and related paintings (including 'Houses at L'Estaque', M. (1907-14) no. 14) were shown, Louis Vauxcelles wrote in *Gil Blas* (14 November 1908) that Braque reduced 'everything, sites, figures and houses to geometric outlines, to cubes'. From then on, the new style was generally referred to as Cubism.

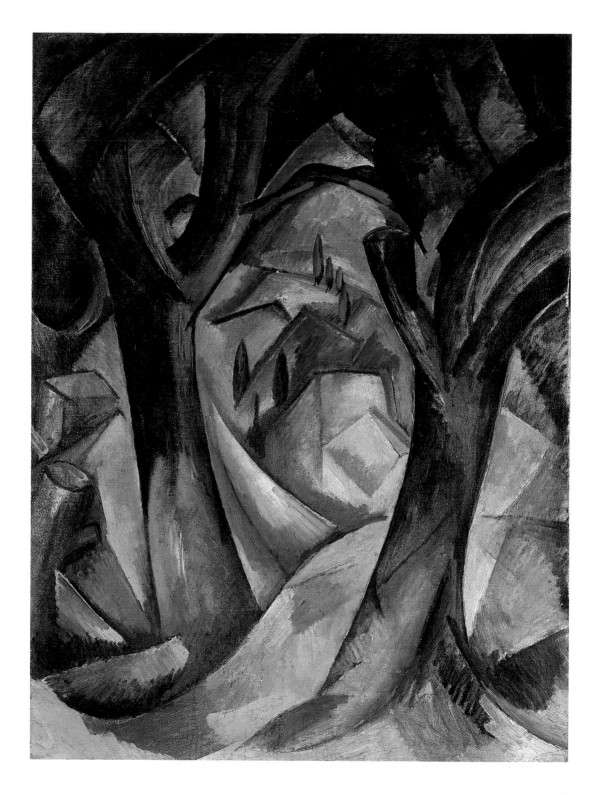

5 Bowl of Fruit

Painted in late summer 1908
Oil on canvas, $21\frac{1}{4} \times 25\frac{1}{2}$ (54 × 65)
Neither signed nor dated

Lit: I. no. 44; M. (1907-14) no. 35; Museum inv. no. 2422

Prov: the artist to Galerie Kahnweiler, Paris (photo no. 1004), 1908; Wilhelm Uhde, Paris; Rolf de Maré, Paris and Stockholm, 1914 until 1960; bequeathed to the museum in 1960
Moderna Museet, Stockholm

It was logical that Braque, who had accepted Cézanne as the master to follow, should turn his attention, after landscapes and the figure, to painting still-lifes. Hitherto he had only painted one, at the end of 1907. In the summer of 1908 he produced a group of about ten examples, which appeared in November at the Kahnweiler exhibition. The present composition, with lemons, pears and other fruit in a fluted metal dish, was perhaps painted at L'Estaque before his departure. Its Cézannian character is evident.

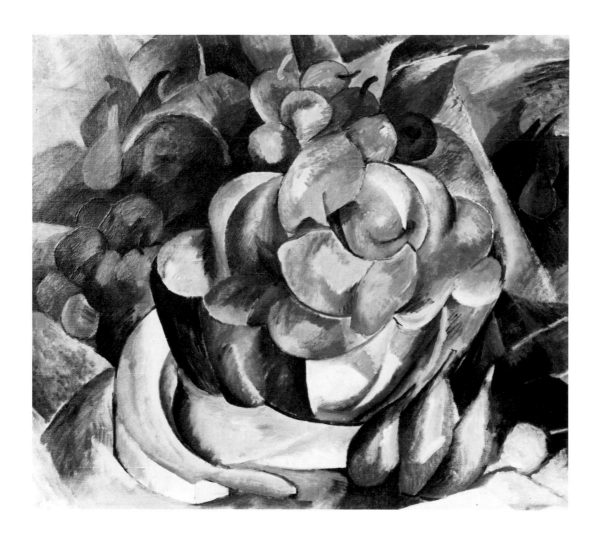

GEORGES BRAQUE

6 Still-life with Musical Instruments

Painted in autumn 1908
Oil on canvas, $19\frac{5}{8} \times 24(50 \times 61)$
Signed and dated bottom left: 'G. Braque / 1908'

Lit: M.(1907-14) no.7

Prov: the artist, Paris, 1908-63; bequeathed to the present owners in 1963
Private collection

Still-life offered Braque, as he was to say later (Vallier 1954), an opportunity to get close to objects and to make real what he described as 'tactile space'. The influence of Cézanne is still visible in the variation of viewpoint. But the closing in of the background space, which brings the objects nearer to the hand and eye, and the bending backward of the mandolin's neck, to counter a sense of flatness while preserving an effect of relief, are Braque's own significant innovations. Probably this painting – the first in which musical instruments appear – was executed in Paris after the artist's return from the south, because Vallier reports him as saying: 'When I introduced musical instruments into my still-lifes it was partly because I was surrounded by them . . .' It is unlikely that Braque had taken these three instruments with him to the south.

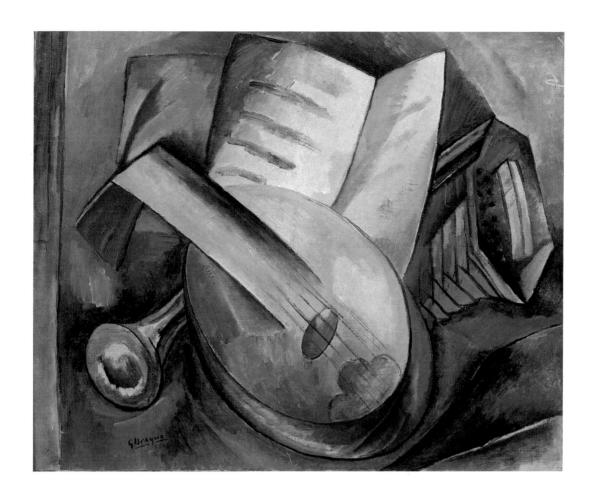

7 A Harbour, Normandy

Painted in early 1909
Oil on canvas, $31\frac{7}{8} \times 31\frac{7}{8} (81 \times 81)$
Neither signed nor dated

Lit: I.no.46; M.(1907-14) no.44; Museum inv.no.1970.98

Prov: the artist to Galerie Kahnweiler, Paris (photo no.1002), 1909 until before 1914; Alfred Flechtheim, Berlin and later London; Mrs Mendelsohn-Bartholdi, London, by 1936; Buchholz Gallery, New York, by 1938; Walter P. Chrysler, New York, 1940-67; E.V. Thaw & Co., New York, 1967-9; to the museum in 1969
Art Institute of Chicago. Samuel A. Marx Purchase Fund

This painting was first exhibited at the Salon des Indépendants of 1909 in Paris, which opened on 25 April.

It was painted from imagination in the artist's Paris studio during the three or four months following his exhibition at the Galerie Kahnweiler. In this major composition Braque first demonstrated his wholly new conception for the representation of space. Above all, he wanted to make of his picture a record of his desire 'to touch things and not merely to see them' and one of his reasons for abandoning scientific perspective was the fact that 'it does not allow one to take full possession of things'. Here, then, we find him feeling his way spatially round the hulls of boats, their masts and the lighthouses (which are modelled), then along the spars into the immediately accessible sky. Braque has used more or less neutral tones to evoke variations of light, for 'light and space are closely allied and we treated them together', as he told Vallier.

Note how the composition is held together by a series of verticals, horizontals and diagonals, which Braque uses as a means 'to measure distances'. Note too the tentative use of facetting to evoke fullness and volume, and to arouse tactile sensations.

Vauxcelles reviewing the Salon des Indépendants of 1909 referred to Braque's 'cubic eccentricities', thus revealing his disapproval of the artist's innovations. At this moment Braque was first seen to be a leading figure of the *avant-garde*.

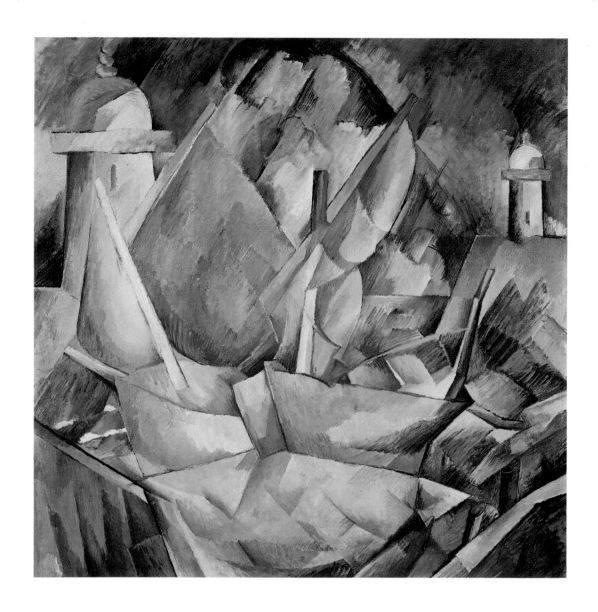

8 La Roche Guyon: the Château

Painted in summer 1909
Oil on canvas, $36\frac{1}{4} \times 29(92 \times 73.5)$
Signed on back: 'Braque'; not dated

Lit: I. no. 56; M. (1907-14) no. 42; Museum inv. no. 1.0051

Prov: the artist to Galerie Kahnweiler, Paris (photo no. 1024), 1909-14; sequestered Kahnweiler stock, 1914-21; 1st Kahnweiler sale, Hôtel Drouot, Paris, 13 June 1921, lot 18, sold for 100 frs. to M. Grassat as agent for the 'Simon syndicate'; Galerie Simon, Paris, 1921-3; Alfred Flechtheim, Berlin, 1923-?; Alphonse Kann, St Germain-en-Laye; Thomas Grange, London; to the museum in 1953
Stedelijk Van Abbemuseum, Eindhoven

The present painting is something of a formal abstraction in regard to what appear to have been the first two views of the scene; one belongs to the Moderna Museet, Stockholm, the other to the Musée d'Art Moderne du Nord at Villeneuve d'Ascq (near Lille). The artist has here moved closer to the château, which now appears slightly below the centre of the canvas and is dominated by the old château at the top. Since his last series of landscapes painted at L'Estaque in the summer and early autumn of 1908, Braque has acquired a great deal of pictorial science. His forms are now geometricised and shorn of descriptive details, while with a new ability to make one form elide into the next, and a subtle arrangement of tilted planes, the buildings rise smoothly and continuously up the surface of the canvas, thereby evoking a sense of recession and hence space. There is no direct source of light here: the artist has articulated his mass of forms by directing light (inconsistently) wherever he needed it.

The La Roche Guyon landscapes, followed a week or two later by others painted nearer to Paris at Carrières-St Denis, constitute Braque's last involvement with the natural scene until the summer of 1910. In the meantime, he worked in his studio concentrating on still-life subjects and an occasional figure piece.

La Roche Guyon is on the right bank of the Seine, close to Vernon and Giverny, to the west of Paris. In May 1885, Renoir had rented a house there and was visited by Cézanne, who worked there for a month in June –July 1885.

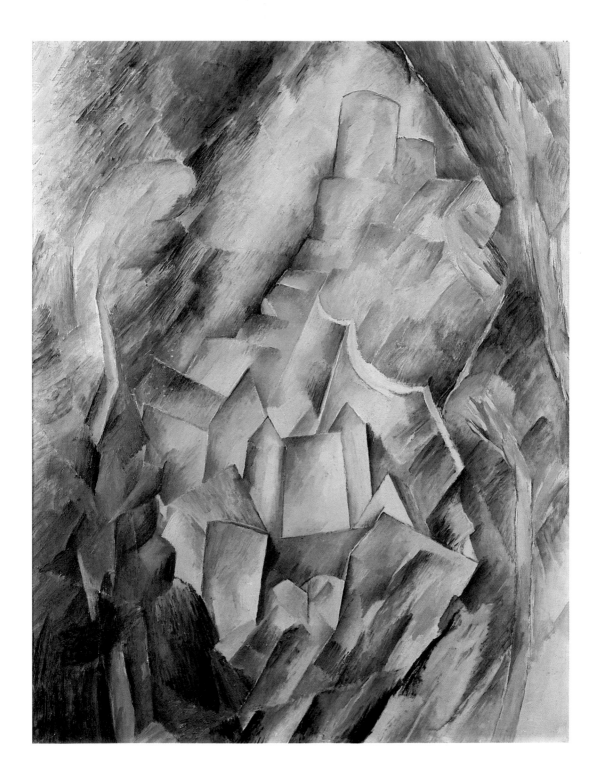

9 Violin and Palette

Painted in winter 1909-10
Oil on canvas, $36\frac{1}{4} \times 16\frac{7}{8}$ (92 × 42.8)
Formerly signed on back (now relined): 'Braque'; not dated

Lit: I. no. 70; M. (1907-14) no. 56; Guggenheim 1976, no. 21; Museum inv. no. 54.1412

Prov: the artist to Galerie Kahnweiler, Paris (photo no. 1034), 1910; Wilhelm Uhde, Paris, 1910; Edwin Suermondt, Die Fifel, Germany, c. 1910 until 1923; Frau Suermondt, c. 1923 until 1926; to Alex Vömel, Düsseldorf, 1926-53; Fine Arts Associates, New York, 1954; to the museum in 1954
Solomon R. Guggenheim Museum, New York

While Braque painted at La Roche Guyon, Picasso spent a long summer holiday working at Horta de Ebro in Catalonia. There he evolved a Cubist idiom based on geometrically simplified forms, and the evocation of volume through facetting. The paintings that resulted had certain affinities with Braque's landscapes of 1908. But where Braque resorted to geometricisation and facetting to give 'material form to his awareness of a new type of space', the space between things, and could achieve continuity in his handling, Picasso chopped up the natural scene into block-like forms and created spatial articulation with emphatic lines of direction established by the forms themselves and their modelling. Hence Braque's paintings have movement while Picasso's are static. Each artist, therefore, had something to offer to the other in the way of technique, and when they compared their respective achievements in Paris at the end of September 1909, they decided from then on to pool their pictorial experiences and work as a team.

The present painting, which forms a pair with 'Piano and Mandola', must have been begun towards the end of 1909. Coming closer to Picasso, Braque's formal analysis here is much bolder than before and he breaks the continuity of outlines in order to express volume through a succession of interlocking cubes. 'Through fragmentation', Braque said to Vallier in 1954, 'I was able to establish space and movement in space.' In short, the various facets of a form are meant to exist and be seen simultaneously as elements disposed on a flat surface where, although no optical illusion is involved, there exists an autonomous formulation of space.

Braque, himself a good musician, once stated that musical instruments had a special significance for him because it was 'possible to bring them to life by touching them'.

The *trompe-l'oeil* treatment (at the top) of a nail, which casts a shadow and on which the palette hangs, caused considerable discussion (led by Picasso and Kahnweiler) when this painting was first seen. But, in fact, the nail has a great significance not only because it points up the contrast between the 'traditional' and the Cubist ways of simulating relief, but also because it affirms an awareness of reality, as well as the realistic intentions underlying the paintings of Braque and Picasso executed in the new Cubist idiom.

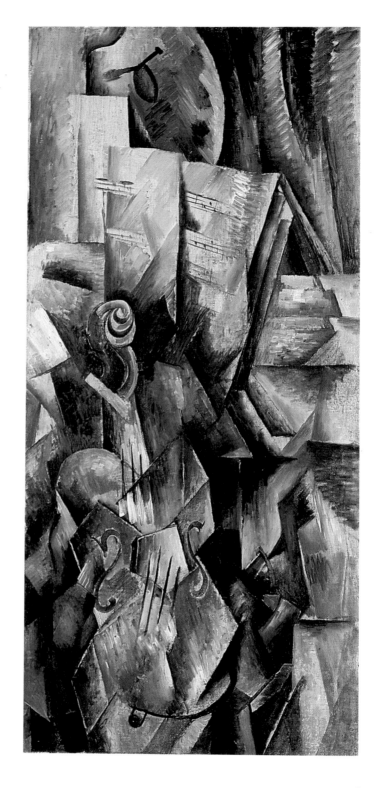

GEORGES BRAQUE

10 Still-life with a Metronome

Painted in winter 1909-10
Oil on canvas, $32\frac{1}{8} \times 21 (81.5 \times 53.5)$
Formerly signed on back (now relined): 'G. Braque'; not dated

Lit: I. no. 68; M. (1907-14) no. 58

Prov: the artist to Galerie Kahnweiler, Paris (photo no. 1026), 1910-14; sequestered Kahnweiler stock, 1914-21; 1st Kahnweiler sale, Hôtel Drouot, Paris, 13-14 June 1921, lot 13, sold for 1600 frs. to M. Miestchaninoff, Paris; André Breton, Paris; René Gaffé, Brussels; Monteau collection, Brussels; E. L. T. Mesens, London, before 1936; to the present owner in 1936
Private collection

The progressive abandonment by Braque and Picasso of bright colours in favour of a neutral range of greys and browns, which were not subject to modulation through light – a palette which they continued to use until 1912 – is here seen fully exploited. This painting has been wrongly catalogued (following Isarlov) by Mme Mangin (Maeght Catalogue) as 'Le Miroir'. But no mirror is shown in the composition. The metronome and some sheet-music appear in the background towards the top of the canvas, while Braque's mandola is visible at centre right.

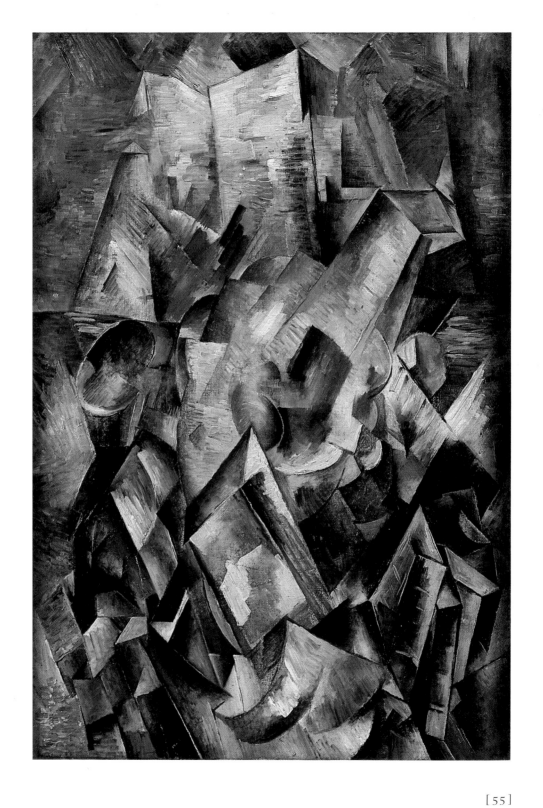

11 Glass on a Table

Painted in early 1910
Oil on canvas, $13\frac{3}{4} \times 15\frac{1}{4}$ (35 × 38.5)
Signed bottom left: 'G. Braque'; not dated

Lit: I. no. 78; M. (1907-14) no. 54

Prov: the artist to Galerie Kahnweiler, Paris (photo no. 1126), 1910; probably to Wilhelm Uhde, Paris, 1910-14; sequestered Uhde stock, 1914-21; Uhde sale, Hôtel Drouot, Paris, 30 May 1921, lot 11 (?), sold for 420 frs. to unidentified Paris collection; Robert Lebel, Paris; A. Tooth & Son, Ltd, London, by 1955; to the present owners in 1955
Sir Antony and Lady Hornby, London

The spatial development of the composition is represented in a rising spiral beginning on the table-top in the upper left, behind the two pears, and ending with the glass seen in a double perspective, from above and from the side. The surface is broken down into flat or tilted planes, some of which belong to cubic forms.

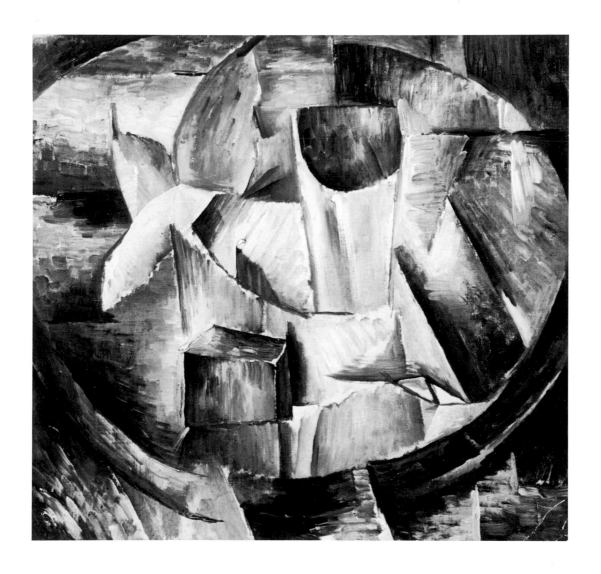

12 The Rio Tinto Factory at L'Estaque

Painted in summer 1910
Oil on canvas, $25\frac{5}{8} \times 21\frac{1}{4}$ (65×54)
Signed on back: 'G. Braque'; not dated

Lit: I. no. 81; M. (1907-14) no. 68; MNAM *Catalogue Braque* 1982, no. 8; Museum inv. no.
AM 3973 P

Prov: the artist to Galerie Kahnweiler, Paris (photo no. 1124), 1910; possibly to Wilhelm Uhde,
Paris, before 1914; sequestered Uhde stock, 1914-21; Uhde sale, Hôtel Drouot, Paris, 30 May
1921, lot 14 (?), sold for 500 frs. to an unidentified buyer; André Lefèvre, Paris, *c.* 1935 until
1952; to the museum in 1952, but not installed until 1964
Musée National d'Art Moderne (Centre Georges Pompidou), Paris. Gift of M. and Mme André Lefèvre

This was probably the first of two closely related paintings of this subject, seemingly painted a few days apart. The Rio Tinto Company produced zinc.

Although the component elements of the landscape composition – buildings, red roofs and a factory chimney – are recognisable, Braque attains here a degree of formal abstraction comparable with 'La Roche Guyon: the Château' (no. 8) painted a year earlier. But in the La Roche Guyon painting volumes are kept intact, whereas in this painting Braque has used modelling and 'reverse' perspectives to frustrate any perception of consistent volume in the forms. The outlines of the buildings here provide a directional structure of verticals, horizontals and diagonals, while the buildings themselves open up into the surrounding space and create a system of varying, interpenetrating planes which establish a sense of movement and recession within the pictorial space.

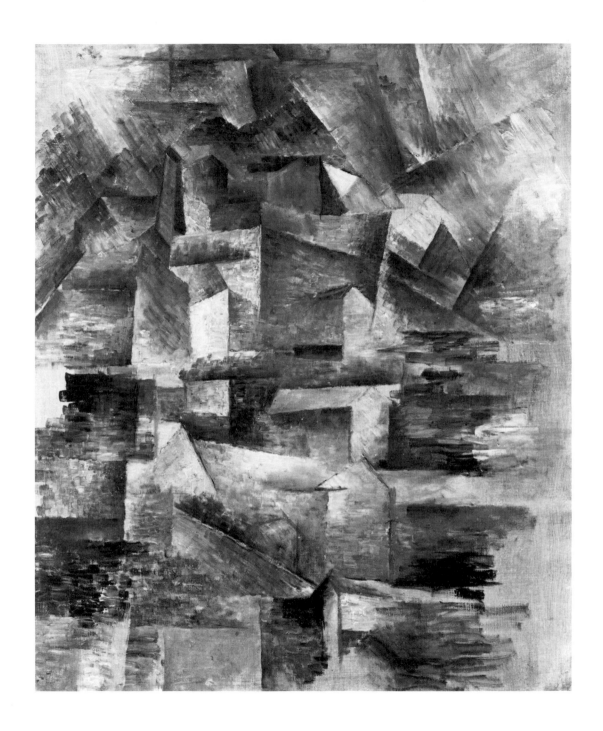

13 Woman Playing a Mandolin

Painted in summer 1910
Oil on canvas, $31\frac{7}{8} \times 21\frac{1}{4} (81 \times 54)$
Signed on back: 'G. Braque'; not dated

Lit: I. no. 82; M. (1907-14) no. 72

Prov: the artist to Galerie Kahnweiler, Paris (photo no. 1035), 1910-14; sequestered Kahnweiler stock, 1914-21; 2nd Kahnweiler sale, Hôtel Drouot, Paris, 17 November 1921, lot 30, sold for 550 frs. to André Breton, Paris; André Lefèvre, *c.* 1935 until 1963; Lefèvre estate, 1963-5; 2nd Lefèvre sale, Palais Galliera, Paris, 25 November 1965, lot 33, sold for 330,000 frs. to Perls Galleries, New York; Alain Tarica, Paris, by 1970; anonymous Swiss collection, 1970-7; to the present owner in 1977
Thyssen-Bornemisza Collection, Lugano

This was the first figure painted by Braque since he completed the 'Standing Female Nude' (no. 2) in June 1908. The analytical treatment of the figure and its situation in space are basically much the same as in 'Glass on a Table' (no. 11), but the forms are now more abstract, only a few elements being specifically identified (arm, hand, breast, guitar). Line plays a greater descriptive part, while a structural scaffolding of lines representing spatial relationships has been developed.

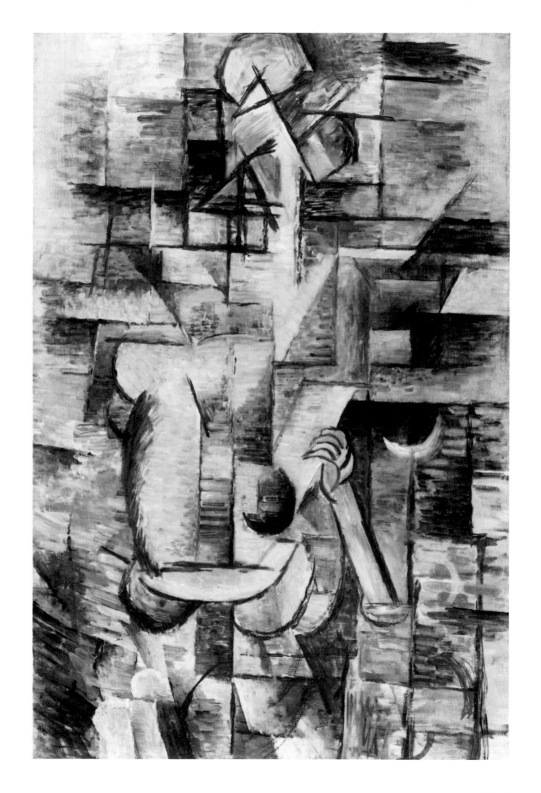

GEORGES BRAQUE

14 Still-life with Fish on a Table

Begun in early summer 1910, but reworked and completed in 1911
Oil on canvas, $24\frac{1}{4} \times 29\frac{1}{2} (61.5 \times 75)$
Signed on back: 'G. Braque'; not dated

Lit: I.no.64; M.(1907-14) no.64; Tate 1981, p.76; Museum inv.no.T445

Prov: the artist to Galerie Kahnweiler, Paris (photo no.1038), 1912-14; sequestered Kahnweiler stock, 1914-23; 4th Kahnweiler sale, Hôtel Drouot, Paris, 7-8 May 1923, lot 130 (repr.), sold for 1500 frs. to an unidentified buyer; Josef Müller, Solothurn, Switzerland, *c.*1925; E. and A. Silberman Galleries, New York, by 1959; Galerie Beyeler, Basel, 1961; to the gallery in 1961
Tate Gallery, London

This painting was probably begun a few months after 'The Glass' (no.11).

Here Braque has carried his cubification and new compositional method a major stage further. Verticals are set off against horizontal planes, which in turn are traversed by a series of diagonal ones, in some of which lie the fragmented fish, while others evoke spatial recession.

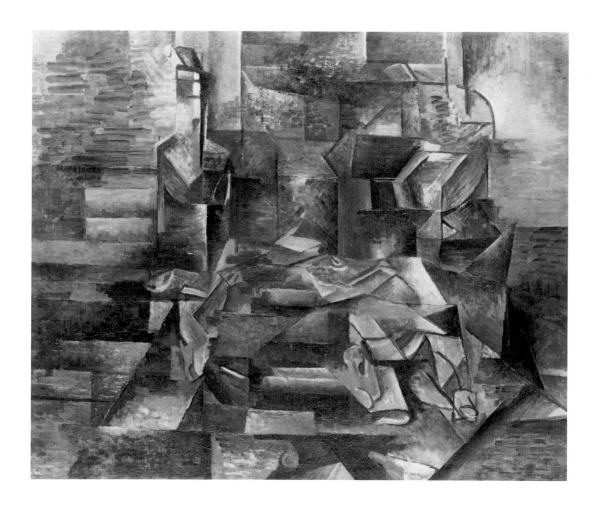

15 The Candlestick

Painted in spring 1911
Oil on canvas, 18 × 15 (45 × 38)
Signed (in 1960) bottom right: 'G. Braque'; formerly signed on back (now relined); not dated

Lit: I. no. 106; M. (1907-14) no. 74; Museum inv. no. 1561

Prov: the artist to Galerie Kahnweiler, Paris (photo no. 1079), 1911-14; sequestered Kahnweiler stock, 1914-21; 2nd Kahnweiler sale, Hôtel Drouot, Paris, 17 November 1921, lot 12, sold for 300 frs. to M. Netter, Paris; René Gaffé, Brussels, by 1925; Galerie Rosengart, Lucerne, by 1958; anonymous Swiss collection; Galerie Maeght, Paris, before 1976; to the gallery in 1976
Scottish National Gallery of Modern Art, Edinburgh

Braque's pictorial idiom did not change fundamentally until the summer of 1912, except in so far as line assumed (as here) an increasingly important role in defining objects and establishing spatial relationships. Throughout the spring and summer of 1911, Braque, with the experience of the *trompe-l'oeil* nail behind him, heightened the reality of his subject matter by introducing relevant lettering into his paintings as a functional element. Braque had first introduced lettering into a still-life entitled 'Le Pyrogène' of late 1909, where the title 'GIL B[LAS]' painted across a form in the foreground simply identifies it as this newspaper. In 1911, however, he began to integrate words and figures as positive structural components. Thus they were not intended to be decorative additions to a subject, but served as useful and informative complements. For example, the newspaper lying on the table behind the foreground glass in this picture is identified as *L'Indépendant* and we are told that it costs 5 centimes. In 1954, Braque explained to Vallier that letters and figures were 'forms which could not be distorted in any way because, being themselves flat, [they] were not in space and thus, by contrast, their presence in the picture made it possible to distinguish between objects situated in space and those which were not'. In other words, Braque saw in them a means of enhancing the two-dimensional nature of the canvas. But they also helped to emphasise the autonomous existence of each painting as a new object added to the visible world. Cubist paintings of this date were not intended to be imitative of or in competition with reality as we think we know and see it. On the contrary, they were conceived as possessing a purely pictorial reality of their own. Hence the designation by Braque and Picasso of their picture as a *tableau-objet*.

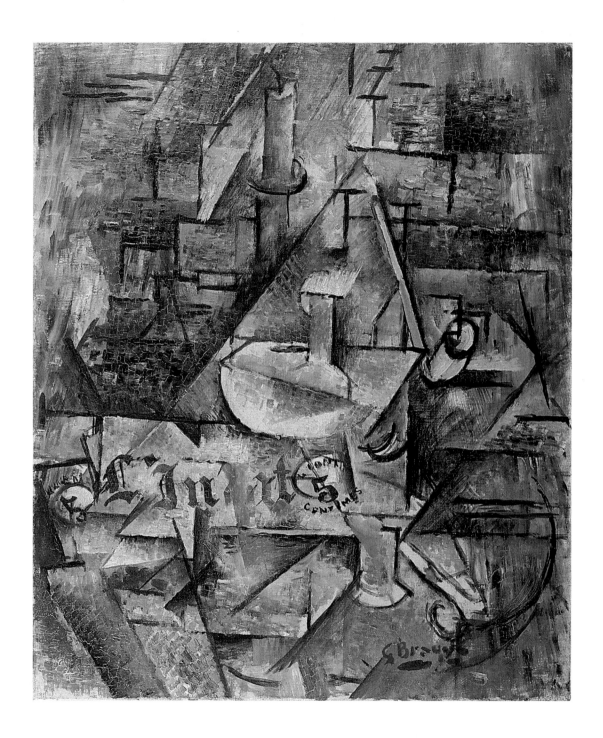

16 Seated Man with a Guitar

Painted early in summer 1911
Oil on canvas, $45\frac{5}{8} \times 31\frac{7}{8}$ (116×81)
Formerly signed on back (now relined); not dated

Lit: I.no.104; M.(1907-14) no.99; MOMA 1977, no.92; Museum inv.no.175.45

Prov: the artist to Galerie Kahnweiler, Paris (photo no.1019), 1911; Wilhelm Uhde, Paris, before 1914; sequestered Uhde stock, 1914-21; Uhde sale, Hôtel Drouot, Paris, 30 May 1921, lot 4(repr.), sold for 850 frs. to an unidentified buyer; Marcel Fleischmann, Zürich, *c.*1924; to the museum in 1945
Museum of Modern Art, New York. Acquired through the Lillie P. Bliss Bequest, 1945

During the second half of 1911 Braque painted four major figure pictures, all of which are masterpieces of Cubism. They are 'Woman Reading in an Armchair' (spring 1911; M.(1907-14) no.92); 'Seated Man with a Guitar' (early summer 1911, in Paris), the present picture; 'The Portuguese' (summer 1911 at Céret; M.(1907-14) no.80); and 'Seated Man with a Violin on a Table' (winter 1911-12, in Paris; M.(1907-14) no.125).

Note the contrast here between the feature-less representation of the man's head and the virtually abstract structure of planes relating it to the surrounding space, as opposed to the rounded volumes and legible details elsewhere in the picture. Corresponding, and yet very different, figure paintings by Picasso of this period are 'The Guitar Player' (spring 1911); 'Man with a Pipe' (summer 1911; no.127 of this catalogue); 'Man Playing a Mandolin' (autumn 1911); and 'Woman Playing a Guitar' (autumn 1911; D. nos.390, 422, 425 and 430).

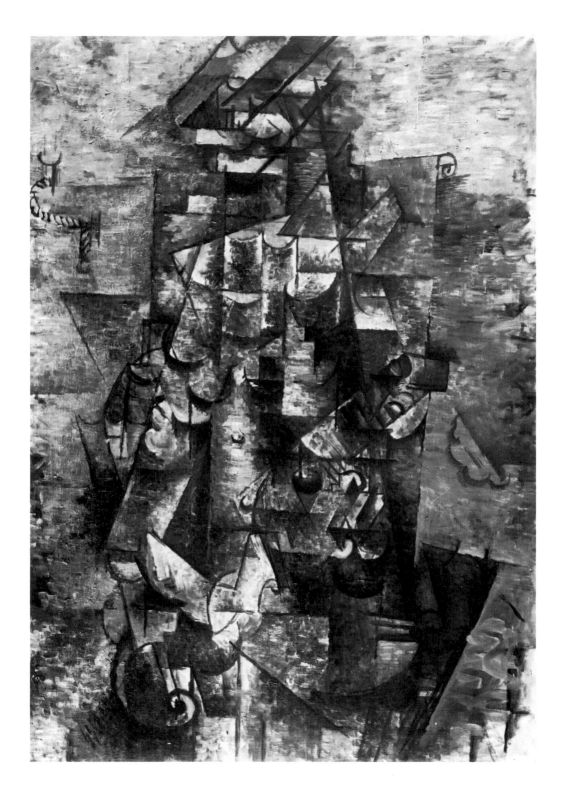

17 Céret: Rooftops

Painted at Céret in summer 1911
Oil on canvas, $32\frac{3}{8} \times 23\frac{1}{4}$ (82.2 × 59)
Signed on back: 'Braque'; not dated

Lit: I. no. 116; M. (1907-14) no. 90

Prov: the artist to Galerie Kahnweiler, Paris (photo no. 1022), 1911; possibly sequestered Kahnweiler stock, 1914-23; possibly 4th Kahnweiler sale, Hôtel Drouot, Paris, 7-8 May 1923, lot 136(?), sold for 520 frs. to an unidentified buyer; Galerie Flechtheim, Berlin, *c.* 1923; subsequent whereabouts uncertain; Galerie Zak, Paris, by 1951; Perls Galleries, New York, 1951; Robert von Hirsch, Basel, 1951; Perls Galleries, New York, 1951; Ralph Colin, New York, 1952-80; E. V. Thaw & Co. with Acquavella Gallery, New York, 1980; to the present owner in 1980
Private collection

Painted probably soon after Braque's arrival at Céret early in August 1911. Picasso was already staying and working there. This townscape (chimneys, windows and sloping roofs can be identified) seen through a wide open window was preceded by a similar – though more naturalistic and much smaller – landscape view, with the railings of the balcony of the room running across the foreground (M. (1907-14) no. 89). The stylistic development of Braque's Cubist handling of landscape can be observed in 'Big Trees at L'Estaque' (summer 1908; no. 4); 'La Roche Guyon: the Château' (summer 1909; no. 8); 'View of the Sacré Coeur, Montmartre' (about May 1910; M. (1907-14) no. 52) and 'The Rio Tinto Factory at L'Estaque' (summer 1910; no. 12). Note the emphatic diagonals of the composition, which rises in triangles up the canvas, as in 'La Roche Guyon'.

After this painting, Braque abandoned landscape as a subject until 1928-9.

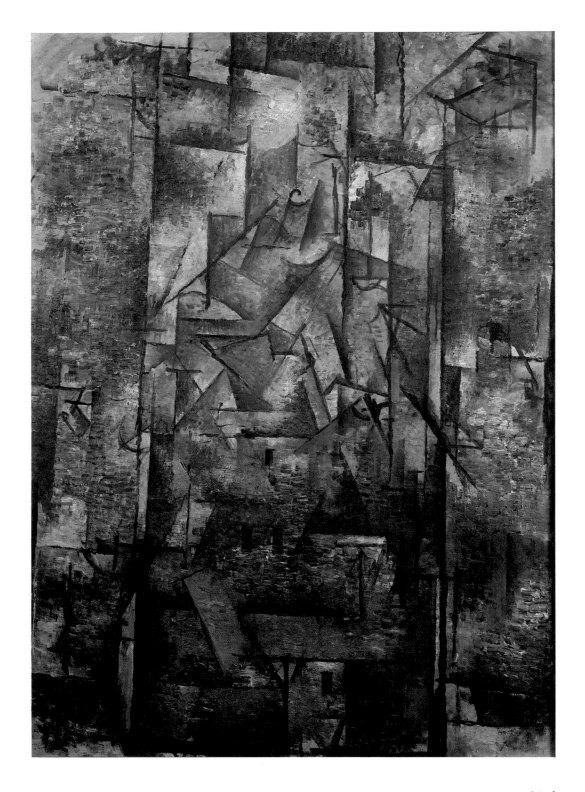

18 Still-life with a Pair of Banderillas

Painted at Céret in summer 1911
Oil on canvas, $25\frac{1}{2} \times 21\frac{1}{4} (65 \times 54)$
Neither signed nor dated

Lit: I. no. 110; M. (1907-14) no. 91

Prov: the artist to Galerie Kahnweiler, Paris (photo no. 1017; stock no. 813), 1911-14; sequestered Kahnweiler stock, 1914-21; 2nd Kahnweiler sale, Hôtel Drouot, Paris, 17-18 November, 1921, lot 26, sold for 450 frs. to M. Grassat as agent for the 'Simon syndicate'; Galerie Simon, Paris (stock no. 6851), 1921-4; Jacques Zoubaloff, Paris, 1924-35; Zoubaloff sale, Hôtel Drouot, Paris, 27 November 1935, lot 124, sold for 3500 frs. to an unidentified buyer; Armand Salacrou, Paris and later Le Havre; Galerie Louise Leiris, Paris (stock no. 6851), 1955 until *c.* 1959; Leigh B. Block, Chicago, *c.* 1959 until 1979; E. V. Thaw & Co., New York, 1979; to the present owners in 1979
Mr and Mrs Jacques Gelman, Mexico

This, the only still-life with tauromaquian references in the whole of Braque's work, undoubtedly reflects Picasso's passion as an *aficionado*. The two artists were then working together and we find a counterpart to this painting in Picasso's 'Still Life' (D. no. 413) and 'Bottle of Rum' (no. 125), both painted at this same moment and in both of which the bull-fighting journal *Le Torero* also appears. It appears again in Picasso's 'L'Aficionado' (summer 1912; D. no. 500), where a single *banderilla* is represented in the foreground. Braque's two *banderillas* are lying diagonally and horizontally on the table.

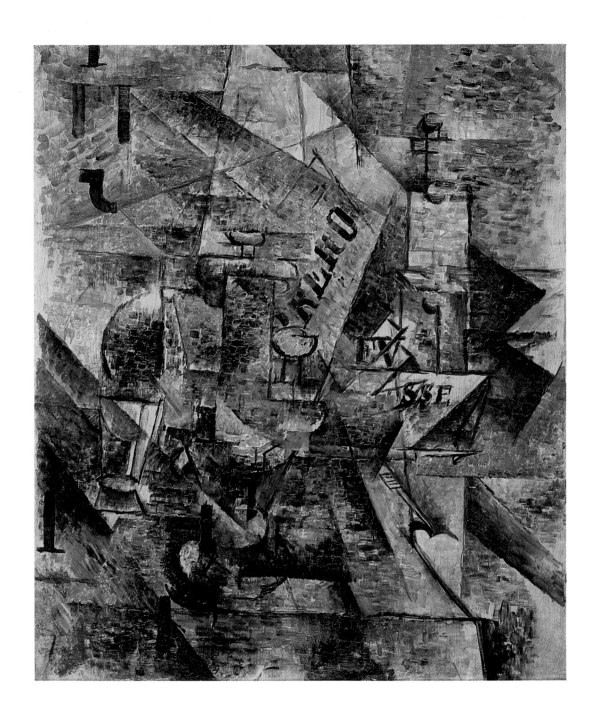

19 Clarinet and Bottle of Rum on a Mantelpiece

Painted at Céret in summer 1911
Oil on canvas, $31\frac{7}{8} \times 23\frac{5}{8}(81 \times 60)$
Signed on back: 'G. Braque / Céret'; not dated

Lit: I. no. 114; M. (1907-14) no. 96; Tate 1982, p. 77; Museum inv. no. 2318

Prov: the artist to Galerie Kahnweiler, Paris (photo no. 1020), 1911-14; sequestered Kahnweiler stock, 1914-23; 4th Kahnweiler sale, Hôtel Drouot, Paris, 7-8 May 1923, lot 137, sold for 400 frs. to Charles E. Jeanneret (Le Corbusier), Paris, 1923-65; Le Corbusier Foundation, Paris, 1965-70; Sale, Palais Galliera, Paris, 10 June 1970, lot 50, sold for 1,260,000 frs. to Galerie Beyeler, Basel, 1970-1; Jorge Brito, Lisbon, 1971-4; Sale, Sotheby's, London, 4 December 1974, lot 41, sold for £240,000 to Confinarte, Switzerland, 1974-8; to the gallery in 1978
Tate Gallery, London

Throughout the year 1911, Braque, rather more than Picasso, concentrated on elaborating the structural notation within each picture, on synthesising and suggesting the forms of objects rather than showing their different aspects, and on representing the relationships between objects (or between different parts of the body) and the space around them. Space was thus 'materialised' instead of being invoked by an illusion. Light was directed at will to give relief where needed, and the principle of a single viewpoint was wholly abandoned. But a link with reality was maintained through the inclusion of legible details. Here, for example, the fireplace below and mantel above it are established in the foreground by the shell-like form attached to the metal draft-curtain at its base and by the scroll-like support of the shelf visible on the right. The depth of this mantel-shelf (presumably of stone) is represented by a line in the right foreground, while the upward progression on the background wall is shown by the *trompe-l'œil* nail securing a piece of paper. Lying or standing on the mantel are two glasses, some sheet-music (with the printed title VALSE), a bottle of rum of which the neck reaches almost to the top of the canvas, and behind this a clarinet, which is bisected by the bottle.

This was one of the first paintings in which Braque used bold stencilled lettering as a positive structural (as well as descriptive) element. Note the contrasts of light and shade across the surface of the canvas and the broken brushwork which gives it a tactile quality, creates a luminous palpitation and helps to differentiate one plane from another.

Braque executed this painting between August and early October 1911 at Céret, a small town on the French side of the Pyrenees frequented by artist friends of Braque and Picasso. In July 1911, Picasso arrived there for the first time to spend the summer in a house that he had rented. Braque and his future wife, Marcelle, joined Picasso there early in August. The two artists then made of the next two months a highly productive period, during which the initial phase of Cubism reached its purest expression.

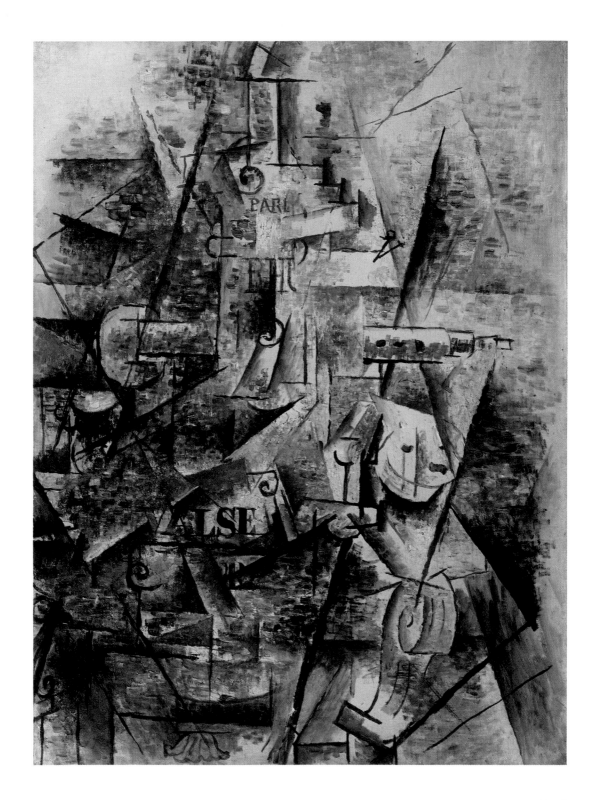

20 Still-life on a Table: Bottle, Newspaper and Glasses

Painted in early 1912
Oil on canvas, 13 × 18 (33 × 46)
Signed on back: 'G. Braque'; not dated

Lit: I. no. 135; M. (1907-14) no. 135; Seligman 1979, no. 8

Prov: the artist to Galerie Kahnweiler, Paris (photo no. 1051), 1912 until before 1914; apparently sold to an unidentified buyer before 1914, as it does not figure in the sales of the sequestered Kahnweiler stock; subsequent whereabouts uncertain; James St L. O'Toole Gallery, New York; Walter Chrysler, *c.* 1936 until 1945; Chrysler sale, Parke-Bernet, New York, 22 March 1945, lot 77, sold for $1500 to Germain Seligman, New York, 1945-78; E. V. Thaw & Co., New York; with Heinz Berggruen, Paris and Artemis, 1978; Acquavella Galleries, New York; anonymous New York collection; anonymous Palm Beach collection; Acquavella Galleries, New York, by 1980; to the present owner in 1980
Private collection, USA

In early 1912, Braque's Cubist style became for a while, as we see here, much less taut and formally precise as he concerned himself with the interrelationships of the different planes. Here Braque has discarded the linear spatial structure of his earlier style and drawing plays almost no part. This produces a certain confusion on the surface of the canvas which Braque was to clarify during the following months. This painting is distinguished by its painterliness and rich *matière*.

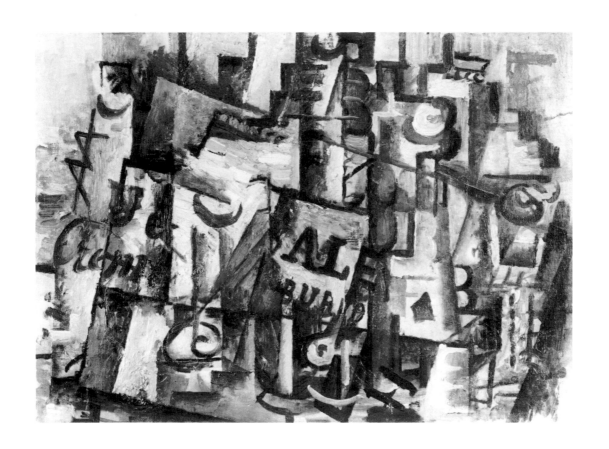

21 The Bottle of Rum

Painted in spring 1912
Oil on canvas, $21\frac{5}{8} \times 17\frac{7}{8}$ oval (55×45.5)
Signed on back: 'G. Braque'; not dated

Lit: I. no. 133; M. (1907-14) no. 24

Prov: the artist to Galerie Kahnweiler, Paris (photo no. 1047), 1912-14; sequestered Kahnweiler stock, 1914-23; 4th Kahnweiler sale, 7-8 May 1923, lot 119(?), sold for 210 frs. to an unidentified buyer, probably Paul Eluard because it was in his possession soon afterwards; Paul Eluard, Paris, *c.* 1923 until 1924; Eluard sale, Hôtel Drouot, Paris, 3 July 1924; Galerie Simon, Paris, 1924-?; Galerie Kaganovitch, Paris, by 1952; to the present owner in 1952
Private collection, Switzerland

Painterliness is once again an outstanding quality of this work, but the objects composing the still-life are more easy to 'read', as are the relationships of one to another.

The introduction of passages of red paint has no representational purpose: they enliven the composition.

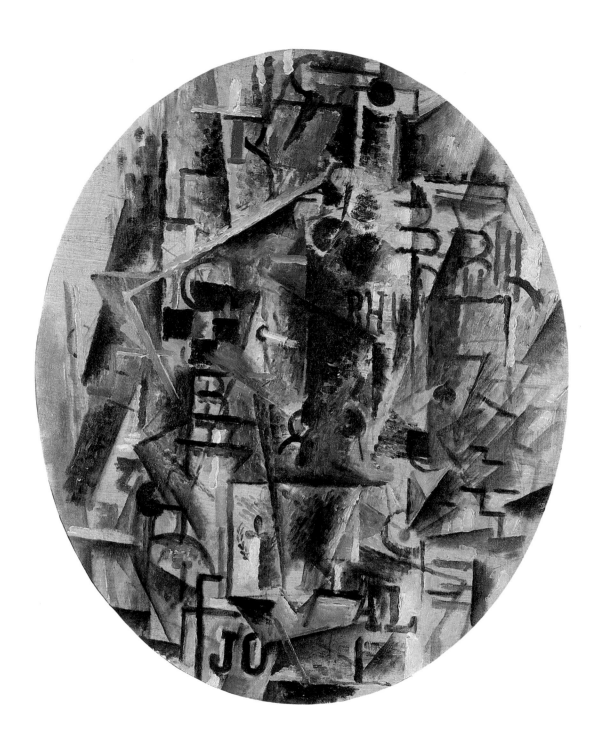

22 Violin and Poster (Mozart/Kubelick)

Painted in spring 1912
Oil on canvas, $18\frac{1}{2} \times 24 (47 \times 61)$
Signed on back: 'G. Braque'; not dated

Lit: I.no.122; M.(1907-14) no.12

Prov: the artist to Galerie Kahnweiler, Paris (photo no.1039), 1912-14; sequestered Kahnweiler stock, 1914-23; 4th Kahnweiler sale, Hôtel Drouot, Paris, 7-8 May 1923, lot 123, sold for 160 frs. to an unidentified buyer, probably an agent for Raoul LaRoche; Dr h.c. Raoul LaRoche, Paris, *c.* 1923 until 1962; to the present owner in 1962
Private collection, Basel

Braque had a great love of music and this is attested to in his paintings by the extraordinary variety of musical instruments represented, as well as the variety of sheet-music which appears in his still-lifes from 1911 on with such identifying titles as 'Valse', 'Bach', 'Petit Oiseau', 'Etude', 'Duo', 'Sonate' or 'Rondo', the single word 'Concert', or as here 'Mozart' and 'Kubelick', the name (misspelt) of a famous violinist. In this painting, Braque introduces a new way of representing both the volume of a violin and its position in space.

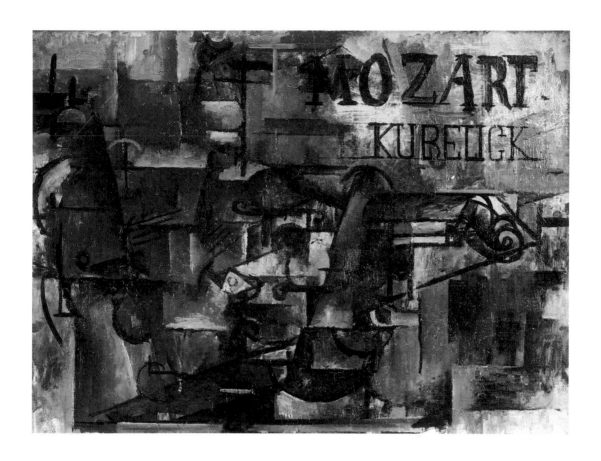

23 Violin and Clarinet on a Table

Painted probably in early summer 1912
Oil on canvas, $21\frac{5}{8} \times 16\frac{7}{8}(55 \times 43)$
Signed on back: 'G. Braque'; not dated

Lit: I.no. 161; M.(1907-14) no. 180; Museum inv.no.0 8029

Prov: the artist to Galerie Kahnweiler, Paris (photo no. 1129), 1912; Vicenc Kramář, Prague, before 1914-60; to the gallery in 1960
Národní Galerie, Prague

This painting has often been assigned to 1913, which is to say that it would have been executed several months after Braque had invented and realised his first work in the technique of *papier collé*. Were this the case, it should resemble stylistically a painting such as 'Fruit-dish, Grapes, Newspaper and Playing-cards' (no.29). But it does not. On the contrary, in its painterliness, looseness, timid use of muted colour in the bottom right corner, and slight confusion, this still-life is more closely related stylistically to 'Still-life on a Table: Bottle, Newspaper and Glasses' (no.20), 'The Bottle of Rum' (no.21) and the two charcoal drawings 'Still-life with Glasses and Newspaper' and 'Still-life with a Clarinet' (nos.44 and 45), all executed in the first half of 1912. This painting exemplifies the structural looseness and overall confusion which Braque was led to clarify, a few months later, through his invention of the technique of *papier collé*. In fact, the vertical background planes here painted in *faux-bois* look like an anticipation of the planes of *faux-bois* wallpaper which were to appear in many of Braque's early *papiers collés* (e.g. nos.25 and 27).

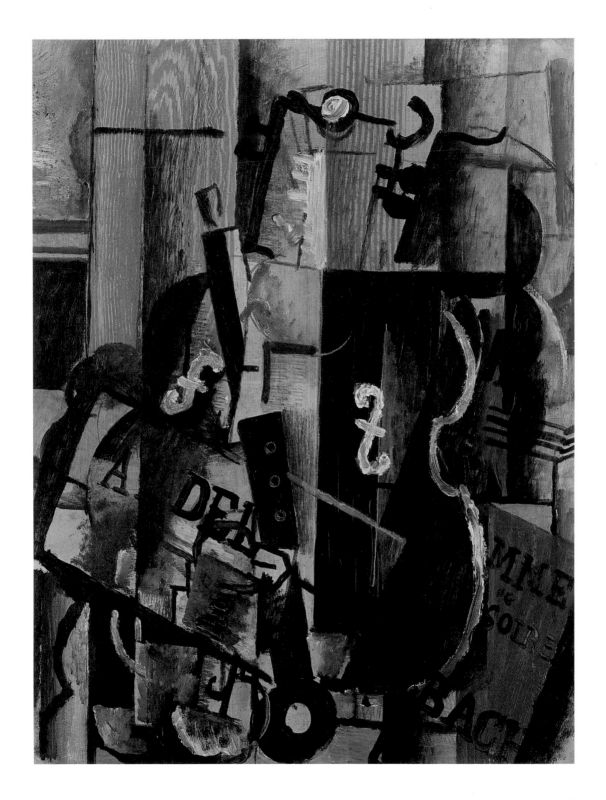

24 Homage to J.S. Bach

Painted in summer 1912
Oil on canvas, $21\frac{1}{4} \times 28\frac{3}{4}$ (54 × 73)
Signed bottom left: 'G. Braque'; formerly signed on back (now relined); not dated

Lit: I.no. 129; M.(1907-14) no. 122

Prov: the artist to Galerie Kahnweiler, Paris (photo no. 1045), 1912-14; sequestered Kahnweiler stock, 1914-1923; 4th Kahnweiler sale, Hôtel Drouot, Paris, 7-8 May 1923, lot 129, sold for 330 frs. to an unidentified buyer; H.P. Roché, Paris, *c.* 1924; Norman Granz, Geneva, *c.* 1955 until 1968; Granz sale, Sotheby's, London, 23 April 1968, lot 134; sold to the present owner
Sidney Janis Gallery, New York

One of the most lucidly structured and complete representations, formally and spatially, of a violin lying horizontally on a wooden table. Forms and planes are in general left open, rather than being confined by contour lines. Thus the general effect is of transparency. Light and air seem to pass everywhere. The lettering 'BACH J S' is attached to nothing: it functions as a floating plane, which assists in establishing spatial relationships and evokes the music of Braque's favourite composer.

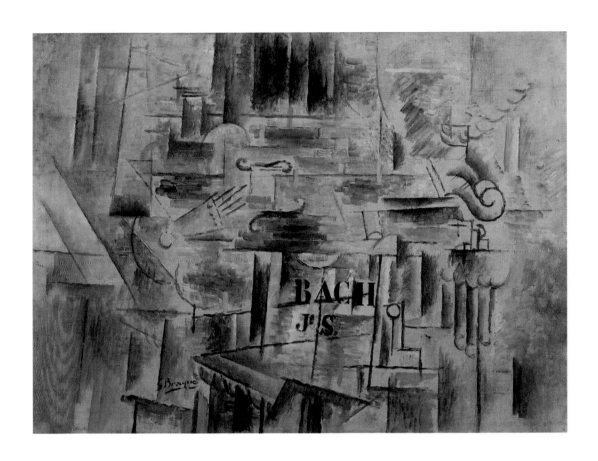

25 Fruit-dish and Glass

Executed in September 1912
Charcoal and printed paper pasted on paper: 24 × 17¾ (61 × 45)
Signed bottom right (c. 1925): 'G. Braque'; not dated

Lit: I. no. 144; M. (1907-14) no. 150; MNAM *Papiers Collés*, 1982, no. 1; Cooper 1982, pp. 7-11.

Prov: the artist to Galerie Kahnweiler, Paris (photo no. 1083), 1912 until before 1914; Wilhelm Uhde, Paris, before 1914; sequestered Uhde collection, 1914-21; Uhde sale, Hôtel Drouot, Paris, 30 May 1921, lot 69, sold for 200 frs. to Léonce Rosenberg; Galerie de L'Effort Moderne (L. Rosenberg), Paris, 1921-?; André Breton, Paris, by the mid-1920s; Mme Simone Breton (later Simone Collinet), Paris, until 1946; to the present owner in 1946
Private collection

This was the first of the many *papiers collés* to be executed by Braque and Picasso from 1912 onward. It was made at Sorgues, a village a few kilometres north of Avignon, where Picasso and Braque both rented houses between July and October 1912. Picasso was in Paris between 3 and 12 September, and it was during these few days that Braque, who had been preparing for the experiment, executed this innovatory work.

During the summer of 1912, a crisis was reached in the evolution of Cubist painting, because Picasso and Braque realized instinctively that they could not carry their 'analytical' methods any further. They had achieved a new manner of representing three-dimensional figures and objects in two-dimensional pictorial terms, while providing, without recourse to illusion, a true depiction of the space involved. There remained the major problem of reintroducing strong colour (apart from light) into the new idiom. This had been the subject of frequent discussions between the two artists.

In the spring, and again in July–August at Sorgues, Picasso had produced some unusual but pleasingly coloured still-lifes (D. nos. 473, 475, 476, 489, 490, 505, 509, 510, for example). Braque then evolved the conception of introducing colour as a 'real' and 'ready-made' element into his pictures. He found the solution through pasting in pieces of coloured paper – 'certainties' as Braque called them – which either represented themselves (cigarette packets, newspaper, wallpaper) or were coloured sheets cut to represent the silhouette of some object or to function structurally as planes. Through this experiment, Braque, who was quickly followed by Picasso, learnt that form and colour exist and function independently of each other.

The basic elements of this composition are three pieces of printed, oak-grained (*faux-bois*) paper, cut in accordance with the artist's pictorial needs, the two pieces at the top representing a panelled background, while the third at the base indicates a wooden table and corresponds to a drawer (the knob is visible) beneath the table-top. The fruit-dish, glass and table-top are drawn in charcoal on the surface of the white paper as well as over the coloured elements. There is thus a comprehensible integration of the various elements of the composition, while their relative positions within the pictorial space are established by structural lines. The three pasted elements here thus have a literal and descriptive role, while enhancing the general effect of the black and white drawing. The words 'BAR' and 'ALE' are attached to nothing but serve to situate the subject within a café context.

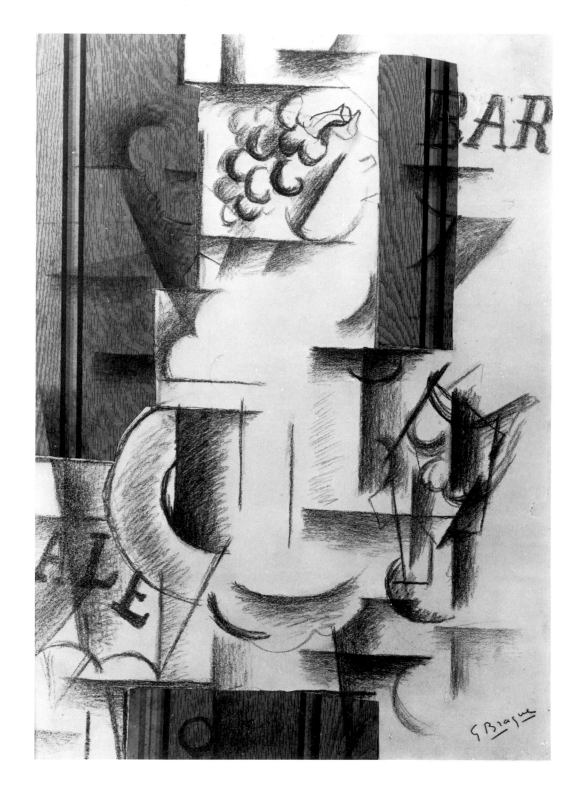

26 Guitar, Glass and Newspaper

Executed in autumn 1912
Charcoal and paper pasted on paper, $27\frac{1}{2} \times 23\frac{3}{4}$ (70.2 × 60.7)
Neither signed nor dated

Lit: M.(1907-14) no.191; MNAM *Papiers Collés*, 1982, no.4

Prov: the artist, Paris, 1912-63; bequeathed to the present owners in 1963
Private collection

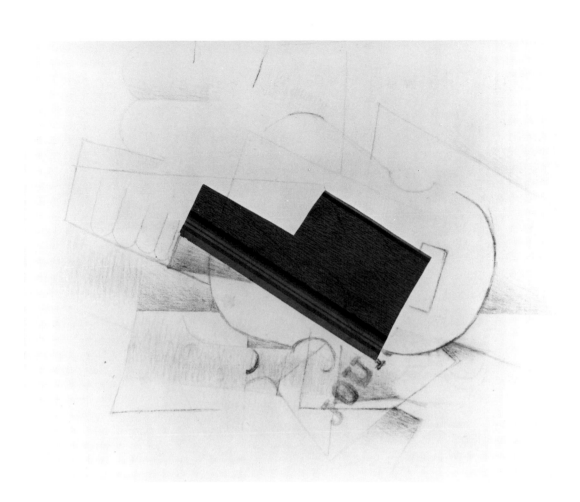

27 Man Smoking a Pipe

Executed at the end of 1912
Pasted papers and charcoal on paper, $24\frac{1}{2} \times 19(62 \times 48.1)$
Signed on back in pencil: 'G. Braque'; not dated

Lit: M.(1907-14) no. 159; MNAM *Papiers Collés*, 1982, no. 9; Museum inv. no. 1963.24

Prov: the artist to Galerie Kahnweiler, Paris (stock no. 1126), 1912-14; sequestered Kahnweiler stock, 1914-23; 4th Kahnweiler sale, Hôtel Drouot, Paris, 7-8 May 1923, lot 46, sold with five other drawings for 210 frs. to an unidentified buyer, probably an agent for Raoul LaRoche; Dr h.c. Raoul LaRoche, Paris, c. 1923 until 1963; to the museum in 1963
Kunstmuseum, Basel, Kupferstichkabinett

The pasted papers serve the same purpose here as in 'Fruit-Dish and Glass' (no. 25) but also help the man's hat and head to stand out in relief from the background wall.

The technique of *papier collé* transformed and reversed the pictorial conceptions which had hitherto guided Braque and Picasso during the evolution of Cubism. Previously, Braque and Picasso had analyzed and dissected the appearance of objects in order to discover a set of forms which would add up to the reality of the whole and constitute the basis of a composition. Now they found that they could create their own pictorial reality by building up towards it through a synthesis of elements. In other words, the basis of a composition could be neutral pictorial elements ('certainties', planes of colour, shaped forms, textural variations) which the artist could 'modify' and endow with the semblance of an objective significance. Such, in essence, is the procedure of the 'synthetic' phase of Cubism, which began in the second half of 1912.

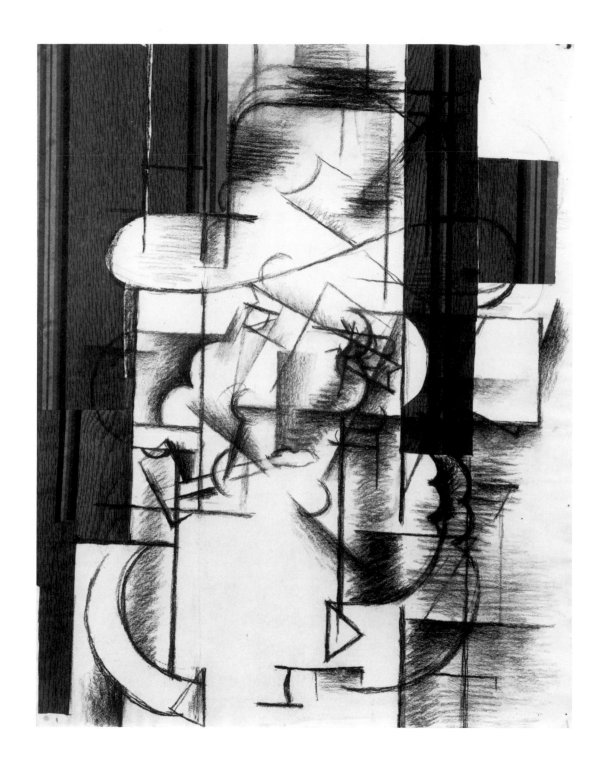

28 Violin and Sheet-music on a Table (Petit Oiseau)

Executed in spring 1913
Oil and charcoal on canvas, $28\frac{3}{4} \times 21\frac{1}{4}$ (73 × 54)
Neither signed nor dated

Lit: I. no. 153; M. (1907-14) no. 175

Prov: the artist to Galerie Kahnweiler, Paris (photo no. 1101), 1913-14; sequestered Kahnweiler stock, 1914-21; 2nd Kahnweiler sale, 17-18 November 1921, lot 28, sold for 800 frs. to M. Sprechholz, Paris; Jean Coutrot, Paris; Jacques Seligman & Co., New York; Meric Callery, Paris, by 1935; Buchholz Gallery, New York, before 1949; to the present owner in 1949
Private collection

Compare and contrast this painting with two major works of the 'analytical' phase: 'Violin and Palette' (1909-10; no. 9) and 'Violin and Poster' (1912; no. 22), for earlier treatments of the same musical instrument.

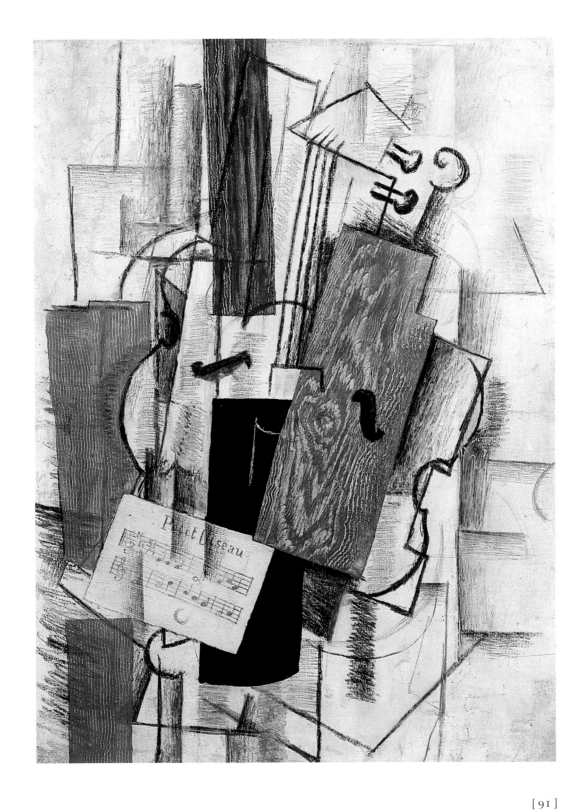

29 Fruit-dish, Grapes, Newspaper and Playing-cards on a Table

Executed in spring 1913
Oil, charcoal and graphite on canvas, $31\frac{7}{8} \times 23\frac{5}{8}$ (81 × 60)
Signed on back: 'G. Braque'; not dated

Lit: I.no.160; M.(1907-14) no.151; MNAM *Catalogue Braque*, 1982, no.11; Museum inv. no.1981.540

Prov: the artist to Galerie Kahnweiler, Paris (photo no.1130), 1910 until before 1914; Wilhelm Uhde, Paris, before 1914; sequestered Uhde collection, 1914-21; Uhde sale, Hôtel Drouot, Paris, 30 May 1921, lot 2, sold for 780 frs. to Paul Rosenberg, Paris, 1921-47; to the museum in 1947
Musée National d'Art Moderne (Centre Georges Pompidou), Paris. Gift of M. Paul Rosenberg

This painting clearly derives from Braque's experience in making his first *papier collé* (no.25). However, the structure and composition of this painting, executed some time during the following six months, is more complex and the artist has represented many additional objects.

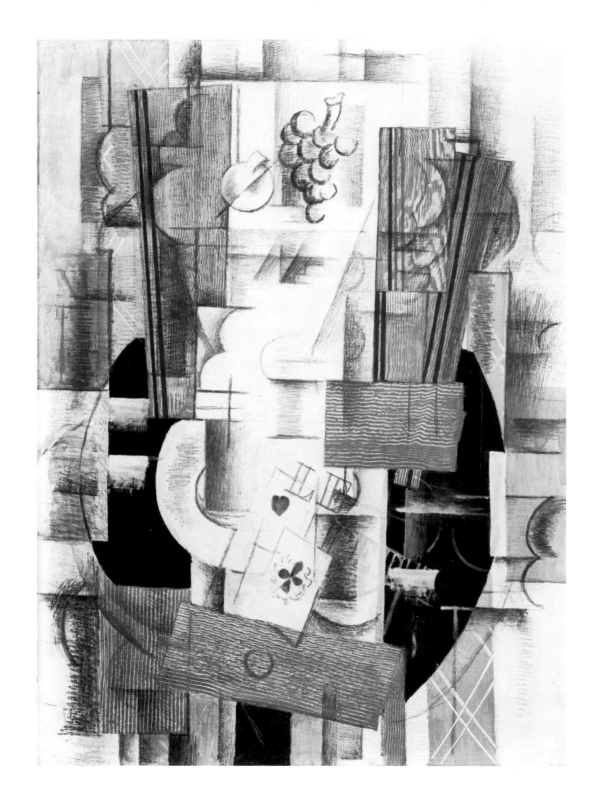

30 Still-life with a Newspaper, Bottle and Glass on a Table

Executed in summer 1913
Oil and charcoal on oval canvas, $39\frac{3}{4} \times 28 (91 \times 71)$
Signed bottom right: 'G. Braque'; formerly signed on back (now relined); 'G. Braque / Sorgues';
not dated

Lit: I.no. 165; M.(1907-14) no. 182

Prov: the artist to Galerie Kahnweiler, Paris (photo no. 1152), 1913-14; sequestered Kahnweiler
stock, 1914-22; 3rd Kahnweiler sale, Hôtel Drouot, Paris, 4 July 1922, lot 40, sold for 400 frs. to
André Breton, Paris; Earl Horter, Philadelphia, by 1926; Douglas Cooper, London and later
Argilliers, 1937-69; Acquavella Galleries, New York, 1969-70; an anonymous Italian
collection, 1970-80; to the present owner in 1981
Private collection

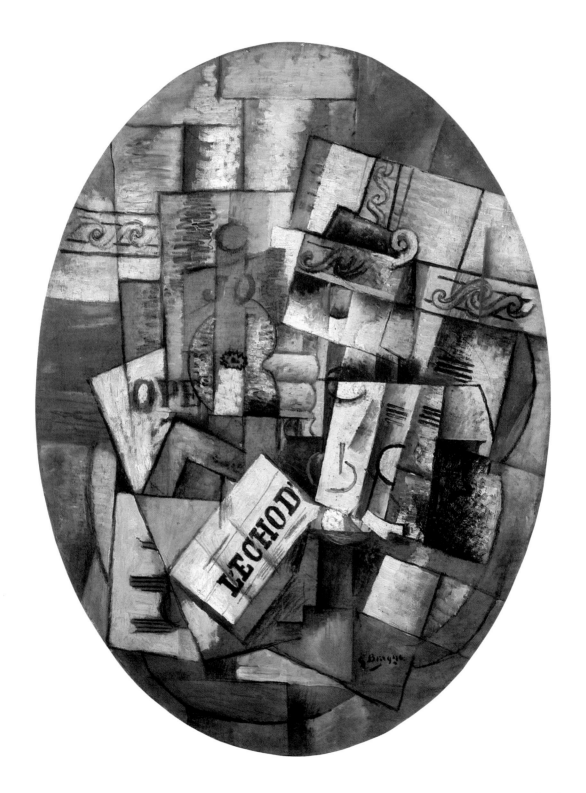

31 Clarinet, Glass and Newspaper on a Table

Executed probably in late summer 1913
Charcoal, newsprint, black and white papers and *faux-bois* paper pasted on paper,
$37\frac{7}{8} \times 47\frac{1}{4}$ (95 × 120)

Lit: I.no.174; M.(1907-14) no.204; MNAM *Papiers Collés*, 1982, no.29; Museum inv.no.947.79

Prov: the artist to Galerie Kahnweiler, Paris (photo no.1171), 1913-14; sequestered Kahnweiler stock, 1914-23; 4th Kahnweiler sale, Hôtel Drouot, Paris, 7-8 May 1923, lot 14, sold for 430 frs. to Léonce Rosenberg, Paris; Galerie de l'Effort Moderne (Léonce Rosenberg), Paris, 1923-?; Amédée Ozenfant, Paris and later New York, until 1951; Nelson A. Rockefeller, New York, 1951-79; to the museum in 1979
Museum of Modern Art, New York. Nelson A. Rockefeller Bequest 1945

The largest of Braque's *papiers collés*, of which he made some sixty-five in all, and a perfectly realized example. The structure and handling of this composition are more complex than would appear. Four differently coloured papers pasted over each other on the right establish planes in recession from the newspaper in the foreground. The piece of brown *faux-bois* (horizontal) evokes the table-top on which lie the objects. The over-drawing of the clarinet shows that it lies on top of the newspaper, which is behind the glass. The plane of the table-top and the background, which corresponds to the black paper, are shown by drawing.

[96]

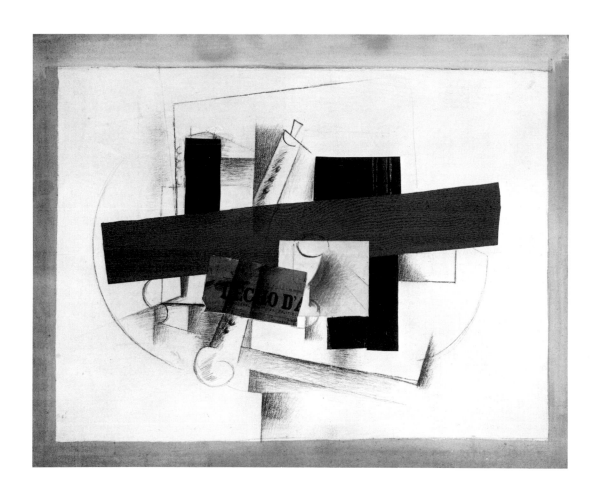

32 Bottle, Newspaper, Pipe and Glass

Executed in autumn 1913
Charcoal and various papers pasted on paper, $18\frac{7}{8} \times 25\frac{1}{4} (48 \times 64)$
Signed bottom right: 'G. Braque'; not dated

Lit: I.no.188; M.(1907-14) no.224; MNAM *Papiers Collés*, 1982, no.41

Prov: the artist to Galerie Kahnweiler, Paris (photo no.1587), before 1914; whereabouts unknown, between 1914-50; Galerie Louise Leiris, Paris (stock no.04718), 1950-53; Sir Edward and Lady Hulton, London, 1953-81; Marlborough Fine Art (London) Ltd, 1981; to the present owner in 1981
Private collection, New York

One of the boldest and most successful of the later pre-war *papiers collés* by Braque. The relationship between the drawing on both sides and the coloured elements in the centre is cleverly balanced. The structure is complex: five layers of differently coloured papers are pasted over and across each other in the centre. Various paradoxes should be noted: for example, the *faux-bois* paper with its moulding, representing the background wall, which stands spatially behind the back edge of the *guéridon*, is actually the top layer of pasted paper; the moulding is prolonged on the left by drawing; the pipe which appears to lie on the newspaper in the foreground, is in fact a form cut out of the printed sheet and lightly modelled internally. A trace of macabre humour is perhaps identifiable in the piece of newspaper at the bottom on the left where, framed between advertisements for Houbigant's perfume 'Fougère Royale' in the form of soap, and a brand of 'Violette de Parme' perfume, is a reportage on 'Le Parricide de Montreuil'.

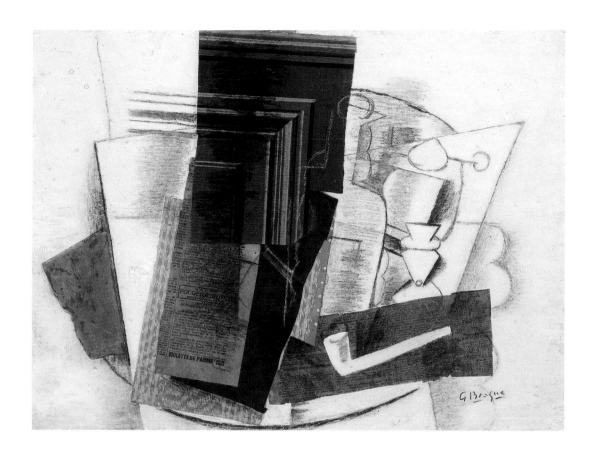

33 Violin on a Table

Painted probably in winter 1913-14
Oil and charcoal on canvas, $25\frac{1}{8} \times 36\frac{1}{4}$ (64 × 92)
Signed on back: 'G. Braque'; not dated

Lit: I. no. 197; M. (1907-14) no. 202

Prov: the artist to Galerie Kahnweiler, Paris (photo no. 1204), 1914; sequestered Kahnweiler stock, 1914-21; 1st Kahnweiler sale, Hôtel Drouot, Paris, 13-14 June 1921, lot 17, sold for 1750 frs. to Amédée Ozenfant as agent for Raoul LaRoche; Dr h.c. Raoul LaRoche, Paris, 1921 until *c.* 1962; to Dr Thomas Speiser, Basel, *c.* 1962 until 1975; to the present owner in 1975 *Acquavella Galleries, Inc., New York*

Compare with *Homage to J. S. Bach* (no. 24).

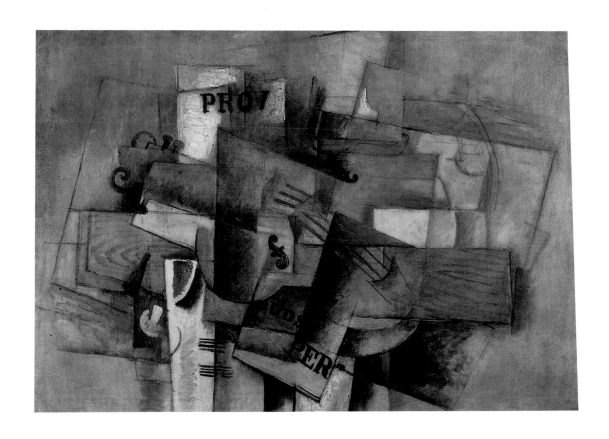

34 Still-life on a Guéridon (Gillette)

Executed in winter 1913-14
Pasted papers, gouache and charcoal on paper, $18\frac{1}{2} \times 24\frac{1}{2}(47 \times 62)$
Neither signed nor dated

Lit: M.(1907-14) no.240; MNAM *Papiers Collés*, 1982, no.44

Prov: the artist, Paris, 1914-63; bequeathed to M. and Mme Claude Laurens, Paris, in 1963;
to the present owners in 1983
Private collection, Paris

Already Braque has begun to develop a less
austere and more decorative type of picture,
enlivened, as here, by lighter colours and
pointillist brushwork.

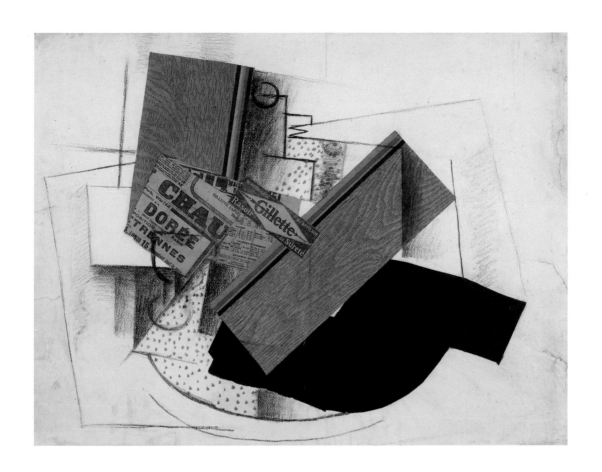

35 Glass, Carafe and Newspapers

Executed in early 1914
Pasted papers, chalk and charcoal on cardboard, $24\frac{5}{8} \times 11\frac{1}{4}$ (62.5 × 28.5)
Signed on back: 'G. Braque'; not dated

Lit: M. (1907-14) no. 233; MNAM *Papiers Collés*, 1982, no. 45

Prov: the artist to Galerie Kahnweiler, Paris (no photo available; stock no. 2242), 1914; sequestered Kahnweiler stock, 1914-23; 4th Kahnweiler sale, Hôtel Drouot, Paris, 7-8 May 1923, sold in a lot of nineteen works on paper (nos. 22-40) to an unidentified buyer as agent for Raoul La Roche; Dr h.c. Raoul LaRoche, Paris, 1923-62; to the present owner in 1962
Private collection, Basel

The fragment of text printed in Italian and with the page number 30 in the top left was extracted from the review *Lacerba*, published on 15 January 1914. *Lacerba*, a cultural review, was founded in Florence in January 1913 by the critic and painter Ardengo Soffici and the writer Giovanni Papini. It appeared fortnightly and sometimes included articles on the French Cubists. *Lacerba* became an official Futurist review in 1913-14; it was politically slanted, with attacks on Germany and Austria and a campaign for Italian intervention in the war. It closed down in mid-1915.

The introduction of pieces of paper of several different colours should be noted here, as well as the unusual format of the work.

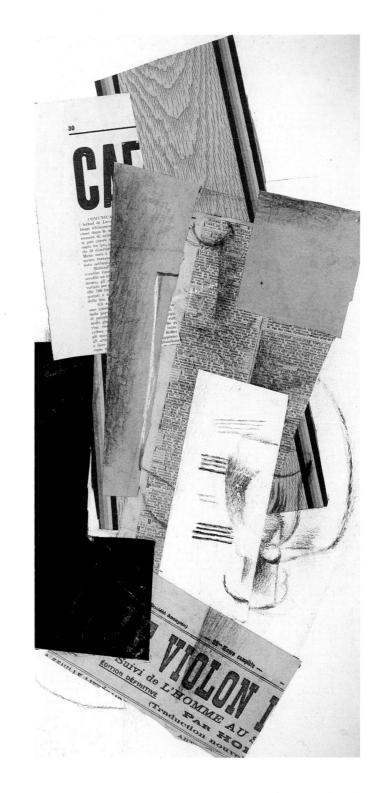

36 **Bottle of Rum**

Executed in spring 1914
Gouache and pasted papers on cardboard, $25\frac{3}{4} \times 18\frac{3}{8}$ (65.5 × 46.5)
Neither signed nor dated

Lit: M. (1907-14) no. 241; MNAM *Papiers Collés*, 1982, no. 52

Prov: the artist, Paris, 1914-63; bequeathed to the present owner in 1963
Private collection

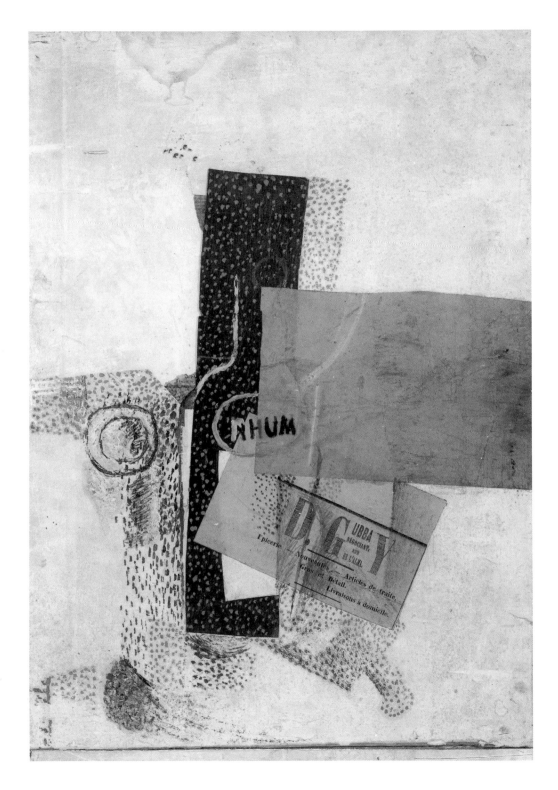

37 Glass, Newspaper, Packet of Tobacco and Sheet-music

Executed in spring 1914
Graphite, chalk, charcoal, gouache and paper pasted on heavy cardboard, $13\frac{3}{4} \times 10\frac{7}{8}$ (35×27.7)
Signed on back in charcoal: 'G. Braque'; not dated

Lit: I. no. 199; M. (1907-14) no. 243; MNAM *Papiers Collés*, 1982, no. 50; Museum inv. no. 1947.879

Prov: the artist to Galerie Kahnweiler, Paris (photo no. 1206), 1914; probably sequestered Kahnweiler stock, 1914-23; probably sold in an unspecified lot in one of the Kahnweiler sales, 1921-3; Mrs Goodspeed, Chicago and later New York (Mrs Gilbert Chapman), by *c.* 1925 until 1947; to the museum in 1947
Art Institute of Chicago. Gift of Mrs Gilbert W. Chapman, 1947

This work represents a more evolved stage in the use of *papier collé* and is based on a decorative pictorial conception. Braque has here dispensed with the basic sheet of white paper and with drawing as a structural or descriptive element. The cigarette packet is itself a 'certainty,' the glass is made up of two hand-cut pieces of paper, shaped as profiles of a glass, while many of the coloured elements are hand-painted not printed. The use of *papier collé* here shows that Braque was preparing for a move back towards real painting.

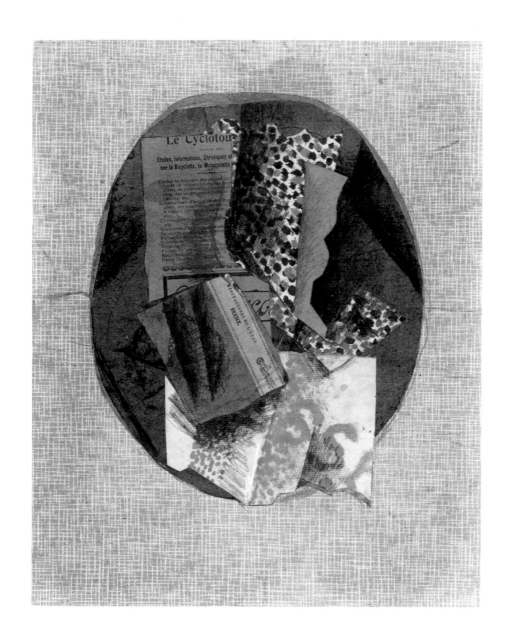

38 Man with a Guitar

Executed in spring 1914
Oil and sawdust on canvas, $51\frac{1}{4} \times 28\frac{3}{4}$ (130 × 73)
Signed on back: 'G. Braque'; not dated

Lit: I. no. 201; M. (1907-14) no. 230; MNAM *Catalogue Braque* 1982, no. 14; Museum inv. no. AM 1981-540

Prov: the artist to Galerie Kahnweiler, Paris (photo no. 1209), 1914; sequestered Kahnweiler stock, 1914-21; 1st Kahnweiler sale, Hôtel Drouot, Paris, 13-14 June 1921, lot 22, sold for 2820 frs. to M. Grassat as agent for the 'Simon syndicate'; Galerie Simon, Paris, 1921-24; Alphonse Kann, St Germain-en-Laye, 1924-?; André Lefèvre, Paris, until 1963; Lefèvre estate, 1963-5; 2nd Lefèvre sale, Hôtel Drouot, Paris, 25 November 1965, lot 32, sold to Heinz Berggruen, Paris, 1965-81; to the museum in 1981
Musée National d'Art Moderne, (Centre Georges Pompidou), Paris. Bought with the participation of the la Scaler Foundation

A masterpiece of the 'synthetic' phase of Cubism and Braque's most important figure composition of the pre-war years. The man is seated in a high-backed armchair, of which one sees the two arms terminating in volutes on both sides in the foreground. He holds a guitar on his lap; in front of him is a small wooden table on which stands a glass. Note the accordion-like succession of six receding planes on the left, beginning with the man's white shirt and finishing with the background wall which has an ornamental dado running horizontally across it. This array of planes is comparable to those in 'Bottle, Newspaper, Pipe and Glass' (no. 32), executed at least six months earlier. The textural contrasts here heighten the sense of reality, while the pointillist brushwork is used to animate dead surfaces and introduce a decorative note.

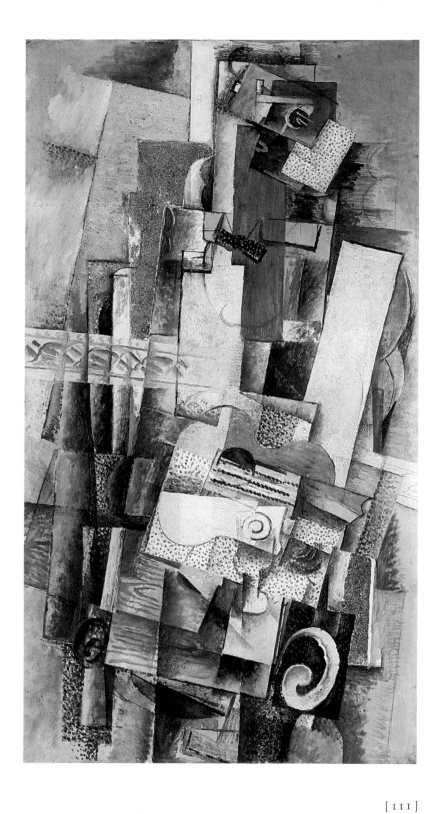

39 Still-life with a Violin, Glass and Pipe on a Table (*also known as* Music)

Executed in late spring 1914
Oil, gesso and sawdust on canvas, 36 × 23½(91.5 × 59.7)
Signed bottom centre in a *trompe-l'œil* name-plate: 'G. Braque'; and on back: 'G. Braque'; not dated

Lit: I. no. 203; M. (1907–14) no. 232

Prov: the artist to Galerie de l'Effort Moderne (Léonce Rosenberg), Paris (photo no. 122; stock no. 5285), 1919-22; Katherine S. Dreier, New York and later Connecticut, 1922-53; bequeathed to the museum in 1953
Phillips Collection, Washington, DC

Since early in 1913, Braque had been progressively reducing the evocation of space in his paintings in order to give a more positive significance to the surface of the canvas. This is evident in 'Petit Oiseau' (no. 28), 'Fruit-Dish, Grapes, Newspaper and Playing-cards on a Table' (no. 29), 'Newspaper, Bottle and Glass' (no. 30) and 'Violin on a Table' (no. 33). As here, the planes become paper-thin and every element seems to be pressed flat on to the surface of the canvas. This flatness is further emphasised by the minimal degree of separation visible between one plane and the next.

The effect is to suggest a comparison with one of those cut-out scenes in children's books which, when the page is opened, rise and transpose the scene three-dimensionally. But here the image is pressed flat. Note how the irregular oval which surrounds the composition, as well as the imitation name-plate with block lettering, combine with the light colouring, pointillist brushwork and textural variations to create a pleasing decorative effect. This is a splendid example of the concept of a *tableau-objet*.

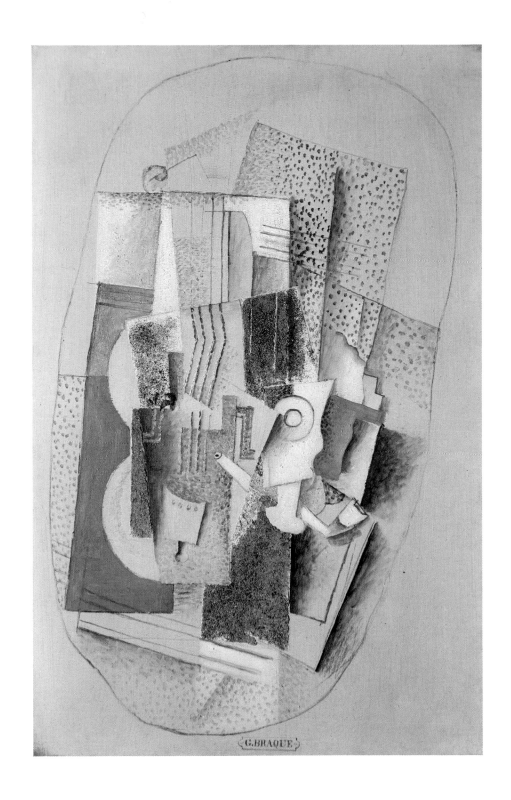

40 The Musician

Painted between autumn 1917 and spring 1918
Oil on canvas, 87 × 44½ (221.5 × 113)
Signed bottom left: 'G. Braque'; not dated

Lit: I. no. 215; M. (1916-23) no. 1; Museum inv. no. 2289

Prov: the artist to Galerie de l'Effort Moderne (Léonce Rosenberg), Paris (photo no. 85; stock no. 5083), 1919-?; Dr h.c. Raoul LaRoche, Paris, sometime in the 1920s until 1952; to the museum in 1952
Kunstmuseum, Basel. Gift of Dr h.c. Raoul LaRoche

The continuity in Braque's work was broken at the end of July 1914 when he was mobilised into the French army. On 11 May 1915 he was severely wounded in the head at Carency, near Arras, and underwent a trepanning operation. His convalescence, spent between Paris and Sorgues, where he still had a house, was prolonged, and he did not start to paint again until mid-1917. By that time he was disoriented and had to pick up as best he could the threads of recent Cubist pictorial developments – Picasso and Juan Gris, as Spaniards, had not been mobilised and were in Paris. Braque looked back of course to his own last works of 1914, and found a new vision in the sculpture and *papiers collés* of his old friend Henri Laurens. Braque also profited from the more severe, later Cubist idiom of Juan Gris, another old friend. Thus his pictures of 1917-19 represent the culmination of 'synthetic'

Cubism in his work. He began with some *papiers collés* (and paintings) which have a firm, more geometrically determined structure. The forms are bolder; there is a greater range of pasted elements with stronger, more contrasted and decorative colours, applied unbroken in broad planes. By contrast with 'Music' (no. 39) the effect here is flatter and suggests painted bas-relief.

The present picture is one of the most ambitious and significant of Braque's figure pieces, as well as of 'synthetic' Cubism. The influence of Juan Gris is apparent in the regularity and stability of the planes, the avoidance of modelling and a play of self-directed light, as well as the variety of surface decoration. For all its richness of colour and elaborate patterning, this is a severe painting. But another change in Braque's stylistic conception was not long in coming.

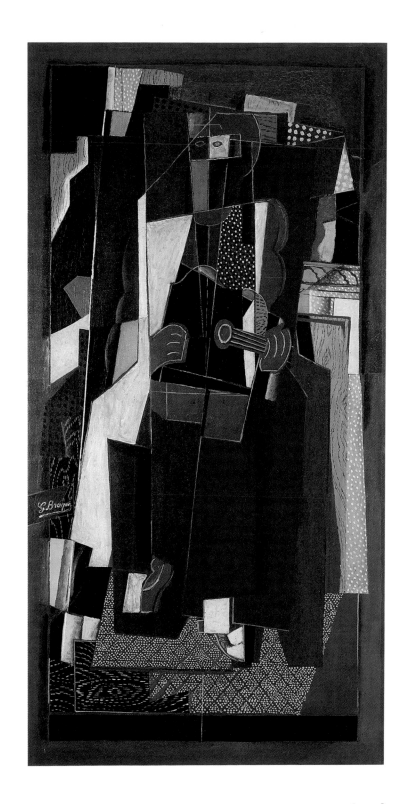

41 Guitar and Sheet-music on a Table

Executed in 1918
Pasted papers and gouache on pasteboard, $25 \times 18\frac{1}{2}(63.5 \times 47)$
Neither signed nor dated

Lit: I.no.230; M.(1916-23) no.17; MNAM *Papiers Collés*, 1982, no.56; Museum inv.no.31.48

Prov: the artist to Galerie de l'Effort Moderne (Léonce Rosenberg), Paris (stock no.5084), 1919-?;
Ferdinand Howald, Columbus, *c.* 1926 until 1931; to the museum in 1931
Columbus Museum of Art, Ohio, Gift of Ferdinand Howald

Already in this *papier collé* the severity of
certain forms is countered by a new looseness
in the drawing of the guitar and sheets of
music.

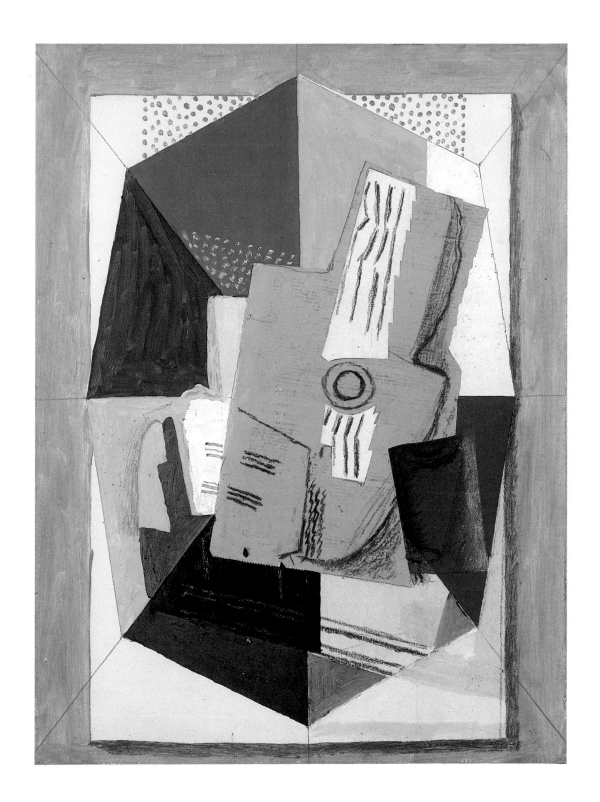

42 Still-life with a Guitar on a Table

Executed in autumn 1918
Oil with sand on canvas, $35\frac{3}{4} \times 21\frac{5}{8}$ oval (91 × 55)
Signed bottom right in 1960: 'G. Braque'; not dated

Lit: I. no. 212 (as 'Violin', 1917); M. (1916-23) no. 6

Prov: the artist to Galerie de l'Effort Moderne (Léonce Rosenberg), Paris (photo no. 390), 1919;
Jacques Doucet, Paris, by the mid-1920s; Doucet estate; César de Hauke, Paris, by 1960; to the
present owner in 1960
Private collection

Beginning in mid-1918, Braque worked on a much larger scale than before and concentrated on still-life subjects. He found a freer and more masterly way of handling form and space in compositions, which were no longer executed in a strictly 'synthetic' Cubist style, but were characterised by large forms, an overall looseness and a richer, more varied palette of colours used, as a rule, descriptively. This reveals an attempt on the part of Braque to 'humanise' his style, so that although the forms are still Cubist in derivation, they correspond more nearly with known appearances. At the same time, Braque tries to arouse in the spectator not so much a visual as a tactile experience of this invented pictorial reality. Such was the essence of Braque's personal contribution to late Cubism, and he continued to elaborate this personal idiom – which is not echoed in the work of Picasso – in a succession of luscious, lyrical compositions executed during the following ten years.

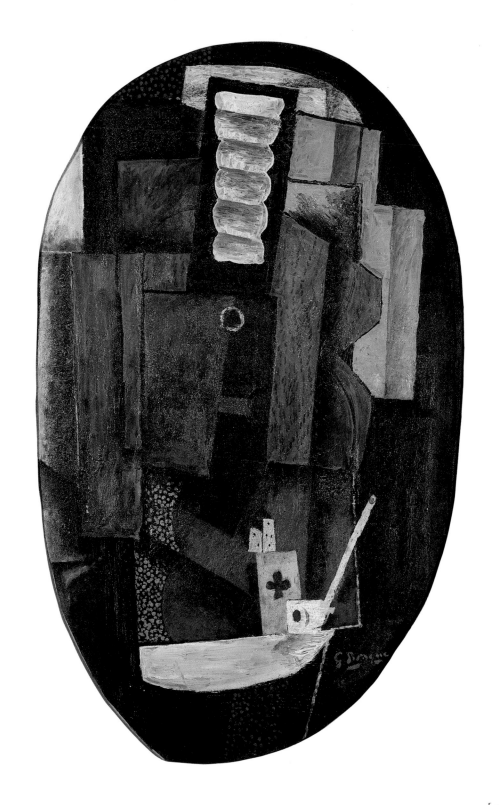

GEORGES BRAQUE

43 Still-life on a Guéridon

Executed in summer 1911
Charcoal on paper, $24\frac{3}{4} \times 19 (62.9 \times 48.1)$
Neither signed nor dated

Lit: M.(1907-14) no.97; Museum inv.no.KK 1963.19

Prov: the artist to Galerie Kahnweiler, Paris (photo no.938), 1911-14; sequestered Kahnweiler stock, 1914-23; 4th Kahnweiler sale, Hôtel Drouot, Paris, 7-8 May 1923, lot 33, sold with eighteen other drawings for 780 frs. to an unidentified buyer, probably an agent for Raoul LaRoche; Dr h.c. Raoul LaRoche, *c.* 1923 until 1963; given to the museum in 1963
Kunstmuseum, Basel, Kupferstichkabinett

Braque was not, like Picasso, a great natural draughtsman, and he used drawing chiefly as a medium for clarifying and expressing in pictorial terms a subject which he had seen or imagined. Thus the present drawing throws light on the structural notation of paintings like 'The Candlestick' and the 'Pair of Banderillas' (nos.15 and 18). Very few drawings by Braque correspond to specific paintings.

44 Still-life with Glasses and Newspaper on a Table

Executed in early 1912
Charcoal on paper, $12\frac{5}{8} \times 18\frac{1}{2} (32 \times 47)$
Neither signed nor dated

Lit: M.(1907-14) no.128

Prov: probably the artist to Galerie Kahnweiler, 1912-14; probably sequestered Kahnweiler stock, 1914-23; probably sold in an unidentified lot in one of the Kahnweiler sales, 1921-3; subsequent whereabouts unknown before 1977; Sale, Palais d'Orsay, Paris, 23-24 June 1977, lot 76 *bis*, sold to an unidentified buyer; on the Paris art market; to the present owner in 1977
Galerie Louise Leiris, Paris

A similar structural looseness and confusion prevails here as in nos.20 and 23.

[120]

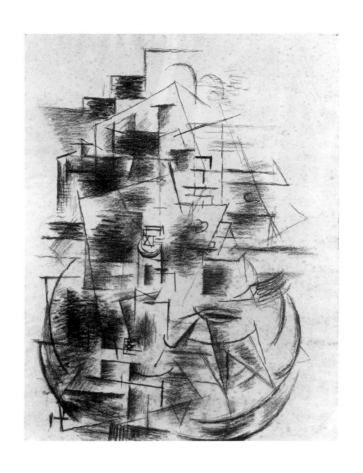

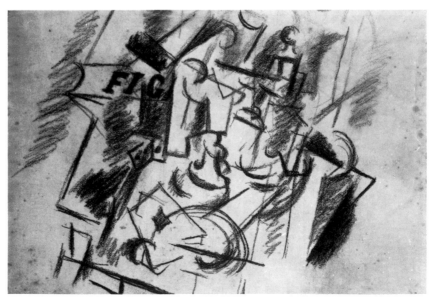

45 Still-life with a Clarinet on a Table

Executed in early 1912
Charcoal on paper, $24\frac{7}{8} \times 18\frac{7}{8} (63.3 \times 48)$
Neither signed nor dated

Lit: M.(1907-14) no.129; Museum inv.no.KK 1963.20

Prov: the artist to Galerie Kahnweiler, Paris (photo no. 1004), 1912-14; sequestered Kahnweiler stock, 1914-23; 4th Kahnwciler sale, Hôtel Drouot, Paris, 7-8 May 1923, lot 32, sold with eighteen other drawings for 780 frs. to an unidentified buyer, probably an agent for Raoul LaRoche; Dr h.c. Raoul LaRoche, *c.* 1923 until 1963; given to the museum in 1963
Kunstmuseum, Basel, Kupferstichkabinett

46 Seated Woman with a Guitar (Sorgues)

Executed in August –September, 1912
Graphite on paper, $13\frac{3}{8} \times 8\frac{1}{2} (34 \times 21.5)$
Not signed but dated towards the bottom: 'Sorgues / 1912'

Lit: M.(1907-14) p.10 (repr)

Prov: the artist, Paris, 1912-63; bequeathed to the present owners in 1963
Private collection

A woman in a hat, seated facing the spectator, is holding a guitar (sound-hole and strings visible just below the centre of the drawing); on the wall behind her left shoulder is a poster announcing the *Fêtes Votives* of Sorgues, where Braque and Picasso spent the summer of 1912. In his desire to represent all that he knows about the spatial relationships involved, Braque has produced a highly complex planar structure, which is not easy to read. This has caused him to lose touch with the physical reality of the figure. Shortly after executing this drawing, Braque began to clarify his methods of representation by exploring the potentialities of his newly invented technique of *papiers collés*.

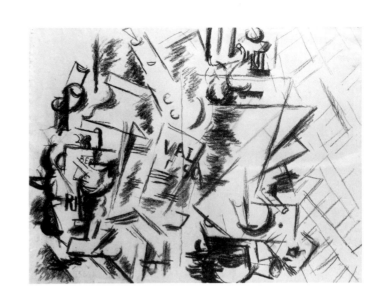

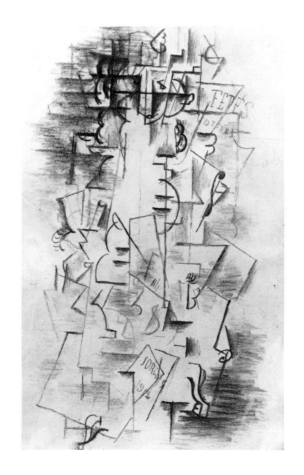

47 Still-life with Dice

Executed in summer 1912
Charcoal on paper, $9\frac{3}{8} \times 12\frac{7}{8}(25 \times 32.7)$
Neither signed nor dated

Lit: M.(1907-14) no.130

Prov: the artist to Galerie Kahnweiler, Paris (no photo available), 1912; probably sequestered Kahnweiler stock, 1914-23; probably sold in an unidentified lot in one of the Kahnweiler sales, 1921-3; André Lhote, Paris, by 1923; Lhote estate, 1955; Marlborough Fine Art (London), Ltd, 1955; to the present owner in 1955
Private collection

48 Still-life with a Guitar on a Table

Executed in 1917
Brown ink on tan paper, $7\frac{3}{8} \times 9\frac{1}{2}(18.8 \times 24.2)$
Signed bottom right: 'G.B.'; not dated

Prov: early whereabouts unknown; the Redfern Gallery, London, by 1944; to the present owner in 1944
Private collection

This drawing was reproduced in the review *Nord–Sud*, no.13, March 1918. *Nord–Sud* was a modest literary review created and edited by Pierre Reverdy, which appeared in Paris irregularly in 1917 and 1918. It contained poems and articles by Reverdy and his friends and defended Cubist art. Historically, *Nord–Sud* fits between *Les Soirées de Paris*, founded by André Billy in February 1912 and taken over by Guillaume Apollinaire in November 1913, which defended Cubism until the magazine closed at the end of 1914, and *L'Esprit Nouveau*, launched in the winter of 1920 by Ozenfant and Le Corbusier, which preached a *rappel à l'ordre* after the years of aesthetic revolution, the break-up of forms as entities by the Cubists, and the physical destruction resulting from the First World War. *L'Esprit Nouveau* stood for a neo-classical revival, Purism and the latest in formally perfect, functional, modern design.

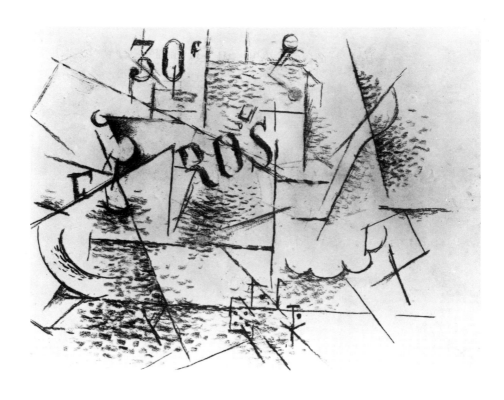

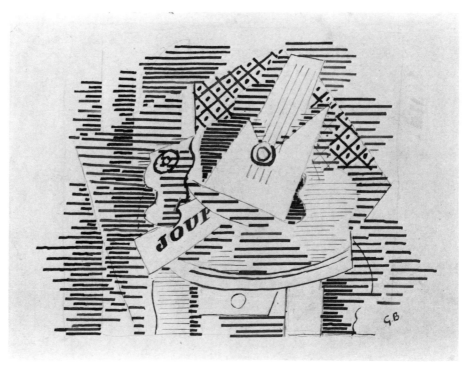

49 Standing Nude

Executed in late 1907
Etching, $10\frac{7}{8} \times 7\frac{1}{2}(27 \times 19.5)$ plate; $22\frac{1}{2} \times 15(57 \times 38)$ sheet
Signed and numbered: '4/25 Braque'

Lit: Vallier no. 1

Edn: a few trial proofs pulled in 1907-08. Edition printed in 1953 (Maeght Editeur, Paris): twenty-five on Auvergne paper, thirty on Rives paper; fifty-five copies in all
Fondation Maeght, St Paul, France

An undated preparatory drawing (pose reversed) in ink for this etching exists in a private collection.
 A second etching, 'Still Life, Paris' (Vallier, no. 3), was made in 1911 on the verso of the same plate (Cat. no. 54).

50 Guitar on a Table

Executed in summer 1909
Etching with drypoint, $5\frac{1}{4} \times 7\frac{5}{8}(13 \times 19.4)$ plate; $9\frac{7}{8} \times 12\frac{5}{8}(25 \times 32)$ sheet
Signed bottom right: 'G. Braque'; numbered *Hors Commerce*.

Lit: Vallier, no. 2

Edn: one trial proof printed in 1909-10. Printed in 1954 (Maeght Editeur, Paris) in an edition of twenty-five on *papier de Chine*
Fondation Maeght, St Paul, France

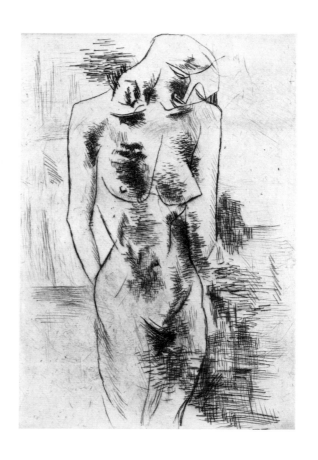

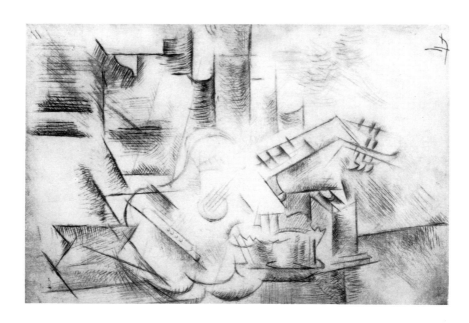

51 Still Life on a Table (JOB)

Executed in 1911
Etching with drypoint, $5\frac{3}{4} \times 7\frac{7}{8}$ (14.5 × 20) plate; $8\frac{1}{4} \times 12\frac{5}{8}$ (21 × 32) sheet
Unsigned; numbered *Hors Commerce*

Lit: Vallier, no. 5

Edn: printed in 1912 (Editions Kahnweiler, Paris) in an edition of 100 on Arches paper
Fondation Maeght, St Paul, France

'JOB' was the brand-name of a popular cigarette paper used for rolling. Note the use of the long-stemmed clay pipe, (its bowl is in the right foreground) to relate the foreground to the background spatially.

This was one of only two engravings by Braque – the other being 'FOX' (Cat. no. 52) – which were printed and put on sale before 1914. Very few copies were sold, so that the greater part of the edition was included in the post-war Kahnweiler Sale (1923). Unlike Picasso, who produced some thirteen Cubist engravings between 1909 and 1914, Braque was not commissioned to provide illustrations for books by friends; most of his Cubist engravings (ten in all) remained unpublished until the 1950s.

52 Still-life with a Bottle of Gin on a Table (FOX)

Executed in 1911
Etching with drypoint, $21\frac{5}{8} \times 15$ (55 × 38) plate; $25\frac{5}{8} \times 19\frac{3}{4}$ (65 × 50) sheet
Unsigned; numbered *Hors Commerce*

Lit: Vallier, no. 6

Edn: printed in 1912 (Editions Kahnweiler, Paris) in an edition of 100 on Arches paper
Fondation Maeght, St Paul, France

The word 'FOX' refers to the owner of a bar near the Gare St Lazare in Paris where Picasso, Apollinaire, Max Jacob and their friends often met.

This engraving was commissioned by Kahnweiler in the autumn of 1910 – at the same time as he commissioned 'Still-life with Bottle of Marc' from Picasso (no. 186) – and was put on sale in 1912. The structure of lines which Braque used in his paintings to represent spatial relationships is shown here in clearly legible terms.

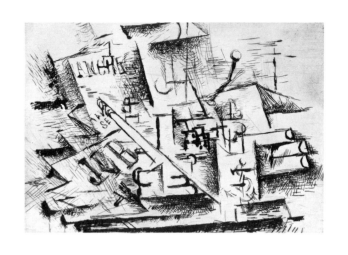

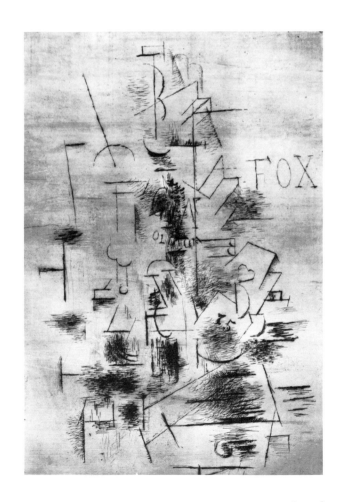

53 Still-life with Bottles of Wine and of Bass on a Table

Executed in 1911
Etching with drypoint, $18\frac{1}{2} \times 13(47 \times 33)$ plate; $18\frac{3}{8} \times 13(46.5 \times 33)$ sheet
Signed and numbered: 'Braque / H C 3/6'

Lit: Vallier, no. 7

Edn: printed in 1950 (Maeght Editeur, Paris) in an edition of fifty on Arches *teinté* paper; six copies *Hors Commerce*
Fondation Maeght, St Paul, France

Note how, at the top on the right, Braque has translated *faux-bois* graining into terms of etching.

54 Still-life on a Table

Executed in 1911
Etching with drypoint, $13\frac{3}{4} \times 8\frac{5}{8}(35 \times 22)$ plate; $22\frac{1}{2} \times 15(57 \times 38)$ sheet
Signed and numbered: 'Braque / *Hors Commerce* 3/6'

Lit: Vallier, no. 8

Edn: printed in 1950 (Maeght Editeur, Paris) in an edition of fifty on Arches *teinté* paper; six copies *Hors Commerce* printed. A few trial proofs pulled in 1911
Fondation Maeght, St Paul, France

This etching was originally joined, on the same plate, with 'Still-life with Glasses' (1912), Vallier, no. 11.

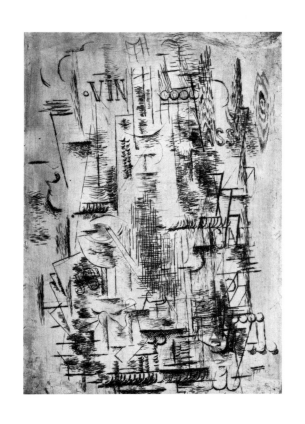

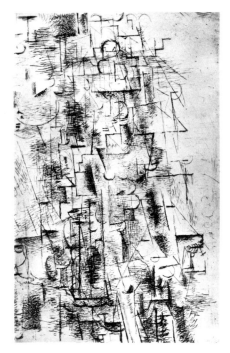

55 Glass and Bottle of Bass on a Table (Pale Ale)

Executed in 1911
Etching with drypoint, $18\frac{1}{8} \times 13 (46 \times 33)$ oval plate; $22\frac{1}{2} \times 17\frac{3}{4} (57 \times 45)$ sheet

Lit: Vallier, no. 9

Edn: printed in 1954 (Maeght Editeur, Paris) in an edition of fifty on Arches *teinté* paper. A few trial proofs pulled in 1911
Fondation Maeght, St Paul, France

Between 1910 and 1912, many of Braque's paintings were made on oval-shaped canvases because, he said, the oval enabled him to 'rediscover his sense of the horizontal and the vertical'.

56 Pipe, Bottle and Glasses on a Table

Executed in 1912
Etching with drypoint, $13 \times 17\frac{7}{8} (33 \times 45.5)$ plate; $19\frac{3}{4} \times 25\frac{1}{2} (50 \times 65)$ sheet
Unsigned; numbered *Hors Commerce*

Lit: Vallier, no. 10

Edn: printed in 1953 (Maeght Editeur, Paris) in an edition of fifty on Arches *teinté* paper, and six sheets *Hors Commerce*.
Fondation Maeght, St Paul, France

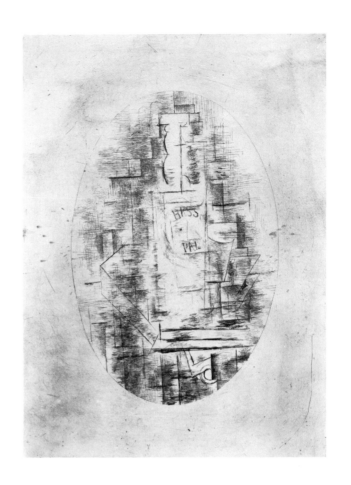

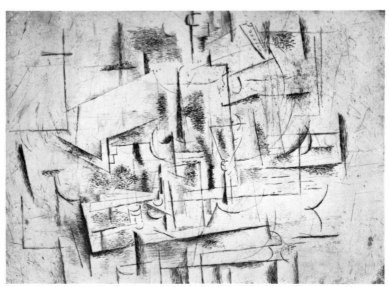

Juan Gris 1887–1927

Juan Gris with Josette in his studio, in the *bateau-lavoir*, 1922 *Photo D.H. Kahnweiler*

JUAN GRIS

57 Bottle and Pitcher

Painted in spring 1911
Oil on canvas, $21\frac{5}{8} \times 13 (55 \times 33)$
Signed bottom left: 'Juan Gris'; not dated

Lit: Cooper no. 6; Kröller-Müller 1969, p. 132; Museum inv. no. 323-21

Prov: the artist to Clovis Sagot, Paris, 1911; Galerie de l'Effort Moderne (Léonce Rosenberg), Paris, until 1921; L'Effort Moderne sale, Mak's, Amsterdam, 22 February 1921, lot 23, sold to Mevr. Kröller-Müller, The Hague; given to the museum in 1938
Rijksmuseum Kröller-Müller, Otterlo

This is an example of Gris's nascent Cubist style. Objects are treated individually, while the pictorial space is indicated through a diagonal receding from the bottom right to top left. Thus the spatial element is not divided and represented by a linear scaffolding, as in the works of Picasso and Braque. Here elementary heavy facetting is used to evoke volume. In the bowl in the left foreground, that part of the surface nearest to the eye is flattened so that the curve of the upper rim encloses more emphatically the internal volume of the bowl. Two ways of representing volume are visible in the handling of the bottle of wine: the liquid in the lower half, with its upward-tilted level assisted by simple facetting, evokes a tubular volume, while a similar effect is obtained in the upper half by facetting and dislocation.

We see Gris here finding his own way towards a Cubist idiom by a personal reappraisal of the sources of Cubist development in the work of Cézanne. The broken contours, the varying perspectives and the clearly stated planes can be sensed in Cézanne's paintings, but are less immediately visible because, unlike Gris, Cézanne did not define them with strong outlines. This painting is the equivalent in Gris's work of early analytical Cubist paintings of 1908-09 by Braque and Picasso. But Gris has not tried to imitate the method of either of these artists. From the start, his Cubist idiom was derived from Cézanne and personal inventions. Gris's fundamental pictorial aim was to represent a three-dimensional experience of reality in two-dimensional terms on the surface of the canvas without recourse to illusion, an aim shared with Braque and Picasso. But Gris did not follow them in remaking this experience in wholly invented terms, because he was not prepared wholly to sacrifice natural appearances. And during the next three years he experimented restlessly with various technical methods to achieve his aim in his own way.

A drawing with a similar composition is shown here as no. 79.

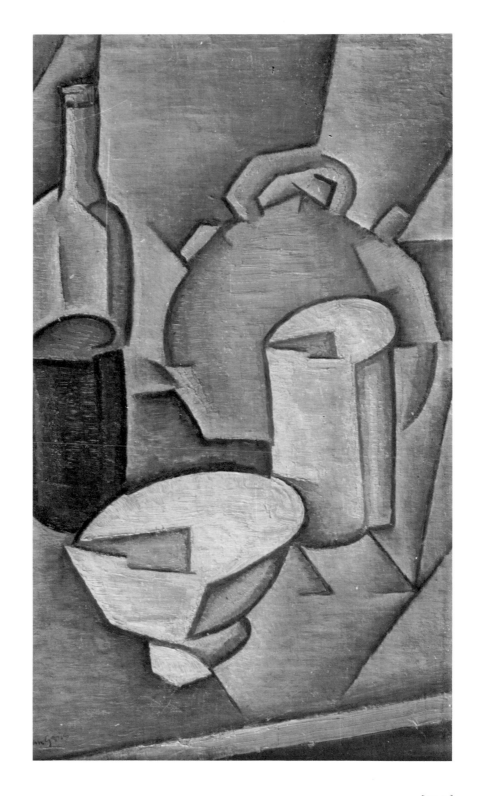

[137]

58 Houses on the Place Ravignan, Paris

Painted in summer 1911
Oil on canvas, $20\frac{1}{2} \times 13\frac{3}{8}$ (52 × 34)
Signed bottom left: 'Juan Gris'; with inscription: 'A mon cher ami Picabia, avec toute l'admiration de Juan Gris'; not dated

Lit: Cooper no. 9

Prov: the artist to Francis Picabia, Paris, 1911; Galerie Zak, Paris; Galerie Percier (André Level), Paris; to the present owner in 1938
Private collection

Although Gris had lived in the *'bateau-lavoir'* in Montmartre since 1906, was a good friend and neighbour of Picasso, whose studio he often visited, and through whom he met Braque, Apollinaire and Salmon, he was to evolve a Cubist idiom of his own once he took to painting full-time in 1910. In Gris's artistic temperament, a natural inclination towards intellectuality and scientific reasoning – he had, in his youth, studied to become an engineer – was countered and held in balance by sensibility and a particular respect for natural appearances. He was fascinated by the mathematical calculations applied as a basis for Cubism by the Villon circle at Puteaux, with which he was rather loosely associated for a brief while in 1911-12. But Gris was never the victim of theory, nor indeed of a mathematically calculated formula in creating his Cubism idiom. Here, for example, we find him adopting a certain degree of facetting in order to give fullness to the forms, but at the same time (unlike either Picasso or Braque) allowing light to play an active role in the composition and to evoke volume in the forms. Gris's handling of light is, however, more consistent than that of Picasso and Braque in so far as it is treated as coming from a single source.

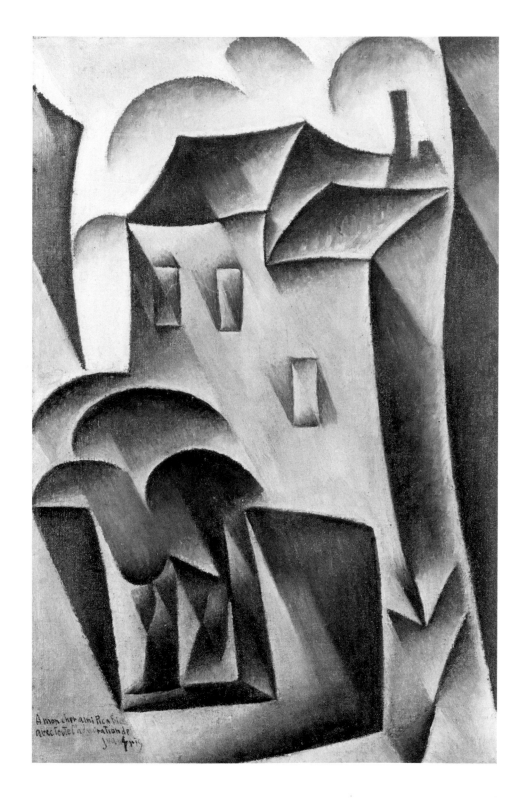

59 Portrait of the Artist's Mother

Painted in about March 1912
Oil on canvas, $21\frac{5}{8} \times 18\frac{1}{8}$ (55 × 46)
Signed top left: 'Juan Gris'; not dated

Lit: Cooper no. 14

Prov: the artist to Galerie Kahnweiler, Paris (photo no. 5003), 1912-14; sequestered Kahnweiler stock, 1914-22; 3rd Kahnweiler sale, Hôtel Drouot, Paris, 4 July 1922, lot 100, sold for 65 frs. to M. (Jacques?) Lipchitz, Paris; Galerie Simon, Paris; Waldemar George, Paris; Galerie Simon, Paris; J.K. Thannhauser, Munich and Paris; Galerie de Beaune, Paris; to the present owner in 1938
Private collection

Gris has here developed his analytical method of representation, by combining full-face and profile views of the head of his mother, by evoking volume through a strong play of light and shade coupled with emphatically rounded, often hollowed-out forms, and by devising a new structure of broad planes through which the head is related to the space around it.

Gris made this portrait from a photograph.

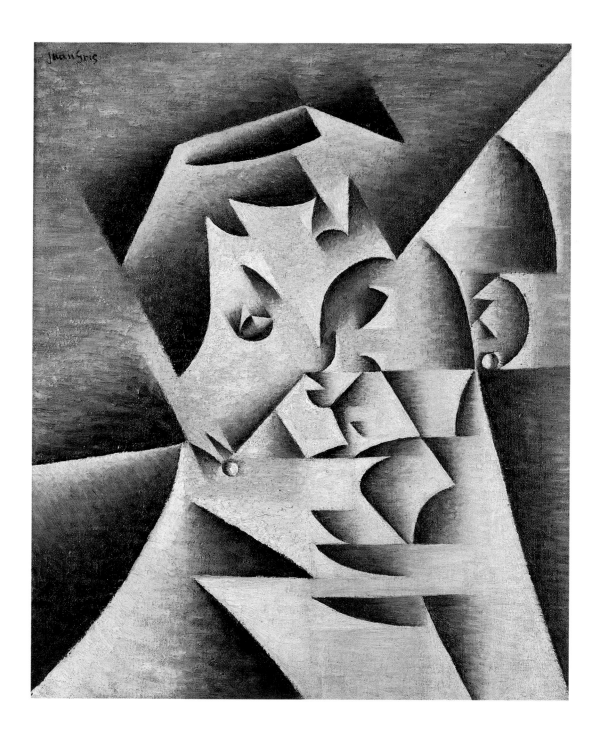

60 Still-life with Flowers

Painted in the first half of 1912
Oil on canvas, $44\frac{1}{8} \times 27\frac{5}{8}$ (112.1 × 70.2)
Signed bottom right: 'Juan Gris'; and on back of canvas: 'Juan Gris / Nature Morte'; not dated

Lit: Cooper no. 20; Museum inv. no. 131.47

Prov: the artist to Galerie Kahnweiler, Paris (stock no. 1394), 1912; Brenner and Coady Gallery,
New York, 1913; Dr P. A. T. Levene, New York, by *c.* 1915; to the museum in 1947
*Museum of Modern Art, New York. Bequest of Anna Erickson Levene in memory of her husband,
Dr Phoebus Aaron Theodor Levene, 1947*

The strict frontality of this composition, which
rests on the leg of the table visible in the centre
of the foreground, the shallow pictorial space
and the flattened volumes of the objects,
combine to endow the painting with a re-
semblance to a low sculptural relief. It is
animated visually by sharp contrasts of dark
and light. A charcoal study for the bunch of
flowers in a vase, visible here in the back-
ground, is shown as no. 82.

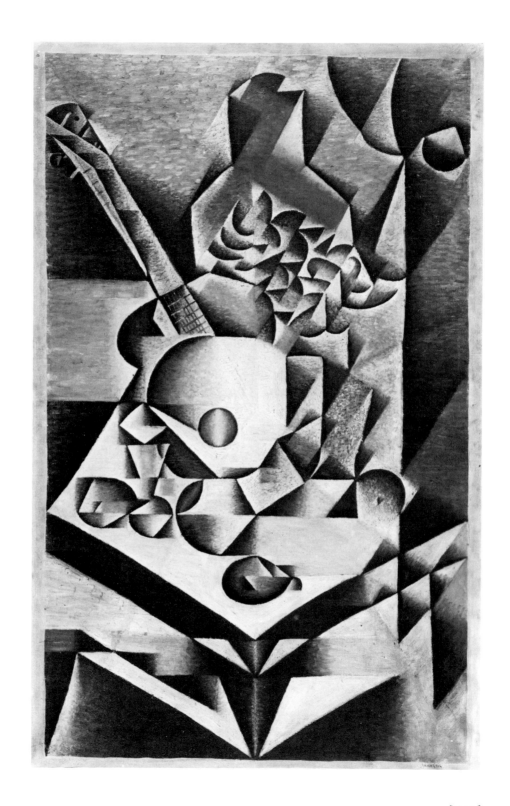

61 The Watch

Painted in September 1912
Oil on canvas, $25\frac{1}{2} \times 36\frac{1}{4} (65 \times 92)$
Signed bottom left: 'Juan Gris'; not dated

Lit: Cooper no. 27

Prov: the artist to Clovis Sagot, Paris, 1912; Galerie de l'Effort Moderne (Léonce Rosenberg) Paris (photo no. 815), 1915; Baron Napoléon Gourgaud, Paris; Galerie de Beaune, Paris, by 1935; Walter P. Chrysler, Jr, New York, 1935-50; Chrysler sale, Parke-Bernet, New York, 16 February 1950, lot 60; E. and A. Silberman Galleries, New York; Curt Valentin Gallery, New York, 1952; G. David Thompson, Pittsburgh, 1953-60; Galerie Beyeler, Basel; to the present owner in 1960
Private collection

By the autumn of 1912, that is to say less than three months after painting the 'Still-life with Flowers' (no. 60), Gris felt he had exhausted the possibilities of a style based on an active play of light; moreover he resented what he regarded as distortions of natural appearances resulting from it. In consequence, he invented a new type of linear pictorial structure – visible here – which served to make forms more explicit, to define spatial relationships and to give stability to the composition as a whole.

The present composition is organised through a division of the entire pictorial space (from left to right) into three broad vertical planes running from top to bottom of the canvas. Each of these has been made self-sufficient and is spatially related to the striped background wall by an internal perspective established with diagonal lines. The essential components of the still-life, which lie on the flat top of a table, are seen frontally and contained within a central plane. Gris has here in-corporated a system of heavy lines which complete the forms, provide spatial indi-cations, and stabilize the outlines of each form.

At the same time Gris analyses different aspects of the form of an object, then assembles them into a more complete image of it, using heavy outlines to define things clearly. Gris has not abandoned the use of chiaroscuro oppositions, however. The book-title *Le Pont Mirabeau* is pasted on to the surface.

Gris is primarily concerned in this painting with the solid, tangible aspects of reality rather than with those subtle spatial and planar relationships which were a major concern of Braque and Picasso. Gris's internal structure of parallel planes here is broad and heavily linear, but it is his way of establishing spatial relation-ships.

Only in his first paintings did Gris work with more or less neutral colours, but these were carried out in pale blue or green greys instead of brown and beige, and allowed for a more active role played by light than did those of Braque and Picasso. After that, Gris moved straight into working with a palette of bright colours. The colours here are naturalistic and are used descriptively.

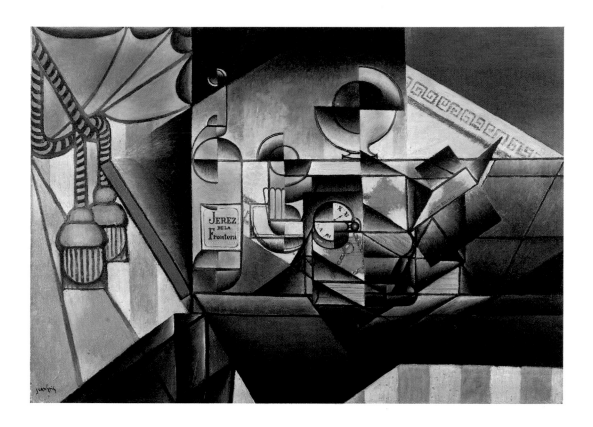

62 The Siphon

Painted in April 1913
Oil on canvas, $32 \times 25\frac{5}{8}(81 \times 65)$
Signed and dated on back: 'Juan Gris 4-13'

Lit: Cooper no. 37; Museum inv. no. 1959.34

Prov: the artist to Galerie Kahnweiler, Paris (photo no. 5008), 1913-14; sequestered Kahnweiler stock, 1914-21; 2nd Kahnweiler sale, Hôtel Drouot, Paris, 17 November 1921, lot 146, sold for 180 frs. to M. Grassat as agent for the 'Simon syndicate'; Galerie Simon, Paris, 1921; Dr Marcel Noréro, Paris; Noréro sale, Hôtel Drouot, Paris, 14 February 1927, no. 54; Galerie Simon, Paris, 1927-40; Galerie Louise Leiris, Paris, 1940-48; Jacques Seligmann and Co., New York, 1948; Edgar J. Kaufmann, Jr, New York; to the museum in 1959
Rose Art Museum, Brandeis University, Waltham, Mass. Gift of Edgar Kaufmann, Jr, New York

By the spring of 1913, when this painting was executed, Gris had abandoned his earlier linear structure in favour of a new compositional method based on broad vertical or diagonally placed planes, many being given a triangular shape. These overlap each other frequently but are not treated as being transparent. This compositional method surely derives to some extent from that used by Braque in his *papiers collés*, the first of which dates from September 1912. These planes, differentiated from each other tonally, and often texturally as well, evoke spatial relationships as they move visually in front of or behind others. On each of them Gris represents a single aspect of one or more objects and uses freely disposed white outlines to complete the representation either of some related aspect or of some invisible structural details. This type of informative Cubist representation was used only by Juan Gris, who experimented with several methods before achieving his greatly clarified and economical Cubist idiom in *papiers collés* and paintings from late 1914 onwards. Gris's work during the first three years of his career as a Cubist painter, that is to say until he launched into *papiers collés* early in 1914, show him making enormous efforts to represent in each painting all that he knows and has seen of every object or human figure included. He was not by nature a simplifier and never accepted the easy way out.

The known look of reality was for Gris a major consideration in the make-up of a picture.

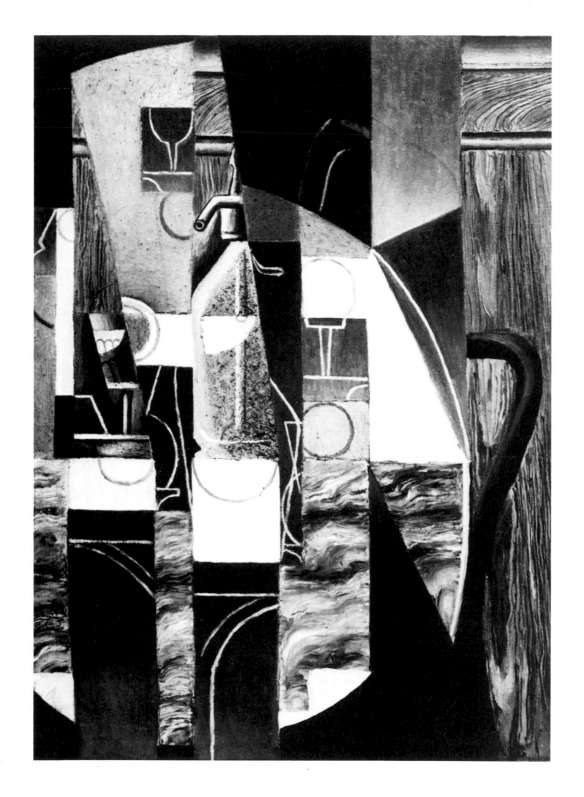

63 Landscape at Céret

Painted in September 1913
Oil on canvas, $36\frac{1}{4} \times 23\frac{5}{8}$ (92 × 60)
Signed and dated on back: 'Juan Gris / Céret 9-13'

Lit: Cooper no. 55; *Letters*, nos. 3 and 4 (of 17 and 29 September 1913); Museum inv. no. NM4898

Prov: the artist to Galerie Kahnweiler, Paris (stock no. 9853), 1913-14; sequestered Kahnweiler stock, 1914-23; 4th Kahnweiler sale, Hôtel Drouot, Paris, 7 May 1923, no. 29, sold with lots 287, 289 and 292 for 85 frs. to an unidentified buyer; Galerie Simon, Paris, 1923-40; Galerie Louise Leiris, Paris, 1940-54; to the museum in 1954
Moderna Museet, Stockholm

Gris went on a working holiday to Céret for the first time between August and October 1913. By this time his handling of his compositional method based on broad vertical planes has gained by experience and he is able to use it as he wishes. Here, for example, the landscape view runs from the sky and the drawn outline in silhouette of a mountain peak in the Pyrenees at the top, to a big hill, below which are some farm buildings, and at the bottom a meadow with some round-topped trees. Strong colours are used throughout, some of them descriptively, others determined by tonal juxtapositions, while still others have been chosen to complete a colouristic harmony. A sense of bright light and heat are symbolically evoked by the high-pitched colours. A second, similar Céret landscape (private collection) of the same date exists.

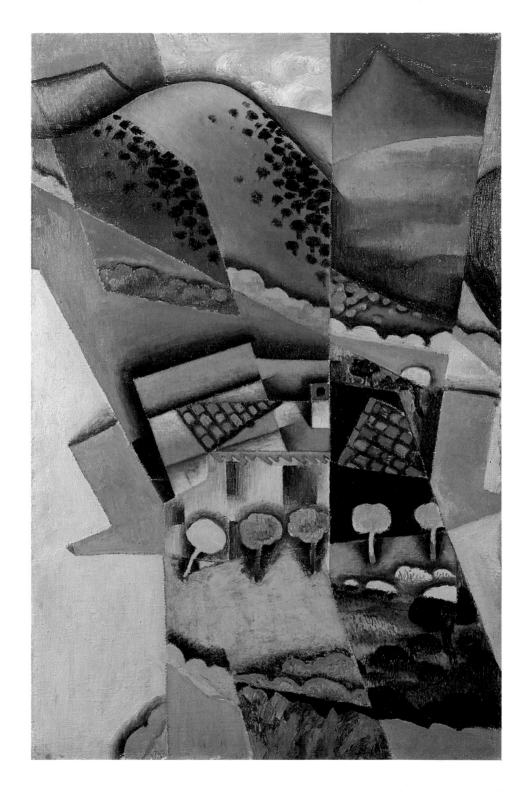

64 Guitar on a Chair

Executed in September 1913
Oil on canvas with some pasted elements, $39\frac{1}{2} \times 25\frac{5}{8}$ (100 × 65)
Formerly signed and dated on back (now relined): 'Juan Gris / Céret 9-13'

Lit: Cooper no. 52; *Letters*, nos. 3 and 4 (of 17 and 29 September 1913)

Prov: the artist to Galerie Kahnweiler, Paris (photo no. 5069), 1913-14; sequestered Kahnweiler stock, 1914-22; 3rd Kahnweiler sale, Hôtel Drouot, Paris, 4 July 1922, lot 97, sold for 75 frs. to Miss Evie Hone, Rathfarnham, Ireland, 1922-1950; to the present owner in 1950
Private collection

Painted at Céret contemporaneously with the 'Landscape' (no. 63). Colour is here used descriptively while, in the manner of Braque and Picasso, Gris has added sand to his paint to create a textural contrast. A section of the tiled floor in the bottom left foreground is obtained with a pasted element. The caning of the chair seat is also pasted on. Here Gris shows his awareness of the small oval composition 'Still-life on a Chair' executed by Picasso in Paris at the end of May 1912 (no. 134). Note Gris's use here of cast shadows to clarify contours and also to detach one plane from another.

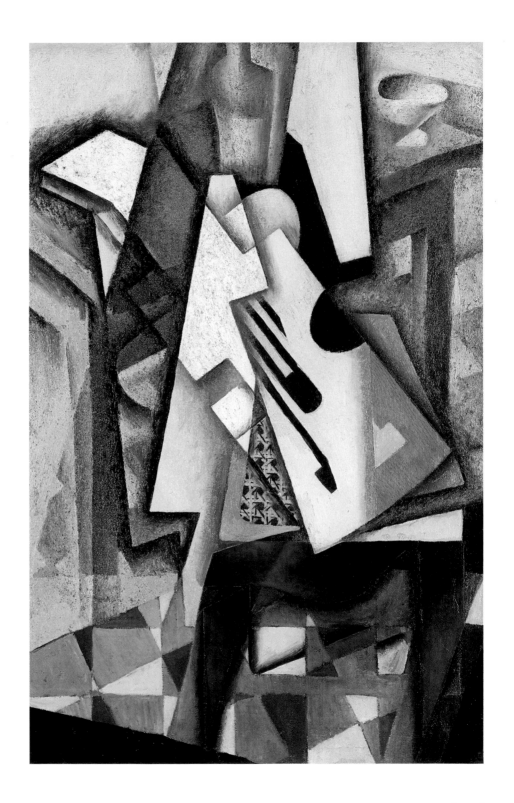

65 Bottle of Rum and Newspaper

Painted between December 1913 and January 1914
Oil on canvas, 18⅛ × 15 (46 × 38)
Signed on back: 'Juan Gris'; not dated

Lit: Cooper no. 67

Prov: the artist to D.H. Kahnweiler, Bern, 1914; to the present owner in 1922
Private collection

Gris has begun to simplify his pictorial struc-
ture and has abandoned the series of over-
lapping planes which he had been using only a
few months previously. A few short planes
only are used here to establish spatial re-
lationships. Gris has more or less given up his
former reliance on heavy modelling and ac-
cepts the flattening of objects. The pictorial
space, closed by the painted wood panelling
(pine) of the background wall, is shallow. The
depth of the wooden table-top on which the
objects stand is clearly indicated on both sides
of the bottle of rum. The introduction of *faux-
bois*, imitated from works by Braque and
Picasso, is a new element in a composition by
Gris

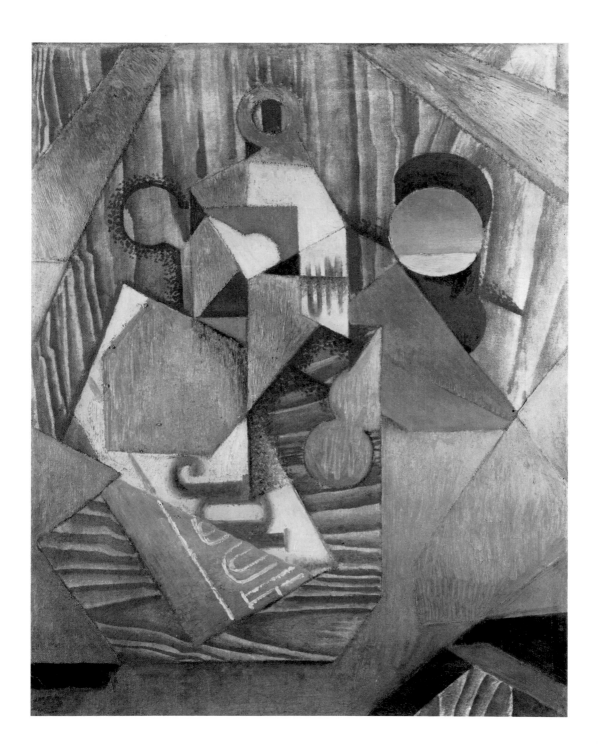

66 A Man in a Café

Executed probably in February–March 1914
Oil and papers pasted on canvas, 39 × 28⅜ (99 × 72)
Signed on back: 'Juan Gris'; not dated, but the newspaper is of Tuesday, 3 February 1914

Lit: Cooper no. 76

Prov: the artist to Galerie Kahnweiler, Paris, 1914; sequestered Kahnweiler stock, 1914-23; 4th Kahnweiler sale, Hôtel Drouot, Paris, 7 May 1923, lot 293, sold with lot 295 for 150 frs. to an unidentified buyer; Galerie Simon, Paris, 1923; Sidney Janis Gallery, New York; Mr and Mrs Leigh Block, Chicago; to the present owner in 1980
Acquavella Galleries, Inc., New York

This is the largest and most important painting made by Gris before he embarked on a major sequence of *papiers collés* executed between April and the end of December 1914. Here he brings to their fullest and most perfect expression the various stylistic methods he had been using for the past six months in paintings such as 'Guitar on a Chair' and 'Bottle of Rum and Newspaper' (nos. 64 and 65). But he has made innovations also. Textural imitation plays a much greater role. There is an abrupt transformation in the right half of the man's hat, represented as a heavily shadowed outline imposed on the wood panelling of the background wall, which is a device for relating one to the other. The shadow cast by the man's hat on the wall, further to the right, evokes a spatial relationship and a sense of volume. Lastly, the large section of the newspaper *Le Matin*, pasted in to represent itself, is Gris's most ambitious use to date of *papier collé* within a painting. Hitherto, Gris's use of *collage* had been restricted to small elements – a book-title, a label on a bottle, fragments of playing-cards or a piece of mirrored glass 'because it could not be imitated', as he said. Now he made the discovery that the introduction of a 'real' element as itself into an oil painting served to heighten the link between his pictorially transposed image of reality and reality itself. This gave him the impetus to try his hand at making pure *papiers collés*.

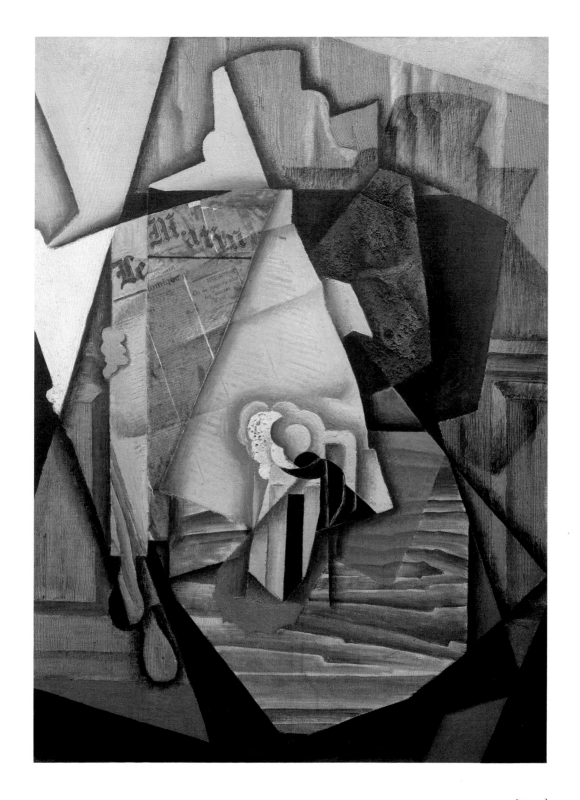

67 Roses in a Vase

Executed probably in May–June 1914
Oil, pasted papers and pencil on canvas, $25\frac{5}{8} \times 18\frac{1}{8} (65 \times 46)$
Signed on back: 'Juan Gris'; not dated, but a newspaper pasted on the verso is of 13 May 1914

Lit: Cooper no. 95

Prov: the artist to Galerie Kahnweiler, Paris (stock no. 2090), 1914; Gertrude Stein, Paris, 1914-46; Stein estate, 1946-69; a consortium of American collectors, 1969; Nelson Rockefeller, New York, 1970; E. V. Thaw & Co., New York; to the present owner in 1972
Mrs Harold Diamond, New York

Unlike Braque and Picasso, Gris never used the technique of *papier collé* simply in conjunction with a charcoal drawing to establish spatial relationships and represent objects. From the beginning, Gris used *papier collé* in a highly personal manner and always with representational intent. Unlike Braque and Picasso once more, his support was never paper or board but always canvas, and his pasted composition covered the whole surface. Gris's method of composition, as here, was first to establish a pre-ordained abstract design, which he realized in terms of differently shaped pieces of coloured paper. He then allowed the forms of this design to suggest the objective content of some picture towards which he should work.

As the image evolved, Gris would improve its total effect, if necessary, either by modifying some forms – he had a horror of distortion – or by pasting in additional elements. And he heightened the realistic effect with modelling added in pencil, with some outlines of forms drawn in white gouache, and also by adding colour in gouache. Apart from introducing patterned wallpaper, Gris avoided using purely decorative elements in his *papiers collés*. That too distinguishes them from those made by Braque and Picasso, but nonetheless, Gris made a significant contribution to the achievements of Cubist art through his highly personal use of this technique.

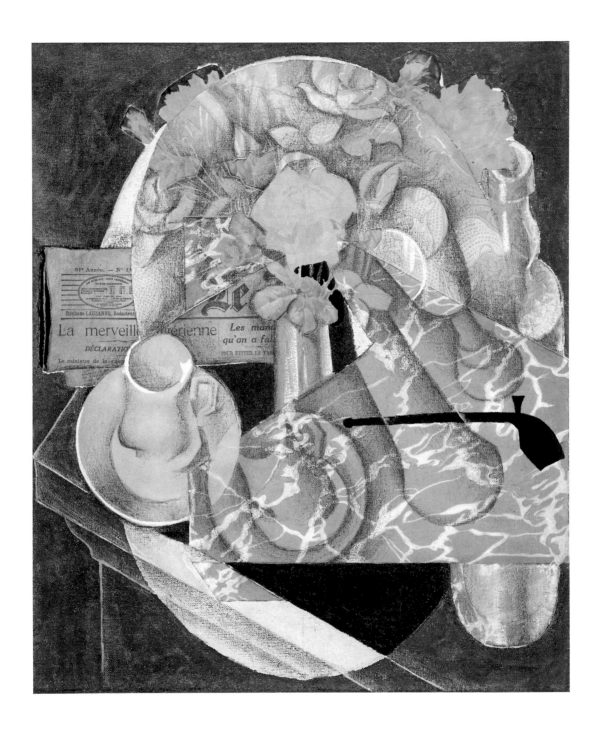

68 The Lamp

Executed in May–June 1914
Pasted papers, gouache and charcoal on canvas, $21\frac{5}{8} \times 18\frac{1}{8} (55 \times 46)$
Signed on back: 'Juan Gris'; not dated

Lit: Cooper no. 93

Prov: the artist to Galerie Kahnweiler, Paris, 1914; John Quinn, New York, *c.* 1915 until 1924; Quinn estate, 1924-6; Quinn sale, Hôtel Drouot, Paris, 28 October 1926, no. 55; Galerie Bing, Paris, 1926; Mme. J. Rückstuhl, Küsnacht, Switzerland; Galerie Rosengart, Luzern; Jos. Hessel, Paris, 1940; André Lefèvre, Paris, 1940-62; Lefèvre estate, 1962-65; 2nd Lefèvre sale, Palais Galliera, Paris, 25 November 1965, lot 8, sold for 195,000 frs. to the present owner
Private collection

The piece of newspaper included in this composition is dated '24 mai, 1914'. This is an exceptionally fine example of what Gris could achieve in *papier collé*. He shows more concern with preserving the appearance of reality than did either Braque or Picasso: the dislocation of the upper part of the lamp enables Gris to express the volume enclosed by the shade, while that part of the foot of the lamp which is not shown in the foreground is represented separately by a drawing on the extreme right.

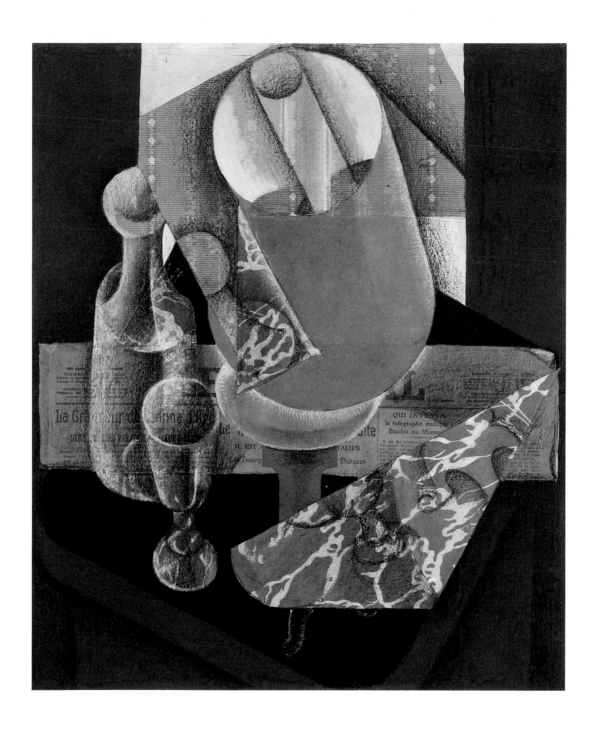

69 The Sunblind

Executed probably between August and October 1914
Pasted papers, white chalk and charcoal on canvas, $36\frac{1}{2} \times 28\frac{5}{8} (92 \times 72.5)$
Signed and dated bottom left: 'Juan Gris 1914'; the newspaper on the table is dated 13 March 1914

Lit: Cooper no. 118; *Letters*, nos. 22 and 83 (reference to *papier collé* size 30F); Tate 1981, p. 339; Museum inv. no. 5747

Prov: the artist to D.H. Kahnweiler, Bern, 1914; Galerie Simon, Paris (stock no. 5010), 1920-26; Mlle Pertuisot, Paris (later Mrs Gerard Lee Bevan, London), 1926-37; Sale, Christie's, London, 23 April 1937, no. 24; sold for 23 guineas to Zwemmer Gallery, London; Miss Valerie Cooper, London, 1937; Zwemmer Gallery, London; to the gallery in 1946
Tate Gallery, London

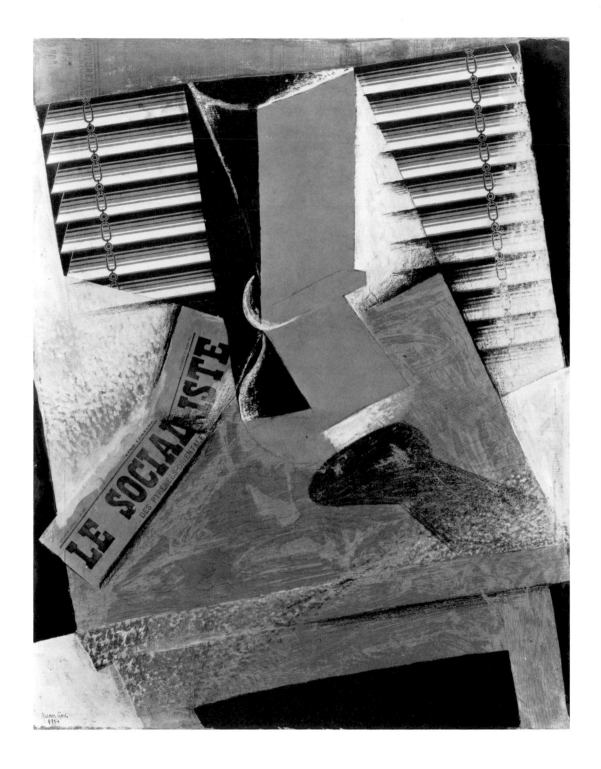

70 The Open Window: Place Ravignan

Painted in June 1915
Oil on canvas, $45\frac{5}{8} \times 35(116 \times 89)$
Signed and dated bottom left: 'Juan Gris / 6-1915'

Lit: Cooper no. 131

Prov: the artist to Galerie de l'Effort Moderne (Léonce Rosenberg), Paris (photo no. 5115; stock no. 1129), *c.* 1916: Pierre Faure, Paris; Louise and Walter C. Arensberg, New York and later Hollywood, *c.* 1930 until 1950; to the museum in 1950 but not installed until 1954
Philadelphia Museum of Art. Louise and Walter Arensberg Collection

In early 1915 Gris felt that his pictures were too hermetic. Three months later, therefore, he threw open the window of his studio in order to represent a subject set between indoor and outdoor space. Neither Braque nor Picasso had envisaged such a subject, so that Gris was a pioneer when he embarked on this painting. The subject is a still-life standing on a table, in front of an open window, beyond which are the houses and trees in the Place Ravignan, where Gris lived. His basic problem here was to effect a smooth transition from one type of space to another without becoming involved either with the modulation of colour through two different degrees of light, or with linear perspective. Gris solved this inventively by keeping the two areas of space separate yet linked to each other by a succession of transparent planes, tonally differentiated and placed one over another at different angles. At the same time, Gris had recourse to a diminishing scale in size from the large objects in the immediate foreground to the smaller windows in the façade of the house in the background. Gris also established an anti-perspectival forward movement from the pale blue façade in the background to the front edge of the table, where he has used warmer tonalities. And this movement is accented by sharp diagonals running inwards from the narrow window opening, where the transition from external to internal space is marked by a vertical plane of darker colour.

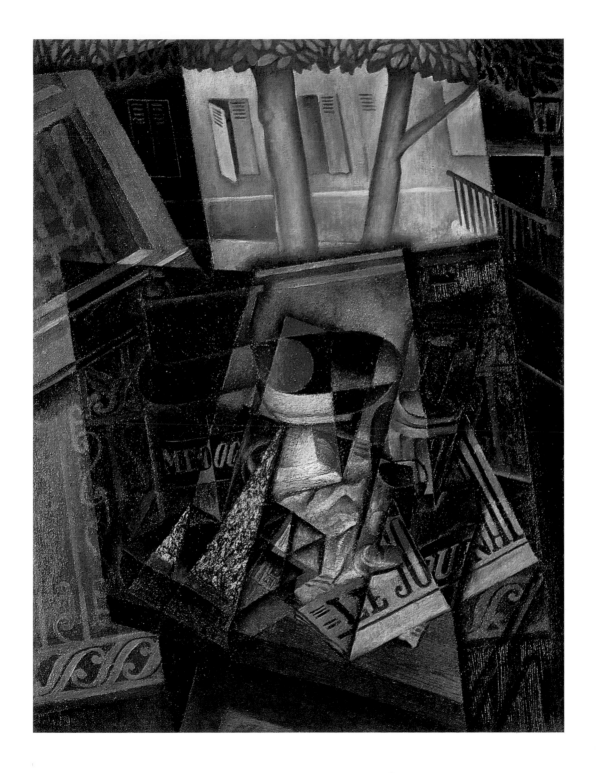

71 Water-bottle, Bottle and Fruit-dish

Painted in November 1915
Oil on canvas, $32 \times 25\frac{5}{8}(81 \times 65)$
Signed and dated bottom left: 'Juan Gris 11-15'

Lit: Cooper no. 153

Prov: the artist to Galerie de l'Effort Moderne (Léonce Rosenberg), Paris (stock no. 5141), 1916; Edmond Rosenberg, Paris, 1919-38; Paul Rosenberg & Co., New York, 1939; Leigh B. Block, Chicago, *c.* 1948-72; Marlborough Fine Art, New York, 1972; to present owner in 1975
Private collection, New York

In 1915, having worked for nine months in 1914 predominantly in *papier collé*, Gris began to simplify and strengthen the structure of his compositions and to represent objects in a less fragmented manner. The content of his paintings thus became more immediately legible and he also explored a new range of colour harmonies in which greens, mauves, maroon red, yellow and blue predominated. In other words he gave up making 'those inventories of objects', as he once described in a letter his earlier analytical treatment of things, based on a combination of varying views. Gris was now able to include a greater number of objects than in his earlier compositions and could handle the representation of volume and the spatial relationships between objects with greater certainty. Gris made considerable use of drawing at this stage, as we see here, to describe objects which he wished to include, as well as to clarify and complete outlines which

were only partially visible: for example, the edge and the leg of the table in the right foreground, the bunch of grapes in a fruit-dish between the *carafe* and the bottle, and the glass to the left of the *carafe* (compare no. 62).

Gris saw his paintings of this date as being 'less dry and more plastic' and as having 'a unity which had hitherto been lacking' in his work. The spatial organisation here is particularly simple and clear. The wooden table stands on a diamond-patterned floor in the corner of the room; the lower part of the walls is covered by wood panelling, along the top of which runs a moulded dado. The width is indicated by the corners of the table-top, while depth is represented by an inverted V-shaped plane, which encloses all the objects and rises from the corner of the table in the right foreground to the top of the canvas, covering the corner where the two wall-surfaces meet.

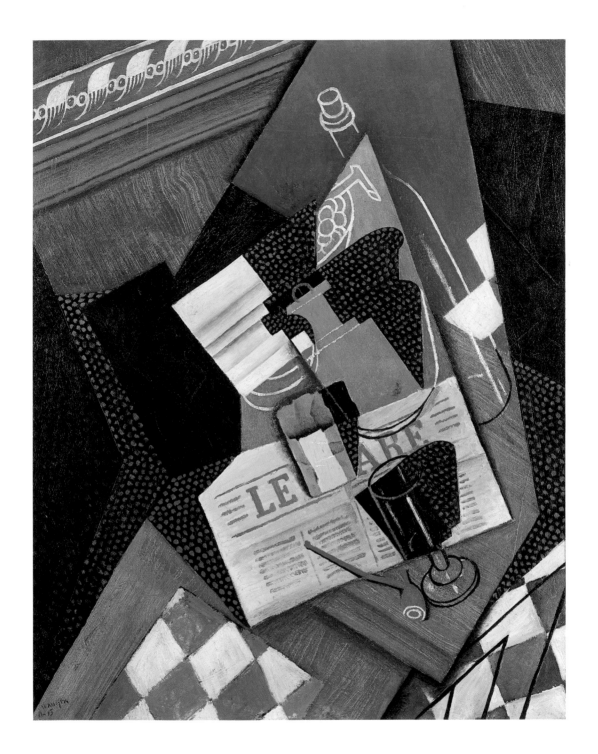

72 The Package of Tobacco

Painted in May 1916
Oil on canvas, $18\frac{1}{8} \times 15 (46 \times 38)$
Signed and dated bottom left: 'Juan Gris / 5-16'

Lit: Cooper no. 169

Prov: the artist to Galerie de l'Effort Moderne (Léonce Rosenberg), Paris (stock no. 5160), *c.* 1916; Dr G.F. Reber, Lausanne, *c.* 1925; Frl. Irmgard Fritsch, Hamburg and Munich, 1930-55; Frau Marianne Feilchenfeldt, Zürich, 1955-57; to Heinz Berggruen, Paris, 1957; to the present owner in 1980
Private collection, Switzerland

During the winter of 1915-16, Gris set out to make paintings which would be more 'concrete and concise', that is to say, he reduced the number of objects represented, relied far less on simultaneous aspects and adopted a bolder and simpler form of spatial representation. His idiom was thus clarified and became more legible. Also Gris began to work with conceptual rather than visually observed forms, so that objects became generalised and regained their formal unity, while his colours became more limited, stronger and more sharply contrasted. Gris made use of pointillist passages to animate certain dull areas and to lighten the general effect.

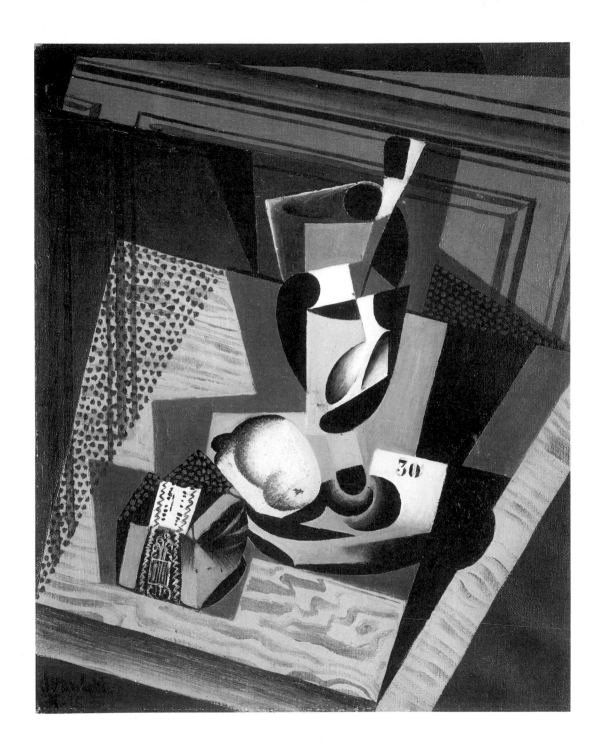

73 **Violin and Bow on a Table**

Painted in July 1916
Oil on three-ply panel, $45\frac{3}{4} \times 28\frac{3}{4}$ (116.5 × 73)
Signed and dated bottom left: 'Juan Gris / 7-16'

Lit: Cooper no. 184; Museum inv. no. 2293

Prov: the artist to Galerie de l'Effort Moderne (Léonce Rosenberg), Paris (photo no. 724; stock no. 5922), *c.* 1916; Dr h.c. Raoul LaRoche, Paris, *c.* 1920 until 1952; to the museum in 1952
Kunstmuseum, Basel. Gift of Dr h.c. Raoul LaRoche

Structurally, this is the least complicated composition that Gris had yet painted. The pictorial space is very shallow and objects are flattened on the surface. The heavy black plane in the background throws the table and the violin into relief. The violin is the only object fractured and recomposed in order to represent its volume. The severity of the colours here matches the severity of the composition.

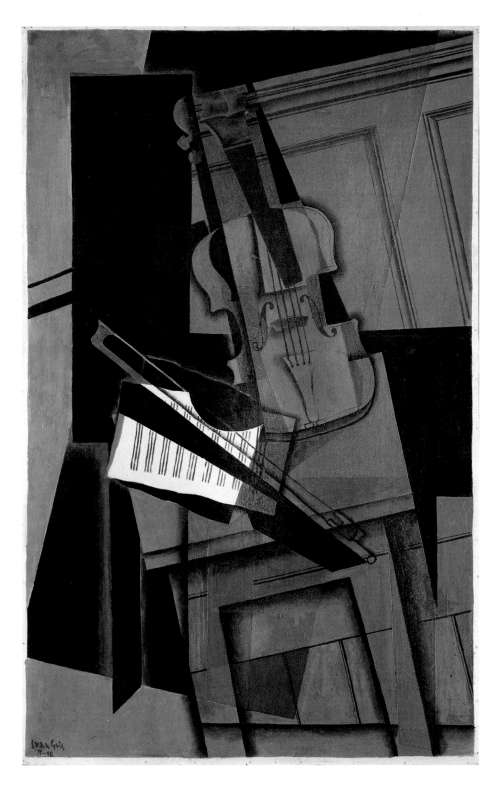

74 Portrait of Josette Gris

Painted in October 1916
Oil on wood panel, $45\frac{5}{8} \times 28\frac{1}{2}(116 \times 73)$
Signed and dated top left: 'Juan Gris / 10-16'

Lit: Cooper: no. 203

Prov: the artist to Galerie de l'Effort Moderne (Léonce Rosenberg), Paris (photo no. 393), *c.* 1917 until 1921; Effort Moderne sale, Mak's, Amsterdam, 22 February 1921, lot 28, sold to M. Taillant; Mlle Pertuisot, Paris (later Mrs Gerard Lee Bevan, London); Sale, Christie's, London, 23 April 1937, lot 39; sold to Douglas Cooper, London and later Argilliers, 1937-77; given to the museum in 1977
Museo del Prado, Casón del Buen Retiro, Madrid

This serene, formally clear and simple monumental portrait of the artist's wife is Gris's masterpiece, and one of the outstanding achievements in the late 'synthetic' Cubist idiom. During the second half of 1915, Gris had realized that he could not carry any further his procedure of building up a coherent pictorial composition by accumulating 'real' details derived from observation. Thus Gris was predisposed to find a stylistic alternative and during the winter of 1915-16 he abandoned direct visual observation in favour of a 'synthetic' idiom, which enabled him to reconcile the formal organisation of his canvas with sufficient representational detail to establish a subject. This he achieved by reviving the conception underlying some of his later *papiers collés*. That is to say, he began by establishing a calculated pattern of coloured forms on the surface of the canvas. He then allowed these, as he was to write in 1923, to evoke in himself 'certain private relationships between the elements of an imagined reality'. Thus, as he said, 'the mathematics of picture making' led him to 'the physics of representation. The quality or the dimensions of a form or a colour suggest to me the appellation or the adjective for an object.' After which, Gris set about modifying his basic design to accommodate such representational details as were necessary to enable the subject envisaged to harmonise with the formal design. 'I work with elements conceived by the mind, and with imagination, and I seek to transform what is abstract into something concrete.' Here, for example, the head and body of Josette are made up of a series of overlapping planes differently coloured. She sits on a chair in front of a wall of which the lower half is covered with wood panelling. The formal structure has been interpreted and modified by a few linear and tonal additions which indicate the hands and fingers, the sleeve of the dress, the upper part of the chair, the panelling and certain features of the face and hair. The dark background plane lying across the wall evokes space and volume. This painting is a perfect example of Gris's conviction that a painting is more the product of intellectual activity than of visual observation, that it should evoke rather than mirror the known appearance of reality.

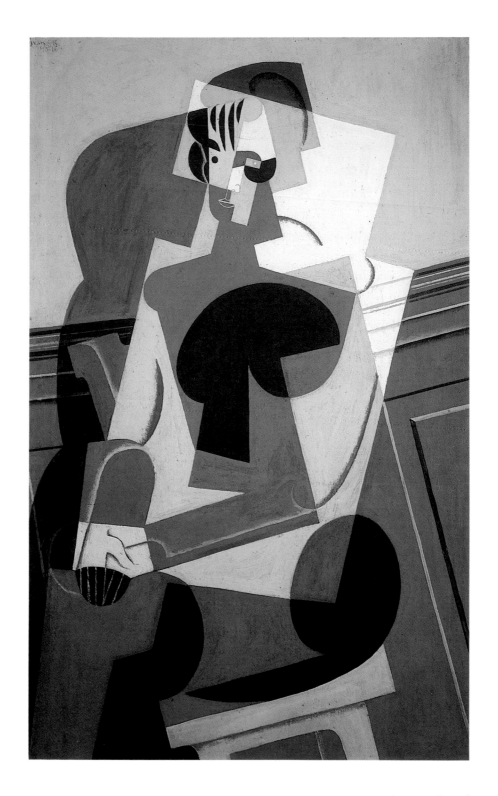

75 Harlequin with a Guitar

Painted in December 1917
Oil on three-ply panel, $39\frac{1}{2} \times 25\frac{5}{8}$ (100 × 65)
Signed and dated bottom right: 'Juan Gris / 12-17'

Lit: Cooper no. 241

Prov: the artist to Galerie de l'Effort Moderne (Léonce Rosenberg), Paris (photo no. 749: stock no. 5557), *c.* 1917; Dr G.F. Reber, Lausanne, by *c.* 1926; Paul Rosenberg & Co., New York, by 1939; to the present owner in 1946
Alex Hillman Family Foundation, New York

In 1917-18, reacting against the purity and austerity of his paintings of 1916, Gris started on a number of more elaborate compositions, painted in bright colours and enriched, as here, with ornamental patterning. He also, once again, employed chiaroscuro to evoke volume.

Gris's unexpected interest at this date in Harlequin as a subject is due in part to Cézanne and in greater part to Picasso and the Ballets Russes.

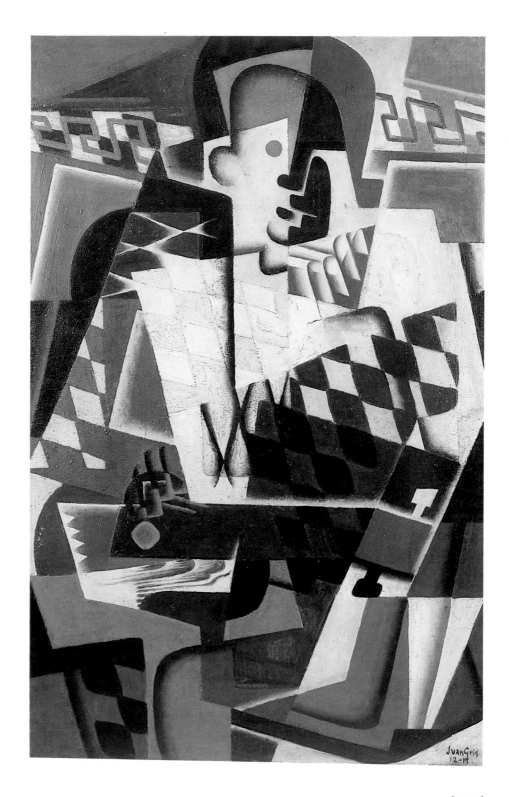

76 Still-life with a Plaque

Painted in December 1917
Oil on canvas, 32 × 25¾ (81 × 62.5)
Signed and dated top centre (on plaque): 'Juan Gris / 12-17'

Lit: Cooper no. 244; Museum inv. no. 2294

Prov: the artist to Galerie de l'Effort Moderne (Léonce Rosenberg), Paris (photo no. 1129; stock no. 5140), *c.* 1918; Dr h.c. Raoul LaRoche, Paris, *c.* 1920 until 1952; given to the museum in 1952
Kunstmuseum, Basel. Gift of Dr h.c. Raoul LaRoche

Between 1917 and 1919, Gris, who as a Spaniard had remained in Paris during the war and continued his pictorial development, was closely in touch with Braque, who profited by this contact when he came out of hospital and began to paint once more. Gris also saw a great deal of the two Cubist sculptors, Henri Laurens and Jacques Lipchitz, whose sculptural aesthetic was much influenced by Gris's later Cubist paintings and the pictorial conceptions which he defined so clearly. But Gris in his turn was influenced at this time by the two sculptors. It was under the supervision of Lipchitz that, in 1918, Gris made his one significant sculpture – a standing 'Harlequin' in plaster which was then painted. And in a painted still-life such as this, conceived in terms of a sculptural low relief, the influence of Lipchitz is again apparent. Note the importance here, for descriptive purposes, of simulated textures.

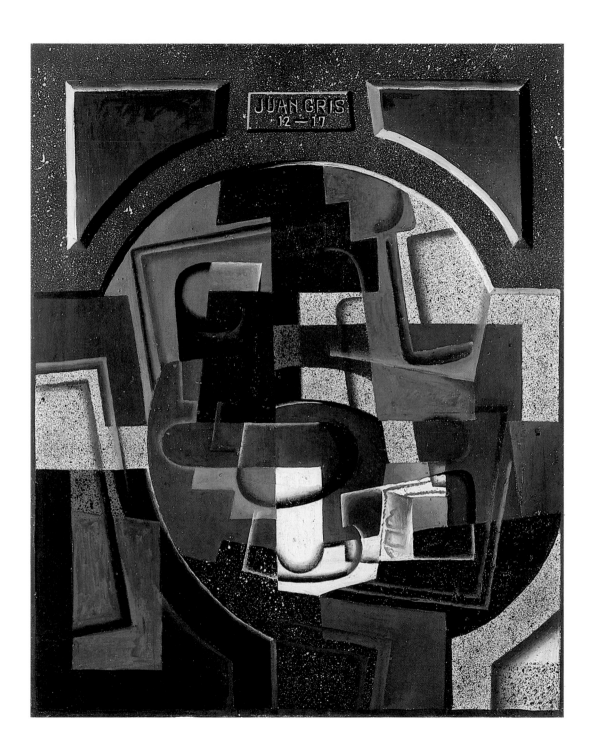

77 Harlequin Seated beside a Table

Painted in June 1919
Oil on canvas, $39\frac{5}{8} \times 25\frac{5}{8}$ (101 × 65)
Signed and dated bottom right: 'Juan Gris / 6-19'

Lit: Cooper no. 308

Prov: the artist to Galerie de l'Effort Moderne (Léonce Rosenberg), Paris (photo no. 747: stock no. 6391); Dr. G.F. Reber, Lausanne, *c.* 1925; Buchholz Gallery (Curt Valentin), New York, 1939; Lee Ault, New York, 1940-50; Buchholz Gallery, New York; to the present owner *c.* 1950
Morton Neumann Family Collection, Chicago

Painted eighteen months later than 'Harlequin with a Guitar' (no. 75), the present painting results, to all intents and purposes, from the same compositional method. But in the meanwhile Gris has introduced new features. There are more overlapping planes; greater importance attaches to the sharply contrasted areas of chiaroscuro; a greater sense of volume is evoked by the bold facetting of the legs of the table and of the figure, as well as by the space between the harlequin's legs. Lastly, Gris has introduced the witticism of using the diamond pattern of Harlequin's costume as the pattern of the floor, where it can be read as extending the width and suggesting the depth of the pictorial space.

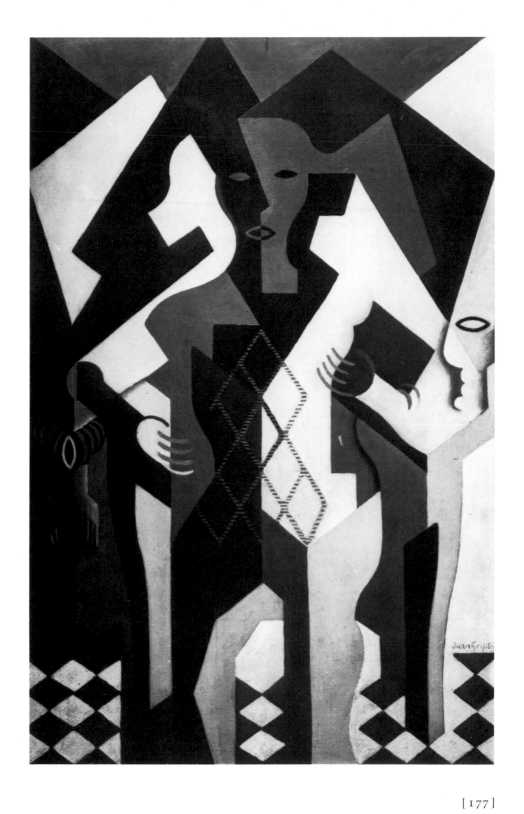

78 Still-life with Guitar and Glasses on a Table

Painted in September 1919
Oil on canvas, 32 × 25⅝ (81 × 65)
Signed and dated bottom left: 'Juan Gris / 9-19'

Lit: Cooper no. 317

Prov: the artist to Galerie de l'Effort Moderne (Léonce Rosenberg), Paris (stock no. 6457), *c.* 1919; Alphonse Kann, St-Germain-en-Laye, *c.* 1925 until 1938; Galerie Bing, Paris, 1938; Buchholz Gallery (Curt Valentin), New York; Frau Lucy Rudolph, Zürich, until 1980; to the present owner in 1981
Private collection, Zürich

In August 1919 Gris wrote in a letter that he felt he had devoted himself, during the last few years, to creating in his paintings 'a too brutal and descriptive reality'. In the latter part of that year, and going on into 1920, Gris therefore abandoned the late 'synthetic' Cubist style that he had developed since 1916 in favour of a more fluid, 'poetic' style of painting, in which he preserved (as here) much of the essential pictorial discipline of Cubism and of his own methods of non-illusionistic representation which he had been developing from the start of his career. New stylistic features here are Gris's insistence on formal resemblances and contrasts, and his extensive use of formal 'rhymes', that is to say, the repetition of the same form – here an ellipse – to signify different things. Here an ellipse is used to represent the opening in the bowl of the pipe, the level of liquid inside the carafe, the mouth of the glass on the left, the foot of the glass on the right and the sound-hole of the guitar.

From that point onward, until his death in 1927, Gris's pictorial idiom became increasingly legible, and from 1921 shows no trace of Cubist influence.

Gris's adoption in 1919 of a more formally elegant, harmonious, neo-classical and, one may say, neo-traditional style of representation was certainly in harmony with, if not actually influenced to some extent by, a wide-spread movement at the time launched under the slogan of a *rappel à l'ordre* (call to order). The most vocal upholders of this idea were the Purists – Ozenfant and Le Corbusier – who opposed all that Cubism had stood for, loudly expressed their conviction that destruction of the past had been carried too far already, not only in the realm of art but in the material world, and preached the necessity for a new, constructively creative aesthetic. In the autumn of 1920, under the aegis of the dealer Léonce Rosenberg, who had recently organised the first major retrospective exhibitions of works by Laurens, Braque, Picasso and Gris, a new periodical, *L'Esprit Nouveau*, was founded to give currency to these ideas. For nine years already, Gris had continued to analyse and define the nature of reality, and had extended in his own limited field the pictorial conceptions and possibilities inherent in Cubism. Where Braque and Picasso had always been guided by their intuition, yet had been ready at certain moments to sacrifice stylistic purity to some personal vision or conceit, Gris never allowed himself to be deflected from the straight path and therefore had remained a highly orthodox exponent of Cubism. Until 1920, his paintings continue to reflect his intellectual lucidity, his scientifically conditioned mind and the integrity of his pictorial practice.

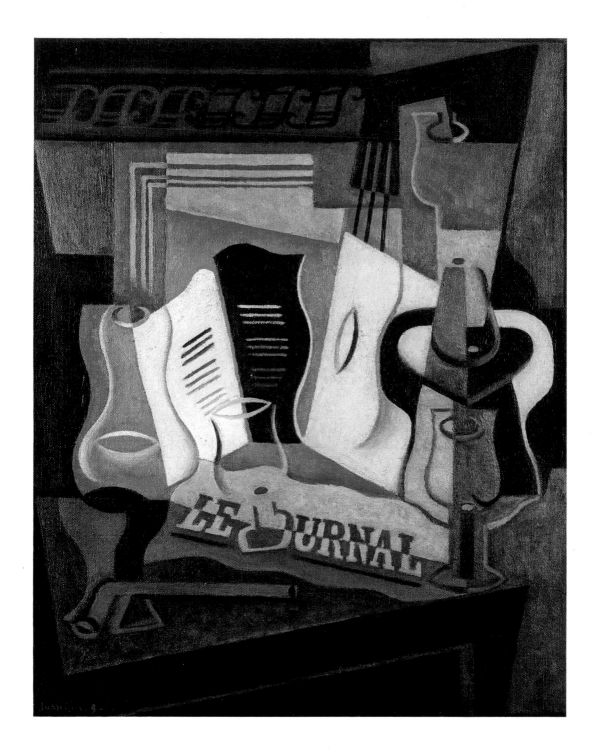

79 Pitcher, Bottle and Bowl

Executed in 1911
Pencil and charcoal on paper, $18\frac{1}{2} \times 12(47 \times 30.5)$
Signed and inscribed bottom left: 'A Madame Galanis / bien sincèrement / Juan Gris'; not dated

Prov: the artist to Madame Galanis, Paris; whereabouts uncertain until 1956; O'Hana Gallery, London, 1956; Galerie Berggruen, Paris, 1956; Galerie Nathan, Zürich, 1956; anonymous New York collection; to the present owner in 1974
Private collection, New York

Some of the same objects figure in the painting 'Bottle and Pitcher', 1911 (no. 57). This early drawing, which is very Cézannian, shows Gris's grasp of form and volume and his understanding of the use of modelling. This rather naturalistic drawing would appear to have been made before the painting, in which the forms are broadly facetted and heavily outlined with shaded contours.

80 Head of a Man (Self-portrait?)

Executed in 1912
Graphite on paper, $29 \times 12\frac{3}{8}(48.1 \times 31.5)$
Neither signed nor dated

Prov: the artist, Paris, until 1927; Gris estate (Mme Josette Gris and M. Georges Gonzales-Gris), until 1965; Galerie Louise Leiris, Paris, (photo no. 11004, stock no. 011173) 1965; Galerie la Tourette, Basel, 1965; to the museum in 1965
Kunstmuseum, Basel, Kupferstichkabinett

This somewhat unfinished pencil drawing, on which one can still see traces of the artist's preliminary mathematical calculations, must have been the first of the series of three known drawings, showing the same male head, which have come to be known as self-portraits of the artist (see no. 81). On at least two occasions (exhibitions at Galerie Louise Leiris in 1965 and in the Kunsthalle, Baden-Baden in 1974) this drawing has been mistakenly catalogued as 'Female Head'.

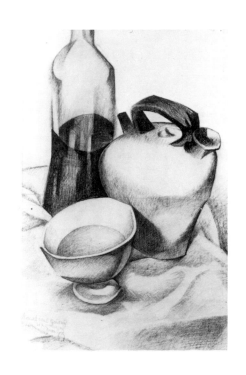

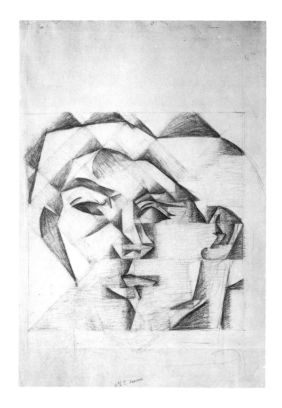

81 Self-portrait(?)

Executed in 1912
Graphite on paper, $17\frac{1}{2} \times 12\frac{1}{2}(45 \times 32)$
Signed bottom right: 'J.G.'; not dated

Prov: early ownership uncertain; Léon Bakst, Paris; Galerie Jacques Bonjean, Paris, before 1934; to the present owner in 1934
Private collection

This drawing of a male head has come to be known as a self-portrait of the artist. There is no proof of this identification, though it is acceptable. Gris executed three stylistically similar drawings of the same head, of which the less finished seems to be the earliest, and the more elaborated charcoal drawing, where the head faces left (repr. Cooper, p.xlvii), the last. This is dated 1912 and thus determines the date of them all. Stylistically they resemble the treatment of the head in the 'Portrait of Picasso' (Cooper no. 13), of the 'Portrait of the Artist's Mother' (no. 59) and of 'Flowers in a Vase' (no. 82), all of 1912.

82 Flowers in a Vase

Executed in 1912
Charcoal on paper, $18\frac{7}{8} \times 12\frac{1}{2}(50 \times 31.7)$
Signed and inscribed bottom left: 'A mon cher Galanis / Juan Gris'; not dated

Lit: Cooper: no.20a; Museum inv.no.75.93

Prov: early whereabouts unknown; E.V. Thaw & Co., New York; James W. Alsdorf, Winnetka, Illinois, *c.*1960 until 1974; Stephen Hahn in partnership with E.V. Thaw & Co., New York, 1974; to the museum in 1975
Indiana University Art Museum, Bloomington. Jane and Roger Wolcott Memorial

Gris used the group of flowers in this drawing in the background of the painting 'Still-life with Flowers' (no.60).

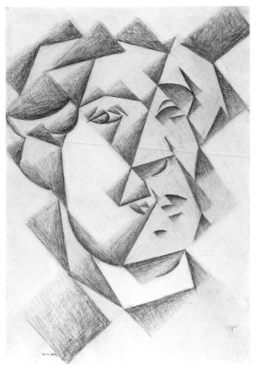

81

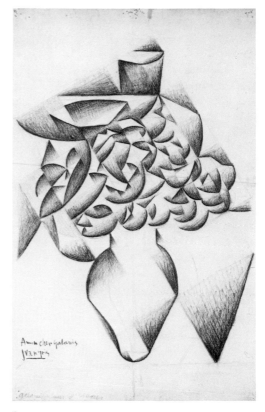

82

83 **Guitar** (verso: **Violin**)

Executed in 1913
Graphite on paper, $25\frac{5}{8} \times 19\frac{3}{4}(65 \times 50)$
Signed and inscribed top left recto: 'A Madame Rousseau / Bien affectueusement / Juan Gris';
signed bottom right verso: 'Juan Gris'; not dated

Prov: the artist to Madame Rij Rousseau, Paris; Galerie Berggruen, Paris, *c.* 1955; to the present
owner in 1955
Private collection

This two-sided drawing shows Gris making an
analytic breakdown of the form and volume of
a guitar, and on the verso, of a violin. Pin-holes
in the paper, visible here and there, were made
by the compass or dividers used by the artist
while he was transposing the angles and
proportions of his basic mathematical calcu-
lations.

84 **Bottle of Rum**

Executed in 1913
Coloured chalks on paper, $18\frac{7}{8} \times 12\frac{5}{8}(48 \times 32)$
Neither signed nor dated

Prov: the artist to Galerie Kahnweiler, Paris, before 1914; sequestered Kahnweiler stock,
1914-21; sold as part of an unidentified lot in the 2nd Kahnweiler sale, Hôtel Drouot, Paris,
17 November 1921; to the Galerie Simon, Paris, 1921-40; Galerie Louise Leiris, Paris, 1940-52;
Albert Skira, 1952; Göran Bergengren, Lund; Galerie L'Oeil, Paris; Sale, Sotheby's London,
16 April 1970, lot 71; to Waddington Galleries, London; to present owners *c.* 1975
Mr and Mrs Ahmet M. Ertegun

This drawing is composed on a basis of parallel
vertical planes, which evoke spatial relation-
ships as they take their place visually in front of
or behind others. By permitting the fragmen-
tation of objects at different levels, they also
serve to complete forms and evoke volumes.
This is further illustrated in paintings such as
'The Book' (Cooper no. 32), 'The Siphon' (no.
62) and 'Violin and Guitar' (Cooper no. 40) all
of 1913.

83 Guitar

83 Violin

84

JUAN GRIS

85 Guitar and Glasses on a Table

Executed in 1913
Graphite and watercolour on paper, $25\frac{5}{8} \times 18\frac{1}{4}$ (65 × 46.5)
Signed and inscribed bottom right: 'A mon cher ami Kahnweiler / Bien affectueusement Juan Gris'; not dated

Prov: the artist to D.H. Kahnweiler, Paris, 1913-14; sequestered Kahnweiler collection, 1914-21; sold as part of an unidentified lot in one of the Kahnweiler sales, 1921-3; subsequent whereabouts unknown; Barbara Church, New York; Sale, Parke-Bernet, New York, 27 January 1961, lot 90; sold for $21,000 to Mrs Joan Whitney Payson, New York; bequeathed to the present owner in 1975
Private collection, New York

The approximate date of execution of this watercolour can be established as the summer of 1913 by its stylistic resemblance to paintings such as 'Guitar and Glass' (Cooper no.45). The guitar is shown in two aspects: profile view of the left side and a frontal view. By an ad-ditional twist, we are shown the four strings stretched by pegs continuing up the handle. The lost profile on the right is shown in a heavy black shadow, a device used by Gris in several paintings of this date to evoke volume more completely.

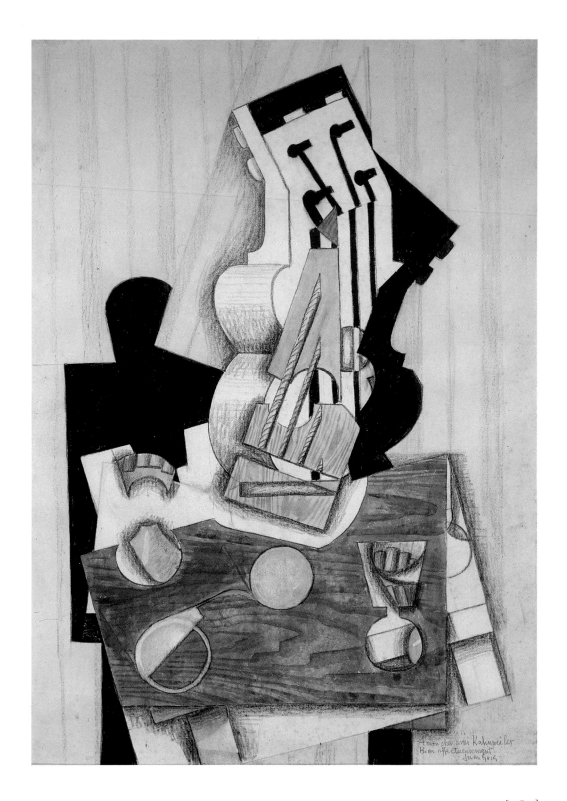

86 Glass, Playing-cards, Newspaper and Checker-board on a Table

Executed in November–December 1915
Gouache and graphite on paper, $8\frac{1}{2} \times 11\frac{3}{4}$ (21.5 × 30)
Signed bottom left: 'Juan Gris'; not dated

Lit: Cooper no. 155a

Prov: the artist to Léonce Rosenberg, Paris, *c.* 1916; the Leicester Galleries, London, 1929; Jacques Seligmann et Fils, New York, 1929; Marie Harriman Gallery, New York, 1932; Mrs Ray Murphy, New York; Alfred H. Barr, Jr, New York, 1948-80; E. V. Thaw & Co., New York, 1980; the Lefèvre Gallery, London, 1981; to the present owners in 1981
Private collection

This gouache is closely related to an oil painting of the same subject dated 'décembre 1915' (Cooper no. 155). In the winter of 1915-16, at the time when Gris planned a set of illustrations for a volume of poems by Pierre Reverdy, *Au Soleil du Plafond* (eventually published in 1955), he made a number of small still-lifes such as this in watercolour or gouache. Several of them are reduced versions of known paintings and therefore probably executed subsequently. All are brightly and attractively coloured, and many are enlivened with pointillist dots of colour.

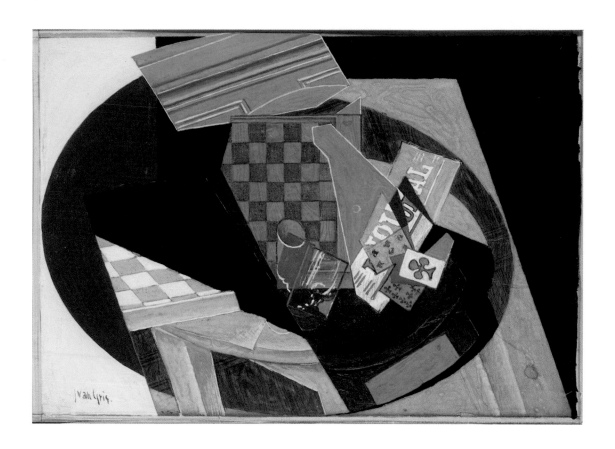

87 Siphon and Glass on a Table

Executed probably in April–May 1916
Coloured chalks, graphite and gouache on paper, $17\frac{3}{4} \times 13\frac{3}{4} (45 \times 35)$
Neither signed nor dated

Prov: the artist, Paris, until 1927; Gris estate (Mme Josette Gris and M. Georges Gonzales-Gris), until 1965; Galerie Louise Leiris, Paris, 1965; Saidenberg Gallery, New York, 1965-66; Heinz Berggruen, Paris, 1966-82; to the present owner in 1982
Private collection

This drawing closely resembles the painting 'Siphon, Glass and Newspaper' (Cooper no. 171) which is dated May 1916.

88 Copy after a Self-portrait by Cézanne

Executed in 1916
Graphite on paper, $15\frac{1}{2} \times 12\frac{1}{8} (39.5 \times 30.7)$
Signed and dated bottom left: 'D'après Cézanne / Juan Gris 1916'

Prov: the artist to Galerie de l'Effort Moderne (Léonce Rosenberg), Paris, c. 1916; Galerie Flechtheim, Berlin, c. 1921; Buchholz Gallery (Curt Valentin), New York, 1937; Richard S. Davis, Minneapolis; Ronald Lauder, New York, until 1980; to the museum in 1980
Art Institute of Chicago. Margaret Day Blake Collection, 1980

Copy made from a photograph of a 'Self-portrait' by Cézanne of 1880-81 (Venturi no. 365), now in the National Gallery, London.

In mid-1916, Gris took another close look at Cézanne's handling of form and volume. A group of ten such pencil drawings made after photographs of paintings of different dates by Cézanne are known, and in 1918 Gris painted an interpretation of 'Portrait of Mme Cézanne' by Cézanne (c. 1886, Venturi no. 572). All these copies and interpretations are of figure paintings. The pose of Madame Cézanne is virtually the same, in reverse, as that of 'Portrait of Josette Gris', painted at the end of 1916 (no. 74).

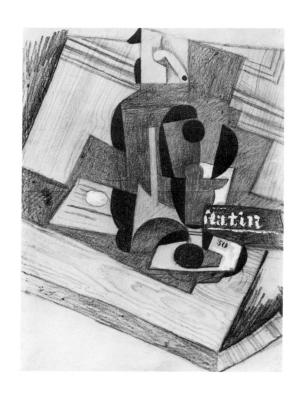

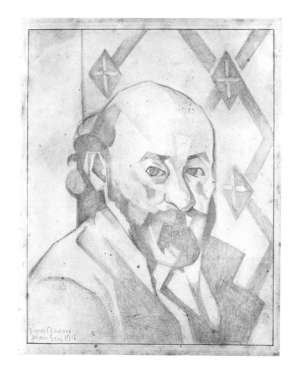

89 **Portrait of Madame Léonce Rosenberg**

Executed in June-July 1917
Graphite on paper, $15\frac{1}{2} \times 11\frac{1}{8}$ (39.5×28.3)
Signed, dated and inscribed top left 'A mon ami Léonce Rosenberg / Juan Gris / Paris 7-17'

Lit: Museum inv. no. 11, 703a

Prov: the artist to M. and Mme Léonce Rosenberg, Paris, 1917-?; subsequent whereabouts unknown; to the museum in 1956
Tel Aviv Museum

Léonce Rosenberg, proprietor of the Galerie de l'Effort Moderne, became Gris's dealer in 1915. Juan Gris was living in Paris throughout 1917, while Rosenberg, serving as an interpreter with the allied armies at the front, came occasionally to Paris and bought new works from his artists for stock.

Since 1916, Gris had executed a number of portraits of his friends, such as Max Jacob, in a naturalistic idiom. This portrait too is basically naturalistic, but Gris has sought to evoke volume in the figure with the help of strong modelling, facetting and a lightly indicated structure of planes.

In 1921, Gris was to adopt a strictly linear idiom for portrait drawings, all of which were naturalistic in conception.

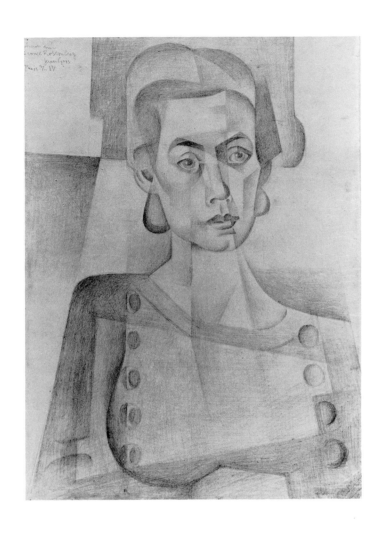

90 Portrait of Madame Berthe Lipchitz

Executed in May 1918
Coloured crayons and graphite on paper, $18\frac{3}{4} \times 12 (47.5 \times 30.5)$
Signed and dated bottom left: 'Juan Gris / 5-18'

Prov: the artist to M. and Mme Jacques Lipchitz, Paris, 1918; Jacques Lipchitz, New York, until *c.*1965; Harold Diamond, New York (?); Sale, Palais Galliera, Paris, 27 May 1972, lot 67; Baron F. Rollin, Brussels; Charles Kriwin, Brussels; Sale, Sotheby's, London, 2 December 1981, lot 195; sold to the present owner for £18,000
Galerie Louise Leiris, Paris

The Lipchitzes had arrived in April 1918 at Beaulieu near Loches, in Touraine, where Gris and Josette had a house and where Josette had been born. They remained there until 24 September. Berthe was Lipchitz's first wife. This is again a naturalistic portrait and in its legibility reflects the development which was occurring in Gris's painting at this period.

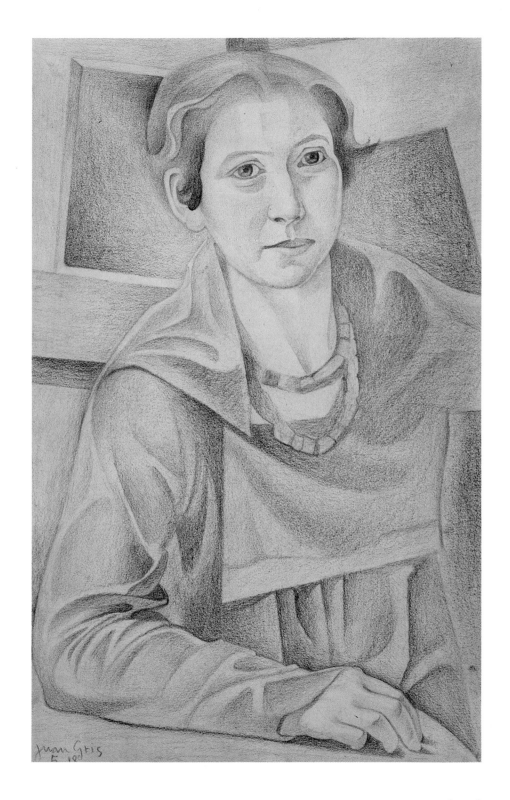

91 Still-life with Apples in a Dish

Executed in 1918
Graphite on paper, $14\frac{1}{4} \times 21 (35.9 \times 53.5)$
Neither signed nor dated

Lit: Kröller-Müller *Tekeningen* 1968, p. 120, no. 18

Prov: the artist to Léonce Rosenberg, Paris, *c.* 1918-?; to Mevr. Kröller-Müller, The Hague; given to the museum in 1938
Rijksmuseum Kröller-Müller, Otterlo

92 Harlequin with a Guitar

Executed in autumn 1918
Graphite on paper, $16\frac{3}{4} \times 9\frac{1}{4} (42.5 \times 23.5)$
Neither signed nor dated

Prov: the artist, Paris, until 1927; Gris estate (Mme Josette Gris and M. Georges Gonzales-Gris)
M. Georges Gonzales-Gris, Paris

Closely related to an oil painting of the same subject dated 'octobre '18' (Cooper no. 286). The use of strong chiaroscuro contrasts is characteristic of Gris's idiom at the end of 1918.

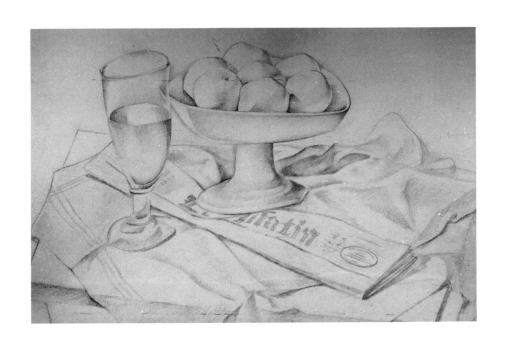

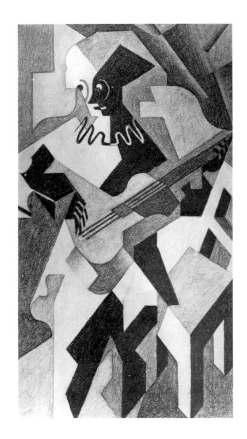

Fernand Leger 1881–1955

Paintings 200

Drawings and watercolours 224

Léger in his studio with Louise, *c.* 1910

93 The Bridge

Painted in Paris, 1909
Oil on canvas, $36\frac{5}{8} \times 28\frac{5}{8}$ (92.5 × 72.5)
Signed bottom left: 'F Léger'; not dated

Lit: Green 1976, p. 10; MOMA *Janis* 1972, pp. 191-2; Museum inv. no. 624.67

Prov: early whereabouts unknown; Galerie Pierre Loeb, Paris, by 1938; Perls Gallery, New York (photo no. 507), 1939; Walter P. Chrysler, Jr, New York, 1939-51; Sidney and Harriet Janis, New York, 1951-67; given to the museum in 1967
Museum of Modern Art, New York. Sidney and Harriet Janis Collection, 1967

Sometime in 1908 or 1909, Léger destroyed most of the paintings he had made over the previous five years. Those pictures which survive, such as 'My Mother's Garden' (Musée Léger, Biot) and several landscapes painted on holiday in Corsica, reveal that Léger had been working in a late Impressionist style with marked tonal contrasts, far removed from the emphasised structure and sober tans, greens and greys of 'The Bridge' and 'Woman Sewing'. Thus, even without the dramatic act of destruction of his early work, Léger's concerted renunciation of his own past and his assertion of a new departure would be evident in these paintings of 1909.

As 'The Bridge' bears witness, Léger's new beginning was based on Cézanne. Just as Braque and Picasso had grappled, in 1907 and 1908, with Cézanne's art in order to find their way out of one way of seeing and painting into another, so too did Léger, for many of the same reasons. In 1913 Léger wrote that to him the importance of Cézanne's art lay in its 'conceptual realism' and its fusion of form, line and colour. These qualities are nascent, if not fully realised, in 'The Bridge'. Here the mounds of earth, the trees, houses and bridge are described in generalised forms lacking all detail:

'conceptual realism' as opposed to 'visual realism'. There is no drawing as such; in its stead Léger relies on variations in tone and hue to articulate the forms and impart a sense of recession. The edges of the planes define the boundaries of the features of the landscape and give direction to the composition, making the objects 'turn, recede and live' in accordance with Cézanne's instructions to Emile Bernard, which Léger had read with great interest.

It is impossible to date this painting with certainty, but the elementary forms suggest that it is contemporary with Léger's first period of work on 'Nudes in a Forest' (Rijksmuseum Kröller-Müller, Otterlo), which he began in 1909 and finished before the spring of 1911. The marked affinities between 'The Bridge' and the paintings Braque exhibited at the Galerie Kahnweiler in the autumn of 1908, such as 'Big Trees at l'Estaque' (no. 4), suggest that the present work may well show Léger's response to the Braque exhibition. While Léger was not to meet Braque and Picasso until 1910, he was nonetheless already in touch with many of their friends, and it is unlikely that he would have failed to see the controversial exhibition of Braque's *bizarreries cubiques*.

94 Woman Sewing

Painted in late 1909
Oil on canvas, $28\frac{1}{4} \times 21\frac{1}{4}$ (72 × 54)
Signed on the back: 'F. Léger'; not dated

Lit: Green 1976, p. 10

Prov: the artist to Daniel-Henry Kahnweiler, Paris (photo no. 6017), 1910-14; sequestered Kahnweiler stock, 1914-22; 3rd Kahnweiler sale, Hôtel Drouot, Paris, 4 July 1922, lot 109, sold for 40 frs. to Léonce Rosenberg, Paris; D.H. Kahnweiler, Paris, by the late 1920s until 1979; Kahnweiler estate to the present owner, 1979
Private collection, Paris

By 1909 Léger had installed himself on the Left Bank of the Seine in the Ruche, a ramshackle warren of rooms – built originally as the wine-tasting pavilion of the 1889 Exposition Universelle – occupied at that time by a number of young artists and writers, of which many, such as Modigliani, Soutine and Chagall, were immigrants. Léger had by then lived in Paris on and off for nearly six years, and could count among his friends the poets Jacob, Raynal, Reverdy, Apollinaire and Blaise Cendrars, and above all the painter Delaunay. But none of these influenced his painting in 1909 as much as his friend Henri Rousseau.

The emphatic volumes and conceptualised forms of 'Woman Sewing' derive in part from Rousseau's painting, as well of course as from that of Cézanne. Léger's primary concern at the time was the clear expression of volume. He later told Dora Vallier that 'Nudes in a Forest' (Rijksmuseum Kröller-Müller, Otterlo), his major work then in progress, was for him 'only a battle of volumes'. By employing rudimentary forms modelled in a primitive fashion, he sought to convey a feeling of solidity and durability in his pictures, and thereby reach the 'antipodes' of Impressionism's fleeting effects. While Rousseau's art was in no manner calculated or programmatical – he painted in the only way he knew – it was, despite himself, patently non-academic, and its clarity, awkward vigour, and literalism served as an inspiration for Léger and Picasso alike.

Léger here has squared-off the volumes in a way somewhat reminiscent of the facetted forms in the paintings Picasso executed at Horta de Ebro in the summer of 1909, such as 'Nude Woman in an Armchair' and 'Woman Wearing a Hat' (nos. 118 and 120), although it is unlikely that Léger knew those Picassos before he completed the present work. 'Woman Sewing' (according to Léger) was exhibited at the 1910 Salon des Indépendants, where the dealer D.H. Kahnweiler saw and bought it; thus the picture was presumably finished by the early spring of 1910. Picasso's Horta de Ebro pictures were not publicly exhibited in Paris before an exhibition organised by the Galerie Notre-Dame-des-Champs in May 1910, though before that they could have been seen in the home of Leo and Gertrude Stein, or on demand at the Galerie Kahnweiler or at Ambroise Vollard's. But even if Léger had seen some of the Picassos in question, there is an important distinction to be drawn between the methods used by the two painters to abstract their forms. While both conceived the figure in essentially plastic terms – as Braque and Gris never did – Picasso dug deep into the subject's anatomy, creating shadows and highlights to emphasise the structure, much as a sculptor would do, whereas Léger here has not yet pierced the skin of his model.

95 Rooftops in Paris

Painted in Paris, mid-1911
Oil on canvas, $24 \times 17\frac{1}{2}$ (61 × 45) Signed bottom left: 'F. LEGER'; not dated

Prov: early whereabouts unknown; René Gaffé, *c.* 1925 until 1949; Galerie Louise Leiris, Paris (photo no. 6693; stock no. 13471), 1949; Svensk-Franska Konstgalleriet, Stockholm, 1950; O.S. Thysselius Lundberg, Drottningholm, by 1954 until 1981; to the present owner in 1981 *Galerie Nathan, Zürich*

Léger pursued his analysis of volume and form within a restricted range of colours for more than a year following the completion of 'Woman Sewing'. While his friend Delaunay introduced strong local colour and fractured objects in his depictions of the Eiffel Tower (see no. 221), Léger pushed to the extreme the facetting he began in the picture of his mother. Concentrating his efforts on two large canvases painted successively, 'Nudes in a Forest' and 'Essay for Three Portraits', Léger experimented with compositions in which the figures and objects were divided into progressively smaller conical units which earned for him the sobriquet *tubiste*. These units were arranged so as to make a pictorial fabric as dense as but much more opaque than that of the contemporary painting of Braque and Picasso (e.g. 'Man with a Pipe', no. 127). Since Léger did not emphasise brushwork at the expense of deflating the sense of volume he desired, he thus achieved in 'Nudes in a Forest' and 'Essay for Three Portraits' a sculptural effect analogous to bas-relief: the paintings suggest large polychrome stone reliefs of which the surfaces had been carved into small, regular, rounded shapes. This was quite at odds with the shimmering, semi-transparent planes that characterised the contemporaneous analytical Cubism of Braque and Picasso.

But soon after his move from the avenue du Maine to the rue de l'Ancienne Comédie, in late spring 1911, Léger began a series of rooftop cityscapes in which he deliberately suppressed the volumetric effect he had previously sought.

The first works in the group, such as the picture now in Minneapolis, were panoramic scenes which displayed a wide view north-east across the Left Bank towards the cathedral of Notre-Dame to the east. The scene Léger depicted was wider than the eye could take in at a glance, so he obliged himself to condense various points of view while describing the variety of buildings placed at odd angles to one another, each sprouting an array of dormers and chimney-pots. Among these he interspersed plumes of smoke, whose volumes and immateriality served by contrast to reduce the jumble of walls and roofs to the planar structure of a stage set. The effect was heightened in subsequent works with different views, such as the 'Rooftops' exhibited here, where the mass of the buildings is diminished by pale, chalky colours, strong contours and restrained modelling.

The large shapes wheeling among the clouds are non-representational forms inserted by Léger to contrast with the scene depicted beneath. These become more assertive in later works in the series, and two years later Léger made their inclusion a major preoccupation. What once had been a 'battle of volumes' thus yielded to the initial formulations of Léger's theory of contrasts, which dominated his painting until it was interrupted by the declaration of war in August 1914.

A smaller version of this composition, in gouache on paper and dated 1911, was sold at Parke-Bernet, New York, on 15 October 1969, lot 62.

96 Smokers

Painted in Paris between late 1911 and early 1912
Oil on canvas, 51 × 37⅞ (129.5 × 96.3)
Neither signed nor dated

Lit: Green 1976, p.37; Guggenheim 1976, pp.452-5; Museum inv.no.38.521

Prov: Galerie Kahnweiler, Paris (photo no.6006), 1911-14; sequestered Kahnweiler stock, 1914-22; 3rd Kahnweiler sale, Hôtel Drouot, Paris, 4 July 1922, lot 103, sold for 800 frs. to Léonce Rosenberg as agent for the artist; F. Léger, Paris, 1922-4; Galerie de l'Effort Moderne (Léonce Rosenberg), Paris (photo no.434), 1924-6; Georges Bernheim, Paris, 1926-38; Galerie Pierre (Pierre Loeb), Paris, 1938; sold to Solomon R. Guggenheim, New York; given to the museum in 1938
Solomon R. Guggenheim Museum, New York

In 'Smokers' Léger states many of the formal problems he would elaborate over the coming eighteen months while summarising those dealt with in his most recent painting. The contrast of billowing clouds with cubic houses stems from his 1911 rooftop views of Paris (see no.95), and the rounded, regularised forms of the fruit in the left foreground and the line of trees at the centre are reminiscent of the tubular and facetted units of 'Woman Sewing' (no.94). The card-like planes of white and blue which Léger had introduced in the rooftop series are here enlarged and given greater emphasis, but within nine months they came to dominate the composition of 'Woman in Blue' (no.97). The juxtaposition of flat forms with round, which characterise the subsequent 1913-14 series of 'Houses among Trees' (nos.99 and 102) is broached here for the first time in the landscape in the middle.

Art historians have recently debated whether in this painting Léger represented one smoker or two in the right foreground, although the original inscription 'Les Fumeurs' (now obscured by lining), would seem to dispel any doubts about the artist's intentions. Yet the issue is important, for the painting was executed during the winter of 1911-12, and the Futurists exhibited their paintings in Paris in February 1912. If Léger, who saw the exhibition and was impressed by the dynamic vision of the Futurists, attempted here to re-create in his own idiom the head of one smoker in different positions, it would constitute the first such response by a French artist to Futurist conceptions. But while Léger would soon adopt (in the large painting he exhibited at the Salon des Indépendants of 1912, 'The Wedding' now in the Musée National d'Art Moderne, Paris) certain devices favoured by the Futurists, such as the telescoping of several experiences into one, the description of motion and the suggestion of a passage of time, there is no evidence of any such influence in the present picture. Although the shallow pictorial space, the linear structure and the partially fragmented forms show the artist approaching the Cubist conception of Braque and Picasso, there nonetheless remains a telling difference between the two. At no point does Léger synthesise multiple views of his subject into a single image, and nowhere does he try to see *round* a figure. This attitude will continue to distinguish Léger's Cubism from that of his colleagues.

Léger excerpted the still-life here for elaboration in a painting now in the Minneapolis Institute of Art as well as for the 'Study for an Abundance' (no.105). Both were probably executed early in 1912.

97 Woman in Blue

Painted in Paris, summer-autumn 1912
Oil on canvas, 76 × 51¼(193 × 130)
Signed bottom right: 'F. LEGER'; signed and dated on back: 'La Femme en bleu / S Automne 1912 / F. LEGER'

Lit: Green 1976, p.47; Museum inv.no.2299

Prov: the artist to Galerie Kahnweiler, Paris (photo no.6023), 1912-14; sequestered Kahnweiler stock, 1914-21; 1st Kahnweiler sale, Hôtel Drouot, Paris, 13-14 June 1921, lot 62, sold for 2150 frs. to M. Borel; Galerie de l'Effort Moderne (Léonce Rosenberg), Paris (photo no.836), 1921; Dr h.c. Raoul LaRoche, Paris, *c.* 1921 until 1952; given to the museum in 1952
Kunstmuseum, Basel. Gift of Dr h.c. Raoul LaRoche

In 1954 Léger remarked that his chief struggle in 1912-13 had been to free himself from the influence of Cézanne:

His grip was so strong that in order to free myself I had to go as far as abstraction. Finally, in 'Woman in Blue' and 'Railroad Crossing' [Vienna] I felt I had liberated myself from Cézanne and at the same time I had moved far from the melody of impressionism.

Significantly, Léger chose to battle with Cézanne on the latter's ground, for he chose a seated woman at a table as his subject, one closely identified with his former mentor. Indeed the pose of the figure in 'Woman in Blue' is virtually identical with Cézanne's 'Woman with a Coffee-pot', a well-known picture of 1890-4, now (though not then) in the Louvre. Thus, having adopted Cézanne's conception of painting as a point of departure, Léger then proceeded to obliterate this influence on himself. The figure is suggested by an arrangement of small rounded forms, which are countered by large planar elements, none of which bears any direct relationship to visual appearances. The blue of the dress is referred to only obliquely by the colour of certain planes, for nowhere in this painting does Léger employ colour descriptively. Most important, Cézanne's empirical, shifting, non-mathematical perspective, is here rejected in favour of a linear and planar framework that permits neither recession nor projection, but establishes a shallow pictorial space in which the forms can be tilted slightly. Although these forms resemble the large planes then employed by Braque and Picasso in their 'synthetic' Cubist paintings and *papiers collés*, such as 'Violin' (no.137), their origin and function here can be counted as Léger's own. They serve as potent contrasts to the few clearly recognisable objects in the composition: for example, the table-top and glass, the turned-wood of the arms and legs of the chair. Léger also renounces here his brief flirtation with Futurist devices in 'The Wedding', and as a result the dynamism of the present composition derives from formal contrasts rather than from implied movement. The huge scale of this painting, destined to dominate a room at the 1912 Salon d'Automne, underscores the importance the artist attached to his declaration of independence. From this moment on, Léger's art became highly individual, and his stylistic evolution self-directed.

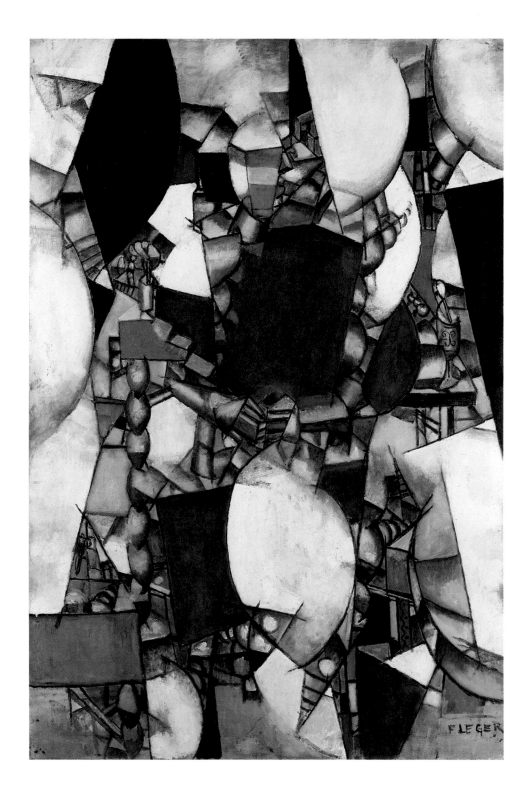

98 Seated Woman

Painted in Paris, 1913
Oil on canvas, $39\frac{1}{2} \times 32 (100 \times 81)$
Signed on back: 'F. Léger'; not dated

Prov: the artist to Galerie Kahnweiler, Paris (photo no. 6035), 1914; sequestered Kahnweiler stock, 1914-21; 2nd Kahnweiler sale, Hôtel Drouot, Paris, 17-18 November 1921, lot 158, sold for 270 frs. to M. Tzanck, Paris, 1921-?; Alphonse Kann, St-Germain-en-Laye; Stephen Higgons, Paris, by 1959; to the present owner in 1961
Private collection, Switzerland

Having exorcised in 'Woman in Blue' the burden of Cézanne's example, Léger felt free to explore again the depiction of volumes, which he had treated earlier under the influence of the master of Aix. True, the cylindrical forms of 'Seated Woman' and their assertive modelling recall those of 'Nudes in a Forest' (Rijksmuseum Kröller-Müller, Otterlo) and 'Woman Sewing' (no. 94), both of which were influenced by Cézanne as well as by Rousseau. But here the modelling is handled in a much coarser fashion: each form is interrupted either by a white highlight or by an area of bare canvas, which breaks up the curve ostensibly being represented. And the forms are carried to an anti-naturalistic extreme far removed from anything for which Cézanne would have accepted the paternity. Léger constructs the figure from standardised elements which exist independently of his subject; in fact, they will serve him equally well in still-life compositions (no. 101), in landscapes (nos. 99 and 102), and in wholly abstract compositions (no. 100). Thus more or less simultaneously with Henry Ford's standardisation of the manufacturing process, Léger isolated and standardised the constituent elements of a painted composition: line, form and colour. The true subject of this painting therefore is not a seated woman but the expressive opposition of certain basic factors of painting: red is opposed to blue, and straight lines are contrasted by curves, while volume is offset by coarse modelling which does not bend with the form. Léger wrote that 'contrast equals dissonance', through which one can achieve the 'maximum expressive effect'. This is here superbly accomplished.

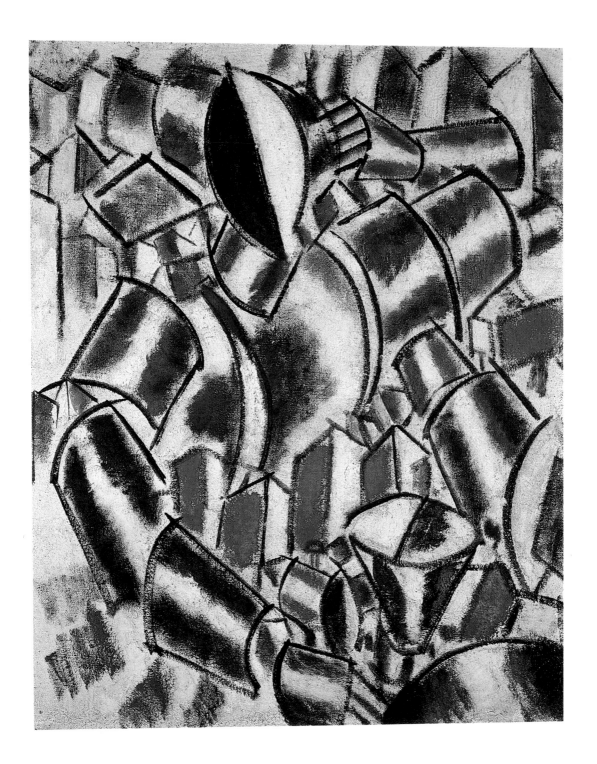

99 Houses among Trees

Painted in Paris, probably in late 1913
Oil on canvas, 28¼ × 36¼ (73 × 92)
Signed and dated on back: 'F. LEGER / LES MAISONS DANS LES ARBRES/13(?)'

Prov: the artist to Galerie Kahnweiler, Paris (photo no. 6040), 1914; sequestered Kahnweiler stock, 1914-23; 4th Kahnweiler sale, Hôtel Drouot, Paris, 7-8 May 1923, lot 299, sold with lot 297, 'Les Maisons dans les Arbres', for 110 frs. to an unidentified buyer; Jacques Dubourg, Paris, by 1956; Sotheby's London, 30 June 1981, lot 62, sold to the present owners
Sara and Moshe Mayer, Geneva

Early in 1913 Léger took up the village scene he had depicted in the middle distance of 'Smokers' (no. 96), again concentrating on the contrast between the spherical forms of the trees and the planar elements of the houses. Working in series, he first opposed attenuated, intersected arcs with cubic forms in a stylistic idiom similar to that of the drawing of a nude exhibited here (no. 107). He soon compacted the forms, however, and by the time he painted the present 'Houses among Trees' he had developed a dense composition in which the forms, whether flat or spherical, were given relatively equal emphasis. This work is distinguished by the powerful compression of the composition and its unusual variety of colours: orange and a touch of pink in addition to the customary green and primary red, yellow and blue. This painting is, as well, unusually dynamic.

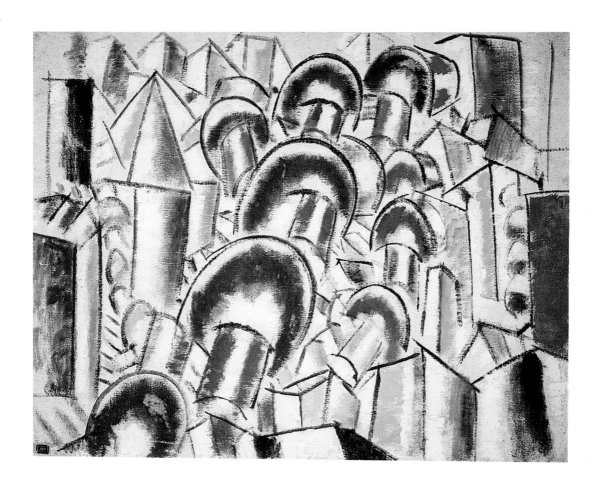

100 Contrasts of Forms

Painted in Paris, 1913
Oil on burlap, $17\frac{15}{16} \times 24 (45.5 \times 61)$
Signed and dated on back: 'F. Léger 13'

Lit: Guggenheim 1976, p.462

Prov: the artist to Galerie Kahnweiler, Paris (photo no.6013), 1914; sequestered Kahnweiler stock, 1914-21; 2nd Kahnweiler sale, Hôtel Drouot, Paris, 17-18 November 1921, lot 152, sold for 110 frs. to M. Grassat, as agent for the 'Simon syndicate'; Galerie Simon, Paris (stock no.6102), 1921-9; Otto Carlsund, Stockholm, 1929-*c.*1938; Galerie Pierre Loeb, Paris, 1938; Solomon R. Guggenheim, New York, 1938; the Solomon R. Guggenheim Museum of Art, New York, 1938-74; Sotheby Parke-Bernet, New York, 3 July 1974, lot 78, sold to Perls Gallery, New York, 1974; to the present owner
Private collection

This painting, one of a series entitled by the artist 'Contrasts of Forms', is no more nor less than that. There is no other subject; no object is depicted. The forms, of course, are recognisable from the preceding series of paintings, and the fact that it is non-representational follows just as logically from Léger's earlier researches. Since he had emphasised the expression of certain elements of painting, while neglecting the subject, the latter inevitably disappeared. Moreover, the relative concision of the forms, the strength of the colour contrasts, the vigour of the drawing – criteria that one adopts for the evaluation of quality in works such as nos. 98, 99 and 100 – are equally valid in the present case: the lack of objects here is hardly noticeable. But that lack was indeed felt by Léger himself no more than a year after he had completed the present painting and, apart from a few decorative murals made several years later, he never made another totally abstract work of art.

The idea of a 'pure art', devoid of objective representation, was hotly discussed by artists and writers in Paris in 1912-13. Apollinaire announced the death of 'the subject' in 1912. It was already implicit in late Symbolist theory, virtually explicit in Picasso's painting of the summer of 1910, and widespread by the end of 1913. Painters with temperaments and expressive aims as diverse as those of Kupka, Mondrian, Delaunay, Kandinsky and of course Léger himself had made non-objective paintings before the end of that year. Of these painters, Léger was the exception in that he rejected it almost as quickly as he took it up; the rest continued their explorations and prepared the way for the abstract art which has prevailed during much of this century. For Léger, however, art was almost always an expression of the material reality of life, and in this sense he remained in harmony with the essential realism of Cubism.

It is significant in this context that the present composition, like, as Christopher Green has remarked, most of the 'Contrasts of Forms' pictures, has strong objective overtones. The 'kite-shaped' trapezoid in the centre is reminiscent of the head in 'Seated Woman' (no.98), while the general disposition of forms is not unlike the landscape 'Houses among Trees' (1913, no.99). Perhaps most important, the painting itself is self-assertive as an object, for Léger has chosen to paint on roughly woven burlap rather than canvas.

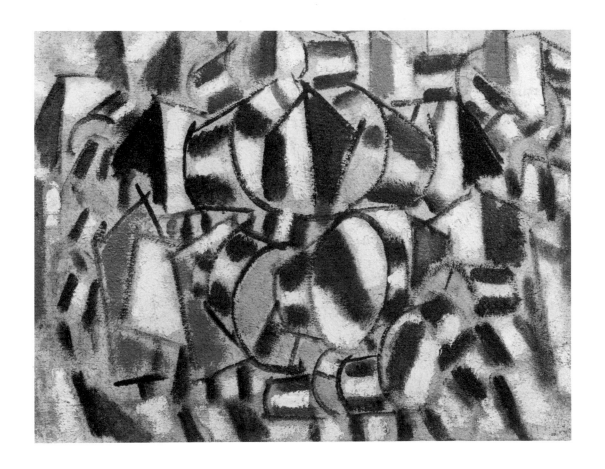

101 Still-life

Painted in Paris, early 1914
Oil on canvas, 35½ × 28½ (90 × 72.5)
Signed and dated bottom right: 'F. Léger 1913'; also signed and dated on back (which is painted
with a sketch of a seated woman): 'F. Léger / nature morte / 1914'

Lit: Green 1976, p.87

Prov: the artist to Galerie Kahnweiler, Paris (photo no.6024), 1914; sequestered Kahnweiler
stock, 1914-21; 2nd Kahnweiler sale, Hôtel Drouot, Paris, 17-18 November 1921, lot 153,
sold for 210 frs. to M. Grassat as agent for the 'Simon syndicate'; Galerie Simon, Paris (stock
no.6887), 1921-2; Alfred Flechtheim, Berlin and later London, 1922-35; Galerie Simon, Paris
(stock no.12132), 1935-8; Galerie Balaÿ et Carré (later Galerie Louis Carré), Paris, 1938-59;
Mr and Mrs Walter Ross, New York, 1959-64; Mrs Ross (later Mrs Charles Stachelberg),
New York, 1964-77; to the present owner in 1977
Galerie Beyeler, Basel

In a number of still-lifes Léger employed the same forms, drawing and colours that he had developed for figurative paintings like 'Seated Woman' (no.98). The underlying theory of contrast and dissonance is the same, but in works such as the present painting the forms have acquired a mechanistic appearance that would soon be imposed in Léger's figure painting and, to a lesser degree, in his landscapes as well. Of the four major Cubists, Léger alone accepted unreservedly all that signified modern life, be it crude and garish advertising, uniform dress, mass-produced artefacts, or anarchists in the streets; and in his art he hoped to find a means of expression consonant with his times. He maintained that 'the existence of modern creative people is much more intense and more complex than the people of earlier centuries . . . [so] the compression of the modern picture, its variety, its breaking up of forms are the result . . .' This belief thus explains in part the dense composition, as well as the unusual appearance of the kerosene lamp at the upper left, the two bowls of fruit on the table, the spoon standing in the coffee-cup (on the right) and the fork to its right.

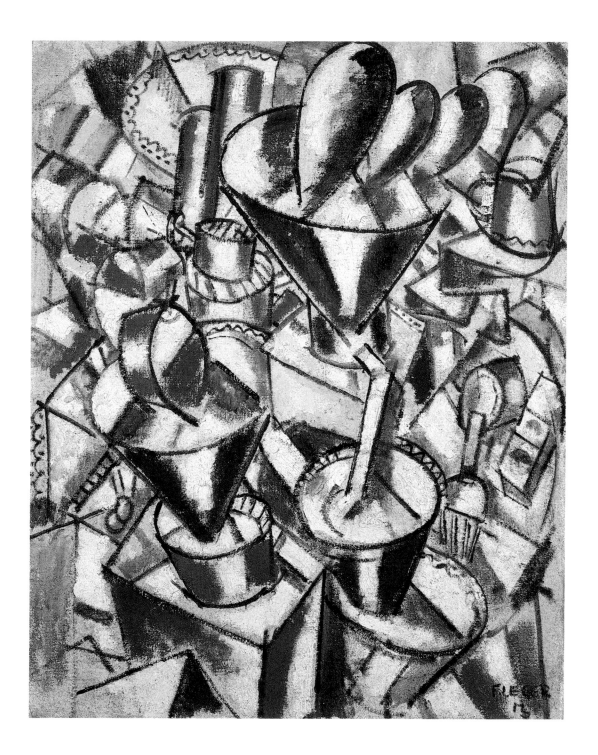

102 Houses among Trees (Landscape no. 3)

Painted in Paris, 1914
Oil on canvas, $51\frac{1}{8} \times 38\frac{1}{4}$ (130 × 97)
Signed on back: 'PAYSAGE Nº 3 F.LEGER'; not dated

Lit: Green 1976, p. 94; Museum inv. no. 2301

Prov: the artist to Galerie Kahnweiler, Paris (no stock or photo no. available), 1914; sequestercd Kahnweiler stock, 1914-23; 4th Kahnweiler sale, Hôtel Drouot, Paris, 6 May 1923, lot 310, sold for 310 frs. to an unidentified buyer, probably Léonce Rosenberg, as it was in his possession soon afterwards; Galerie de l'Effort Moderne (Léonce Rosenberg), Paris (photo no. 615), by 1924; Dr h.c. Raoul LaRoche, Paris, *c.* 1924 until 1952; given to the museum in 1952
Kunstmuseum, Basel. Gift of Dr h.c. Raoul LaRoche

Léger extended his series of houses among trees well into 1914. There are few differences to be drawn between this version and no. 99, except that here the formal elements are larger and fewer in number; it would seem that the artist no longer felt it necessary to fill the interstices between the objects with inessential forms. This corresponds with the quick, economical manner in which the painting was realised. Large areas of the canvas were left bare, the outlines rapidly sketched and the modelling quickly effected. With the ex-perience of several similar compositions behind him, Léger forcefully summarises here his researches of the preceding two years. Approximately coincidental with work on this painting, Léger wrote:

It is the logical spirit that will achieve the greatest result, and by the logical spirit in art, I mean the power to order one's sensibility and to concentrate one's means in order to yield the maximum effect in the result.

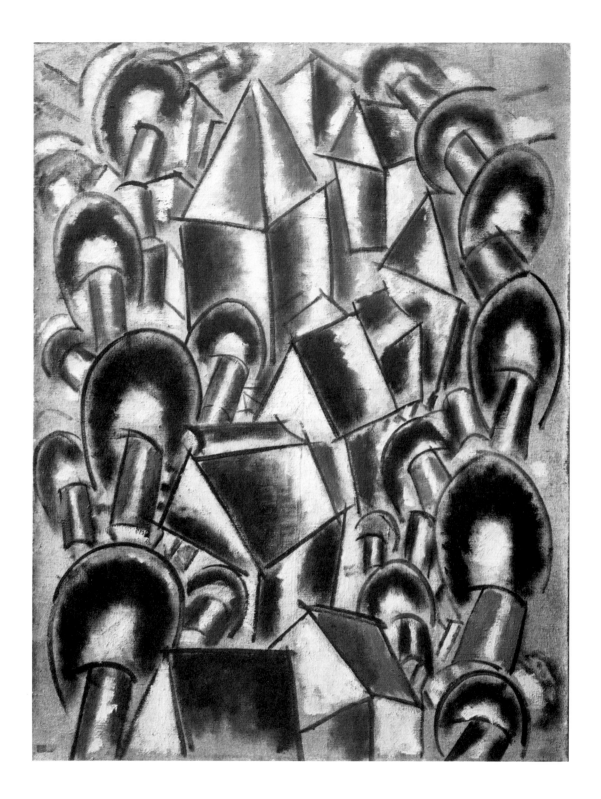

103 Soldier Smoking

Painted in Paris, summer 1916
Oil on canvas, $51\frac{1}{4} \times 38\frac{1}{4}$ (130 × 97)
Signed and dated bottom right: 'F. LEGER / 16'. A sketch of women on a balcony is painted on the back

Lit: Green 1976, p. 116; Museum inv. no. 1028

Prov: sold by the artist for 2000 frs to Rolf de Maré, Paris and Stockholm, 1920 until *c.* 1955; Philippe Dotremont, Brussels, *c.* 1955 until 1961; Yamamura collection, Osaka, 1961-4; Minami Gallery, Tokyo, 1964; Galerie Beyeler, Basel, 1965; sold to the museum in 1965
Kunstsammlung Nordrhein-Westfalen, Düsseldorf

The outbreak of war in August 1914 had an immediate effect on the art of Braque and Léger: it prevented them from painting, at least in the beginning. Gris and Picasso, as Spaniards, were not mobilised and they continued therefore to paint more or less uninterrupted. But the effect of the break on Léger was even more profound than would at first be obvious, for whereas Braque took up his work, as soon as he could, from the point at which he had left it, Léger's vision was transformed by the experience of war, and his subsequent painting reflected this change. He later told Dora Vallier how impressed he was by the sight of the sunlight hitting the breaches of the cannons, by the crude reality of war material, by the soldiers in their uniforms. 'It was in the war that I discovered the magnificence of the French people, the richness, the beauty of the slang, the strength of their expressions.' It is well worth remarking that Léger was the only *avant-garde* artist in France to benefit constructively from his experience at the front. While the future Dadaists, when faced with the horror of war, turned to nihilism and anti-artistic activities, Léger embraced the spectacle which he was seeing and experiencing and attempted to seize it for his art: the mud, the new technology, the death, the courage and *camaraderie* of peasant boys.

As in 'Smokers' (no. 96), Léger here depicts man at rest, but this time the figure is in uniform and the venue has been changed from a café terrace to a dug-out at the front. Accordingly, everything is drab and grey; the red cheek of the soldier provides the only relief. The forms of which he is composed, large, tubular and metallic, resemble the equipment of war. And while the *poilu* is not featureless, his expression is anonymous. Thus the standardised forms Léger had elaborated in paintings such as 'Seated Woman' (no. 98) are here given a new function and consequently take on new meaning.

No works are known from the first year Léger spent at the front, although a large number of drawings has survived (see no. 110), which date from July 1915 onwards to the spring of 1917, when he was gassed and demobilised. This canvas, painted in Paris during a leave in summer 1916, was his first large work of the war years. 'The Card Players' (Rijksmuseum Kröller-Müller, Otterlo), an enormous painting of soldiers in a dug-out made during Léger's convalescence a year later, is a summation of his wartime experiences.

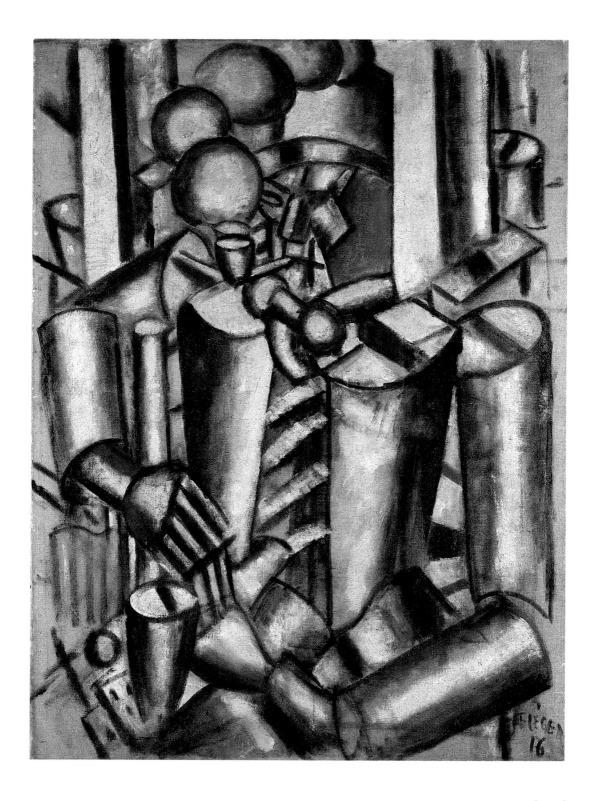

104 The Typographer

Painted in Paris, 1919
Oil on canvas, $51\frac{1}{4} \times 38\frac{1}{4}$ (130 × 97)
Signed bottom right: 'F. LEGER'; on back: 'LE TYPOGRAPHE / F. LEGER 19 / ETAT DEFINITIF'

Lit: Green 1976, pp. 151-7; Museum inv.no. 50-134-125

Prov: the artist to (?) Galerie de l'Effort Moderne (Léonce Rosenberg), Paris; Galerie Pierre (Pierre Loeb), Paris, before 1931; Marcel Duchamp as agent for Louise and Walter Arensberg, New York and Hollywood, 1931-50; given to the museum in 1950 but not installed until 1954
Philadelphia Museum of Art. Louise and Walter Arensberg Collection

The 'man as machine' idea implicit in the 'Soldier Smoking' is here expressed in terms less clearly legible but no less potent. Léger came back from the front firmly convinced of the importance of modern industrial life as the basis of his subject matter, and for the next four years was to work on compositions of men in industrial environments. 'The Typographer' was the most important of these compositions; it required numerous drawings and four complete versions before Léger was satisfied with the effect. The present work is the final painting in the series.

Léger wrote during the time he worked on 'The Typographer' that a subject was still essential to his art, but in this painting we see that representation in the traditional sense, which Léger had reaffirmed in 'Soldier Smoking', was now expendable. Léger has not depicted a typographer, nor even the tools of his trade. Instead he has produced a composition of machine-like forms which, in their placement and general shape, suggest by analogy the presence of a human figure. The tubes and cones of his figure painting since 1914 have been abandoned for a slicker, precisionistic aesthetic, one less humanising in its effect. At the same time, the constituent elements of the composition have become larger, and – more important – flatter. In this respect, Léger approached the monumental Cubism of wartime paintings by Picasso and Gris, such as 'Harlequin and Woman with a Necklace' (no. 151) and 'Portrait of Josette' (no. 74), while asserting nonetheless his own preference for machine imagery. With the war over and the Cubists back in Paris, a completely new style of painting sprang from the old Cubist roots. This painting stands at the crossroads, reflecting the achievements of the past while indicating things to come.

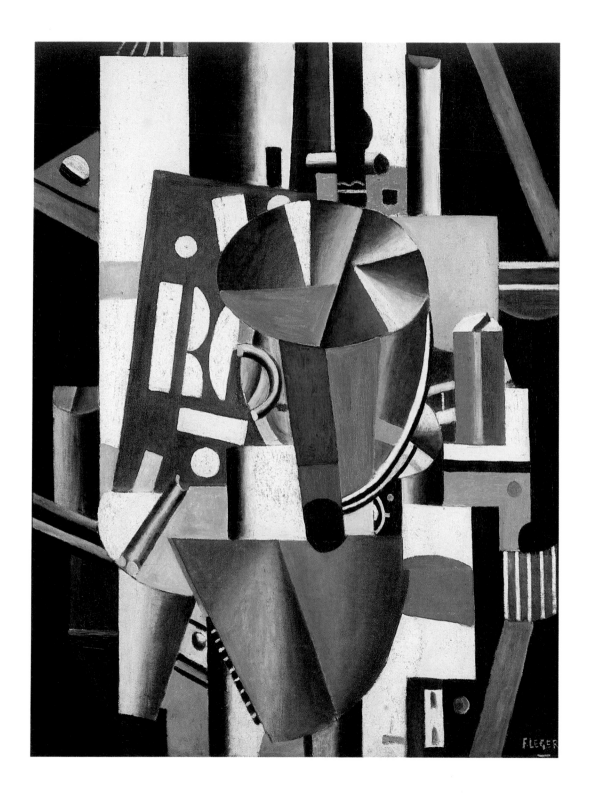

105 Study for an Abundance

Executed in Paris, early 1912
Ink on light brown paper, $12 \times 7\frac{1}{2}$ (30.5 × 19)
Neither signed nor dated

Lit: Gleizes and Metzinger 1912 (repr.); Green 1976, p. 32

Prov: the artist to Galerie Kahnweiler, 1912-14; sequestered Kahnweiler stock, 1914-21; sold in an unidentified lot at one of the Kahnweiler sales, 1921-3; whereabouts unknown, 1923-67; James Wise, Paris, by 1967; Galerie Louise Leiris, Paris (photo no. 30503, stock no. 14931), 1967-69; Galerie Berggruen, Paris, 1969; Parke-Bernet, New York, 17 December 1969, lot no. 30, sold to the present owner
Private collection

Léger made this drawing during his work on 'Smokers' in the winter of 1911-12. Echoing the theme of a large painting by Le Fauconnier that made a sensation at the Salon des Indépendants of 1911, it may have been the first sketch for a projected painting which remained unrealised. Soon after it was made, Gleizes and Metzinger reproduced the sheet in the original edition of their *Du Cubisme*, published by Eugène Figuière in December 1912.

106 Seated Nude

Executed in Paris, winter 1912-13
Charcoal on paper, $19\frac{1}{2} \times 12\frac{5}{8}$ (49.5 × 32)
Signed and dated bottom right: 'F.L. 13'

Lit: Cassou 1972, no. 14; Stuttgart 1981, no. 6

Prov: early whereabouts unknown; G. David Thompson, Pittsburgh, *c.* 1954 until 60; Galerie Beyeler, Basel, 1960-4; Gerd Hatje, Stuttgart, 1964
Private collection

After completing 'Woman in Blue' (no. 97), Léger began work on another large composition of a woman in an interior. This time, however, the model was conceived as a nude in a studio, although the play of abstract forms revealed even less of the subject than in 'Woman in Blue'. A relatively large number of preparatory studies were made for the painting, which was finished early in 1913 (and now hangs in the Guggenheim Museum), in addition to a group of drawings and gouaches in which Léger explored the results of slightly different poses and compositions. This drawing and the following work both belong to the latter group. The Guggenheim drawing, being more abstract, was probably made somewhat later than the drawing now in Stuttgart.

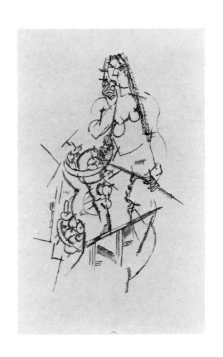

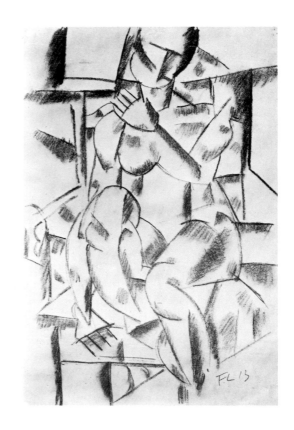

FERNAND LEGER

107 **Study of a Nude**

Executed in Paris, winter 1912-13
Charcoal and gouache on paper, 25 × 18⅞ (62.5 × 48)
Signed top left: 'F.L.'; not dated

Prov: the artist to Galerie Kahnweiler, Paris (no photo no.; stock no. 1513), 1913-14; probably sequestered Kahnweiler stock, 1914-23; probably sold in an unidentified lot at one of the Kahnweiler sales, 1921-3; whereabouts unknown, *c.* 1923 until *c.* 1940; bought by Peggy Guggenheim with André Breton in New York, *c.* 1940; Peggy Guggenheim, New York and later Venice, *c.* 1940 until 1980; in the museum since 1980
Peggy Guggenheim Collection, Venice (The Solomon R. Guggenheim Foundation)

108 **Still-life**

Executed in Paris, 1913
Wash and gouache on paper, 18 × 23¼ (45 × 60)
Signed and dated bottom right: 'F.L. 13 / nature / morte'

Prov: probably the artist to Galerie Kahnweiler, Paris (no stock or photo no. available), 1913-14; sequestered Kahnweiler stock, 1914-21; sold in an unidentified lot in one of the Kahnweiler sales, 1921-3(?); Galerie de l'Effort Moderne (Léonce Rosenberg), Paris (no photo no.), *c.* 1923 until 1936; to the present owner in 1936
Private collection

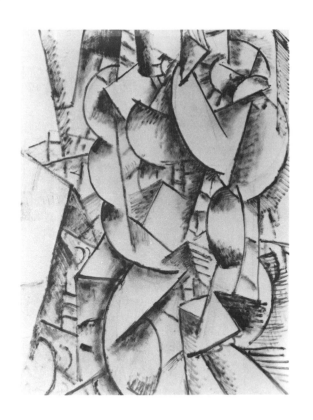

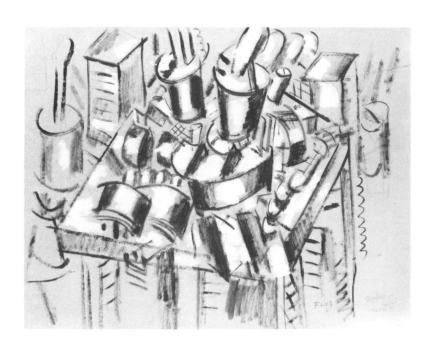

109 Contrast of Forms

Executed in Paris, 1913
Black wash and gouache on paper, $17\frac{5}{8} \times 21\frac{3}{8}$ (44.8 × 54)
Signed and dated bottom right: 'F.L. 13'

Lit: Guggenheim 1976, p.463

Prov: the artist to Galerie Kahnweiler, Paris (photo no.6058), 1914; sequestered Kahnweiler stock, 1914-23; sold in an unidentified lot in one of the Kahnweiler sales, 1921-3, to Galerie de l'Effort Moderne (Léonce Rosenberg), Paris (stock no.7972); subsequent whereabouts unknown until 1955; to the present owner in 1955
Rosengart Collection, Lucerne

Despite the constructive role colour played in Léger's 'Contrasts of Forms', many of the paintings were preceded by studies executed only in black and white. In them, Léger quickly sketched the essential forms which were then highlighted by white gouache. This work, while close in composition to several of the horizontal paintings of 'Contrasts of Forms', does not appear to have an exact equivalent on canvas.

110 Sappers

Executed in autumn 1916
Watercolour on paper, $9 \times 5\frac{5}{8}$ (23 × 14.5)
Signed and dated bottom right: 'Verdun / les foreurs / F.Léger'

Lit: Cooper 1956, pl. 1

Prov: early whereabouts unknown; Paul Adamidi Frasheri Bey, Geneva, before 1945; to the present owner in 1945
Private collection

Léger's few wartime paintings were all executed while he was on leave, but his active battle duty did not prevent him from making hundreds of drawings at the front. The machinery of war and the activities of his comrades in uniform became his new subject. This drawing, made sometime during the large counter-offensive mounted by the French at Verdun against the German army, depicts two sappers at work in a dug-out and is carried out in a style still close to that of Léger's pre-war painting. The sharp break in his formal style did not come until after Léger returned from the front in the spring of 1917.

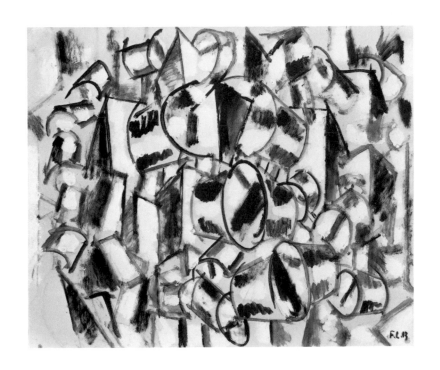

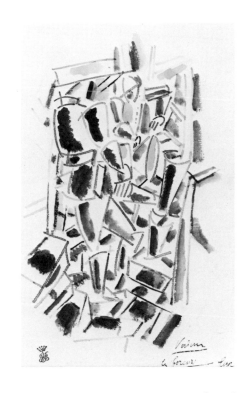

Pablo Picasso 1881–1975

Picasso in his studio, 11 Boulevard de Clichy, dressed in Braque's army uniform *c.* 1910-11

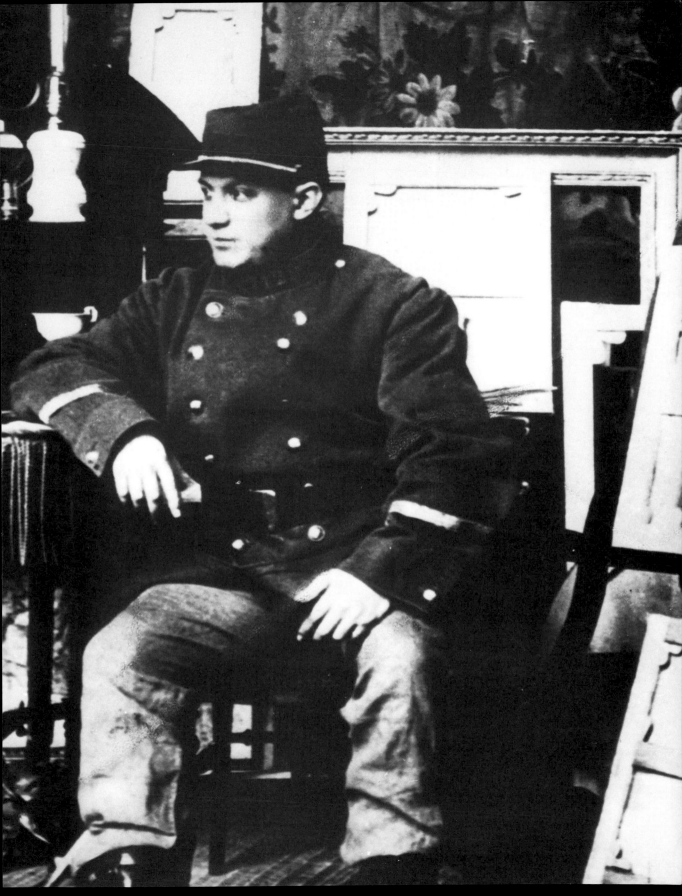

111 Self-portrait

Painted in Paris, spring 1907
Oil on canvas, 22 × 18 (56 × 46)
Signed on back: 'Picasso'; not dated

Lit: Z.II* 8; D.25; Museum inv. no. 08021

Prov: the artist to Ambroise Vollard, Paris, before 1911; sold for 400 frs. to Vicenc Kramář, Prague, 1911-60; bequeathed by Kramář to the gallery in 1960.
Národní Galerie, Prague

Picasso was twenty-five when he made this painting, living contentedly in a bohemian *ménage* with his mistress, Fernande Olivier, in the same building in Montmartre where he had lived since 1904 and into which Juan Gris had moved in 1906. Picasso already had a market for much of his work; some collectors, such as the Steins, were beginning to follow closely his career. More important, he had behind him the experience of the several hundred paintings and perhaps one thousand drawings that he had made over the previous ten years – that is to say, during what are now known as his Barcelona Period, his Blue Period, and his Rose or Circus Period. While Picasso no longer submitted works to the recognised Salons, he did benefit from a number of joint or one-man exhibitions at several dealers' galleries in Paris and Barcelona, and these in turn generated a considerable amount of attention in the press. Among others, Apollinaire steadfastly published short reviews of Picasso's latest work, remaining always a close friend and partisan. Max Jacob had known Picasso since the painter's second trip to Paris in 1900, and had introduced him into the world of young Parisian writers and poets. By 1907 Picasso knew older painters like Matisse fairly well (through the Steins) and frequently saw the circle of Fauve painters, particularly André Derain.

In sum, by 1907, Picasso had achieved more than he could have hoped for in the way of accomplishments and esteem. Yet with this picture he renounced much that his previous painting had stood for. Gone was the symbolism, sentimentality and idealism of his earlier work; gone too were the strangely inflated volumes and claustrophobic space of the paintings that Picasso had just completed in the winter of 1906-7. Here one finds instead a flat, coarsely limned image, pressed close to the picture plane, with no concessions to traditional notions of light or modelling. While the features have been generalised, they have not been idealised. The emphasis on the almond-shaped eyes and prominent ear are reminiscent of a pre-Roman, Iberian stone head that Picasso possessed briefly in March 1907, but otherwise there are no borrowed effects.

When Picasso painted the present picture, he had probably already embarked on his large, ambitious composition of female nudes in an interior now known as 'Les Demoiselles d'Avignon' (New York, Museum of Modern Art), which was to be marked by crudely applied paint, angular planes, and highly conceptualised, wholly unclassical figures. This 'Self-portrait', while unrelated in subject is in fact quite close in style to the early appearance of the 'Demoiselles'. It seems natural that Picasso would put his new ideas to the test in a self-portrait; in this work one feels that the artist is verifying his ability to carry through the assault on tradition he had already begun.

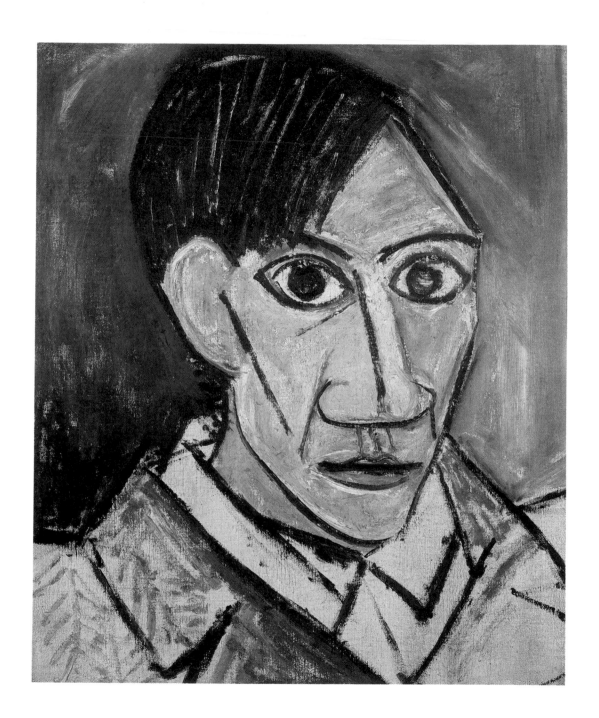

112 Standing Nude

Painted in Paris, summer 1907
Oil on canvas, $36\frac{5}{8} \times 16\frac{15}{16}(93 \times 43)$
Signed and dated top left (after 1921): 'Picasso / 1907'

Lit: Z.II* 40; D.40

Prov: the artist to Galerie Kahnweiler, Paris (photo no. 72, stock no. 276) before 1914; sequestered Kahnweiler stock, 1914-21; 1st Kahnweiler sale, Hôtel Drouot, Paris, 13-14 June 1921, no. 70, sold for 1100 frs. to Galerie Durand-Ruel for Dr Albert C. Barnes, Merion, Pennsylvania, 1921-c.1925; to Moderne Galerie (J. Thannhauser), Munich, before 1925; James Johnson Sweeney, New York; Mrs Marion Martins, Rio de Janeiro, before 1960; to Galerie Beyeler, Basel, 1960; to the present owners in 1960
Riccardo and Magda Jucker

The most provocative aspect of Picasso's work in 1907 was clearly his adoption of certain conventions of African carvings. While Derain and Matisse were the first, in 1906, to discover African masks and statuettes and to use some of the 'primitive' formal stylisations in their own art, Picasso was the first to attempt to re-create the religious power and savage expression which the carvings often conveyed. This painting is a particularly brilliant example of the 'African' works associated with 'Les Demoiselles d'Avignon'. The colours are bright and harshly juxtaposed, the drawing is crude and graphic, and the anatomy is coarsely defined. Nothing could be further from the refinement of most contemporary French painting, and it would therefore appear that Picasso wished more than anything else to shock his fellow painters and himself out of their former complacency.

Nearly twenty years later, Gris reflected on the importance of African art to the development of Cubism. He wrote:

Negro sculptures provide a striking proof of the possibilities of anti-idealistic art. Religious in spirit, they represent precisely, but in different ways, great principles and universal ideas. How can one deny the artistic validity of a creative process which can thus individualise generalities, each time in a different way? It is the reverse of Greek art, which started from the individual and attempted to suggest *an ideal type.*

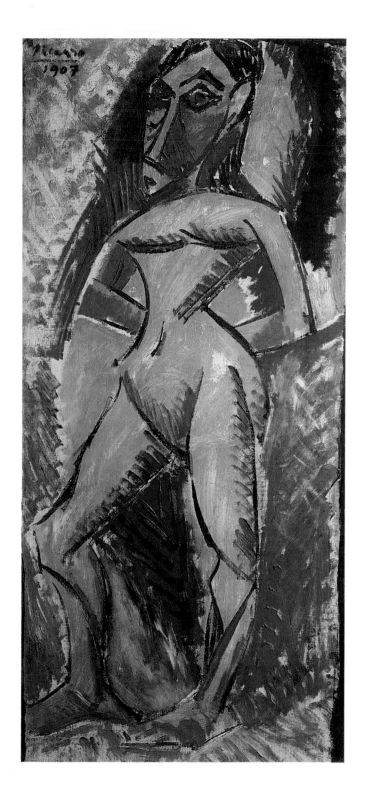

113 Three Figures under a Tree

Painted in Paris, winter 1907-8
Oil on canvas, 39 × 39 (99 × 99)
Signed top right: 'Picasso'; not dated

Lit: Z.II* 53; D.106

Prov: the artist to Ambroise Vollard (?): the work apparently did not pass through Galerie Kahnweiler; Dr G.F. Reber, Lausanne, from *c.*1925 until 1937; to the present owner in 1937
Private collection

Throughout winter 1907-8, Picasso concentrated on taming the barbarisms present in works like the preceding 'Standing Nude' in order to arrive at a more controlled and consistent formal vocabulary. In 'Three Figures under a Tree', Picasso has regularised and rhythmised the forms with arc-like contours which serve to unify the composition with their bold pattern. The wedge-like anatomical sections are similar to those in the earlier 'Demoiselles d'Avignon', but here they rhyme more closely with one another, thus enabling Picasso to create some extraordinary spatial elisions. The limbs of the figure on the extreme left, for example, merge rather freely into those of the middle figure. And while the central figure sits in front of the other two, its head is joined to the right-hand figure with a single contour. Further, the tree trunk seems to spring from behind the figures and yet to exist simultaneously on the picture-plane. This dovetailing of spatially separated objects into a single pictorial unit would later become an important Cubist device.

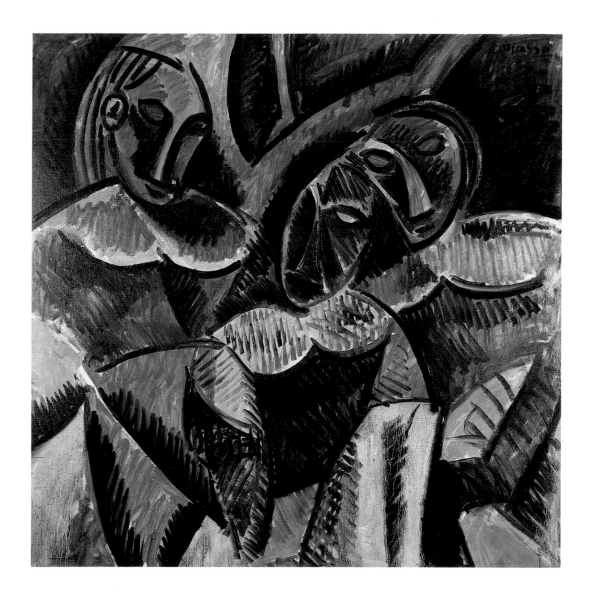

114 Head and Shoulders of a Woman

Painted in Paris, first half of 1908
Oil on canvas, $28\frac{3}{4} \times 23\frac{5}{8}$ (73 × 60)
Signed on back: 'Picasso'; not dated

Lit: Z.II* 64; D.134; Museum inv.no.08022

Prov: the artist to Galerie Kahnweiler, Paris (photo no.49, stock no.128), 1908-*c.*1911; to
Vicenc Kramàř, Prague, *c.*1911 until 1960; bequeathed to the gallery in 1960
Národní Galerie, Prague

For two years after the completion of 'Les Demoiselles d'Avignon' in the summer of 1907, Picasso equivocated in his path of development. Although many pictorial advances of Cubism were present in his large painting, he failed to pursue any one of them consistently. Indeed in some subsequent paintings he looked back as much as forward. In this work, with its bold, simple lighting, clear, volumetric expression of form, and inscrutable mask-like face, Picasso takes up again problems which he faced in paintings of winter 1906-7, most notably in the 'Two Nudes' (Z.I 366), now in the Museum of Modern Art, New York. While the operative influence in the latter is apparently pre-Roman Iberian sculpture, and that of the present painting is African, Picasso's pictorial aim remained the same: to convey in two dimensions a sculptural mass perceived in three dimensions.

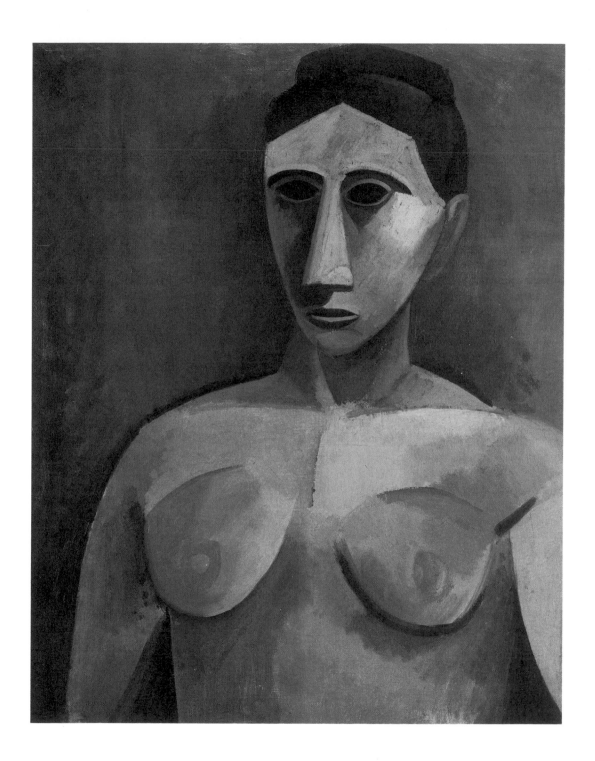

115 Landscape

Painted in La Rue des Bois, August 1908
Oil on canvas, $28\frac{3}{4} \times 23\frac{5}{8}$ (73×60)
Signed at right: 'Picasso'; not dated

Lit: Z.II* 86; D.186; Kahnweiler archive photo no. 7

Prov: the artist to Leo and Gertrude Stein, Paris, *c.* 1909 until 1913; Gertrude Stein, Paris, 1913-46; Stein estate, 1946-57; Galerie Louise Leiris, Paris, 1957; to the present owners in 1957
Riccardo and Magda Jucker

Throughout 1908, Picasso drew inspiration from African sculpture, Henri Rousseau, and Paul Cézanne. From each source he learned a different manner of conceptualising and rationalising nature in order to integrate it better into his art, which by now had become highly intellectual. Picasso rarely mixed his discoveries in a single work, but instead tended to work, for example, on a group of 'African' figure pieces, while working simultaneously on a series of still-lifes influenced by Cézanne. Although some art historians think that the waves of influence on Picasso's work happened sequentially, they were in all probability simultaneous; nonetheless, it is important to note that Picasso's approach was indeed methodical, if not oriented towards a specific goal. Unlike Braque, who at this time was exploring exclusively and rather consistently a novel kind of Cézannism, Picasso developed several differing and parallel styles of expression, but always in the context of a group or series of works in which he could take his researches to their just conclusions.

This landscape belongs to a group of paintings influenced by Rousseau which Picasso made while on holiday in August 1908, at a small village near Paris called La Rue des Bois. No doubt the dense, green foliage of the Ile de France reminded Picasso of paintings by the Douanier Rousseau, but Picasso had in fact executed several imaginary landscapes in the same 'literal' manner before he left for the country. Here, as in many of Rousseau's late works, the forms are highly emblematic.

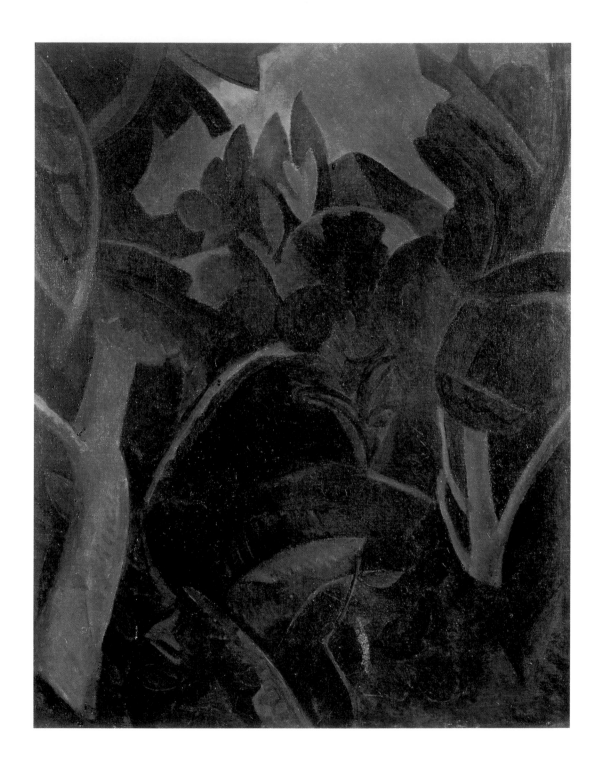

116 **Fruit-bowl with Pears and Apples**

Painted in Paris, autumn 1908
Oil on panel, $10\frac{5}{8} \times 8\frac{1}{4}$ (27 × 21)
Signed and inscribed on back: 'à mon ami Monsieur Arq[?] affectueusement Picasso'; not dated

Lit: Z.XXVI 424; D.200

Prov: the artist to Monsieur Arq(?); subsequent whereabouts unknown until *c.* 1940; Emile Spaeth, New York, until 1948; Perls Gallery, New York (no. 5664), 1948; Lee Ault, New York, 1948; Perls Gallery, 1948; Jacques Sarlie, New York, 1948-60; sale, Sotheby's, London, 12 October 1960, lot 9, sold for £7000 to O'Hana Gallery, London; Galleria Toninelli, Milan, before 1968; to Galerie Berggruen, Paris, 1968; to the present owner in 1968
Private collection, Switzerland

One of a group of still-lifes painted on small wood panels that were markedly derivative of Cézanne. Here one notices the high viewpoint, and the muted colours, while in others of the series one finds the repeated contours and inconsistent lighting which evoke Cézanne's example and betray as well a strong affinity to Braque's contemporary work. Braque's first one-man exhibition, held at the Galerie Kahnweiler from 9-28 November 1908, included works such as 'Bowl of Fruit' (no. 51), which may have inspired Picasso to work on the series of pictures to which the present painting belongs. At any rate, from this moment on Picasso began to focus his studies on Cézanne – the result of his increased contact with Braque, and the establishment of a close, collaborative working relationship with the younger painter.

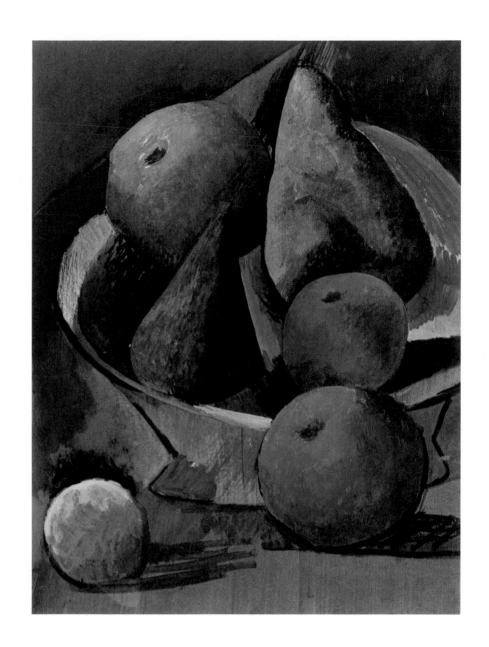

117 Reservoir at Horta de Ebro

Painted in Horta de Ebro, summer 1909
Oil on canvas, $23\frac{5}{8} \times 19\frac{3}{4}$ (60 × 50)
Neither signed nor dated

Lit: Z.II* 157; D.280; Kahnweiler archive photo no. 3

Prov: the artist to Leo and Gertrude Stein, Paris, 1909-13; Gertrude Stein, Paris, 1913-46; Stein estate, 1946-67; to the present owner in 1968
Private collection, New York

It was at Horta de Ebro that Picasso made the first of his paintings that in retrospect we may call Cubist. Gertrude Stein, who bought this picture from Picasso soon after he returned to Paris in the autumn of 1909, wrote:

Once again Picasso in 1909 was in Spain and he brought back with him some landscapes which were, certainly were, the beginning of Cubism. . . . Cubism is part of the daily life of Spain, it is in Spanish architecture. The architecture of other countries always follows the line of the landscape, it is true of Italian architecture and of French architecture, but Spanish architecture always cuts the lines of the landscape and it is that that is the basis of Cubism, the work of man is not in harmony with the landscape, it opposes it . . .

Picasso here opposes landscape with art, by deliberately short-circuiting traditional perspectival representation, restricting his palette to neutral tans and ochres, and applying light arbitrarily. Picasso carefully placed the forms one to the next not so much to record accurately the visual scene before him, but instead to create a tapestry-like composition in which the surface pattern counts as much as or more than the depicted scene. But despite Picasso's increased concern for respecting the surface of the canvas, it is important to note that he is still representing solids and masses much as a sculptor would: there is no evidence here of the 'painterliness' of Braque's contemporary Cubist work.

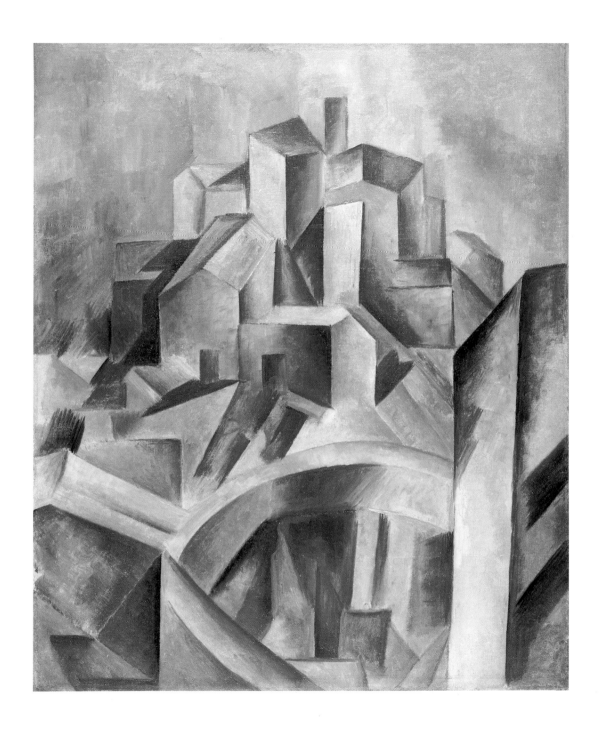

118 Nude Woman in an Armchair

Painted in Horta de Ebro, summer 1909
Oil on canvas, $36\frac{1}{4} \times 28\frac{3}{4}$ (92 × 73)
Neither signed nor dated

Lit: Z.II* 174; D.302

Prov: the artist to Ambroise Vollard, Paris; Dr G.F. Reber, Lausanne, from before 1933 until 1937; to the present owner in 1937
Private collection

Picasso placed his lover Fernande Olivier in an armchair outside a house in Horta and treated the figure by geometricising its various features. In the earlier 'Reservoir' he had treated buildings in much the same manner. But, as Gertrude Stein noted, architecture lends itself more readily to Cubism than does human anatomy, so the violence inherent in Picasso's early Cubism is here revealed by the rearrangement of Fernande's arms and shoulders, the deep gouges in the neck and throat, and the overall objectification of her figure into geometric units.

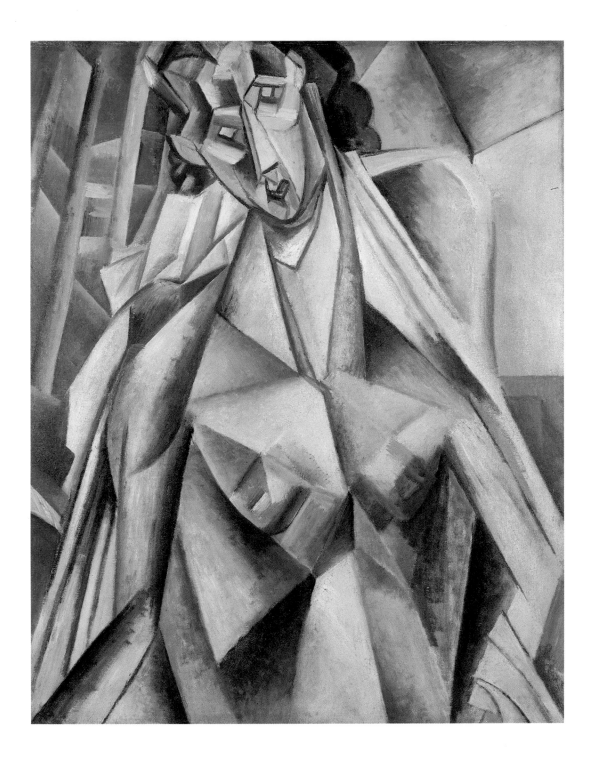

119 Fan, Salt-box and Melon

Painted in Paris, autumn 1909
Oil on canvas, $31\frac{15}{16} \times 25\frac{3}{16}(81 \times 64)$
Neither signed nor dated

Lit: Z.II* 189; D.314; Museum inv.no.69.22

Prov: early whereabouts unknown; Antoine Villard, Paris (?); Dr G.F. Reber, Lausanne before
1928; A.E. von Saher, Amsterdam; M. Knoedler & Co., New York, before 1948; Hyde Collection,
Glens Falls, NY, 1948-68; Hirschl & Adler Galleries, New York, 1968-9; to the museum in 1969
Cleveland Museum of Art. Purchase, Leonard C. Hanna Bequest

Perhaps the most ambitious of a series of still-lifes executed by Picasso after his return from Horta. The arrangement of objects and the high point of view are patently Cézannian, but the break-up of forms into small planar units of similar size is obviously more extreme than any abstraction Cézanne had attempted. The handling of the fan at top left might well be considered analogous to the way Picasso constructed the whole composition, for the background and foreground are related to each other by step-like gradients, just as the open fan is represented by an array of similar shapes spread out and merged one into another.

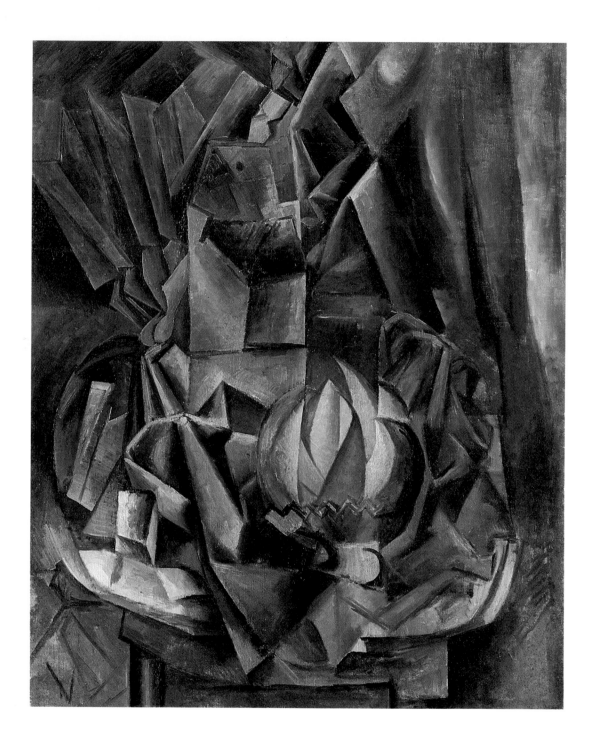

120 Woman Wearing a Hat

Painted in Paris, winter 1909-10
Oil on canvas, $28\frac{3}{4} \times 23\frac{5}{8}$ (73 × 60)
Signed on back: 'Picasso'; not dated

Lit: Z.II* 178; D.329

Prov: the artist to Galerie Kahnweiler, Paris (photo no.43, stock no.435), 1909; Wilhelm Uhde, Paris, 1910 until sometime before 1914; Alfred Flechtheim, Düsseldorf, before 1914; Franz Kluxen; Ida Bienert, Dresden and Munich, from *c.*1918 until 1967; Galerie Beyeler, Basel, 1967; Mrs Jane Engelhard, Far Hills, New Jersey, 1967-80; to the present owner in 1980
Galerie Beyeler, Basel

A striking, modish portrait of Fernande set in Picasso's new studio in the Boulevard de Clichy at the foot of Montmartre. Fernande was often photographed wearing hats, which seemed to set off her large eyes and strong features to great advantage.

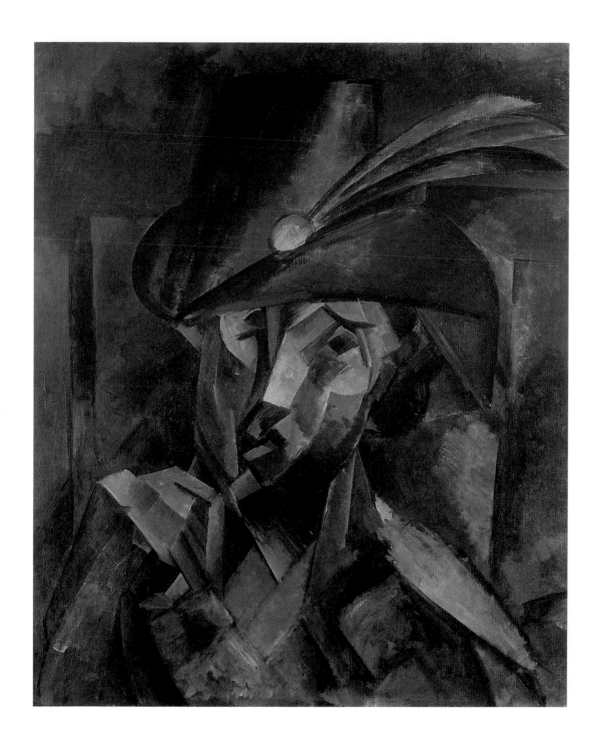

PABLO PICASSO

121 Head and Shoulders of a Woman

Painted in Paris, winter 1909-10
Oil on canvas, $28\frac{3}{4} \times 23\frac{5}{8}$ (73 × 60)
Signed top right: 'Picasso'; not dated

Lit: Z.II 218; D.335

Prov: the artist to Galerie Kahnweiler, Paris (no photo no.), 1910-14; sequestered Kahnweiler stock, 1914-21; 2nd Kahnweiler sale, Hôtel Drouot, Paris, 17-18 November 1921, lot 196 (?), sold for 760 frs. to M. Spichtz (or perhaps Spietz); anonymous French private collection, until 1970; to D.H. Kahnweiler, Paris, 1970-9; Kahnweiler estate to the present owner
Private collection

Here the setting is almost identical to that of the preceding 'Woman Wearing a Hat', but Picasso's technique is at once more advanced and less resolved than in the earlier picture. He has abbreviated the woman's features to simple signs – note especially the mouth, nose and eyes – suppressed the volumes until they practically disappear, and virtually eliminated all colour. Yet he seems to have been undecided over the final disposition of the woman's left shoulder, and uncertain over how much detail to include in the background.

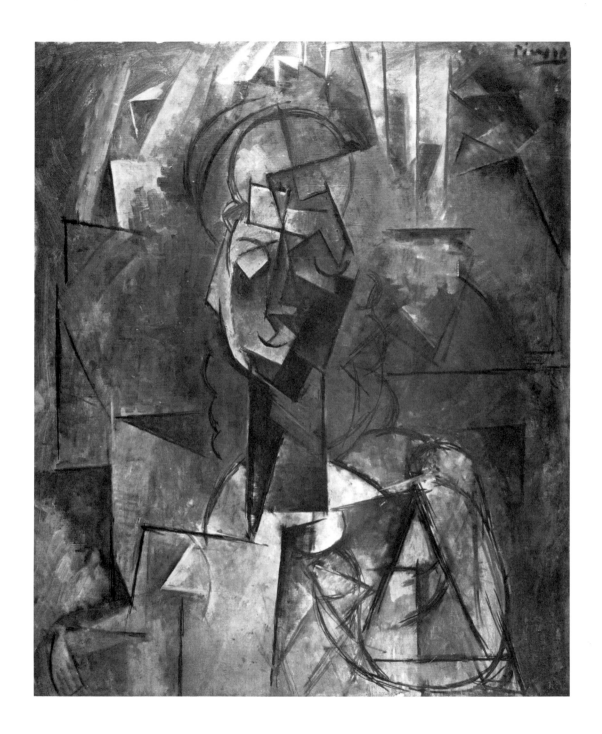

122 Seated Female Nude

Painted in Paris, spring 1910
Oil on canvas, $36\frac{1}{4} \times 28\frac{3}{4}$ (92 × 73)
Signed and dated (after 1921 but before 1932) bottom left: 'Picasso 9'

Lit: Z.II* 201; D.343; Tate 1981, p.595; Museum inv.no.5904

Prov: the artist to Galerie Kahnweiler, Paris (photo no.54), 1910; to Frank Haviland, Céret, 1910-13; to Galerie Kahnweiler, Paris, 1913; Wilhelm Uhde, Paris, 1913-14; sequestered Uhde collection, 1914-21; Uhde sale, Hôtel Drouot, Paris, 30 May 1921, lot 43 (1800 frs.); to Christian Tetzen Lund, Copenhagen, 1921-5; Tetzen Lund sale, Frie Udstilling, Copenhagen, 18-19 May, 1925, lot 101; bought for 900 kr. by Vil Hansen, 1921-?; Alphonse Kann, St Germain-en-Laye; Galerie Pierre (Pierre Loeb), Paris, 1932-49; to the gallery in 1949
Tate Gallery, London

In this work, Picasso brought to a magnificent resolution many of the problems broached in the earlier 'Head and Shoulders of a Woman' (no.121). Both the figure and the setting are composed of small planar configurations evenly distributed throughout the painting. Picasso does not distinguish between those planes which make up the figure and those of the inanimate objects which surround it: each has been subjected to the same rigorous analysis. But through subtle distinctions of colour and an extremely sophisticated, almost Rembrandtesque handling of light, Picasso has made the figure palpable within a well-defined interior space. This still sculptural realisation of form and volume sets Picasso's work apart from Braque's, for Braque by now was more concerned with painting the space between objects than the objects or figures themselves. Consequently, Braque had practically banished all vestiges of traditional perspective from his painting. Picasso, on the other hand, continued in paintings such as the present 'Seated Female Nude' to suggest certain spatial relationships through recession and other traditional devices, even if, as here, he conflated different views of an object into one image.

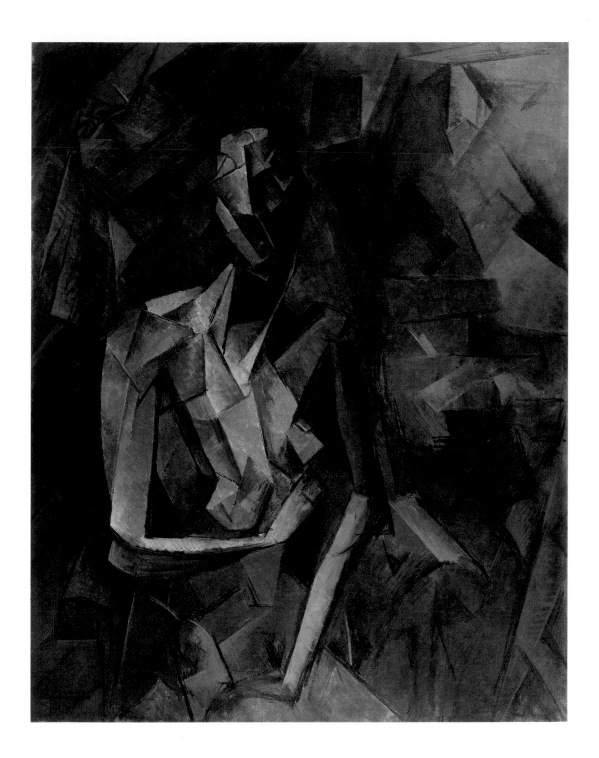

123 Standing Female Nude

Painted in Paris, spring 1910
Oil on canvas, $38\frac{1}{2} \times 30(97.7 \times 76.2)$
Neither signed nor dated

Lit: Z.II* 194; D.349; Museum inv.no. 54.11

Prov: the artist to Ambroise Vollard, Paris, *c.* 1910 until 1915; to Caroll Galleries, New York, 1915; sold for $2500 to John Quinn, New York, 1915-24; Quinn estate, 1925-7; to Earl Horter, Philadelphia, 1927-?; to Picrre Matisse Gallery, New York, *c.* 1937 until 1954; to the museum in 1954
Albright-Knox Art Gallery, Buffalo, New York. General Purchase Funds 1954

Although the figures and objects in Picasso's Cubism before 1914 are, for the most part, highly static, this work suggests a certain amount of motion. The formal vocabulary is much the same as that of the preceding 'Seated Female Nude', but the twist of the figure and the blurred planes seem to imply movement. No doubt it was the group of pictures to which the present painting belongs that served as the inspiration for Marcel Duchamp's famous 'Nude Descending a Staircase' (1912). Picasso, however, did not really concern himself with the representation of movement, though not long afterwards this became an issue of great interest among artists in Paris, Milan and elsewhere.

The pose of this figure bears a strong resemblance to that of the woman in Matisse's series of plaster reliefs, 'The Back', begun in spring 1909 and later reworked. Picasso could have easily seen the first version, 'Back 0', either in the spring of 1909 at Matisse's art school in the Boulevard des Invalides, or in the following autumn at this artist's new studio at Issy, where Matisse remade it into the version now known as 'Back 1'.

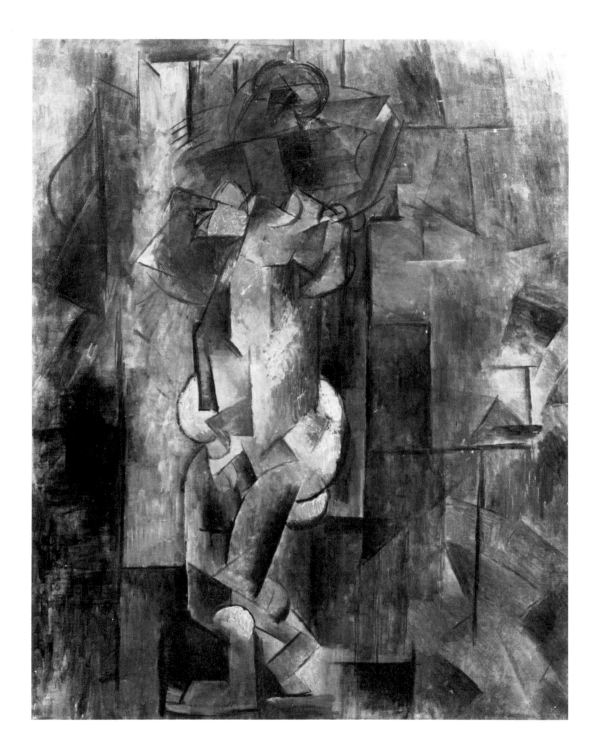

124 Portrait of a Woman

Painted in Paris, autumn 1910
Oil on canvas, $39\frac{3}{8} \times 31\frac{7}{8}$ (100 × 81)
Signed on back: 'Picasso'; not dated

Lit: Z.II* 234; D.367; Museum inv.no. 1977.15

Prov: early whereabouts unknown, apparently did not pass through Galerie Kahnweiler; Earl Horter, Philadelphia, by the late 1920s; to Mrs Charles Goodspeed, Chicago (later Mrs Gilbert W. Chapman, New York), by the early 1930s until 1977; to the museum in 1977
Boston Museum of Fine Arts. Charles H. Bayley Fund and partial gift of Mrs Gilbert W. Chapman

Picasso spent the summer of 1910 in the Spanish coastal town of Cadaqués. Unlike most of his summer work periods, this one was marked by false starts, unfinished canvases, and (according to his lover Fernande Olivier) boredom and listlessness on the part of Picasso. At Cadaqués, Picasso produced some of the most abstract paintings he ever made. But upon his return to Paris, he completed a group of still-lifes and a series of three-quarter length portraits, of which this is one, that are brilliantly and confidently realised. They are hardly less abstract than the Cadaqués pictures – only a few details, such as the hair at top left, the long face, and the sharp collarbone at centre, identify this portrait of a woman – but they succeed through a striking interplay between the architecture of the planes that compose the figure and the small, stubby brushstrokes that delineate the studio setting. Here, for example, Picasso denotes the stacks of paintings turned against the wall with a series of 90-degree angles rising up in the background. This is nonetheless a moment of austerity in Picasso's Cubism. He has replaced local colour with an unrelieved *grisaille* of grey and brown in order the better to concentrate on the structure of the composition.

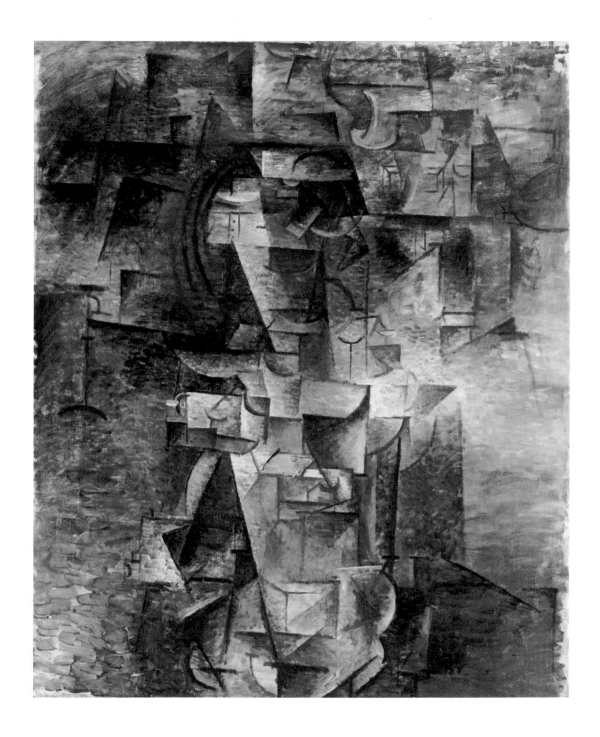

125 Bottle of Rum

Painted in Céret, summer 1911
Oil on canvas, 24 × 19¾ (61 × 50)
Signed on back: 'Picasso'; not dated

Lit: Z.II* 267; D.414

Prov: the artist to Galerie Kahnweiler, Paris (photo no. 101, stock no. 794), 1911-14; sequestered Kahnweiler stock 1914-21; 2nd Kahnweiler sale, Hôtel Drouot, Paris, 17-18 November 1921, lot 189, sold for 370 frs. to Amédée Ozenfant, Paris; to Charles Jeanneret (Le Corbusier), Paris, from *c.*1921 until 1963; Fondation Le Corbusier, Paris, 1963-9; sale, Palais Galliera, Paris, 9 December 1969, lot A, sold for 1,130,000 frs. to Stephen Hahn and E.V. Thaw & Co., New York, 1970; to the present owners in 1971
Mr and Mrs Jacques Gelman, Mexico

Picasso spent little more than six weeks in Céret during July and August 1911, but the time spent there was highly profitable. He continued to alternate between still-lifes and figure studies, as he had throughout the year, but during his stay in Céret he introduced into his painting a new element: letters and portions of words. Braque was the first to include painted letters in his picture 'Match-box and Newspaper' of 1910, but Picasso did not follow suit until the following year. Here the letters 'LE T R' evoke the bullfighting journal *Le Torero*. But as one can readily see, Picasso has not fixed them to a particular object on the table-top; instead they float rather independently, suggesting as opposed to describing, the object they signify. At top left, one finds sheets of music and perhaps a pipe just beneath them; standing upright at centre is a bottle of rum; a bit lower to the left is a wine-glass, and to its right is a pipe – all arranged on a round table.

Braque's response to Picasso's inclusion of a reference to the bullfighting season in Céret may be found in 'Still-life with a Pair of Banderillas' (no.18).

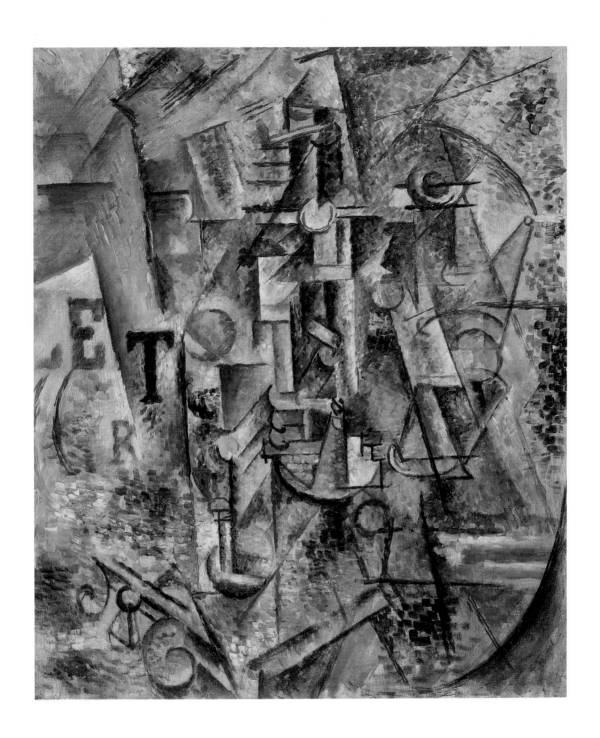

126 **Still-life with Clarinet on a Table**

Painted in Céret, summer 1911
Oil on canvas, 24 × 19$\frac{11}{16}$(61 × 50)
Signed on back: 'Picasso / Céret'

Lit: Z.II* 265; D.415; Museum inv.no.0.8026

Prov: the artist to Galerie Kahnweiler, Paris (photo no. 99), 1911; Vincenc Kramář, Prague, 1911-60; bequeathed to the gallery in 1960
Národní Galerie, Prague

Painted simultaneously with 'Bottle of Rum', this composition shares many of the same objects: a rum bottle at top centre, a clarinet lying diagonally across the upper centre, a fan at mid-right, sheet-music at lower right, and a pipe at the bottom centre. Picasso has arranged these forms in a densely packed, centrifugal composition.

This painting was bought by the Czech art historian Vicenc Kramář soon after it was made. (See the essay on early purchasers of Cubist art, p.26.) In an introduction to a Picasso exhibition in Prague in 1922, Kramář, one of the most important pre-war collectors of Cubism, wrote an explanation of Picasso's art that is relevant to the present painting:

Objects as presented by Picasso are not to be found in nature – if only because they are not products of merely visual perception but of a great variety of experiences, in fact the whole human experience. These pictures, moreover, combine several aspects of an object in one entity and, most importantly, they destroy the spatial connection between objects by reducing them to their elements and recombining them into new entities, which reflect the lyrical mood of the artist's inner self, stirred by the beauty of shapes in the world . . .

The reality of this art is therefore not the accidental and transient reality of naturalism and its derivatives, but a compact, enduring reality stemming from the laws governing our mental functions. (Quoted from McCully 1981, p.151; translated by Ewald Osers.)

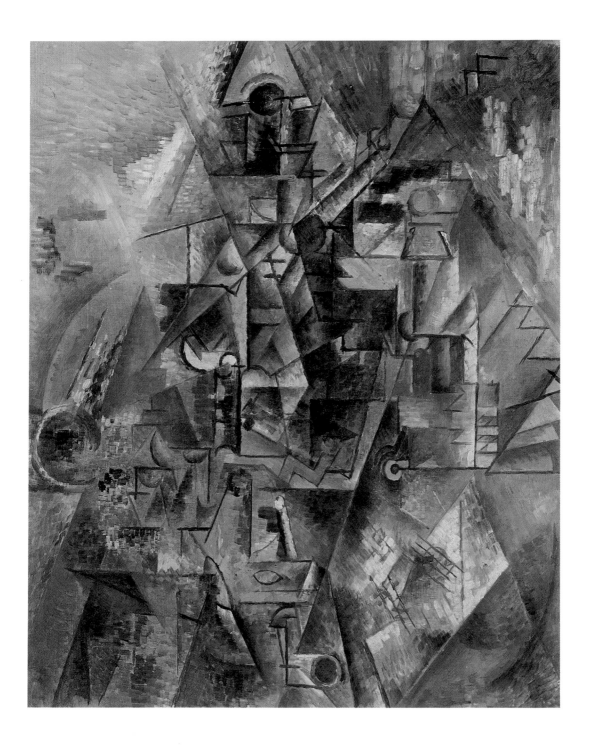

PABLO PICASSO

127 **Man with a Pipe**

Painted in Céret, summer 1911
Oil on canvas, $35\frac{3}{4} \times 27\frac{7}{8}$ (90×71)
Signed top right: 'Picasso'; not dated

Lit: Z.II* 738; D.422; Museum inv.no. AP 66.8

Prov: early whereabouts unknown; Rolf de Maré, Paris and Stockholm (by the mid-1920s? Knoedler archives refer to de Maré although the painting does not figure in the catalogue of that collection); Carlo Frua de Angeli, Paris and Milan, *c.*1950 until 1960; Galerie Beyeler, *c.*1960; Galerie Krugier, Geneva, by 1966; to M. Knoedler, New York (stock no. A9000), 1966; to the museum in 1966
Kimbell Art Museum, Fort Worth, Texas

This splendid painting displays the pyramidal composition toward which Picasso had worked for the previous six months. The man's head – with moustache and pipe – crowns the summit, while his shoulders and torso have been respectively narrowed and widened in order to fit them to the triangular arrangement. Filling in the scene to the left of the figure is an object hanging on a wall; at his right a bottle and a newspaper (the letters 'AL' from *Le Journal*) rest on a café table. By now Picasso, encouraged most probably by Braque, has abandoned his volumetric approach to the depiction of form in favour of one in which planes are aligned in a shallow space parallel to the picture surface. The observer mentally reconstructs the depicted objects or figures through small visual clues – such as the moustache here – but in no way could he fashion a three-dimensional model by relying solely on the visible evidence provided by the artist. This signifies that Picasso's Cubism has ceased to be sculptural in conception and has entered a purely painterly mode.

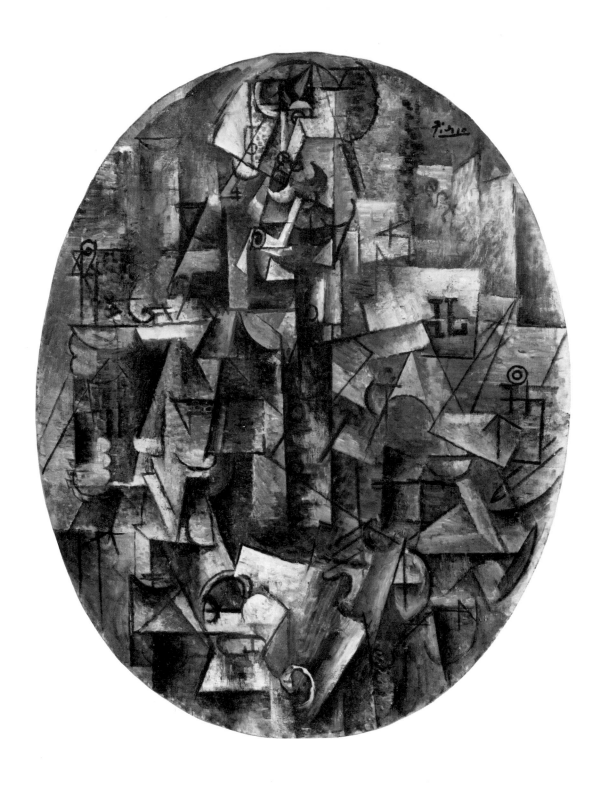

128 View of Céret

Painted in Céret, summer 1911
Oil on canvas, $25\frac{5}{8} \times 19\frac{3}{4}$ (65.1 × 50.3)
Signed bottom left: 'Picasso'; not dated

Lit: Z.II* 281; D.419; Guggenheim 1976, p.602; Museum inv.no. 37.538

Prov: early whereabouts unknown; Pierre Loeb or Pierre Colle, Paris, *c.* 1930; Valentine Dudensing, New York, before 1936; Solomon R. Guggenheim, New York, 1936; given to the museum in 1937
Solomon R. Guggenheim Museum, New York. Gift of Solomon R. Guggenheim

Comparison with 'Reservoir at Horta de Ebro' (no.117) reveals the change Picasso's art has undergone in a period of two years. Picasso has here divided the architecture into much smaller planar units, and they in turn are expressed by a mosaic of small, independent brushstrokes. Indeed, without benefit of the title it would be difficult to decipher the depicted objects – but they are still there no matter how abstract Picasso's notation appears. The artist told his friend Christian Zervos in 1935 that:

There is no abstract art. You must always start with something. Afterward you can remove all traces of reality. There's no danger then, anyway, because the idea of the object will have left an indelible mark. It is what started the artist off, excited his ideas, and stirred up his emotions. Ideas and emotions will in the end be prisoners in his work. Whatever they do they can't escape from the picture. They form an integral part of it, even when their presence is no longer discernible.

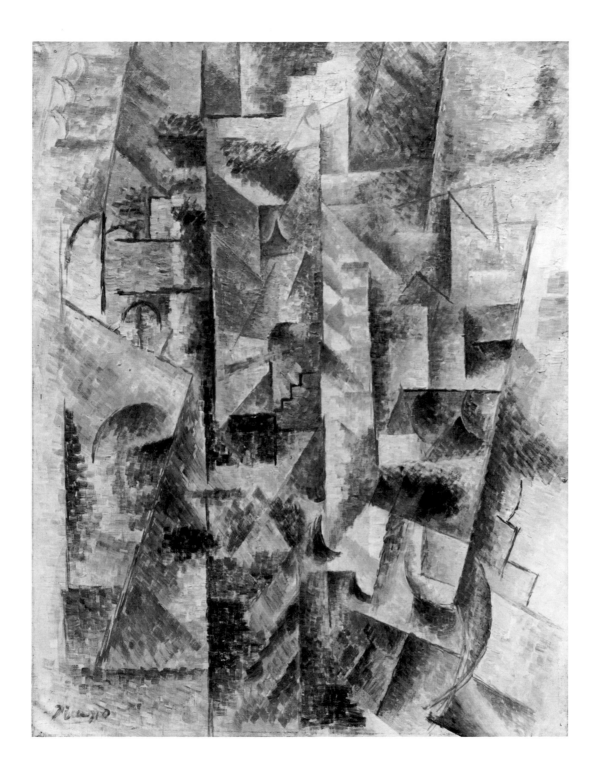

PABLO PICASSO

129 Man with a Mandolin

Painted in Paris, autumn 1911
Oil on canvas, $38\frac{3}{16} \times 27\frac{9}{16} (97 \times 70)$
Signed on back: 'Picasso'; not dated

Lit: Z.II* 270; D.425

Prov: the artist to Galerie Kahnweiler, Paris (photo no. 82), 1911; Alfred Flechtheim, Düsseldorf, 1912-1915; sold for 3000 marks to Rolf de Maré, Stockholm and Paris, 1915-*c.*1950; to Fernand C. Graindorge, Liège, *c.*1950 until 1975; to the present owner in 1975
Galerie Beyeler, Basel

Braque joined Picasso at Céret for only three weeks in August 1911. But while he was there he painted one of his Cubist masterpieces, a man with a guitar now known by the name 'The Portuguese' (Kunstmuseum, Basel). Picasso may have painted the present picture, as Pierre Daix has suggested, in response to 'The Portuguese'. For not only did Picasso choose a canvas similar, although not identical, in size, but in this work he followed Braque's habit of depicting a great deal of incidental detail around the figure while leaving the figure itself only schematically indicated. Here Picasso has taken a particular delight in carefully painting decorative details – the chair moulding at centre right, the drapery tassel at centre left and the fringed edge of a wrought-iron table the artist kept in his studio – which help establish different levels of depth in the composition.

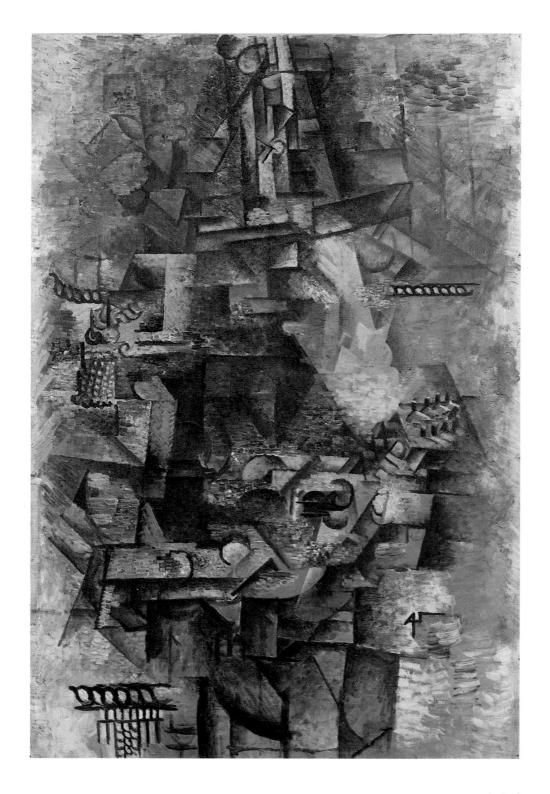

130 Man with a Mandolin

Painted in Paris, autumn 1911
Oil on canvas, 62¼ × 28 (158 × 71)
Neither signed nor dated

Lit: Z.II* 290; D.428; Museum inv. no. MP 35

Prov: the artist, 1911-73; estate of the artist, 1973-9; given in lieu of taxes to France (Dation Picasso), 1979
Musée Picasso, Paris

One of the largest of Picasso's Cubist figure pieces, and one of two which show the figure full-length (the other canvas [D.427], also in the collection of the Musée Picasso, was however reworked in 1912 and 1913). Picasso has depicted the figure seated in an upholstered armchair, while a table with a few objects scattered on top – a pipe and fruit-bowl with perhaps some grapes – stands to his left. In 'Man with a Mandolin', as indeed with nearly all his compositions in a long, tall format, Picasso has left the lower third of the canvas only schematically outlined. But he has made of the upper two-thirds a skyscraper of pictorial architecture. Horizontal lines and plumb-line verticals are set off by 45-degree diagonals, circles and ellipses that would seem only incidentally to add up to a seated figure. Particularly noteworthy is the lighting, which Picasso has fixed so that it appears to emanate from the interstices of the forms. William Rubin has likened this 'interior' lighting to that of Rembrandt's late painting; although Picasso's result is less dramatic, it is certainly no less striking.

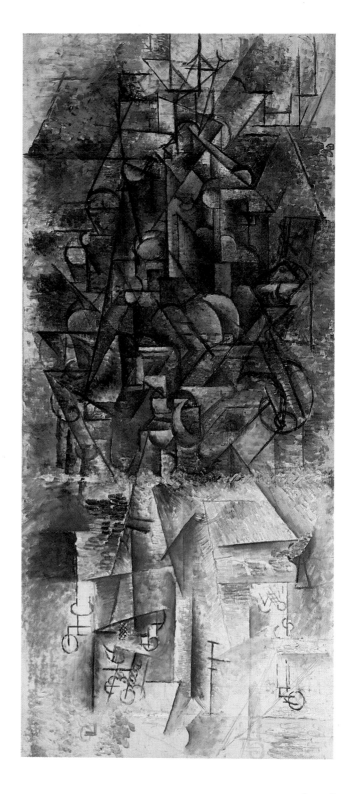

131 Still-life on a Piano

Begun in Céret, summer 1911 and completed in Paris, spring 1912
Oil on canvas, $19\frac{3}{4} \times 51\frac{3}{16}$ (50 × 130)
Signed bottom left: 'Picasso'; not dated

Lit: Z.II** 728; D.462

Prov: the artist to Carlo Frua de Angeli, Milan and Paris, *c.* 1936; to Christian and Yvonne Zervos, Paris; to Jane Wade, New York, 1965; to the present owner in 1965
Private collection, Switzerland

Picasso began this painting in Céret, summer 1911, along with another of almost identical dimensions, 'Pipes, Cup, Coffee-pot and Carafe' (D.417). However the present work was probably not completed until the following spring. Arranged upon the top of an upright piano (the candle-holder is visible at left) are, from left to right, a glass with an absinthe spoon and sugar cube, a bottle, a partially folded fan, a metronome (just above the fan to the right), a pipe (the holes pierced at the bottom of the bowl to allow inhalation are shown on the *outside*), a violin, and a clarinet (of which the reed is visible directly above the f-holes of the violin and the mouth in the foreground beside the piano keys). Picasso has represented the piano keys in two passages at the bottom right; the stencilled letters 'CORT' refer to the pianist Cortot, 'CER[ET]' and more faintly 'GRAN [DES] FETES' to festivities in the village where the painting was begun. Though Picasso has fractured and divided his notations for the various objects, they are nonetheless much more legible than in pictures painted nine months earlier. After returning to Paris Picasso made the Cubist notation in this painting more direct and complete than it had been in Céret.

The reproduction of this work is shown vertically for reasons of scale – the letters 'CORT' appear in the top left hand corner on the original

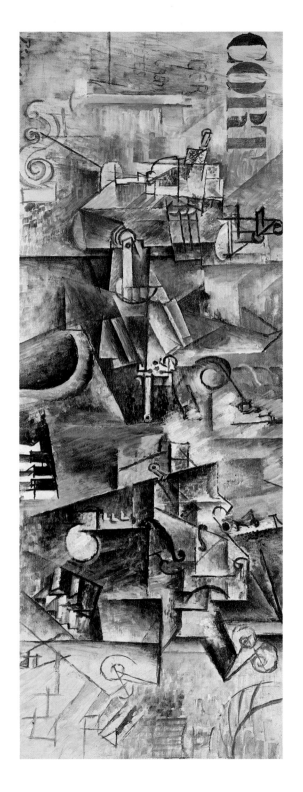

132 **Man with a Violin**

Painted in Paris, spring 1912
Oil on canvas, $39\frac{3}{8} \times 28\frac{3}{4}$ (100 × 73)
Signed on back: 'Picasso'; dated on back (perhaps in another hand): '1910'.

Lit: Z.II* 289; D.470; Museum inv.no.50.134.168

Prov: the artist to Galerie Kahnweiler, Paris (photo no.243, stock no.1213), 1912-14; sequestered Kahnweiler stock, 1914-21; 1st Kahnweiler sale, Hôtel Drouot, Paris, 13-14 June 1921, lot 80, sold for 1650 frs. to M. Jean Crotti, Paris, 1921-*c.*1932; bought in 1932 by Marcel Duchamp (Crotti's brother-in-law) as agent for Louise and Walter C. Arensberg, New York and later Hollywood, 1932-50; given to the museum in 1950, but not installed until 1954
Philadelphia Museum of Art. Louise and Walter Arensberg Collection

Although Picasso no longer employed the stubby brushstrokes he had used in the summer of 1911, the head of this figure is taken almost directly from the wash drawing 'Man with a Pipe' (no.165), which he had made then in Céret. If one compares the drawing to the present painting, one immediately sees the direction Picasso's art has taken: the planes are emphatically expressed; the forms are complete and for the most part uninterrupted; and the figure amounts to an integral entity which is detached from the background.

The fine quality of this painting is enhanced by a subtle play of warm and cool tones, which is once again visible thanks to recent cleaning.

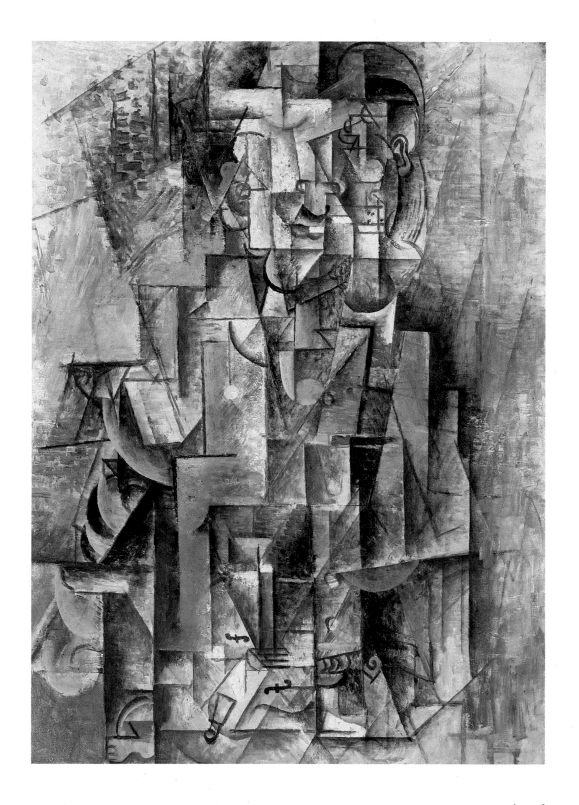

133 Still-life with Glass, Scallop Shells, Pipe, Newspaper and Pamphlet ('Notre Avenir est dans l'air')

Painted in Paris, spring 1912
Oil on canvas, $15 \times 21\frac{7}{8}$ (38×55.5)
Signed on back: 'Picasso'; not dated

Lit: Z.II* 311; D.464

Prov: the artist to Galerie Kahnweiler, Paris (photo no.181, stock no.795), before 1914; sequestered Kahnweiler stock, 1914-21; 1st Kahnweiler sale, Hôtel Drouot, Paris, 13-14 June 1921, lot 77, sold for 1500 frs. to M. Vogelveith (11 Boulevard Clichy), Paris; Joseph Mueller, Solothurn, before 1932; E. and A. Silberman Galleries, New York, before 1962; Sotheby's, London, 7 November 1962, lot 74, sold for £18,000 to Mr and Mrs Leigh Block, Chicago, 1962-80; to E.V. Thaw & Co., New York, 1981; to the present owners in 1981
Private collection

Picasso seems to have bought sometime in winter or early spring 1912 a set of eight oval canvases of graduated sizes on which he painted a group of pictures that form a decisive turning-point in the development of the artist's Cubism. 'The Architect's Table' (D.456, Museum of Modern Art New York), 'Violin, Glass, Pipe and Anchor' (D.457, Národní Galerie, Prague), 'Souvenir of Le Havre' (D.458, Swiss private collection), and five still-lifes (D.461, 463, 464-6) that feature either scallop shells and/or the propaganda pamphlet *Notre Avenir est dans l'air*, chart Picasso's movement away from the high 'analytic' style he had developed until then with Braque towards a new 'synthetic' style that occupied both artists until the outbreak of war in 1914.

The change was immediately apparent. Gino Severini remembered seeing 'Souvenir of Le Havre' soon after it was made. 'I was in his studio in the rue Ravignan [Picasso was living in the Boulevard de Clichy but rented a studio in his former house] when he showed the picture to Braque. The latter was taken aback and said in a rather sarcastic tone: "So we're changing our tune," to which Picasso did not reply.' (Quoted in McCully 1981, p.73; translated by P.S. Falla.)

Picasso had already introduced some colour in his work, as in the thinly applied patch of green in 'Still-life on a Piano', but Braque had not yet followed suit. Until the present work, however, neither had attempted to include strong, undivided colours, such as the red and blue of the pamphlet, since late 1909. Braque responded with the roseate area in 'Violin and Poster' (no.22), and the patch of red in 'Bottle of Rum' (no.21), but it was summer 1912 before he began to use local colour in a constructive fashion, preferring until that moment to work with a palette limited to a few neutral colours.

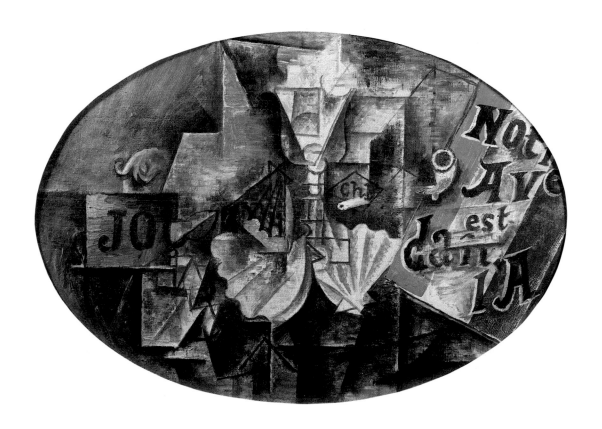

134 Still-life with Chair-caning

Executed in Paris, May 1912
Oil and printed oil-cloth on canvas, $11\frac{7}{16} \times 14\frac{9}{16}(29 \times 37)$
Neither signed nor dated

Lit: Z.II*; D.466; Museum inv.no.MP 36

Prov: the artist, 1912-73; estate of the artist, 1973-9; given in lieu of taxes to France (Dation Picasso), 1979
Musée Picasso, Paris

The important innovative feature of this work is the printed oil-cloth that Picasso glued across the bottom half of the canvas. As such, it represents the first deliberate collage in a painting of the twentieth century and precedes by fully three months Braque's invention of *papier collé*. Picasso's use of collage follows quite naturally, however, from the *trompe-l'œil* devices, such as a projecting nail or passages of *faux-bois*, that we find in Braque's paintings from the winter 1909-10 onward. These devices functioned as spatial indicators, private jokes, clues to the identity of material used in objects, and also as reminders that the realism of all art is ultimately dependent on artifice and illusion.

Here, Picasso has used an actual piece of over-printed oil-cloth rather than paint an imitation of chair-caning or devise a Cubist notation for it. This type of oil-cloth was commonly used as a table-covering in the kitchens of modest homes, and the objects Picasso has selected are equally unassuming: a newspaper, glass, pipe, sliced lemon and scallop shell. Picasso framed the work with a rope in the way that sailors would treat mirrors in their spare time. As Picasso had just returned from Le Havre when he made this work, the frame could well have been inspired by something he saw in this port. Other writers have interpreted this painting more literally, seeing the oil-cloth as representing the caned seat of a chair on which the still-life is placed. Either way, Picasso clearly exploited the ambiguity of the cloth printed in imitation of a real element.

Although Picasso did not experiment further with collage until after Braque had initiated his series of *papiers collés*, the writer Apollinaire was quick to seize the implications of Picasso's innovation. He wrote in his treatise *The Cubist Painters* that Picasso

did not scorn to make use of actual objects, a twopenny song, a real postage stamp, a piece of oil-cloth imprinted with chair-caning. The painter would not try to add a single picturesque element to the truth of these objects. . . . It is impossible to envisage all the consequences and possibilities of an art so profound and so meticulous.

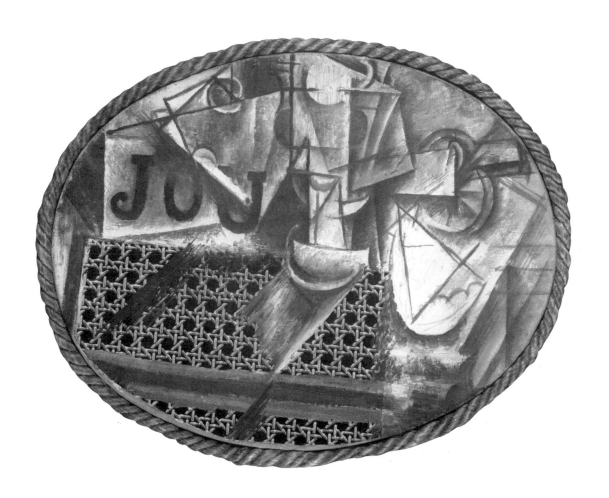

135 **Guitar, Sheet-music and Glass**

Executed in Paris, autumn-winter 1912
Pasted paper, gouache and charcoal, $18\frac{7}{8} \times 14\frac{3}{8} (47.9 \times 36.5)$
Signed on back: 'Picasso'; not dated

Lit: Z.II** 423; D.513; Museum inv.no.1950.112

Prov: the artist to Galerie Kahnweiler, Paris (photo no.282), 1912-14; probably sequestered
Kahnweiler stock, 1914-21; probably sold in an unidentified lot in one of the Kahnweiler sales,
1921-3; subsequent whereabouts unknown until 1943; Bignou Gallery, New York, by 1943; to
Dalzell Hatfield Galleries, Los Angeles, 1946; to Marion Koogler McNay, San Antonio, 1946-50;
given to the museum in 1950
McNay Art Institute, San Antonio, Texas

While the circumstances surrounding Braque's creation of the first *papier collé* are known in detail (see the notice for *Fruit-dish and Glass*, no.25), the exact chronology of Picasso's adoption of the technique remains obscure. What is known is that Picasso responded to it immediately and quickly appropriated *papier collé* to pursue artistic ends of his own.

This work may be among the first *papiers collés* Picasso made. On a simple ground of lozenge-patterned wallpaper, the artist placed just seven separate pieces of paper to establish his still-life composition: three of these represent a guitar (the wood-grained paper was made by hand by Picasso and not the store-bought variety used by Braque); one represents the guitar's sound hole; a fragment of printed sheet-music represents itself (analogous in this respect to the oil-cloth in no.134); a sixth piece is filled with a drawing of a glass in Picasso's contemporaneous Cubist style; while the seventh is a fragment of a newspaper title featuring a headline probably intended to provoke his friendly rival Braque: *'La Bataille s'est engagé[e]'*.

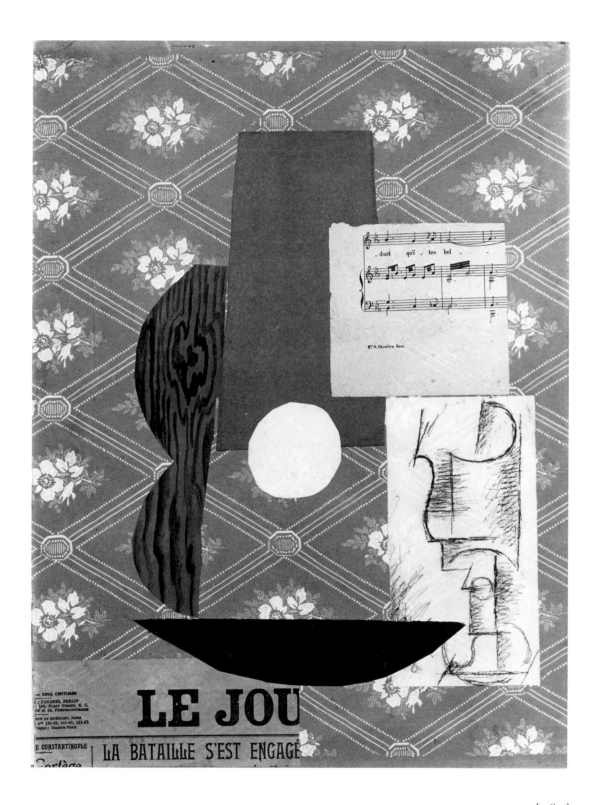

136 Bottle, Guitar, Glass and Pipe

Painted in Paris, autumn 1912
Oil on canvas, $23\frac{3}{4} \times 28\frac{3}{4}$ (60 × 73)
Neither signed nor dated

Lit: Z.II** 377; D.510

Prov: early whereabouts unknown; bought in Sweden for 1800 frs by Rolf de Maré, Paris and
Stockholm, 1918 until *c.* 1950; Philippe Dotremont, Brussels; Galerie Rosengart, Lucerne; sold to
the museum in 1964
Museum Folkwang, Essen

An elaboration of the decorative idiom which appears in some paintings done at Sorgues, such as 'Guitar' (D.505, Oslo), enriched now by Picasso's experience with his first *papiers collés*. In contrast to the almost uniformly flat alignment of planes in 'Guitar', the forms in this work are stepped back (or forward, depending on the spectator's point of view) to establish a shallow space represented by superimposed planes. This spatial arrangement is operative in most of the *papiers collés* made by both Picasso and Braque.

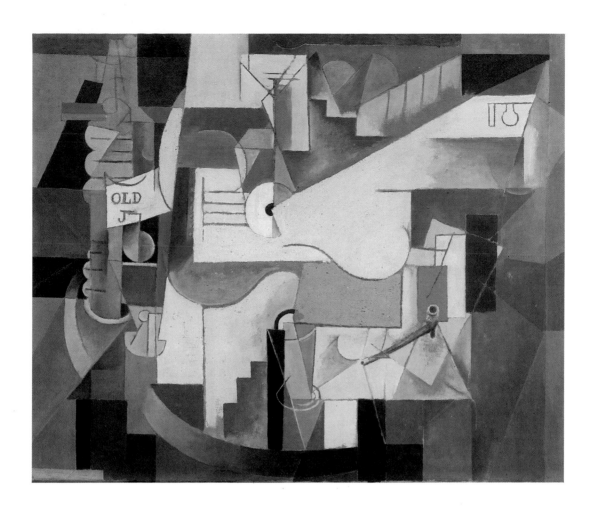

137 **Violin**

Executed in Paris, autumn 1912
Pasted papers on paper, $25\frac{5}{8} \times 19\frac{11}{16}(65 \times 50)$
Neither signed nor dated

Lit: Z.II** 774; D.517; Museum inv.no.MP 367

Prov: the artist, 1912-73; estate of the artist, 1973-9; given in lieu of taxes to France (Dation Picasso), 1979
Musée Picasso, Paris

Similar in spirit and execution to 'Guitar, Sheet-music and Glass' (no.135), this work also depends on a play of positive shapes and voids, such as that which characterised the paper sculptures on which Picasso and Braque were working at this same moment. See the notice for 'Guitar' (no.191).

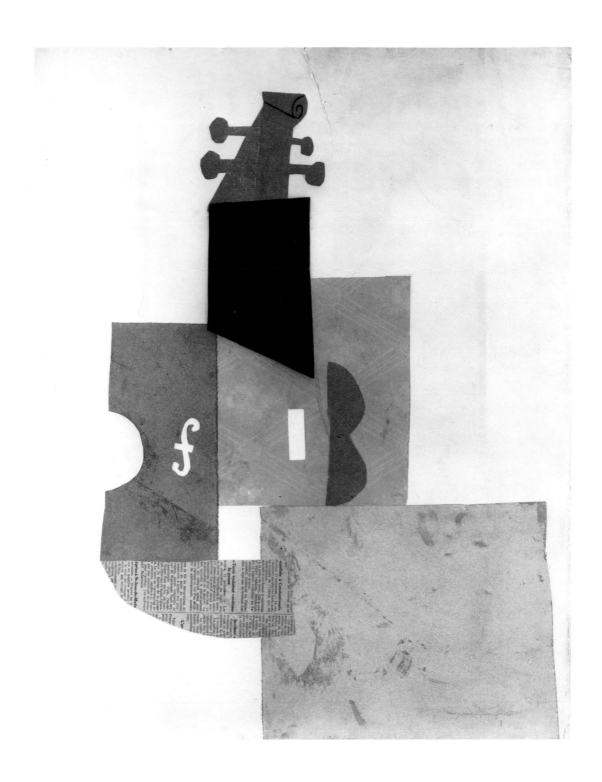

138 Siphon, Glass, Newspaper and Violin

Executed in Paris, autumn-winter 1912
Pasted papers and charcoal on paper, $18\frac{1}{2} \times 24\frac{7}{16}(47 \times 62)$
Signed on back: 'Picasso'; not dated

Lit: Z.II* 405; D.528; Museum inv.no.NM6083

Prov: the artist to Galerie Kahnweiler, Paris (photo no.292), 1913-14; sequestered Kahnweiler stock, 1914-23; sold as part of an unidentified lot in (probably) the 4th Kahnweiler sale, 1923; to Tristan Tzara, Paris, *c.* 1923 until 1963; bequeathed to Christophe Tzara, Paris, 1963; given to Claude Sarraut-Tzara, Paris, before 1967; sold to the museum in 1967
Moderna Museet, Stockholm

Although Picasso has here used fewer coloured and no patterned papers, the result is much freer and livelier than his slightly earlier *papiers collés.* The artist has already begun to engage in visual games, so that the newspaper, for example, is identified by its name, but cuttings of actual newsprint are used to represent the siphon, glass and scroll of the violin.

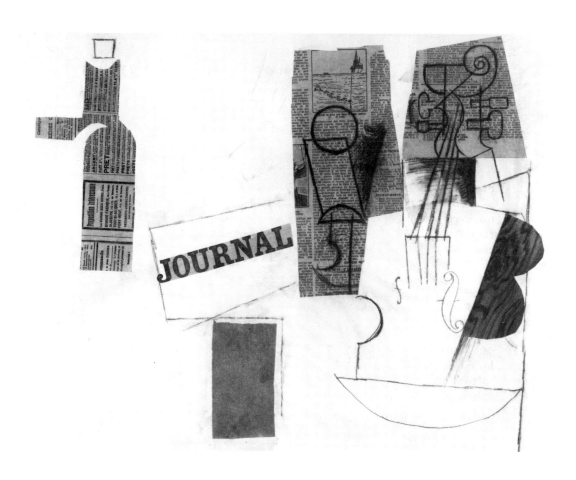

139 Bottle of Marc, Glasses and Newspaper

Executed in Paris, early 1913
Oil, sand and pasted papers on canvas, $18\frac{1}{8} \times 15 (46 \times 38)$
Signed, dated and inscribed on back: 'Sur une table ronde une bouteille de Marc de Bourgogne / un verre et un journal au fond / une glace / 1913 / Picasso'*

Lit: Z.II** 432; D.567

Prov: the artist to Galerie Kahnweiler, Paris (photo no.254, stock no.1228), 1913-14; sequestered Kahnweiler stock, 1914-21; 2nd Kahnweiler sale, Hôtel Drouot, Paris, 17-18 November 1921, lot 192, sold for 680 frs. by André Breton, 1921-?; Sarah Lewis, Portland, Oregon, by the late 1930s; Mr and Mrs B.E. Bensinger, Chicago; Paul Haim, Paris, 1972-3; to the present owner in 1973
Private collection, Geneva

*'On a round table a bottle of Marc de Bourgogne / a glass and a newspaper, in the background / an ice-cream / 1913 / Picasso'

Braque added sand to his paintings as early as 1911 as a means of providing heightened texture and relief. Picasso, however, did not pick up this device until autumn 1912, when he began to work extensively with *papier collé*. Thus the structure of this work is borrowed from the artist's contemporary charcoal drawings with added newsprint cuttings, but the sand and thickly impasted paint add a new level of depth and richness to the composition, something as yet unseen in a *papier collé*.

The unusually precise inscription (see above) on the back of this work bears witness to the care Picasso took in painting specific, if mundane, objects.

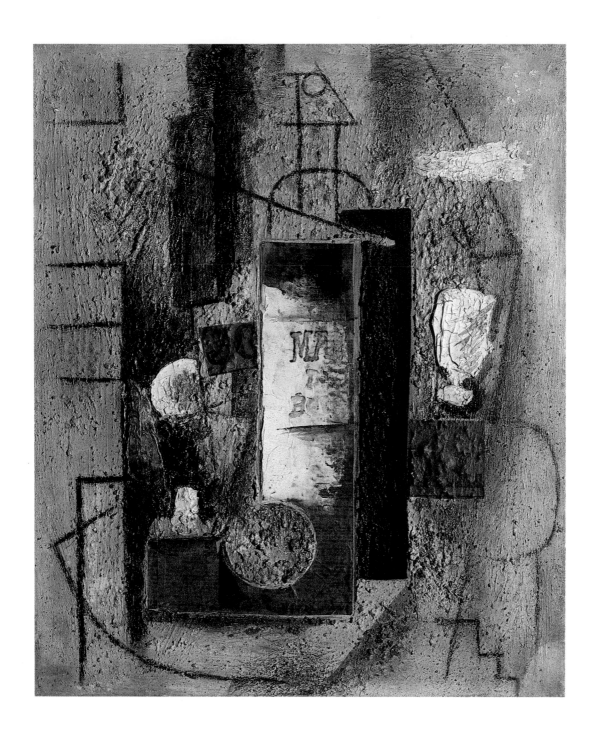

140 Guitar, Newspaper, Glass and Bottle

Executed in Céret, spring 1913
Pasted papers and ink on paper, $18\frac{3}{8} \times 24\frac{5}{8}$ (46.5 × 62.5)
Signed on back: 'Picasso'; not dated

Lit: Z.II* 335; D.604; Tate 1981, p.595; Museum inv.no.T414

Prov: the artist 1913-*c.*1941; to Pierre Gaut, Paris, *c.*1941-60; to Galerie Berggruen, Paris, 1960; to the gallery in 1961
Tate Gallery, London

The newspaper clippings employed by Picasso in his *papiers collés* provide useful *termini ante quem* for the dating of the works. It seems, for example, that at the start Picasso used more or less contemporary newspapers – as in nos.137-8 – and since those clippings can frequently be traced to November and December 1912, we know roughly the date of execution of the work. But the clipping that appears in the present work comes from *Le Figaro* of 28 May 1883, as Robert Rosenblum has established, when Picasso was only one and a half years old. Since Picasso used additional cuttings from this same newspaper in other *papiers collés* that he made in Céret in spring 1913, one may conclude that Picasso chose this paper because it carried some special significance for him, or perhaps simply because it had turned an appealing colour.

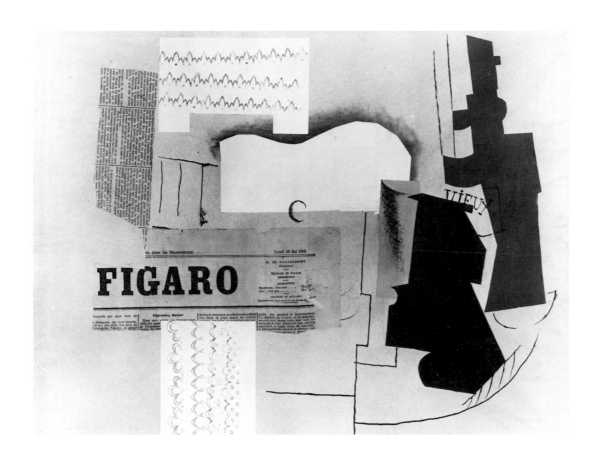

141 **Student with Newspaper**

Executed in Céret or Paris, summer 1913
Oil on sand on canvas, $28\frac{3}{4} \times 23\frac{7}{16}$(73 × 59.5)
Signed on back: 'Picasso'; not dated

Lit: Z.II** 443; D.621

Prov: the artist to Galerie Kahnweiler, Paris, 1913-14; sequestered Kahnweiler stock, 1914-21; 2nd Kahnweiler sale, Hôtel Drouot, Paris, 17-18 November, 1921, lot 204, bought for 1250 frs. by Amédée Ozenfant as agent for Raoul LaRoche; Dr h.c. Raoul LaRoche, Paris, 1921-62; given to the present owner in 1962
Private collection, Basel

There are two versions of this picture. The first version, composed with pasted paper, sand, charcoal and paint on canvas, is now in the collection of the Museum of Modern Art, New York; the present picture includes no elements of collage, though Picasso has painted some passages in imitation of *papier collé*. The artist has made the planes paper-thin and has painted cast shadows at their edges, suggesting that the planes are curling away from the surface of the picture. This sort of *trompe-l'oeil* assumed an increasingly large role in Picasso's art through the winter of 1913-14 and into the summer, as did the device of animating the surface with planes of colour applied in *pointillé* dots. Ironically, these new interests came at a moment when Picasso's ability to depict human anatomy with clever and economical signs – seen here in the eyebrows, eyes, nose and mouth – reached a new level of achievement. Kahnweiler attributed such schematic notations to Picasso's study of certain Wobé masks from the Ivory Coast.

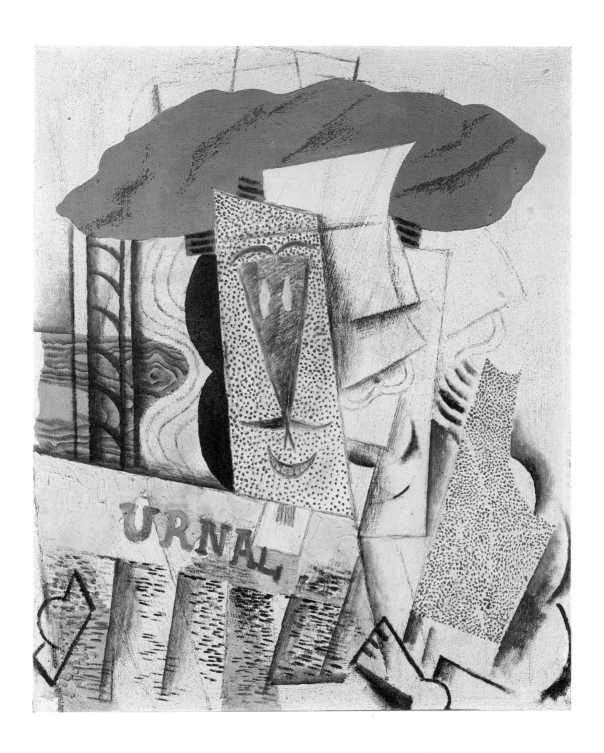

142 Bottle, Clarinet, Violin, Newspaper and Glass

Painted in Paris, autumn-winter 1913-14
Oil on canvas, $21\frac{11}{16} \times 18\frac{1}{8}$ (55 × 46)
Signed on back: 'Picasso'; subsequently signed on front, bottom right: 'Picasso'; not dated

Lit: Z.II** 496; D.623; Museum inv.no.G1981.39

Prov: the artist to Galerie Kahnweiler, Paris (photo no. 318; stock no. 1835), before 1914; to Wilhelm Uhde, Paris, before 1914; sequestered Uhde collection, 1914-21; Uhde sale, Hôtel Drouot, Paris, 30 May 1921, lot 51, sold for 2850 frs. to an unidentified buyer; private collection, Switzerland; to the museum in 1981
Kunstmuseum Bern

A rather complicated still-life, set on a round wooden table and viewed from above. As in the preceding 'Student with Newspaper', the planes are thin and cast shallow shadows, but the arrangement is looser and somewhat confused. The freedom and informality of the composition is analogous to the wooden reliefs Picasso was simultaneously constructing, such as 'Mandolin and Clarinet' (no. 192).

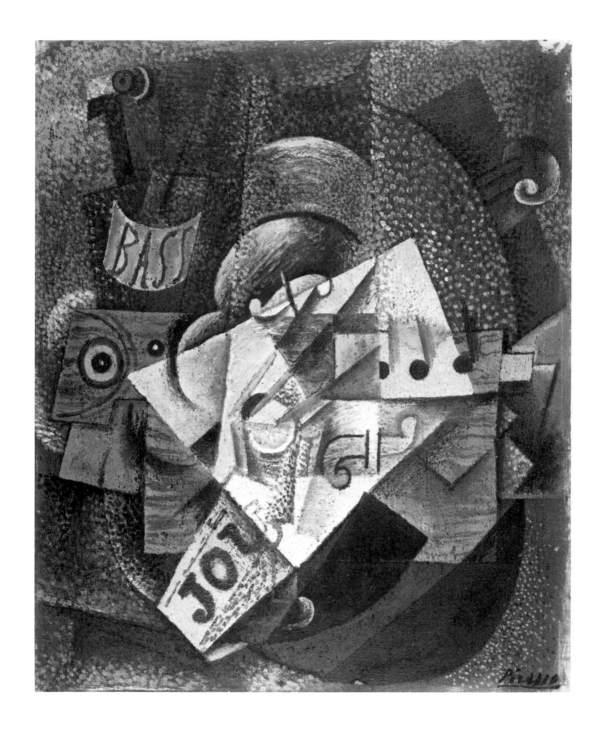

143 Head of a Man

Painted in Paris, late 1913 (?)
Oil on canvas, $25\frac{5}{8} \times 18 (65 \times 45)$
Neither signed nor dated

Lit: Z.II** 467; D.649; Collection inv.no. 1728

Prov: early whereabouts unknown, apparently did not pass through Galerie Kahnweiler; Galerie Jeanne Bucher, Paris, before 1955; Galerie Berggruen, Paris, *c.* 1955; to G. David Thompson, Pittsburgh, 1955-61; to Galerie Beyeler, Basel, 1961; to the Leumann collection, Turin, 1961-73; Finarte sale, Milan, 15 March 1973; Galleria Internationale, Mailand to the present owner in 1973
Thyssen-Bornemisza Collection, Lugano

A further elaboration of the schematic no-tations of 'Student with Newspaper' (no. 141) set within a composition of superimposed planes. Picasso's subject was apparently a man of some distinction, for in addition to long hair and a neatly trimmed moustache, he wears an elegant fur collar and the rosette of the Légion d'honneur.

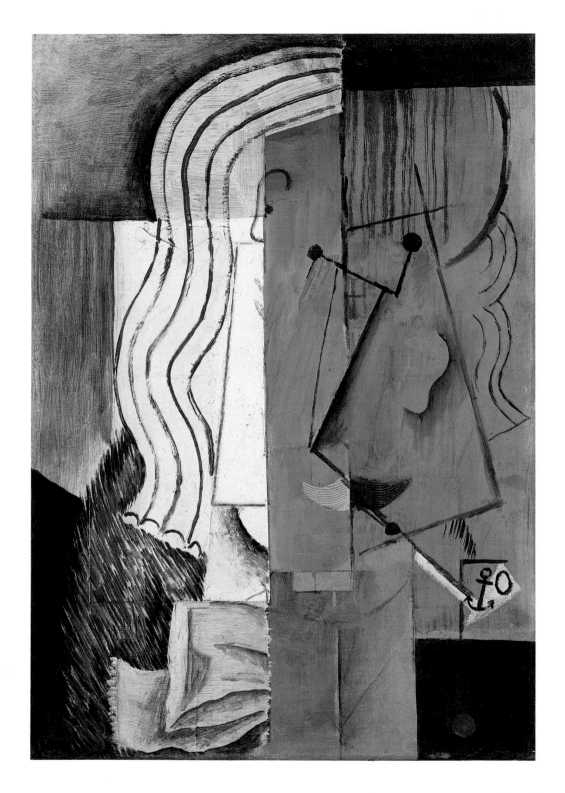

144 Glass, Pipe, Lemon, Ace of Clubs and Packet of Tobacco

Executed in Paris, spring 1914
Pasted papers, oil, charcoal and graphite on paper, $19\frac{3}{4} \times 25\frac{1}{2} (50 \times 65)$
Signed and dated top right: 'Picasso 1914'

Lit: Z.II** 482; D.674

Prov: the artist to Galerie Kahnweiler, Paris (photo no. 377), 1914; probably sequestered Kahnweiler stock, 1914-21; probably sold in an unidentified lot in one of the Kahnweiler sales, 1921-3; Alfred Flechtheim, Berlin, from *c.* 1923 until 1932; to Margaret Schulthess, Basel, 1932; to an anonymous Swiss collector, 1932-82; to the present owner in 1982
Galerie Gmurzynska, Cologne

Spring and summer 1914 were among the most fruitful work periods in Picasso's career. He had moved from Montmartre to a new apartment and studio in the rue Schoelcher, overlooking the Montparnasse cemetery, where he lived with his lover Eva Gouel. (Picasso had left Fernande Olivier definitively by spring 1912.) Picasso was now receiving regularly a rather high income as a result of the exclusive contract he had signed with Kahnweiler in December 1912. Picasso's renown was also greatly enhanced by the record price achieved by his 1906 painting 'The Family of Saltimbanques' (National Gallery, Washington, DC) at auction in Paris in March 1914. His resulting contentment found expression in a group of free and lyrically arranged compositions, mostly still-lifes, that have since, owing to Picasso's elaborate use of pattern and stippling, been referred to as 'Rococo Cubism'.

This work is virtually a dictionary of the motifs Picasso employed in his contemporary work: a glass, a playing-card, a pipe and a lemon appear repeatedly, as do the table, wallpaper, dado, and tobacco label, here glued on the extreme right. The planes with *pointillé* stippling that converge diagonally from upper left and upper right are most probably meant to be read as shafts of light.

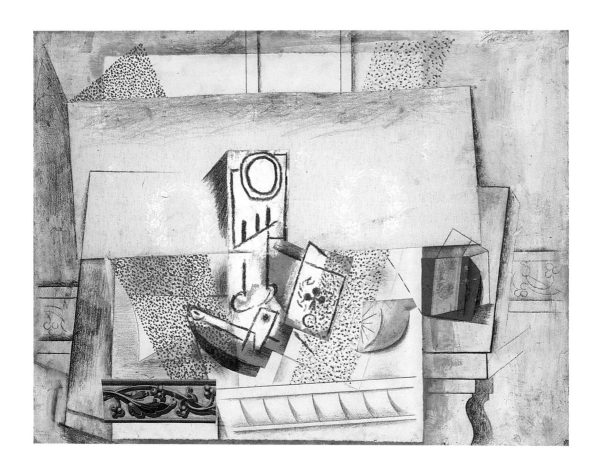

145 Fruit-dish with Grapes, Glass and Playing-card

Executed in Paris, spring 1914
Pasted papers, oil and charcoal on paper, 24 × 18¾(61 × 47.5)
Signed on back: 'Picasso'; not dated

Lit: Z.II** 504; D.681

Prov: Galerie Kahnweiler, Paris (photo no. 380; stock no. 2129), before August 1914; John Quinn, New York (? suggested by Pierre Daix, although it does not figure in any of the Quinn exhibitions or sales); Carlo Peroni, by 1942; Carlo Frua de Angeli, Milan, by *c.* 1950; to Christian Zervos, Paris, until 1970; to Galerie Berggruen, Paris, 1970-3; to Harold Diamond, New York, 1973-*c.*1980; to the present owner in 1980
Private collection

A monumental composition composed of three objects, of which only the glass has been analysed in Cubist terms. The fruit-dish and playing-card are presented whole, and they even cast shadows, consonant with Picasso's contemporary practice of including illusionist elements in his pictures, particularly in his works on paper.

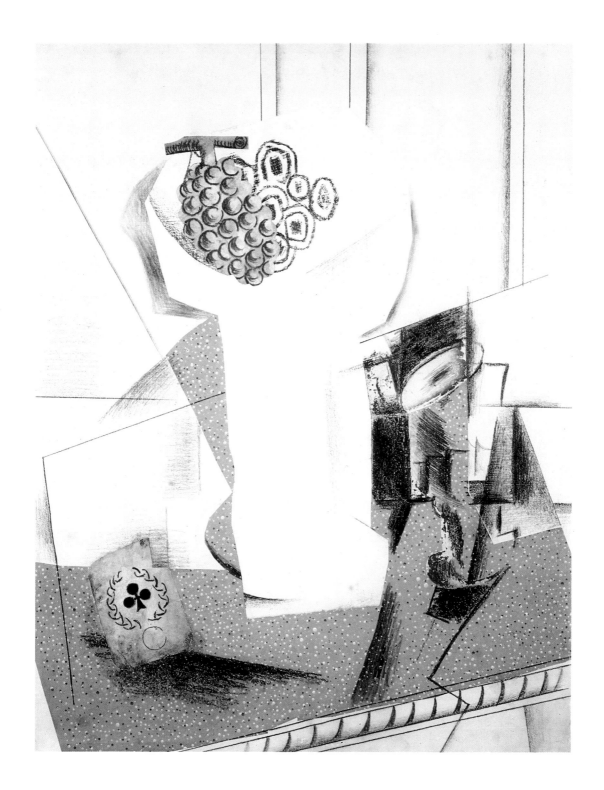

146 Still-life with Fruit-dish on a Table

Painted Paris, winter 1914-15
Oil on canvas, $25\frac{1}{4} \times 31\frac{1}{2}$ (64 × 80)
Signed and dated bottom right: 'Picasso / 15'

Lit: Z.II** 537; D.805; Museum inv.no. 31.87

Prov: the artist to Galerie de l'Effort Moderne (Léonce Rosenberg), Paris (photo no. 111), *c.* 1917 until 1920; sold for 25,000 frs. to H. P. Roché as agent for John Quinn, New York, 1920-4; Quinn estate, 1924-6; to Paul Rosenberg & Co., New York, 1926; to Ferdinand Howald, Columbus, Ohio, 1926-31; given to the museum in 1931
Columbus Museum of Art, Ohio. Gift of Ferdinand Howald

The outbreak of war in August 1914 naturally led to a change in Picasso's life and consequently in his art. As a Spaniard, he was not conscripted into the French army, though his friends Derain, Braque and Apollinaire were. When Picasso returned from Avignon to Paris in autumn 1914, he brought with him a number of unfinished canvases – always a bad sign with Picasso – and his overall production, after a tremendous outpouring during the preceding spring and summer, declined markedly. Eva had contracted tuberculosis, and her failing health did not help matters.

Picasso did, however, muster his energies for this summation of the series of still-lifes he had begun one year earlier. Naturalistic passages and illusionism are combined within the shallow space created by superimposed planes that is characteristic of 'synthetic' Cubism. Stippled planes of light pass freely among the forms, now much less fragmented than they had been for several years. In many ways this picture, with its 'impurely' Cubist passages of naturalism, is closer to Cézanne's late still-lifes than were the Cézanne-inspired works Picasso had made late in 1908 and which became a starting point for his Cubism. But this is no coincidence, for Picasso had again studied intensely Cézanne's work in spring and summer 1914, and a radical stylistic change is evident already in such drawings as 'Glasses and Bottle' (no. 172).

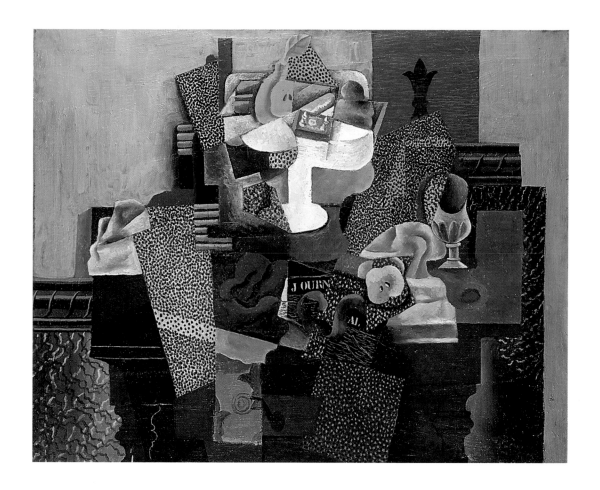

147 Guitar and Newspaper on an Armchair

Executed in Paris, first half of 1915
Oil and sand on canvas, $39\frac{3}{8} \times 25\frac{5}{8}$ (100 × 65)
Signed and dated top right 'Picasso / 1915'

Lit: Z.II** 539 (also Z.VI 1296); D.809

Prov: early whereabouts unknown; Myriam Hopkins, Los Angeles, by the mid-1920s until
c. 1949; to Sidney Brody, Los Angeles, from before 1954 until 1971; to Frank Perls, New York,
1971; to Galerie Berggruen, Paris, 1971; to the present owner
Private collection, Switzerland

Picasso's happiness was shattered by the death of Eva in December 1915, but for six months already his life had been made miserable by her illness: in a letter of the time to Gertrude Stein he complained that his life was hell. He was also deprived of the stimulation formerly provided by his friends now at the Front, and in consequence he painted very little. What he did paint, however, is marked by a new se-verity in the composition and an intellectual treatment of form. Here Picasso has propped a guitar in an armchair and placed a newspaper in the seat, but there is no figure present to animate the objects. The passages of stippling and applied sand add a warm textural note, but do not mask the sense of stillness and isolation the painting conveys.

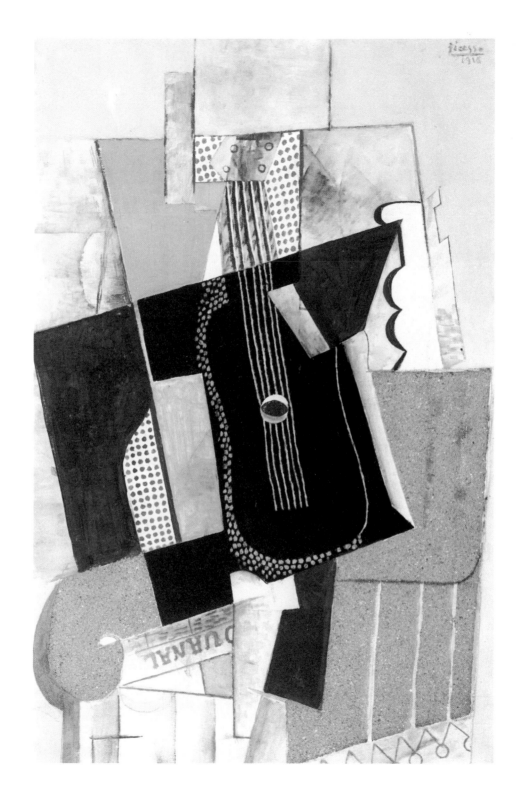

148 Bottle of Anis del Mono, Glass and Playing-card

Painted in Paris, second half of 1915
Oil on canvas, $18\frac{1}{4} \times 21\frac{3}{4}$ (46.3 × 55.2)
Signed bottom centre: 'Picasso'; not dated

Lit: Z.II** 552; D.838; Museum inv.no. 70.192

Prov: the artist to Galerie de l'Effort Moderne (Léonce Rosenberg), Paris, (no photo no. available), *c.* 1916; Dr G.F. Reber, Lausanne, by the mid 1930s; A.E. von Saher, Amsterdam, by 1933; Fine Arts Associates, New York, by 1948; sold to Robert H. Tannahill, Detroit, 1948-70; bequeathed to the museum in 1970
Detroit Institute of Arts. Bequest of Robert H. Tannahill

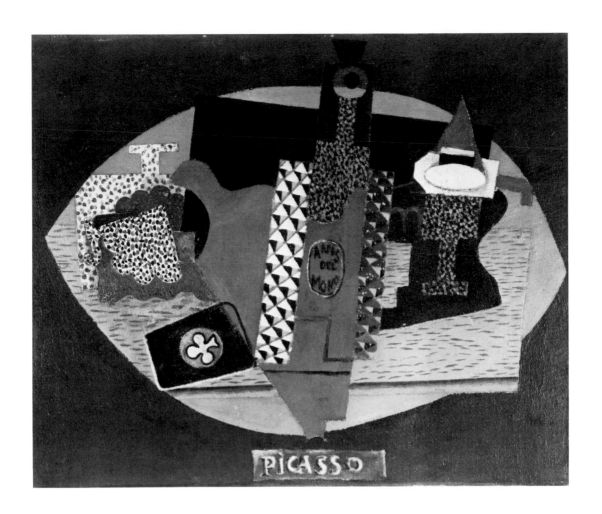

149 Man Leaning on a Table

Painted in Paris; begun in 1915, reworked and finished in 1916
Oil on canvas, 78¾ × 52(200 × 132)
Signed and dated bottom right: 'Picasso / 1915-16'

Lit: Z.II** 550; D.889

Prov: the artist to Eugenia Errazuriz, Paris, *c.* 1918-*c.* 1930; Count Etienne de Beaumont, Paris, *c.* 1930 until 1956; de Beaumont heirs, 1956-*c.* 1965; Marlborough International Fine Art Ltd, London, *c.* 1965; to the present owner
Private collection

Far and away the largest and most ambitious picture Picasso had made since 'Three Women' of 1908 (Hermitage, Leningrad). The artist began it sometime in 1915 in a style (known from photographs of the work in progress) close to that of the 'Still-life' in Columbus, Ohio (no. 146). But only the undulating *pointillé* strip at bottom centre, representing the turned leg of the table, and the rectangles of marbleised green at mid-left and mid-right remain from the first state. Picasso expunged all naturalistic and descriptive details in reworking the painting and geometricised all the forms, so that our sole clues to the subject reside in the two somewhat sinister polka-dot eyes at top and the brown curve at centre of the figure's right knee crossing his left leg. All the planes have been made strictly parallel to the surface in a manner suggestive of the technique of *papier collé*; although they overlap one another, there is no real suggestion of recession or depth. Even the stippling has been organised into regimented rows.

In the reworking of this painting, Picasso essentially defined the style of 'synthetic' Cubism as he would continue to practise it through his work in 1921 on the two versions of 'Three Musicians' (Philadelphia and Museum of Modern Art, New York). He has also established the point of departure for the post-war Cubism of Braque and Léger, as well as for most of the younger later Cubists, like Henri Hayden, Ozenfant, Jeanneret, etc.

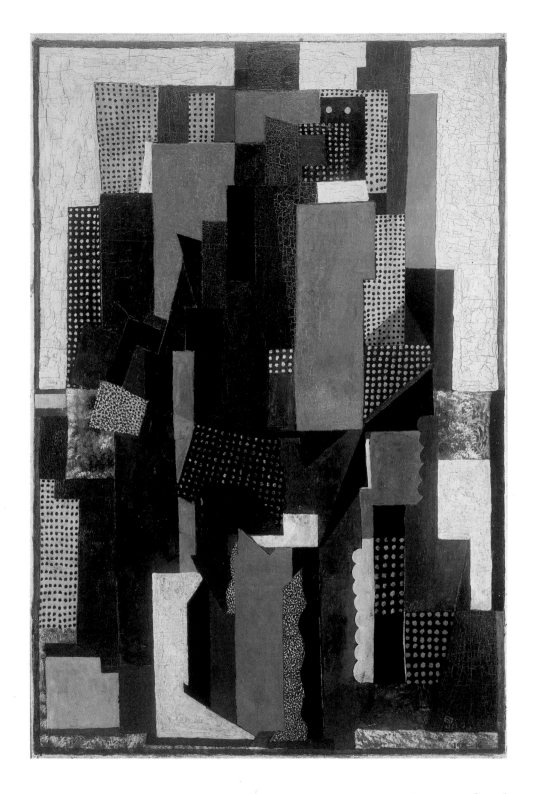

150 Playing-card, Glass and Bottle on a Guéridon

Executed in Paris, 1916
Oil and sand on canvas, $10\frac{5}{8} \times 13\frac{3}{4}(27 \times 35)$
Neither signed nor dated

Lit: Z.II** 571

Prov: the artist to Galerie de l'Effort Moderne (Léonce Rosenberg), Paris (photo no. 107), *c.* 1916-?; sold to André Lefèvre, Paris ?-1967; 4th Lefèvre sale, Hôtel Drouot, Paris, 24 November 1967, lot 122; unidentified collection, 1967-80; Sotheby's, London, 1 July 1980, lot 10 to the present owner
Private collection, Switzerland

This small painting is executed in a refined and more precise version of the style devised by Picasso for 'Man Leaning on a Table' (no. 149) of some six months earlier.

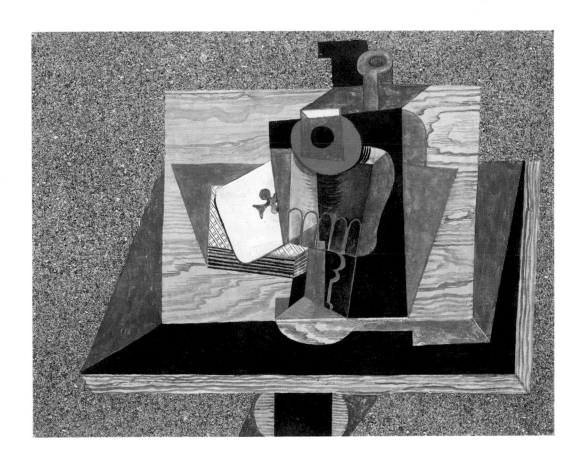

151 Harlequin and Woman with a Necklace

Painted in Rome, spring 1917
Oil on canvas, $78\frac{3}{4} \times 78\frac{3}{4}$ (200 × 200)
Signed and dated lower right: 'Picasso / Rome 1917'

Lit: Z.III 23; Museum inv. no. AM 3760 P

Prov: early whereabouts uncertain, although it probably passed directly from the artist to Paul Rosenberg in the early 1920s; Baron Napoléon Gourgaud, Paris, *c.* 1925 until 1944; Baroness Gourgaud, Yerre, 1944-59; Gourgaud estate, 1959-65; finally given to the Musées Nationaux in 1965
Musée National d'Art Moderne (Centre Georges Pompidou), Paris. Bequest of the Baroness Napoléon Gourgaud

The poet Jean Cocteau first visited Picasso in his Montparnasse studio sometime late in autumn 1915 and saw in progress Picasso's painting 'Harlequin', now in the Museum of Modern Art, New York. Cocteau returned in April or May 1916, wearing a Harlequin's costume, and solicited Picasso's collaboration in a project for a modern ballet, of which he had written the scenario, to be performed by Diaghilev's Ballets Russes. Picasso eventually yielded and designed the *décor* and costumes for *Parade*, first performed to Satie's music in Paris in May 1917. Cocteau, who liked telling good stories after his own fashion, wrote rather defensively in 1923 about the obstacles he had encountered in persuading Picasso to join him:

His circle did not wish to believe that he would follow me. A dictatorship weighed upon Mont-martre and Montparnasse. We were traversing the austere period of Cubism. The objects found on a café table were, with the Spanish guitar, the only pleasures permitted. To paint a setting, and above all for the Russian Ballet (this devoted adolescence knew not Stravinsky), constituted a crime. M. Renan, in the wings, never scandalised

the Sorbonne as much as Picasso did the Café Rotonde when he accepted my offer. The worst was that we had to join Serge Diaghilev in Rome, because the Cubist code forbade all journeys except that from north to south between the Place des Abbesses and the Boulevard Raspail. . . . We lived, we breathed. Picasso laughed to see the figures of our painters growing smaller as the train left them behind.

This is one of two paintings Picasso began while he was in Rome, according to a postcard he sent Gertrude Stein; the second, 'La Italienne', is in the Bührle collection, Zurich. The style, a slick, sophisticated variant of his 1916 Cubism, betrays none of the profound impressions made on Picasso by his visits to the Vatican, to Naples and to Pompeii. But it does reflect the gaiety of his nights in Rome, where he visited night-clubs and met the *dames romaines*. It was only in his drawings that Picasso began to toy with a new neo-classical style influenced by Italy and her art.

It is worth noting that Gris had already attained a comparable degree of abstraction and synthesis a year earlier in his 'Portrait of Josette' (no. 74).

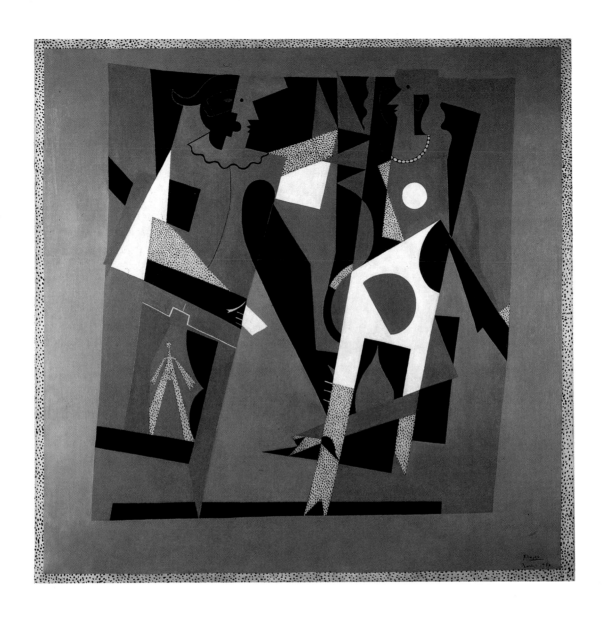

152 Girl with a Hoop

Executed in Paris, winter 1918-19
Oil and sand on canvas, 56⅛ × 31⅛ (142.5 × 79)
Signed and dated upper right: 'Picasso / 19'

Lit: Z.III 289; Museum inv. no. AM 4312 P

Prov: the artist to Paul Rosenberg, Paris, 1919-20; sold for 25,000 frs. to H.P. Roché as agent for John Quinn, New York, 1920-4; Quinn estate, 1924-6; Paul Rosenberg & Cie., Paris, 1926; Baron Napoléon Gourgaud, Paris, *c.*1926 until 1944; Baroness Gourgaud, Yerre, 1944-59; Gourgaud estate, 1959-65; finally given to the Musées Nationaux in 1965
Musée National d'Art Moderne (Centre Georges Pompidou), Paris. Bequest of the Baroness Napoléon Gourgaud

While in Rome Picasso met Olga Koklova, a dancer in Diaghilev's *corps de ballet*, whom he married in 1918. Late in that year the two moved to a smart apartment in the rue La Boëtie in the centre of Paris. Picasso depicted the dining-room of their new home in a drawing (no. 177), and the present painting too was probably executed there.

Here Picasso has once again achieved a marriage of flat Cubist forms with descriptive details, but the picture is marked by a painterliness and concern for texture that could derive from paintings by Braque such as 'The Musician' (no. 40). Both artists seemed intent on giving post-war Cubism a monumental appearance in the face of renewed attacks in the press and in certain artistic circles. André Lhote, for example, wrote in a review of Braque's one-man exhibition at Léonce Rosenberg's gallery in March 1919 that Cubism was dead, while two months later Blaise Cendrars asked in a basically hostile article: 'Why is the "Cube" Disintegrating?'

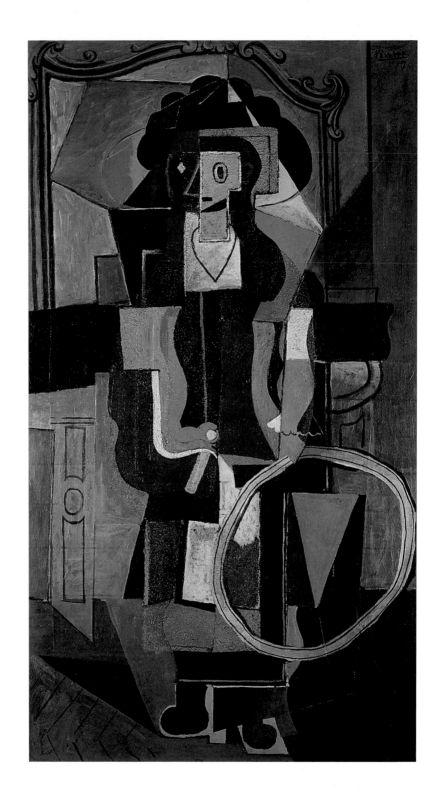

153 Guitar, Bottle and Glass on a Table

Painted in Paris, first half of 1919
Oil on canvas, $39\frac{3}{8} \times 31\frac{7}{8}$ (100 × 81)
Signed and dated bottom left: 'Picasso 19'

Lit: Z.VIII 165

Prov: the artist to Paul Rosenberg, *c.* 1920; Dr G.F. Reber, Lausanne by the mid-1920s; Dr Chiodera, Zürich, by the mid-1930s; Marlborough Fine Art, London; Walter Ross, New York, 1957-64; sale, Parke-Bernet, New York, 21 October 1964, lot 44, sold for $117,500; Heinz Berggruen, Paris, 1964 until *c.* 1970; to Artemis, S.A., Luxembourg; Stephen Hahn, New York; Modarco, Geneva; Stephen Hahn, New York; Galerie Rosengart, Lucerne; sale, Sotheby's, London, 1 April 1981, lot 60, to the present owner
Stanley J. Seeger Collection, Sutton Place

Like the contemporaneous 'Girl with a Hoop' (no. 152), a majestic and painterly statement on the possibilities of post-war Cubism. From this moment on until the mid-1920s Picasso would elaborate his figure painting in one of the various neo-classical or naturalistic styles he had developed – with the obvious exception of the two versions of 'Three Musicians' – but he did not abandon the Cubist idiom in his still-lifes. No doubt a sense of competition with Braque played a part because Braque continued to produce magnificent still-lifes in a similar late Cubist manner.

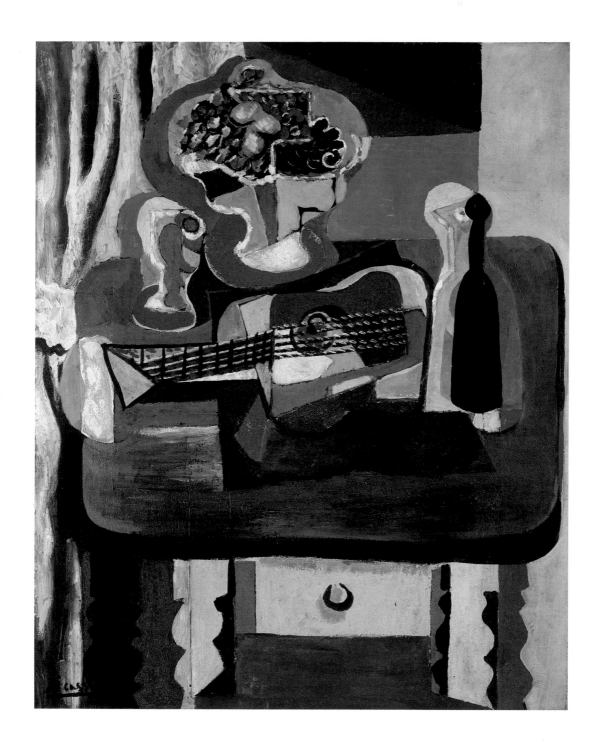

154 La Grande Odalisque, after Ingres

Executed in Paris, summer 1907-winter 1908
Gouache, watercolour and graphite on paper, $18\frac{7}{8} \times 24\frac{3}{4}$ (48×63)
Neither signed nor dated

Lit: Z.XXVI 194; Tinterow 1981, p.90; Museum inv.no.MP 545

Prov: the artist, 1907-73; Picasso estate 1973-9; given in lieu of taxes to France (Dation
Picasso), 1979
Musée Picasso, Paris

Despite an apparent incongruity between Ingres' highly refined art and the primitive sculpture which obsessed Picasso in 1907 and 1908, Ingres was an important source of stylistic inspiration for Picasso in the period leading up to and following 'Les Demoiselles d'Avignon'. This was neither the first time that Picasso found inspiration in Ingres – that was in 1906 – nor was it to be the last, for each time Picasso looked at Ingres' art he found different points of interest, corresponding to his own current preoccupations. Here Picasso clearly wished to study Ingres' wilful distortions of anatomy and his construction of a narrow pictorial space through the use of large, slightly modelled planes – two devices Picasso had recently used to great effect in the 'Demoiselles'.

155 Five Figures in a Forest

Executed in Paris, spring 1908
Charcoal on paper, $18\frac{7}{8} \times 24\frac{1}{2}$ (47.7 × 60.2)
Neither signed nor dated

Lit: Z.XXVI 292; Museum inv.no. MP 604

Prov: the artist, 1908-73; Picasso estate, 1973-9; given in lieu of taxes to France (Dation Picasso), 1979
Musée Picasso, Paris

This drawing served as a study for a large five-figure composition Picasso envisioned during the winter of 1907-8. Probably intended to rival 'Les Demoiselles d'Avignon', the painting was never realised, although elements of the composition were excerpted by Picasso as subjects for individual paintings throughout the spring and summer of 1908. The two figures at left appear in 'Friendship' (D.104, Hermitage, Leningrad), which is in turn related to 'Three Figures under a Tree' (no. 113), while the three figures at right were treated in a large number of drawings and gouaches which were ultimately transformed into 'Three Women' (D.131, Hermitage, Leningrad), the largest, and arguably the most important work produced by Picasso in 1908. In addition, Picasso isolated the central figure of the triad on the right of the present drawing in 'Standing Nude Woman', (no. 156), and that drawing served as a study for a painting (D.116) of the same title now in the Museum of Fine Arts, Boston.

Although the numerous works mentioned above were completed in a brief nine-month period, they were painted in a variety of stylistic idioms: from the primitivism of 'Three Figures under a Tree' to a formalism of smooth, rhyming arcs in 'Standing Nude Woman'. This vacillation in style may explain in part why Picasso was reluctant to execute the entire composition as depicted here; or, he may simply have sensed that he had failed to make the two figural groups cohere.

The pentagonal form at bottom right represents the prow of a boat which is more clearly elaborated in some related watercolours (D.126-8).

156 Standing Nude Woman

Executed in Paris, spring 1908
Watercolour and graphite on paper, $24\frac{5}{8} \times 16\frac{1}{2}$ (62 × 41)
Signed bottom right: 'Picasso'; not dated

Lit: Z.II* 101; D.114; Museum inv.no. 67.162

Prov: early whereabouts unknown; Galerie Percier (André Level), Paris, by 1942; Dr Avrom Barnett, New York, by the late 1950s; to the museum in 1967
Metropolitan Museum of Art, New York. Anonymous Gift in Memory of Dr Avrom Barnett

See the preceding commentary.

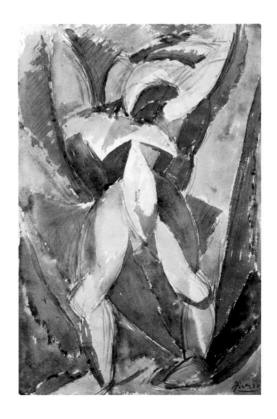

157 Head of a Woman

Executed in Paris, spring 1908
Gouache on paper pasted on cardboard, $25\frac{3}{8} \times 19\frac{3}{4}$ (64.5 × 50)
Signed on back: 'Picasso'; not dated

Lit: Z.II* 75; D.135; Museum inv.no. 1640

Prov: early whereabouts unknown; Galerie Ferdinand Moller, Berlin, by 1942; gift of General Schmittlein to the museum in 1952
Mittelrheinisches Landesmuseum, Mainz

Closely related to 'Head and Shoulders of a Woman' (no.114), and executed at more or less the same time as the preceding two drawings. Here Picasso concentrates on the creation of a mask-like face, not unlike the inscrutable masks of figures in earlier paintings such as 'Two Nudes' of autumn 1906 (Z I 366, Museum of Modern Art, New York), but more severely stylised in the manner of African sculpture. The woman's head is lit in a way which evokes a sculptural image, while the handling of the gouache, derived from Cézanne but executed in a cruder fashion, tends to flatten the forms. This inherently contradictory approach was characteristic of Picasso's art before 1909.

158 Head of a Man

Executed probably in late 1908
Ink and charcoal on paper, $24\frac{3}{4} \times 18\frac{7}{8}$ (63 × 48)
Signed lower right: 'Picasso'; not dated

Lit: Z.II** 715

Prov: whereabouts unknown until the late 1930s; Pierre Loeb, Paris, by 1938; to the present owner in 1938
Private collection

This striking drawing shares its strong contours and dramatic shadows with other works of winter 1908 such as 'Seated Male Nude' (D.229, Musée d'Art Moderne du Nord, Lille), but it does not appear to relate specifically to a completed painting. The idiom is still essentially Cézannian; similar, but less exaggerated figuration can be found in details of Cézanne's late pictures of bathers. The impressive iconic character of this work, however, must derive from Picasso's study of primitive art.

Barely visible at centre is a drawing in charcoal of a standing female nude which Picasso erased before completing the head of a man.

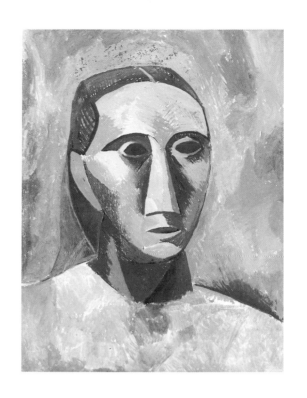

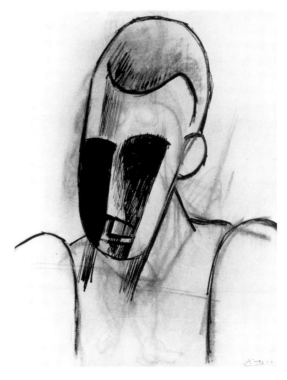

159 **Still-life with a Chocolate-pot**

Executed in Paris, early 1909
Watercolour on paper, $24\frac{1}{4} \times 18\frac{1}{2}$ (61.3 × 47.5)
Signed top right: 'Picasso'; not dated

Lit: Z.II* 131; D.223

Prov: the artist to Ambroise Vollard, from *c.* 1909 until 1939; Madame de Galéa, Paris, 1939-52; Reid & Lefevre Gallery, London, by 1953; to the present owner in 1953
Private collection

Through the autumn and winter of 1908 and the spring of 1909, still-life proved to be as important a subject in Picasso's work on paper as it was for his painting. Most of his drawings served as preparatory studies for works in other media, but he did occasionally make highly finished, independent works on paper, as here.

In this capital work Picasso achieves what he had sought over the previous six months: to effect a synthesis of the direct, veristic art of Henri Rousseau with the spatial complexities of Cézanne's paintings and watercolours of 1895-90. Each object – fruit-bowl, mustard-pot, cup and saucer – is viewed from a different point of view and lit from a different direction, yet the composition nonetheless exhibits the stability and irreducible logic of Rousseau's best work.

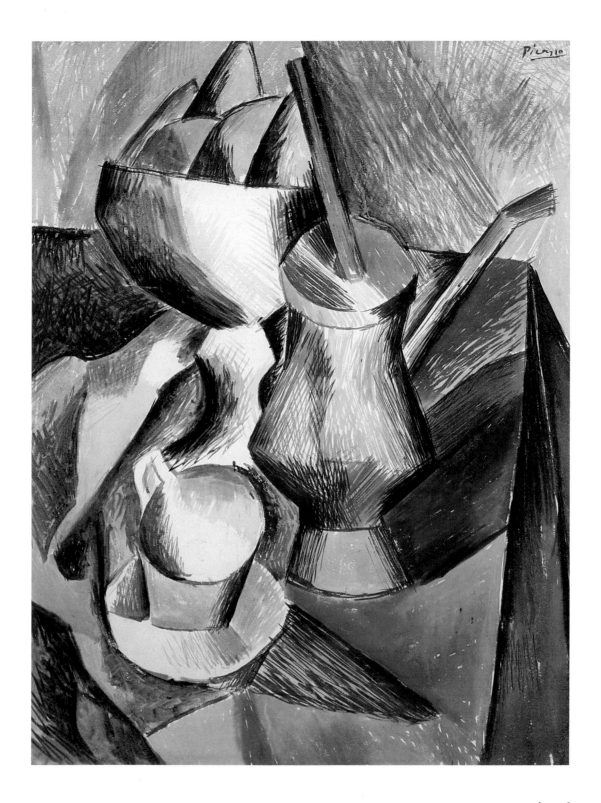

160 Head of a Woman

Executed in Paris, early 1909
Ink and wash on paper, $24\frac{3}{4} \times 18\frac{7}{8}$ (62.5 × 48)
Signed and dated on back: 'Picasso / 1909'

Lit: not in Zervos; Museum inv.no.49.70.28.

Prov: the artist to (probably) Marius de Zayas, as agent for Alfred Stieglitz, New York, 1910-46;
Stieglitz estate, 1946-9; given to the museum in 1949
Metropolitan Museum of Art, New York. The Alfred Stieglitz Collection

In this drawing Picasso has abandoned his sculptural approach to form in favour of an expressive arrangement which is at once anti-natural and more closely attuned to the flat support. Here the forms are splayed out on the paper – the head is pushed down on the neck, the lower left jaw is inverted, the nose is broken and seen simultaneously from two sides, the right breast has been relocated in the woman's armpit – in a wilful manner which can only be understood as an assertion of the artist's right to re-create reality. Such an assertion was, naturally, an essential pre-condition for the creation of the new pictorial language of Cubism, and six months later Picasso created in Horta de Ebro his first series of works in a wholly Cubist idiom.

161 Head of a Woman, Casket and Apple

Executed in Paris, first half of 1909
Graphite on paper, $9 \times 12\frac{3}{8}$ (23 × 31.5)
Signed lower left: 'Picasso'; not dated

Lit: Z.II** 714

Prov: early whereabouts unknown; Léonce Rosenberg, Paris, by c.1919 (?); Richard Wyndham, London, by the late 1920s; Rudolf Stulik, London; Gallery Arnold Haskell, London, 1933; to the present owner in 1933
Private collection

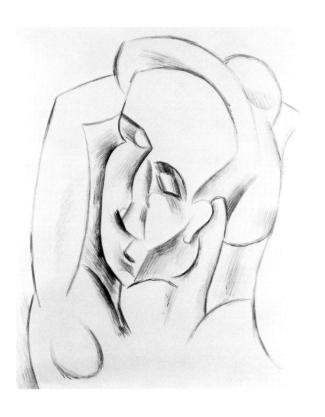

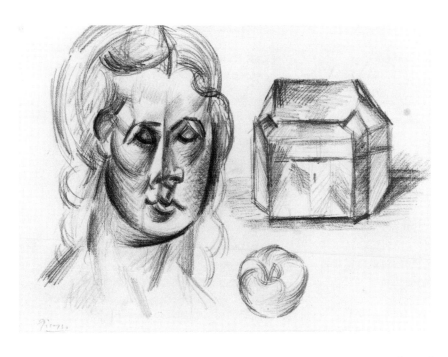

162 Houses and Palms

Executed in Barcelona, May 1909
Black ink on paper, $6\frac{3}{4} \times 4\frac{3}{8}$ (17 × 11)
Neither signed nor dated

Lit: Z.VI 1092; Museum inv.no.MP 637

Prov: the artist, 1909-73; Picasso estate, 1973-9; given in lieu of taxes to France (Dation Picasso), 1979
Musée Picasso, Paris

Pierre Daix has identified this sketch of a group of buildings as having been executed by Picasso from his hotel window in Barcelona, where he stopped for some time with Fernande on his way to Horta de Ebro. Although the dates of this trip have not been firmly established, Picasso seems to have left Paris in late April and to have arrived in Horta by the end of May.

Already evident here is the planar analysis of form that would distinguish Picasso's work at Horta.

163 Head of a Man

Executed in Paris, autumn 1910
Charcoal on paper, $25\frac{1}{4} \times 19\frac{1}{8}$ (64.2 × 48.6)
Neither signed nor dated

Lit: not in Zervos; Museum inv.no.MP 643

Prov: the artist, 1910-73; Picasso estate, 1973-9; given in lieu of taxes to France (Dation Picasso), 1979
Musée Picasso, Paris

In this work Picasso uses light, shadow and line to create planar forms roughly analogous to those of a human head; his earlier, sculptural conception of representation has been abandoned for a wholly new, wholly Cubist manner of notation. We cannot imagine this head existing as a solid entity situated in space, as we could the Mainz 'Head of a Woman' (no.157), for example. Here the forms exist only on paper and in relation to one another, from whence follows the purely pictorial nature of this phase of Picasso's Cubism.

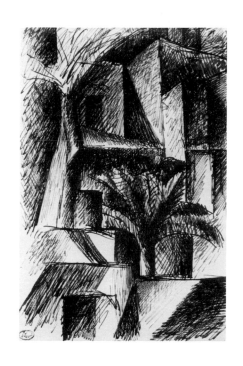

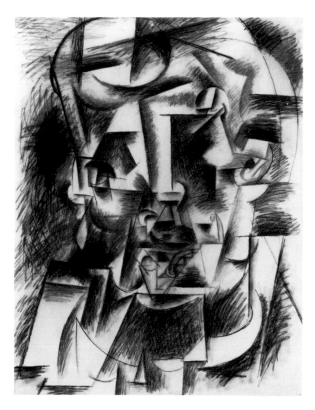

164 Spanish Woman

Executed in Paris, autumn 1910
Charcoal on paper, $25\frac{1}{4} \times 19\frac{1}{4}$ (64.3 × 49)
Neither signed nor dated

Lit: Z.VI 1126; Tinterow 1981, p. 104; Museum inv. no. MP 657

Prov: the artist, 1910-73; Picasso estate, 1973-9; given in lieu of taxes to France (Dation Picasso), 1979
Musée Picasso, Paris

Executed at the same time as the previous drawing, that is to say, after Picasso's return from Cadaqués and his decision to make his painting and drawing more legible: hence the clearly recognisable hair, mantilla, nose and eyes, etc.

165 Man with a Pipe

Executed in Céret, summer 1911
Black chalk and grey oil wash on paper, $25\frac{1}{4} \times 18\frac{3}{8}$ (64.2 × 46.7)
Signed on back: 'Picasso'; not dated

Lit: Z.II* 280; Tinterow 1981, p. 108; Museum inv. no. 1952.35

Prov: the artist to Galerie Kahnweiler, Paris (stock no. 1733), 1911-14; sequestered Kahnweiler stock, 1914-21; sold in an unidentified lot in one of the Kahnweiler sales, 1921-3, probably to Alfred Flechtheim, Berlin, from *c.* 1923 until after 1932; Jacques Seligmann and Co., Inc., New York, by 1949; to the museum in 1952
Fogg Art Museum, Harvard University, Cambridge, Mass. Purchase: Annie S. Coburn Fund

Each summer away from Paris – in Cadaqués in 1910, Céret in 1911, and Sorgues in 1912 – Picasso would push to an extreme conclusion the stylistic innovations and inventions that he had developed during the previous winter and spring. In 'Man with a Pipe' Picasso takes the notations he had developed in drawings like the Musée Picasso's 'Head of a Man' (no. 163). executed several months earlier, integrates those notations more closely into the overall fabric of short strokes and small planes which he has created, and as a result severs all contact with traditional representational devices. Even connoisseurs of Cubism would be hard pressed to identify the subject of this work without benefit of the title. But by the time Picasso returned to Paris in the autumn of 1911, he was once again reintroducing visual aids to enable the viewer to identify his subjects, as in 'Standing Woman' of 1911-12 (no. 167).

This same head, with more legible details of hair and an ear, appears in the painting 'Man with a Violin' (no. 132).

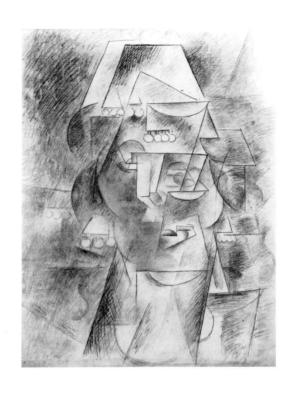

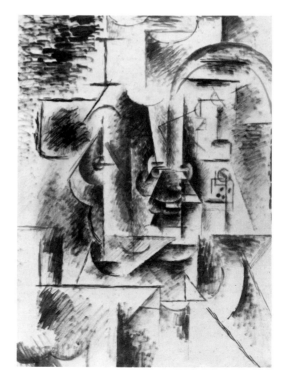

166 Man with a Clarinet

Executed in Céret, summer 1911
Black ink and crayon on paper, $12\frac{1}{6} \times 7\frac{3}{4}$ (30.8 × 19.5)
Neither signed nor dated

Lit: Z.XXVIII 48; Museum inv. no. MP 659.

Prov: the artist, 1911-73; Picasso estate, 1973-9; given in lieu of taxes to France (Dation Picasso), 1979
Musée Picasso, Paris

Closely related to the painting 'Man with Guitar' (D.427, Musée Picasso, Paris) which Picasso began in the summer of 1911 and did not complete until 1913.

167 Standing Woman

Executed in Paris, autumn-winter 1911-1912
Ink and wash on paper, $21\frac{5}{8} \times 8\frac{1}{2}$ (55 × 21.6)
Signed bottom right: 'Picasso'; not dated

Lit: Z.II** 725

Prov: the artist, 1912-36; Galerie Renou et Colle, Paris, 1936; to the present owner in 1936
Private collection

From the autumn of 1910 through the summer of 1912, Picasso executed a number of drawings of a standing woman, of which the most famous is the 'Standing Nude' of 1910 in the Metropolitan Museum of Art (Z II* 208), which has the same tall format as the present drawing. These works are each elaborated in a style consistent with Picasso's other contemporary work, but they share a graceful *contraposto* and elegance of proportion which set them apart from most of the artist's production.

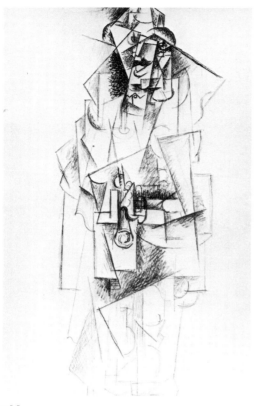

166

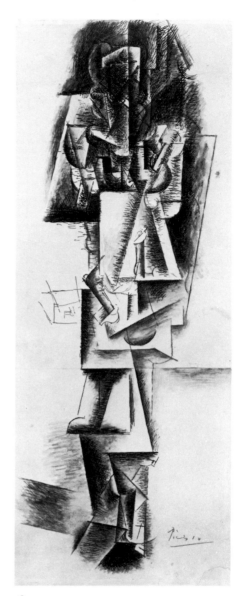

167

168 Still-life on a Table

Executed probably in Sorgues, summer 1912
Black crayon on paper, $12\frac{1}{4} \times 7\frac{3}{4}$ (30.8 × 19.6)
Neither signed nor dated

Lit: Z.XXVIII 155; Museum inv.no.MP 669

Prov: the artist, 1912-73; Picasso estate, 1973-9; given in lieu of taxes to France (Dation Picasso), 1979
Musée Picasso, Paris

Picasso has here abandoned the subtle, elusive forms characteristic of his drawings of the summer of 1911, such as 'Man with a Pipe' (no.165), in favour of large planar shapes and easily recognisable objects. But the spatial organisation here is no less complex than in his earlier drawings. The objects mount up the page yet do not recede: they are bound to the foreground, bound indeed to the surface of the sheet on which the drawing is made, by a succession of flat, vertical, unifying planes. Such planes increasingly became the compositional basis in Picasso's paintings and drawings made at Sorgues in the summer of

1912. Thus by the time Braque invented the technique of *papier collé*, in September 1912, Picasso was ready to incorporate ready-made planes of newsprint and wallpaper cuttings into the type of composition he had developed during the previous three months. Hence the apparent facility with which Picasso was able to adopt Braque's discovery for his own ends.

Of particular interest in this drawing is Picasso's use of shadow to create alternative profiles for depicted objects. A little later, Gris became particularly fond of this device and used it to great effect in paintings such as the 1913 'Guitar on a Chair' (no.64).

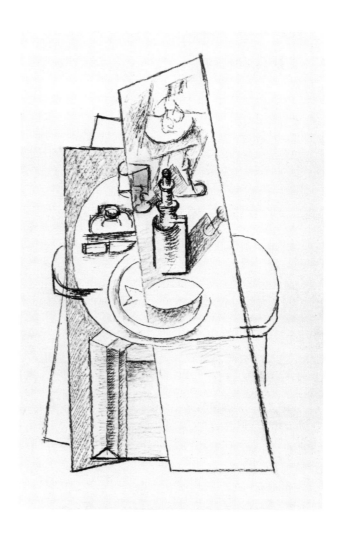

169 **Bottle of Bass and Guitar**

Executed in Paris, autumn 1912
Pastel, charcoal and stencilled black ink on paper, $18\frac{1}{2} \times 24\frac{5}{8} (47 \times 62.5)$
Signed on back: 'Picasso'; not dated

Lit: Z.II** 376; D.511; Tinterow 1981, p.122

Prov: the artist to Galerie Kahnweiler, Paris (photo no.287), 1913-14; sequestered Kahnweiler stock, 1914-21; probably sold in an unidentified lot in one of the Kahnweiler sales, 1921-3; subsequent whereabouts unknown until the early 1930s; Dr G.F. Reber, Lausanne, from the mid-1920s until 1939; to the present owner in 1939
Private collection

An unusually colourful work which seems to be coincidental with Picasso's first *papiers collés* made in the autumn of 1912. Its high-key colours relate this work to the paintings executed in the summer at Sorgues, while the composition of overlapping planes and stepped forms (the neck of the guitar, for example), ties this pastel to a *papier collé*, 'Guitar and Sheet-music' (D.506), and the painting 'Bottle, Guitar, Glass and Pipe' (no.136), both executed in autumn 1912.

This is one of two pastels (the other is reproduced in Zervos, Z.II** 375) of which photographs are preserved in the Kahnweiler archives. No other Cubist work by Picasso before 1914 is known in this medium.

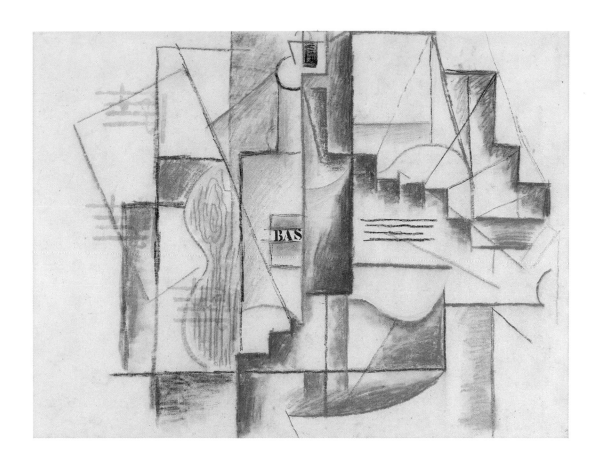

170 Seated Woman with a Guitar

Executed in Paris, winter 1912-13
Black ink and graphite on paper, $13\frac{1}{2} \times 8\frac{3}{4}$ (34.2 × 22.2)
Neither signed nor dated

Lit: Z.XXVIII 237; Museum inv.no.MP 728

Prov: the artist, 1912-73; Picasso estate, 1973-9; given in lieu of taxes to France (Dation Picasso), 1979 *Musée Picasso, Paris*

One of a group of drawings related to a painting 'Female Nude' (D.541) in Columbus, Ohio, and a triumph of Picasso's new style of notation. While a few forms, such as the almond-shaped eye and mouth, have been abstracted from nature, the remainder have been freely invented by Picasso. The woman's hair, the armchair in which she sits, the guitar which she holds, are each easily identified, yet they have been represented in radically new terms. Picasso neither follows an object's outline, nor determines its inner structure, but instead invents a new shape that will remind the observer of the represented object without depicting it in a traditional, illusionary manner.

171 Head of a Man (Portrait of Guillaume Apollinaire)

Executed in Paris, early 1913
Black ink, wash and graphite on paper, $8\frac{1}{4} \times 5\frac{7}{8}$ (21 × 15)
Signed lower right: 'Picasso'; not dated

Lit: Z.XXVIII 214; Tinterow 1981, p.120

Prov: the artist to Guillaume Apollinaire, Paris, 1913-18; Madame Apollinaire, Paris; to the present owner by 1966 *Lionel Prejger, Paris*

Given by Picasso to Apollinaire to serve as a frontispiece for the latter's collection of poems, *Alcools,* published in 1913. There is no evidence that Picasso intended this drawing as a portrait in the strict sense of the term; rather, he seems simply to have selected a fine example of his contemporary work, quite unrelated to the text it would illustrate. This was also Picasso's approach toward the etchings commissioned by Kahnweiler to enhance *Saint Matorel* and *Le Siège de Jérusalem* by Max Jacob (nos.181-4 and 187).

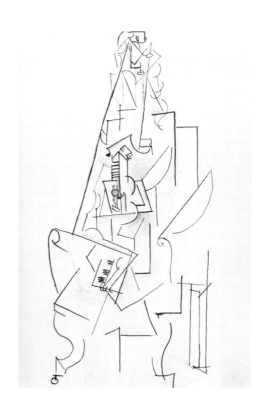

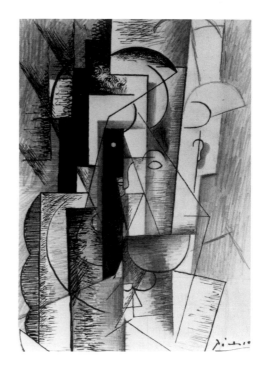

172 Glasses and Bottle

Executed in Avignon, summer 1914
Graphite on paper, $14\frac{7}{8} \times 19\frac{1}{2}$ (37.8 × 49.6)
Inscribed: 'FÊTE D'AVIGNON'; neither signed not dated

Lit: Not in Zervos, Museum inv.no. MP 741

Prov: the artist, 1914-73; Picasso estate, 1973-9; given in lieu of taxes to France (Dation Picasso), 1979
Musée Picasso, Paris

The cheerfulness and whimsy of this sheet of studies of glasses is characteristic of the mood of Picasso's work in summer 1914. With the inscription 'Fête D'Avignon' he records the location of his summer work place, where he was accompanied by his mistress Eva Gouel. The Derains were staying nearby in Montfavet, while Braque and his wife were 12 kilometres away in Sorgues. The simple style of drawing adopted here was part of an effort by Picasso to develop a naturalistic mode of representation in contrast to his Cubism.

173 Man Reading a Newspaper

Executed in Avignon, late summer 1914
Graphite, watercolour and charcoal on paper, $12\frac{1}{2} \times 9\frac{3}{8}$ (31.7 × 23.7)
Neither signed nor dated

Lit: Z.XXIX 66; Tinterow 1981, p. 134; Museum inv.no. MP 759

Prov: the artist, 1914-73; Picasso estate, 1973-9; given in lieu of taxes to France (Dation Picasso), 1979
Musée Picasso, Paris

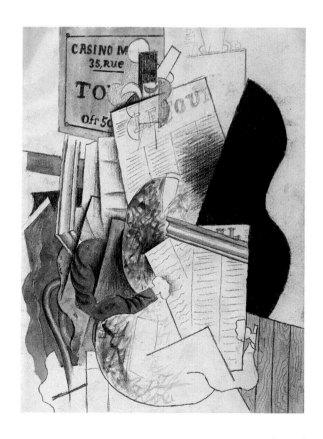

174 Glass, Pipe, Newspaper and Playing-card

Probably executed in Avignon, summer 1914
Graphite on paper, $12\frac{5}{8} \times 9\frac{1}{4}$ (32.2 × 23.5)
Neither signed nor dated

Lit: Z.XXIX 32; Museum inv. no. MP 765

Prov: the artist, 1914-73; Picasso estate, 1973-9; given in lieu of taxes to France (Dation Picasso), 1979
Musée Picasso, Paris

A striking sheet which is typical of Picasso's work in Avignon: illusionism and Cubism combined and contrasted within a single composition. Space has been suppressed in favour of a shallow group of overlapping planes, so as to heighten the *trompe-l'oeil* illusionism of the woodgraining and fragment of newspaper; the glass, on the other hand, has been depicted in purely Cubist terms. Picasso had not yet attempted such a sophisticated blend of different styles in any painting, which therefore gives to his drawings a special importance at this time.

175 Man with a Pipe

Executed in Paris, 1915
Graphite on paper, $10\frac{3}{4} \times 8\frac{1}{2}$ (27.3 × 21.5)
Signed and dated bottom right: 'Picasso / 1915'

Lit: not in Zervos

Prov: the artist to H. P. Roché, *c.* 1916?; Paul Rosenberg & Co., Paris and New York, until *c.* 1952; Mr and Mrs Daniel Saidenberg, New York, *c.* 1952-80; to the present owner in 1980
Alex Reid & Lefevre Ltd., London. Executive Pension Scheme

A work very close in subject and style to 'Man Reading a Newspaper' (no. 173) but executed nearly one year later. Picasso began in spring 1914 to make several successive studies – this drawing being one – of seated men, depicted at first naturalistically, then in a Cubist fashion, and finally, as here, in a composite style of both modes of representation. Soon however, naturalism was to win out, for during the war Picasso executed several highly finished drawings in a style reminiscent of mid-nineteenth century French portraitists such as Ingres and his followers. Gris's 'Portrait of Madame Berthe Lipchitz' (no. 90), made three years later than the present work, testifies to that artist's interest in developing a similar style as an alternative to Cubism.

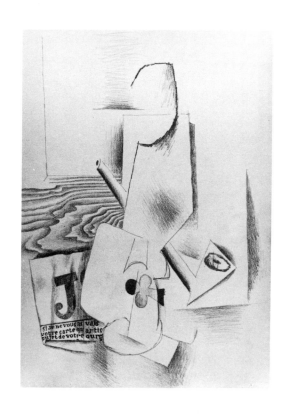

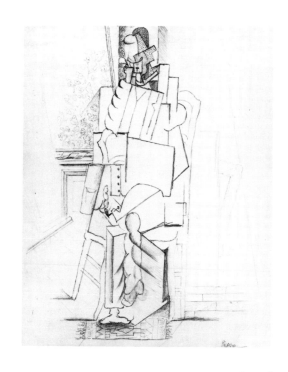

176 Seated Woman

Executed in Paris, 1918
Charcoal, black crayon and graphite, $13\frac{1}{2} \times 12\frac{7}{8}$ (34.5 × 32.6)
Neither signed nor dated

Lit: not in Zervos; Museum inv.no. MP 835

Prov: the artist, 1918-73; Picasso estate, 1973-9; given in lieu of taxes to France (Dation Picasso), 1979 *Musée Picasso, Paris*

A characteristic example of Picasso's post-war Cubism: the planes are sharply defined and overlap in shallow relief. The organic and eccentric shapes which enlivened his work in 1914 have by now been geometricised in accordance with a cooler, more precisionistic aesthetic conception.

177 The Artist's Dining-room, rue La Boëtie

Executed in Paris, autumn 1919
Watercolour, gouache and graphite, $8\frac{3}{4} \times 12\frac{1}{2}$ (22.1 × 31.6)
Neither signed nor dated

Lit: not in Zervos; Museum inv.no. MP 837

Prov: the artist, 1919-73; Picasso estate, 1973-9; given in lieu of taxes to France (Dation Picasso), 1979 *Musée Picasso, Paris*

In March 1919 Léonce Rosenberg organised in his Galerie de l'Effort Moderne an exhibition of the recent work of Georges Braque. It was Braque's first one-man exhibition in Paris since 1908 and thus aroused considerable interest from the artistic community, as well as from his former collaborator. Picasso must have been deeply impressed by Braque's showing of a group of large still-lifes, for during the summer, which he spent at Juan-les-Pins, Picasso executed in gouache a series of still-lifes arranged, like Braque's, on a *guéridon* in front of a window. These were elaborated in an informal Cubist idiom very similar to that recently developed by Braque. This adoption by Picasso of Braque's new style of painting constitutes the last of the many fruitful exchanges between the two painters; shortly afterwards they drifted apart, remaining on friendly terms, though no longer so close.

This work is similar in style and spirit to Picasso's earlier series of gouaches. This time, however, the scene is not Picasso's salon at Juan-les-Pins, but the dining-room of his new apartment at 23 rue La Boëtie. Picasso and his wife Olga had moved there late in 1918. The apartment, next door to Paul Rosenberg's gallery and a few hundred yards from the Wildenstein house, had been found for them by Rosenberg, and the artist still felt a desire to inventory and come to terms with his new domestic surroundings.

PABLO PICASSO

178 **Pierrot and Harlequin**

Executed in Juan-les-Pins, summer 1920
Gouache and graphite on paper, $10\frac{3}{4} \times 8\frac{3}{8}$ (27.3 × 21.3)
Signed lower left: 'Picasso'; not dated

Lit: Z.IV 69; Museum inv.no.B-31,627

Prov: the artist to Paul Rosenberg, Paris, *c.* 1920; to Mrs Charles B. Goodspeed, Chicago (later Mrs Gilbert W. Chapman, New York), from before 1934 until 1980; Chapman estate, 1980-1; to the gallery in 1981
National Gallery of Art, Washington, DC. Gift of Mrs Gilbert W. Chapman

This gouache is one of a group made by Picasso in the summer of 1920 in which he perfected the flat, decorative, and brightly coloured Cubism that would inform his late Cubist masterpieces – the two versions of 'Three Musicians' (Z.VI 331, Z.VI 332) executed in summer 1921. Harlequin and Pierrot had again become important subjects for Picasso in 1915; but as soon as he was deeply immersed in Diaghilev's world, which occurred in 1917, these familiar figures from the *commedia dell'arte* assumed an increasingly large role in his art, both Cubist and, later, neo-classical.

179 Two Figures

Executed in the first half of 1909
Drypoint, $5\frac{1}{8} \times 4\frac{3}{8}$ (13×11)
Signed lower right: 'Picasso'; not dated

Lit: Geiser 21, III b

Edn: 100 copies published in 1909 by Kahnweiler, pulled by Delâtre, printed on laid Arches paper
Kunstmuseum, Basel, Kupferstichkabinett

Picasso took up printmaking again in 1909 after four years of inactivity.* Like his earlier etchings, the present works, 'Two Figures' and 'Still-life', relate directly to his contemporary painting and drawing. Both are essentially Cézannian in inspiration. 'Two Figures' derives from certain of Cézanne's late compositions of bathers; 'Still-life', with its bosc pears, vase, up-tilted table and crumpled napkin, is strongly reminiscent of several Cézanne still-lifes of the first years of this century. But, of course, Picasso's stylisations here are more extreme, the spatial elisions more acute, and the interlocking forms more compact than those of the Master of Aix. One can also find traces of the influence of Braque in these works, particularly in the still-life, an indication that he and Picasso were already in close contact.

*The exceptions being a woodcut (Geiser 12) of late 1906 that was not printed until the 1930s and a celluloid engraving (Geiser 19) of early 1907 that exists only in four trial proofs.

180 Still-life

Executed in the first half of 1909
Drypoint, $5\frac{1}{4} \times 4\frac{3}{8}$ (13.5×11.1)
Signed in pencil lower right: 'Picasso'

Lit: Geiser 22, III b

Edn: 100 copies published in 1909 by Kahnweiler, pulled by Delâtre, printed on laid Arches paper.
Kunstmuseum, Basel, Kupferstichkabinett

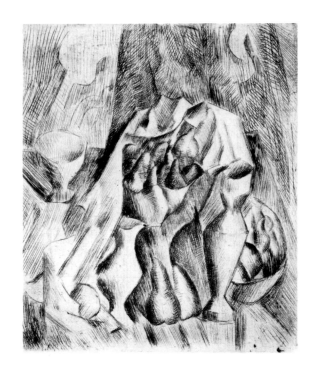

Illustrations for 'Saint Matorel' (181-4)

181 Mademoiselle Léonie

Executed in Cadaquès, summer 1910
Etching, $7\frac{3}{4} \times 5\frac{1}{2}$ (20 × 14.1)
Neither signed nor dated

Lit: Geiser 23, II b.

Edn: 106 copies published in 1911 by Kahnweiler, pulled by Delâtre; this sheet printed on Holland paper
Galerie Louise Leiris, Paris

182 Still-life on a Table

Executed in Cadaquès, summer 1910
Etching, $7\frac{3}{4} \times 5\frac{1}{2}$ (20 × 14.1)
Neither signed nor dated

Lit: Geiser 24, b

Edn: 106 copies published in 1911 by Kahnweiler; this sheet pulled by Delâtre, printed on Holland paper
Galerie Louise Leiris, Paris

183 Mademoiselle Léonie in a Chaise-longue

Executed in Cadaquès, summer 1910
Etching, $7\frac{5}{8} \times 5\frac{5}{8}$ (19.8 × 14.2)
Neither signed not dated

Lit: Geiser 25, III b

Edn: 106 copies published in 1911 by Kahnweiler; this sheet pulled by Delâtre; this sheet printed on Holland paper
Galerie Louise Leiris, Paris

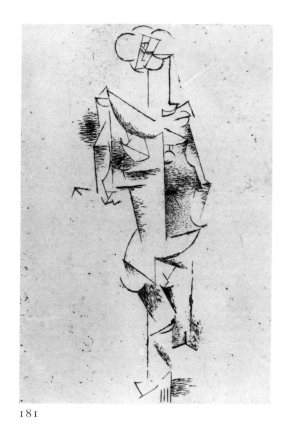

181

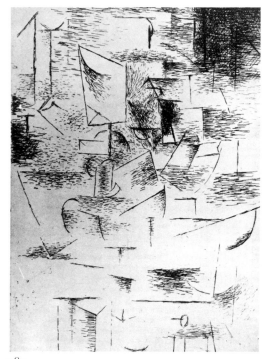

182

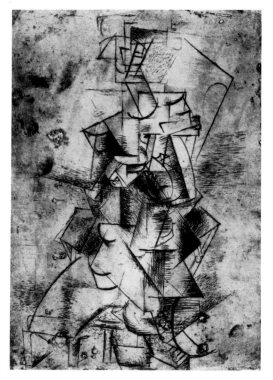

183

Illustrations for 'Saint Matorel' (181-4)

184 The Convent

Executed in Cadaquès, summer 1910
Etching, $7\frac{5}{8} \times 5\frac{5}{8}$ (19.8 × 14.2)
Neither signed nor dated

Lit: Geiser 26, b.

Edn: 106 copies published by Kahnweiler in 1911, pulled by Delâtre; this sheet printed on Holland paper
Galerie Louise Leiris, Paris

In April 1910, D.H. Kahnweiler, having decided to publish a novel by Max Jacob, set out to find an artist to contribute illustrations. Kahnweiler took a great interest in the poets who championed the painters of his gallery, and had already published in the previous year *L'Enchanteur pourissant* by Guillaume Apollinaire, which constituted, with its woodcuts by Derain, Apollinaire's first published book and Derain's first attempt at book illustration. Kahnweiler thought of Derain as well for Jacob's book, *Saint Matorel*, but Jacob militated for his old friend Picasso, whose already considerable fame would, in Jacob's estimation, enhance the prestige of the book. Kahnweiler and Picasso consented, and Picasso left Paris for Cadaquès with Jacob's text in his baggage.

The resulting illustrations only loosely relate to Jacob's strange tale of the conversion and eventual canonisation of a Parisian *petit bourgeois*. The first plate, a study of a nude, has been entitled 'Mademoiselle Léonie', a young girl who appears as a character in the second chapter of the novel. The second plate, a still-life, may refer to an inn in which Matorel dines in chapter 5. In the third plate, Mademoiselle Léonie reappears, holding a lute while sitting in a *chaise longue* – a product of Picasso's, not Jacob's imagination. The fourth plate, a landscape, has been called 'The Convent', a reference to a monastery in Barcelona where a decisive debate between Matorel and a friend occurs. This last work is curiously similar to the sketches Picasso made in Barcelona in early May, 1909, while on his way to Horta de Ebro (no. 162), so this may in fact reflect a deliberate reference by Picasso to Jacob's work. Otherwise, the titles of the works would seem to have been arbitrarily assigned after the fact of their execution.

Thus Picasso's etchings, the first Cubist book illustrations, initiated a new approach to the *livre de peintre* – one in which the illustrations stand quite independently of the text. But regardless of their relevance to the story by Jacob, Picasso's style in 1910, with its emphasis on a kind of linear, structural scaffolding, was particularly well suited to the process of etching. These four works are especially prized today for their beauty, even if *Saint Matorel* had barely sold before 1914. A majority of the 106 copies were seized in 1914 in the Kahnweiler sequestration, and sold in the first Kahnweiler sale in 1921.

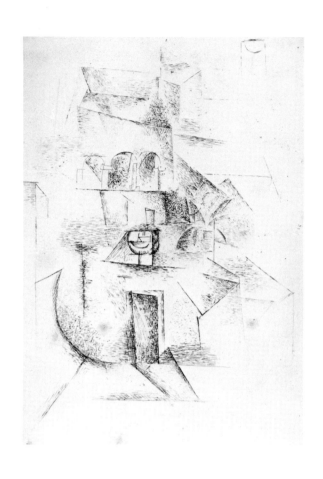

185 Head of a Man

Probably executed in 1911
Etching, $5\frac{1}{8} \times 4\frac{5}{16}(13 \times 11)$
Signed lower right: 'Picasso'

Lit: Geiser 32 b

Edn: 100 copies published in 1912 by Kahnweiler, pulled by Delâtre, printed on Arches paper
Private collection

Though Kahnweiler did not publish this etching until 1912, the figuration is extremely close to that of the drawing 'Head of a Man' (no. 163), which Picasso executed sometime in late 1910 or early 1911. Thus a revision of the date traditionally assigned to this etching, 1912, should be considered.

186 Still-life with Bottle of Marc

Executed in August-September 1911
Drypoint, $19\frac{11}{16} \times 12(50 \times 50.6)$
Signed lower right: 'Picasso'

Lit: Geiser 33 b

Edn: 100 copies published by Kahnweiler, pulled by Delâtre, printed on laid Arches paper
EWK, Bern

Commissioned by Kahnweiler in 1910 and published in 1912 along with 'Still-life with a Bottle of Gin (Fox)' by Braque (no. 52). Braque and Picasso each executed the plates late in the summer of 1911, while working together in Céret. The two resulting drypoints, of approximately equal dimensions, were undoubtedly considered by the two artists as pendants. They represent the moment of closest *rapprochement* of style between Picasso and Braque. While idiosyncratic characteristics betray the author of each work, each is nonetheless distinctive enough to suggest that the artists deliberately strove to create, in these two prints, a common, non-personal style. Both Picasso and Braque were sparing in their use of shadow and line, yet the compositions are still legible – essentially due to a liberal use of words and signs.

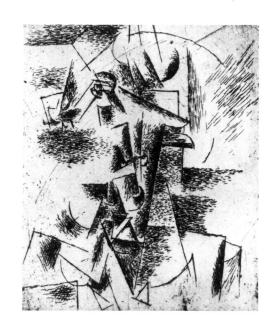

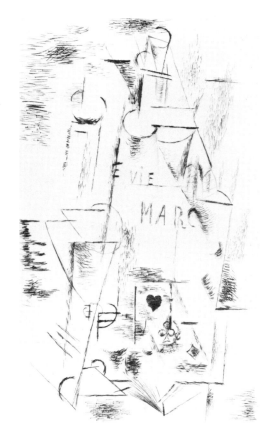

187 Still-life with a Skull

Executed in early 1914
Drypoint, $6\frac{1}{8} \times 4\frac{1}{2}(15.4 \times 11.4)$
Neither signed nor dated

Lit: Geiser 36, II b

Edn: 106 copies published in 1914 by Kahnweiler, pulled by Delâtre; this sheet printed on laid Arches paper
Galerie Louise Leiris, Paris

One of three prints commissioned from Picasso by Kahnweiler for inclusion in Max Jacob's *Le Siège de Jerusalem, Grande Tentation Celeste de Saint Matorel*. Kahnweiler first approached Derain to make illustrations for this book but he felt little sympathy for the mystical, revelatory content of Jacob's text. Picasso, on the other hand, was happy to oblige his dealer Kahnweiler and friend Jacob, knowing all along that he would disregard Jacob's text entirely. He supplied two etchings of a female nude in addition to the present 'Still-life with a Skull'. While some writers have identified the skull in this work as a *memento mori* associated with the book's sub-title, there is, to the contrary, no evidence that Picasso had seen or read the text before he submitted his three plates for printing.

188 Man with a Dog

Executed in spring 1914
Etching, $10\frac{15}{16} \times 8\frac{9}{16}(27.8 \times 21.8)$
Signed lower right: 'Picasso'

Lit: Geiser 39 III

Edn: 102 copies printed in 1930 on laid Arches paper
Trustees of the British Museum, London

Stylistically similar to the watercolour 'Man Reading a Newspaper' (no. 173) in that the figure and its setting here are constructed with a series of overlapping planes, as in a *collage* or a *papier collé*. Picasso probably intended originally to shade and tone more of the composition, but the plate was abandoned in 1914, and printed in its unfinished state when finally published in 1930.

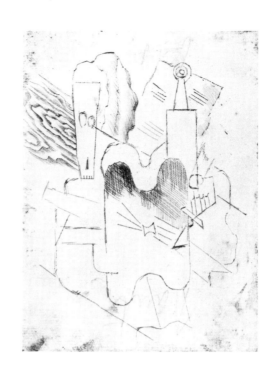

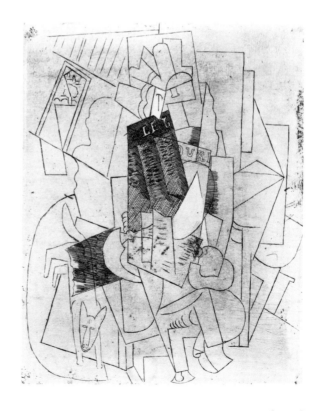

189 **Harlequin**

Executed in Paris, 1917
Etching and engraving, $6\frac{3}{8} \times 4\frac{5}{8}$ (16.3 × 11.8)
Neither signed nor dated

Lit: Geiser 54, II

Edn: 14 copies printed in 1917 for inclusion in the *édition de tête* of *Le Cornet a Dés* by Max Jacob (Paris, privately printed for the author); an unspecified number of additional loose sheets were also printed
EWK, Bern

This was the last Cubist print made by Picasso. While printmaking would become a major activity for Picasso in the 1920s and 1930s, his later works were all in a neo-classical idiom – apart from one or two exceptions in a modified late Cubist style, such as Geiser 99 and 241.

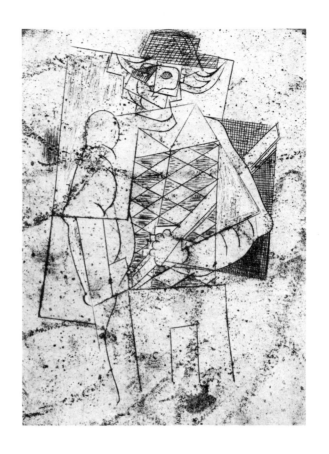

190 Head of a Woman

Original plaster modelled in Paris, autumn 1909, and cast in bronze by Vollard soon after; the cast exhibited here is one of nine cast from the original plaster (then in the Jacques Ulmann collection, now collection Marina Picasso) by Galerie Berggruen in a re-edition of 1959.
Bronze, 16¼ (41.3) high
Incised at back near the bottom edge: 'Picasso'; no. 6/9; not dated

Lit: Z.II** 573; S.24

Prov: Galerie Berggruen, Paris, 1959; to the present owner
Private collection, Switzerland

Although Picasso spent the summer of 1909 painting and drawing in Horta, his artistic approach to form was primarily sculptural. That is to say, he was most concerned with depicting objects in the round, and finding some means to reproduce on canvas his understanding of form in three dimensions. This he achieved in paintings like 'Nude Woman in an Armchair' (no. 118). But as soon as he returned to Paris in the autumn he applied his researches to modelling in plaster a head, which Vollard later cast in bronze. This 'Head of a Woman' looks like a three-dimensional translation of the portraits of Fernande he had recently painted: Picasso made the hair into a rhythmic mass of arcs, facetted the face to emphasise the structure of the bones under the skin and twisted the neck in order to show the back with the front simultaneously.

To be sure, this is the first example of Cubist stylisation applied to sculpture, but with it Picasso did not make a great sculptural innovation. He has gouged deep into the surface of the sculpture, but so had Rodin before him. In 'Head of a Woman' Picasso still fundamentally respects a traditional, monolithic conception of sculpture. While more important innovations would appear in Picasso's later Cubist sculpture and reliefs, one can nonetheless appreciate the substantial formal strength and poignant expression of this work.

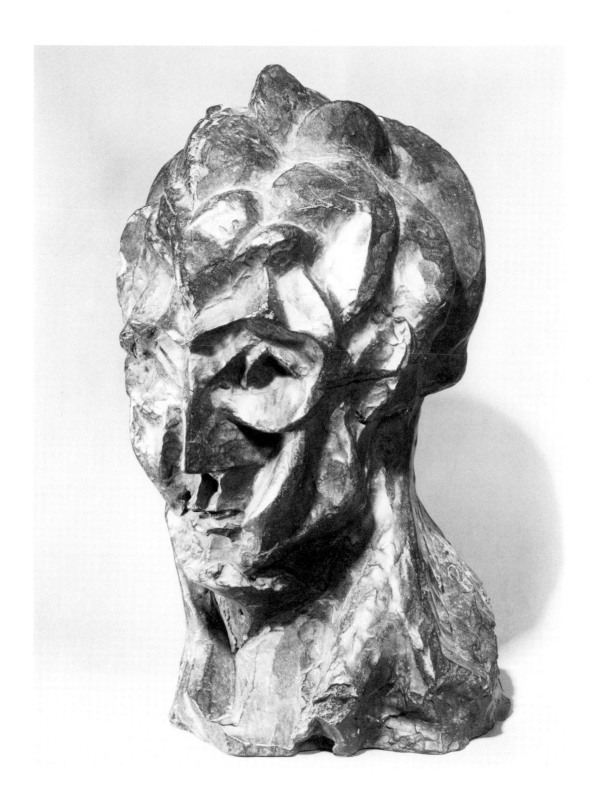

191 **Guitar**

Executed in Paris, autumn 1912
Cardboard, pasted papers, string, canvas, oil and graphite, $13 \times 6\frac{1}{2} \times 3(33 \times 16.3 \times 7.5)$
Neither signed nor dated

Lit: Z.II** 770; D.555; S.30; Museum inv.no. MP 244

Prov: the artist, 1912-73; estate of the artist, 1973-9; given in lieu of taxes to France (Dation Picasso), 1979
Musée Picasso, Paris

After Picasso first translated some *papiers collés* into cardboard and sheet-metal constructions in late summer, autumn and winter of 1912-13, he continued for three years to work in three dimensions while also making paintings and *papiers collés*. Constructions such as the present 'Guitar' were at first assembled casually from materials at hand and held together only with string and glue. An exception is the sheet-metal guitar of early autumn 1912 (now in the Museum of Modern Art, New York) that Picasso made after a cardboard *maquette*, but otherwise he did not work in durable materials until autumn 1913. At that time he used pieces of wood and assembled his constructions more carefully: this appears to reflect a change in Picasso's attitude and intentions. What first began as an independent experiment by Braque using cardboard and paper – Braque wrote in September 1912 to his dealer Kahnweiler that he was profiting from his stay in Sorgues by making, among other works, 'things that could not be made in Paris', i.e., little cardboard reliefs – was soon taken up by Picasso and exploited as a new means of expression. But neither Braque nor Picasso seems to have attached much importance to these works, at least at the beginning, for none of Braque's constructions survived the First World War, and none of Picasso's were exhi-bited or even sold to Kahnweiler. Indeed, while Picasso underscored in his contract with Kahnweiler of 18 December 1912 that all the *'escultures'* he produced would be bought, not one appears in the Kahnweiler photo-archives apart from the 1914 bronze, 'Glass of Absinthe' (no. 193). In his contract Picasso reserved the right to keep whatever he deemed necessary for his work, thus perhaps the early constructions were retained for that very reason. Several drawings Picasso made from late summer 1912 through 1913 reveal that he was studying his constructions in order to determine how light fell on the objects and how in turn shadows could be used to estab-lish spatial relationships in his paintings and *papiers collés*.

Regardless, however, of the immediate func-tion served by works like this 'Guitar' they were subsequently of great consequence for future developments in sculpture. For the first time, the physical mass of a sculpture was abandoned for a new constructive method in which volume and mass were suggested in-stead of being literally re-created. The internal space of a work could thus play just as active a role as the exterior, and Picasso's juxtaposition here of solid and void forces the observer to think in a totally new manner about the properties of everyday objects.

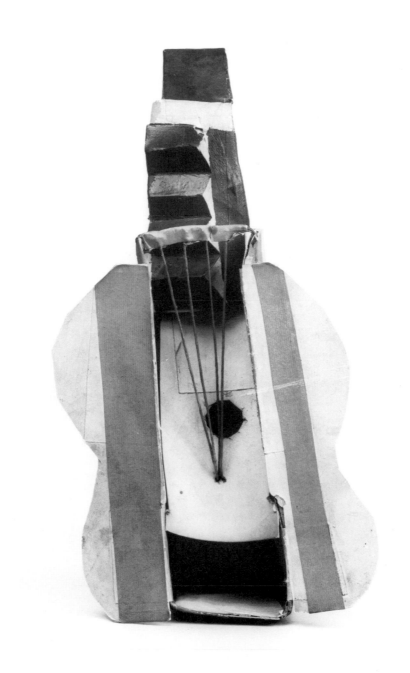

192 **Mandolin and Clarinet**

Executed in Paris, probably late autumn 1913
Graphite, oil and pine, $22\frac{5}{8} \times 14\frac{1}{8} \times 9 (58 \times 36 \times 23)$
Neither signed nor dated

Lit: Z.II 853; D.632; S.65; Museum inv.no. MP 36

Prov: the artist, 1913-73; Picasso estate, 1973-9; given in lieu of taxes to France (Dation Picasso), 1979
Musée Picasso, Paris

One of a group of works probably made in autumn 1913 of which five, though not the present construction, were published in *Les Soirées de Paris* on 15 November 1913. This publication created a great stir in Paris; André Breton, for one, still remembered in 1961 the impression made on him by seeing these re-productions:

I rediscover my youthful vision when I call to mind my first encounter with Picasso's work, at second hand, through an issue of Apollinaire's Soirées de Paris *which included rather hazy reproductions of five of his latest still-lifes (the date was 1913). Four of them were composed of an assemblage of materials of a residual nature such as slats, spools, discarded fragments of linoleum, lengths of string, all borrowed from everyday life. The initial shock provoked by an entirely new visual experience was succeeded by an awareness of the incomparable balance achieved by these works, which were thus endowed, willy-nilly, with an organic life that justified the necessity of their existence. Since then nearly half a century has gone by. I gather, from what Picasso said to me one day, that these early constructions have long since been dismembered [in fact, only fragments remain of the published pieces], but the image that remains of them suffices to demonstrate to what degree they anticipate those forms of expression today which are most convinced of their own daring. To what a degree, too, most often, they tower above these later forms through the sheer authority they radiate, an authority which immediately dispels the slightest suspicion of gratuitousness.*

(Quoted in McCully 1981, p.243; translated by Simon Watson Taylor.)

193 Glass of Absinthe

Original wax modelled in Paris, spring 1914; Kahnweiler had six casts made in bronze before summer 1914; these were then painted by Picasso
Painted bronze and perforated silver-plated absinthe spoon, $8\frac{1}{2} \times 6\frac{1}{2}$ (21.5 × 16.5)
Neither signed nor dated

Lit: Z.II** 581; D.755; S.36

Prov: the artist to Galerie Kahnweiler, Paris, 1914; sequestered Kahnweiler stock, 1914-21; 1st Kahnweiler sale, Hôtel Drouot, Paris, 13-14 June 1921, lot 139, sold for either 400 or 320 frs. to Léonce Rosenberg, Paris; Paul Rosenberg & Cie., Paris; Alexandre Rosenberg, New York, until 1958; Otto Gerson, New York, 1958; to the present owner in 1958
Private collection, Switzerland

By piercing the core of this sculpture and exposing simultaneously the interior and exterior of a glass of absinthe, Picasso has applied to a work cast in bronze the formal innovations he had made with his constructions of 1912 and 1913. But he has gone further and painted the bronze in the bright, decorative manner of his contemporary works in oil and *papier collé* and included a typically paradoxical reference to the illusory world of art. For the silver-plated sugar-strainer is real, whereas the cube of sugar is painted bronze. Picasso painted each of five casts differently, stressing from cast to cast one plane or curve at the expense of another; the sixth cast is uniformly painted white and covered with sand. Of them all, the present example is by far the wittiest and aesthetically the most successful.

194 Glass, Knife and Sandwich on a Table

Executed in Paris, spring 1914
Painted wood with upholstery fringe, $10 \times 18\frac{7}{8} \times 4 (25.5 \times 48 \times 10)$
Neither signed nor dated

Lit: D.746; S.47; Tate 1981, p.596; Museum inv.no.T1136

Prov: the artist, Paris, from 1914 until (probably) the mid-1920s; given to Paul Eluard, Paris, from c.1925 until 1938; to Sir Roland Penrose, London, 1938-69; sold to the gallery in 1969
Tate Gallery, London

'Glass, Knife and Sandwich on a Table', made sometime in the course of spring 1914, differs from Picasso's first constructions in that it was deliberately made to last and carefully painted. Yet Picasso still seems to cultivate both a casual approach to assemblage, and the use of heteroclite materials. But now a work like this was meant to exist as an independent object, hence its durable nature, even though its existence as free-standing sculpture is not established. For Picasso's constructions were all reliefs meant to be hung on a wall and seen from one side only: thus they were still fundamentally pictorial in nature. Even the radical advance Picasso and Braque had achieved in their first cardboard constructions – the opening up of solids and the adoption of transparencies, voids and internal volumes as positive elements of composition – is forgotten in the present work, which is based on a straightforward, if somewhat abridged, form of illusionism. The knife and sandwich are painted to appear as if they were authentic, and of course the fringe around the table's edge is just that. The only purely Cubist element here is the representation of the glass, in which a circular plane of painted wood projects forward, as does the front rim, in order to indicate the glass's diameter.

Nevertheless this assemblage has its novelty: while *trompe-l'oeil* had often appeared in sculpture of other periods, a sandwich appearing as a subject was quite new. No doubt Picasso was amused by such humorous inventions and that is perhaps another reason why he kept a construction like this for himself. Apart from one small paper and cardboard construction, 'Man with a Guitar and Sheetmusic' (D.582), which he gave to Gertrude Stein at the time, and the present work, which he gave much later to the poet Paul Eluard, none of his early constructions left Picasso's possession.

195 Glass, Pipe and Ace of Clubs

Executed in Paris, spring 1914
Painted metal and wood on wood 13¾ (34) diameter, 3½ (8.5) deep
Neither signed nor dated

Lit: Z.II** 830; D.788; S.45; Museum inv.no.MP 48

Prov: the artist, 1914-73; Picasso estate, 1973-9; given in lieu of taxes to France (Dation Picasso), 1979
Musée Picasso, Paris

Made slightly later than the preceding construction, this work shares many of the same *trompe-l'oeil* devices. On a round café table, here painted in green *faux marbre*, Picasso depicts a pipe, glass, ace of spades, and a die, all seen from above, save the glass, which the artist shows in profile. By painting the assemblage as a decorative ensemble, Picasso has fashioned a heraldic tribute to the pleasures of the café.

196 Violin

Executed in Paris, second half of 1915
Painted sheet-metal and wire, $37\frac{1}{4} \times 25\frac{5}{8} \times 7\frac{1}{2}$ ($95 \times 65 \times 19$)
Neither signed nor dated

Lit: Z.II** 580; D.835; S.55; Museum inv.no. MP 255

Prov: the artist, 1915-73; Picasso estate, 1973-9; given in lieu of taxes to France (Dation Picasso), 1979
Musée Picasso, Paris

Picasso's work in any one medium was, as a rule, intimately linked to his contemporary work in others. Thus when his painting style changed from the whimsical, decorative work of 1914 to the more rigorous and abstract style of 1915, the shift was soon apparent in his sculpture. Here Picasso has analysed the object in a 'synthetic' Cubist idiom composed of razor-thin planes of sheet-metal. The artist has banished *trompe-l'oeil* and humour in favour of a cool, dispassionate, but extremely satisfying analysis of form.

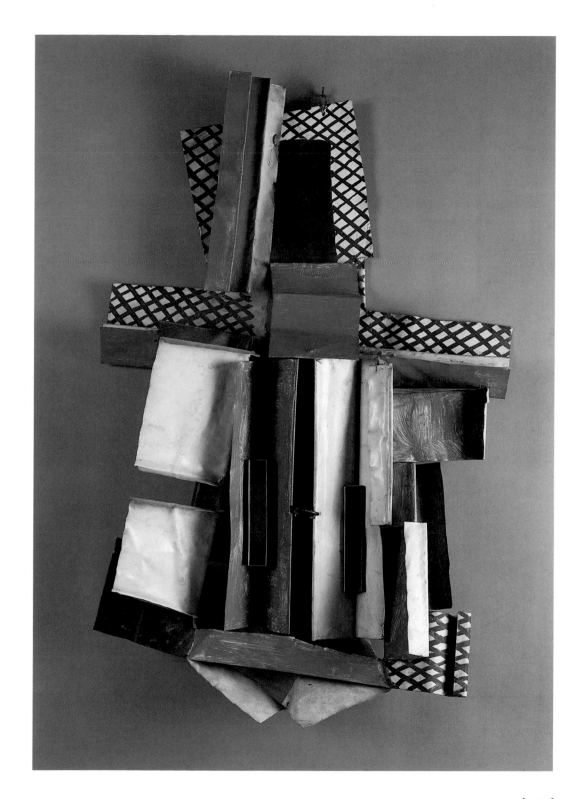

Henri Laurens 1885–1954

Sculpture and works on paper

Jacques Lipchitz 1891–1973

Sculpture

Works on paper

Marthe and Henri Laurens, Impasse Girardon, Montmartre, *c.* 1915 *Archives Laurens*

Jacques Lipchitz in his studio, 54 Rue de Montparnasse, *c.* 1920 *Archives Rubin Lipchitz*

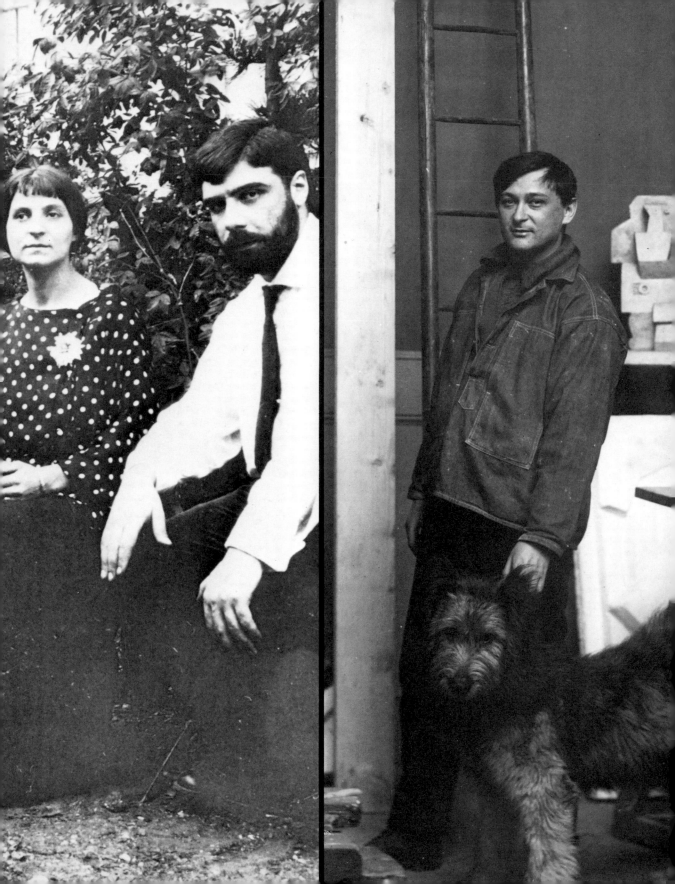

197 The Spanish Dancer

Executed in 1914 or 1915
Painted wood, 13⅜ (34) high
Signed on back at bottom: 'H.L.'; not dated

Lit: Museum inv. no. AMS 7

Prov: the artist to Galerie Simon, Paris (photo no. 7005; stock no. 6036), 1920; Jacques Zoubaloff, Paris, *c.* 1924 until 1935; Zoubaloff sale, Hôtel Drouot, Paris, 27-28 November 1935, lot 199; Comte Emmanuel Sarmiento, Paris, 1935-36; to the museum in 1936
Musée d'Art Moderne de la Ville de Paris

Laurens, who first worked as assistant to an academic, ornamental sculptor, before attending an open academy in Paris, met Braque in 1911 and established with him a close friendship that lasted for his lifetime. Laurens was clearly a born sculptor and from the start of his career was greatly impressed by the idiom of Cubism. Before 1911, neither Braque nor Picasso had made a truly Cubist sculpture, probably because the translation of a two-dimensional painted representation into three dimensions seemed to involve too many contradictions. Picasso's 'Woman's Head' of 1909 (no. 190), in which the artist explores the form and volume of a human head through facetting, is a bold attempt to extend the expressive range of the conventional representational idiom, but it does not overturn the inherited conception of sculptural representation as the new Cubist conception was actively doing in painting.

Braque was the first (August 1911) to evolve a new Cubist conception of sculpture in some three-dimensional sculptural assemblages, composed of cut-out representational forms in paper which, because they were apparently not intended to be free-standing, can best be classified as high reliefs. The materials being fragile, they soon fell apart or were lost. So Braque gave up making them, and today we only know one or two through photographs of the time. In any case, as

Braque himself told Christian Zervos (*Cahiers d'Art*, 1932, nos. 1-2), these reliefs were primarily intended to help 'to clarify and enrich his pictorial idiom' and were not thought of by Braque as sculptures. Yet at once Picasso sensed the importance of this new conception and started to make similar constructions himself. These – made between late 1912 and early 1914 – were more solid in so far as Picasso used wood, tin, sheet metal and cardboard. In most of them he cut and shaped the materials, then painted them to indicate forms and volumes. Once again, Picasso did not conceive of these constructions as free-standing sculptures but as high reliefs intended to be hung on a wall. They were literally extensions into three dimensions of objects and groupings which one encounters in Picasso's paintings of the period. But in two respects they represented wholly new sculptural conceptions: not only were they intended to be seen frontally, although they exist in real space, but also the artist sometimes treated mass as a void and represented it, as well as the inner space of objects, by a process of opening up.

Laurens, whose first sculptures were made in 1914-15, was shown the paper sculptures by Braque in 1912-13, and could also have seen reproductions of Picasso's Cubist reliefs as early as 1913. At all events, at the Salons of 1914 he also saw painted sculptural constructions by Archipenko, which were made

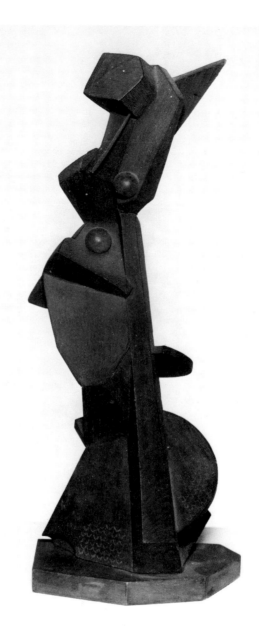

with various materials. All three experiences influenced Laurens's conception of his first Cubist sculptures, of which this is one.

This 'Dancer' is conceived as a free-standing figurine and is composed according to a pre-conceived design, that is, of a series of shaped wooden elements which represent both the dancer's costume and the planar structure of the figure. These are built around the central core of a tapering, more or less vertical plane which, at the level of the bust, yields to a strong diagonal ending in a sharp point. This probably signifies the dancer's elbow raised behind her head. By a rhythmic progression upwards from the swirling ornamented skirt at the base, a sense of movement is invoked.

198 **Head**

Executed in 1917
Pasted papers and charcoal on paper, $15\frac{3}{4} \times 22\frac{1}{2} (40 \times 57)$
Signed bottom right: 'Laurens'

Prov: Galerie Louise Leiris, Paris
Ida Chagall, Paris

The underlying sculptural conception is more
evident here than in no. 197. The modelling on
the planes, which rounds the forms and sep-
arates one plane from another, is an inno-
vation, but the features of the face drawn on a
white ground have been derived from known
works by Picasso.

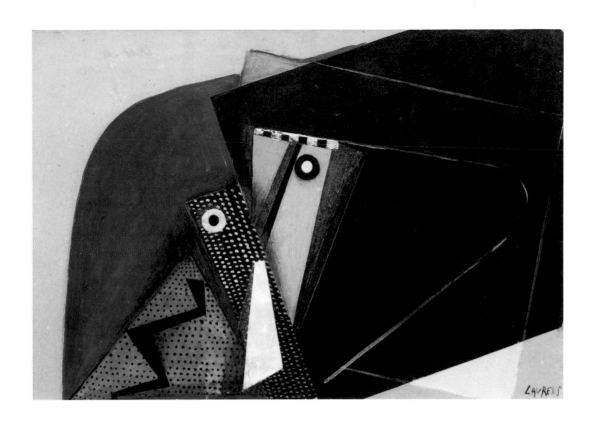

199 Head

Executed in 1917
Pasted papers, gouache and chalk on board, 19¾ × 23¼ (40 × 59)
Signed and dated bottom right: 'Laurens / 17'

Prov: Galerie Jeanne Bucher, Paris; to the present owner in 1955
Vieira da Silva-Arpad Szenes, Paris

A more elaborately constructed head with several overlapping planes. Volumes have been flattened and the elements composing the head spread out across the surface of the paper. The two eyes and the black plane of the nose are focal points, while the other two circles represent the ears. Laurens has constructed this head on the basis of light and dark areas in immediate opposition and in reverse from one side to the other, thereby evoking a play of voids and unbroken outer surfaces. A similar 'Head' (though carried down to the base of the neck), executed as a relief in painted wood, with a play of planes and voids which evoke mass, exists in the collection of the Museum of Modern Art, New York.

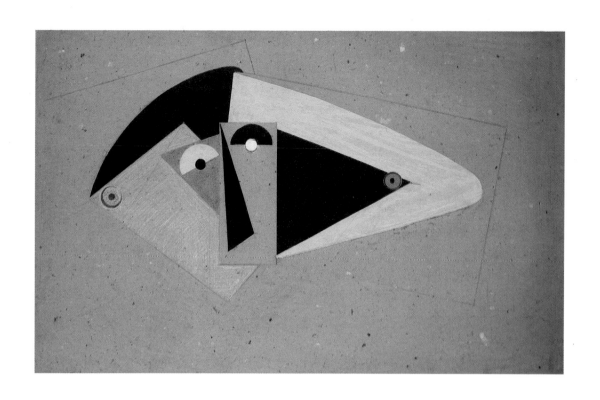

200 **Bottle and Glass**

Executed in 1917
Pasted papers, chalk and graphite on board, $23\frac{1}{4} \times 15\frac{1}{2}$ (59 × 39.5)
Signed and dated bottom right: 'Laurens / 17'

Prov: early whereabouts unknown; Sale, Sotheby's, London, 7 November, 1962, lot 31; sold to Galerie Leiris, Paris (stock no. 14518; photo no. 20132); to present owner in 1962
Private collection

Laurens, who was unfit for military service, remained in Paris during the war and was in touch with later Cubist developments through his friends Picasso and Gris. After 1916 he embarked on a series of *papiers collés* which were more ambitious than any he had made hitherto and which preceded some relief assemblages reminiscent of those made by Picasso between 1912 and 1914. They were in fact *tableaux-objets*. The *papiers collés* which Laurens made at the same time were still composed with overlaid planes of coloured paper, but the forms were now bolder than before, bolder even than those in *papiers collés* by Braque and Picasso. Drawing played a greater descriptive role, while Laurens used chiaroscuro freely to increase a sense of relief. There is an element of wit here in the neck of the bottle, the long black plane evoking a standing figure, while the hole (represented by pasting on a circular white form) evokes an eye. Note the abrupt change in the colours of the papers used by Laurens and the decorative value of the purple area. Note too that the glass on the left is represented with a succession of planes which are separate from those composing the bottle of wine. The transparency of the glass is indicated by over-drawing, while its mouth is represented by a white circle.

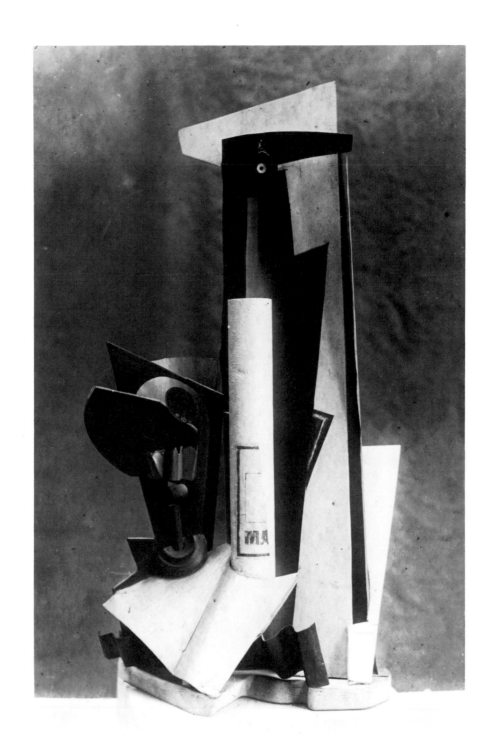

201 Seated Nude

Executed in 1917-18
Charcoal and pasted papers on board, $35\frac{3}{8} \times 26\frac{3}{4}(100 \times 68)$
Neither signed nor dated

Prov: early whereabouts unknown; G. David Thompson, Pittsburgh, *c.* 1955 until 1966;
Thompson sale, Parke-Bernet, New York, 23 March 1966, lot 28; Alain Tarica, Paris, 1966-70;
to the present owner in 1970
Private collection

A second, very similar, version of this composition (oval, $12\frac{4}{5} \times 9\frac{1}{5}[32 \times 23]$) is known from a photograph (no. 20145) in the Kahnweiler archives at the Galerie Louise Leiris, Paris.

This is an unusually large and yet economical *papier collé*. The representation of the seated nude figure is achieved solely with four overlaid sheets of coloured paper cut and shaped to indicate the component elements. Drawing is used to indicate one breast and the woman's navel. One eye is represented by a small round piece of white paper pasted on. The woman holds a guitar with her left hand: it can be identified in the bottom right corner.

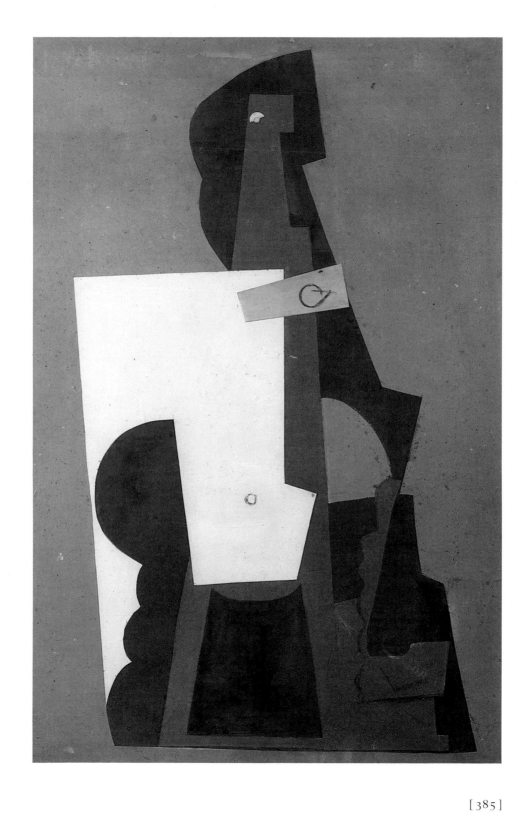

202 Bottle and Glass

Executed in 1917-18
Painted wood and metal, 23⅝ (61) high
Neither signed nor dated

Prov: the artist to Galerie Simon, Paris (photo no. 7000, stock no. 6032), 1920-?; 1920-1960 whereabouts unknown; Christian Zervos, Paris; Galerie Louise Leiris, Paris (photo no. 7000, stock no. 14593) in December 1963; to the present owner in 1963
Private collection, Paris

This free-standing relief assemblage is closely related to the preceding *papier collé* of the same subject (no. 200). Here Laurens has painted the planes in different colours to emphasise the structure of volumes. The round white tube with a label, which represents the internal volume of the bottle, serves as the central core from which the planes radiate outwards, thus situating the objects in a fictitious space, as opposed to the real space in which the sculpture stands.

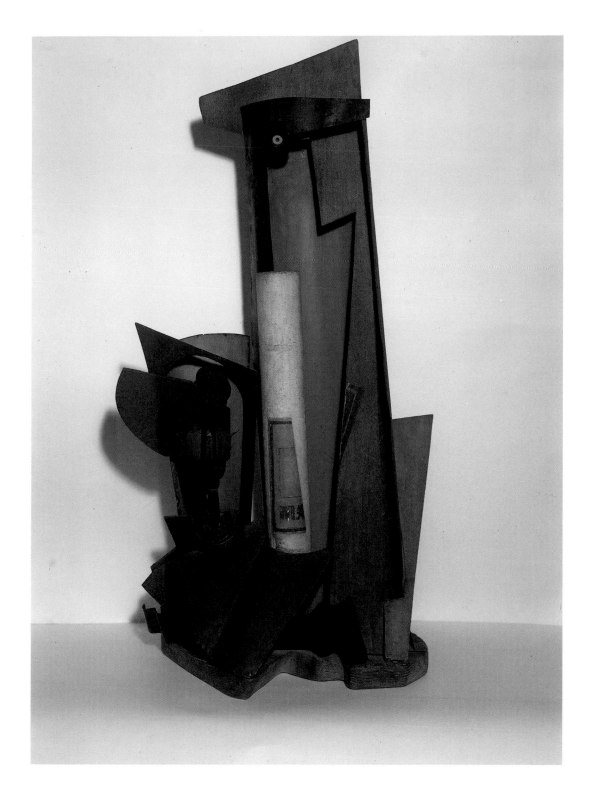

203 Fruit-dish with Grapes

Executed in 1918
Painted wood and metal, $25\frac{1}{4}$ (64) high
Neither signed nor dated

Prov: the artist to Galerie de l'Effort Moderne (Léonce Rosenberg), Paris (photo no. 93), 1918;
Maurice Raynal, Paris; Raymond Raynal, Paris; Galerie Ile de France, Paris; A. Backstrom,
Stockholm; Sale, Sotheby's, London, 28 March 1973, lot 62; sold to the present owners
Private collection

Conceived as a free-standing sculpture raised
on its own base. The foot of the fruit-dish serves
as a central core to which the various planes
relate and which holds up the hollow, rounded
volume of the dish in which the grapes are
lying. Here the full implications of the opening
up of sculpture and the potential of assemblage
are realised in a masterpiece of Cubist
construction.

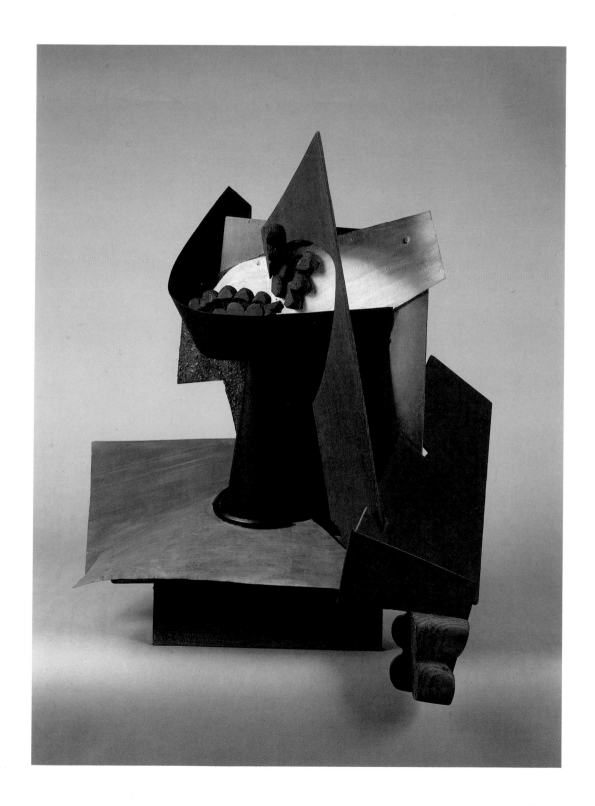

HENRI LAURENS

204 **Guitar on a Table**

Executed in 1918
Pasted papers, $19\frac{7}{8} \times 26\,(50.5 \times 66)$
Signed and dated top left: 'Laurens 1918'

Prov: the artist, Paris; Christian Zervos Paris; Jacques Dupin, Paris; Galerie Creuzevault, Paris;
to the present owner in 1965
Madame Denise Laurens, Brussels

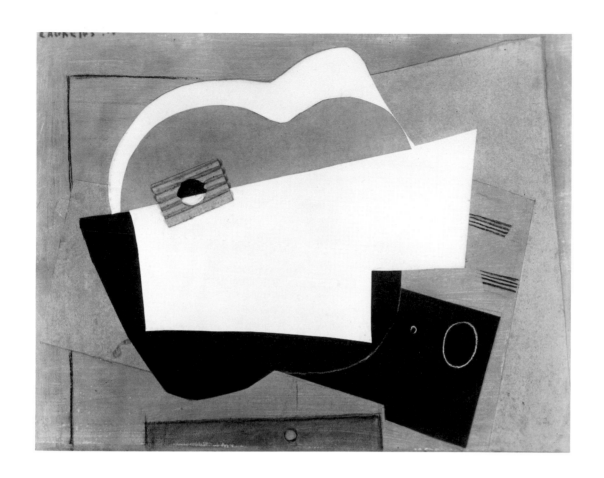

205 **Guitar**

Executed in 1919
Painted stone, 14½(37) high
Neither signed nor dated

Prov: the artist to Galerie de l'Effort Moderne (Léonce Rosenberg), Paris (photo no. 96), 1919; Galerie Simon, Paris (photo no. 7560; stock no. 10755), *c.*1924; to the present owner in 1941
Private collection

Though cut from a single block of stone, this free-standing guitar is intended to be seen only in its frontal aspect. Two colours, pink and white, are used to show planes retreating in depth. The two final planes, one on each side, are shaped to echo the outline of the instrument as established in the foremost plane on the left. Laurens here conveys a sense of the mass and depth of the guitar, but is not concerned with its inner volume. He was by now moving away from the issues raised by his Cubist constructions of the preceding years towards the aesthetic of the monolithic works he would make in the early 1920s.

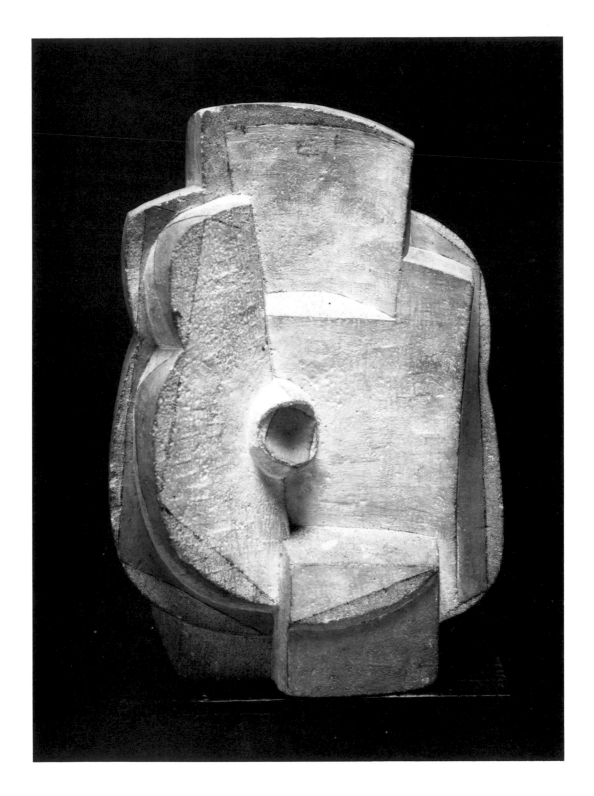

206 Bottle, Pipe and Glass

Executed in 1919
Wood relief, carved and painted, $16\frac{1}{8} \times 15\frac{3}{4}(41 \times 40)$
Signed bottom right: 'HL'; not dated

Prov: the artist to Galerie Simon, Paris (photo no. 7551; stock no. 10612), 1928; subsequent whereabouts unknown; Arnold Maremont, Chicago, by *c.* 1955; Galerie Tarica, Paris; to the present owner in 1982
Private collection, Paris

The conception here is pictorial rather than sculptural. Volumes have been suppressed and there is virtually no relief. The forms are distinguished from each other by the use of colour – colours which remind one of a painting by Braque. One is also reminded of Braque's predilection for irregular forms by the way the surrounding oval is brought to a point at the top and cut off at the base. This is a decorative panel of a kind one might find used in elaborate schemes of interior decoration.

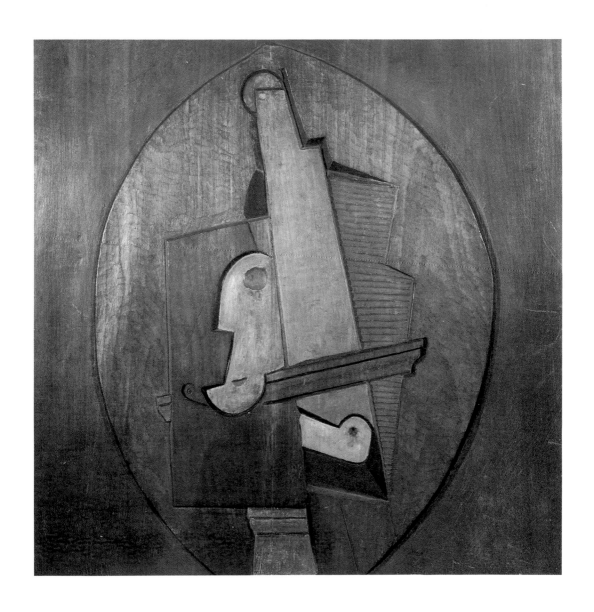

207 Head

Executed in 1919
Pasted papers, graphite and chalk on board, $20\frac{5}{8} \times 11\frac{5}{8} (52.5 \times 29.5)$
Signed and dated lower right: 'HL 1919'

Prov: the artist to Galerie Simon, Paris; Jacques Zouboloff, Paris, before 1935; André Lefèvre, Paris, until 1962; Lefèvre estate, 1962-65; 2nd Lefèvre sale, Palais Galliera, Paris, 25 November 1965, lot 12; sold to the present owner
Private collection

Here the underlying idea is of a sculptural nature. The head is composed of four planes of coloured paper – black, brown, white, grey – pasted in succession over each other (such as one finds in *papiers collés* by Braque and Picasso of 1914), shaped at the top to create the form of the skull and tapered at the base to represent the neck. Over this basic structure, Laurens has drawn a series of abbreviated notations (such as one finds in works by Picasso of 1913) to represent the eye, the ear, the line of the nose, the moustache and the hair of the man.

A second, very similar 'Head' in *papier collé*, also dated 1919, passed through the Galerie Simon, Paris, in the early 1920s (stock no. 13522; photo no. 7710).

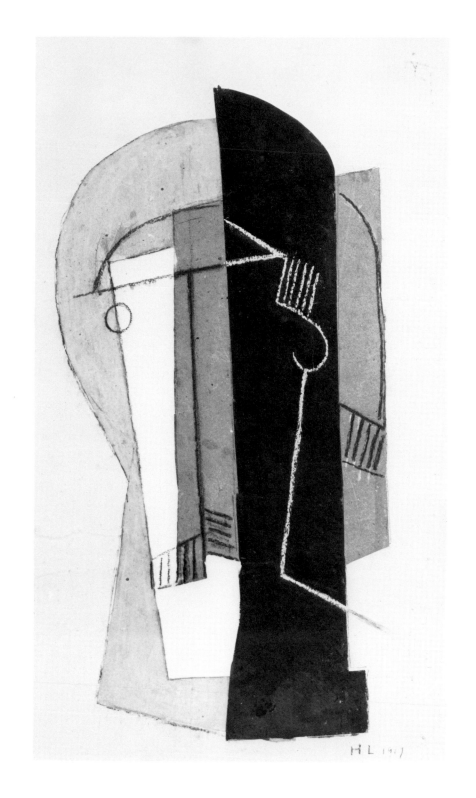

208 Woman with a Guitar

Executed in 1919
Stone, 23¼ (59) high
Neither signed nor dated

Prov: the artist to Galerie de l'Effort Moderne (Léonce Rosenberg), Paris (photo no. 181) 1919;
Sale, Hôtel Drouot, Paris, 26 March 1928, lot no. 62; Galerie Simon, Paris (photo no. 7835; stock
no. 10398), 1928; to Galerie Louise Leiris, Paris, until 1958; to the present owner in 1958
Private collection

In 1919 Laurens, who a year previously had begun to carve directly in stone, made a series of figures which exist fully in the round. This development was accompanied by an important change in his conception of Cubist representation, visible here. Forms were greatly simplified and appear as interlocking stone masses virtually devoid of descriptive detail. Basically, Laurens still relied on frontality. But by turning his forms in different directions and hollowing out certain areas, by subtle changes of level, the variation of angles and the penetration of one form by another, Laurens succeeds in persuading the eye to move around and through the mass as a whole, to feel its solidity and sense its volume, while establishing an understanding of the sculptural space involved. As he himself said: 'In a sculpture it is necessary for the voids to have as much importance as the full volumes. Sculpture is first and foremost a matter of taking possession of space, a space limited by forms.'

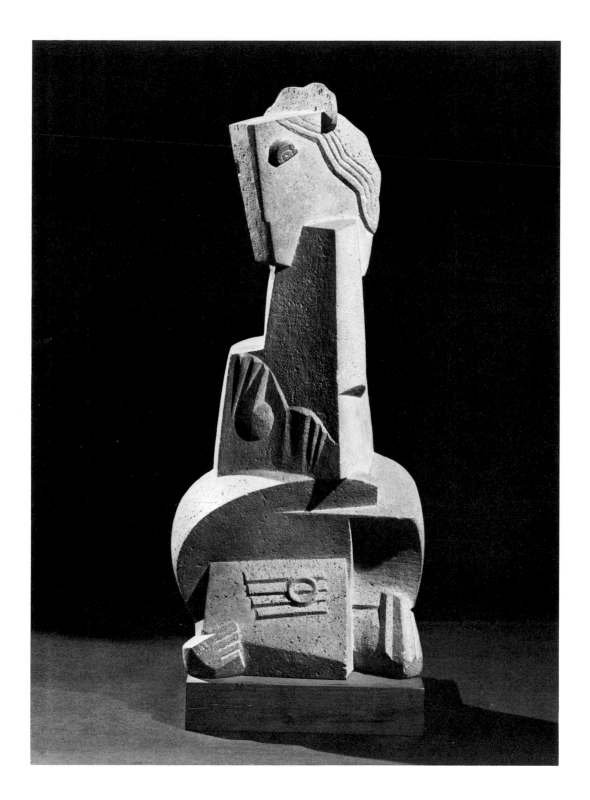

209 Guitar and Clarinet

Executed in 1919-20
Painted stone relief, $16\frac{1}{8} \times 23\frac{5}{8}$ (41 × 60)
Neither signed nor dated

Prov: the artist to Galerie de l'Effort Moderne (Léonce Rosenberg), Paris (photo no. 175), *c.* 1920; Jacques Doucet, Paris; Sale, Hôtel Drouot, Paris, 8 November 1972, lot no. 55; sold to the present owners
Private collection

At the same time as he was carving his figures, Laurens produced a succession of carved and painted stone reliefs, some with figures but the majority with still-lifes, as here. These derive, as a rule, from his *papiers collés* and are intended to be decorative. The black and white striped area behind the guitar, which represents nothing but gives relief to the instrument, is included for decorative reasons.

After 1921, Laurens abandoned the disciplined idiom of his Cubist-inspired sculpture in favour of a more conventional treatment of the figure with fully rounded volumes. And after 1924 he modified even this idiom considerably and created a very personal figural style based on more massive forms and heavy, curving rhythms.

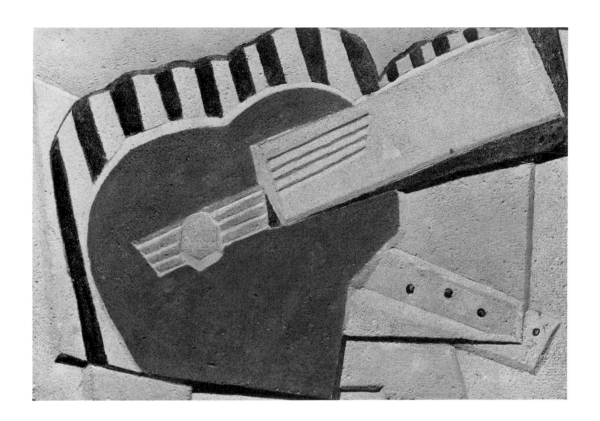

210 **Head**

Executed in 1915
Bronze, 24½ (62.2) high
Neither signed nor dated

Edn: five casts are known in bronze. The same sculpture was also transposed by a specialist into stone between 1915 and 1920. The plaster in the collection of the Musée National d'Art Moderne, Paris, made in 1915, served for making a single bronze cast (*Valsuani fondeur*) in 1915-16 in Paris. The other four casts, including the bronze exhibited here, were made after 1960 in America.

Lit: MNAM *Catalogue Lipchitz*, no. 5, pp. 23-5; Museum inv. no. T 310

Prov: the artist to Marlborough Fine Art, New York and London (after 1960); to the gallery in 1981
Tate Gallery, London

Lipchitz, coming directly from his birthplace in Lithuania, arrived in Paris to study sculpture at the age of eighteen in October 1909. During the next two years he attended the Ecole des Beaux Arts as a 'visiting student' and spent much time in the major museums of the city. By 1912, in receipt of an allowance from his well-to-do parents, he was living in a studio in Montparnasse next door to Brancusi, through whom he met Diego Rivera, a figure at that time on the fringe of Cubism. Rivera introduced Lipchitz to Picasso and other artists in Montparnasse and in 1916 Lipchitz became a close friend of Juan Gris. Lipchitz's first sculptures, made in 1913-14, were stylised *art nouveau*-type figures in which the joint influences of African negro sculpture and Archipenko are jauntily blended. By the end of 1914, however, he was constructing the figure with massive individual block forms facetted to evoke volume and create an interplay of planes.

This 'Head', composed of abstract forms, was Lipchitz's first essay in a Cubist-inspired idiom. Nonetheless, the artist has maintained a degree of figurative representation. The mass of the head is evoked by an uncomplicated structure of planes, rounded forms and directional lines which, as a result of the different angles at which they are placed to each other, produce a continual opposition between areas of light and shade. Such physical detail of the head as the forehead, the nose, the cheek and the rounded skull are legible.

According to Lipchitz's brother Rubin, the model for this 'Head' was Grégoire Landau, the son of friends of their parents. Landau was a student in Paris in 1910 when he encountered Lipchitz. He seems to have had a larger allowance than Lipchitz, whom he helped financially, even paying for his journey to Spain in 1914-15. A carved stone version of this 'Head' was given to Landau.

Lipchitz modelled each of his Cubist sculptures in plaster. They were then translated into stone in Paris, under his direction, by a professional stone-carver. Bronze casts of each of these were made in New York (Modern Art Foundry) at different times between 1960 and 1970.

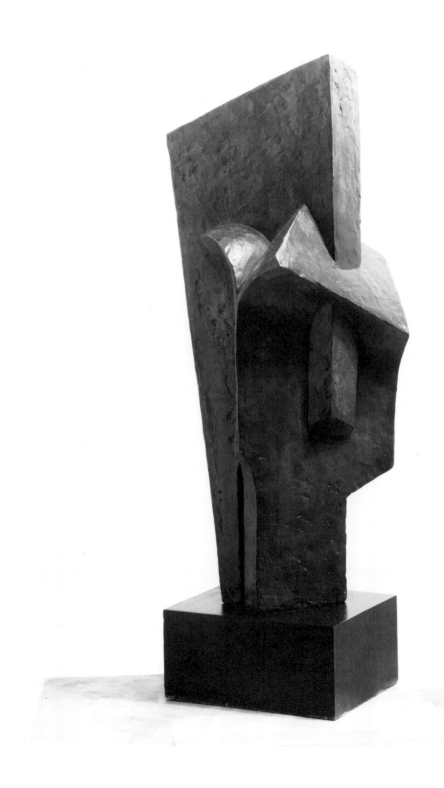

JACQUES LIPCHITZ

211 **Standing Figure**

Executed in 1915
Sandstone, 38½ (98) high
Signature and date inscribed on back of base: 'J. Lipchitz / 15'

Edn: seven bronze casts have been made in America since 1960. This version in stone was made
by a specialist in Paris between 1915 and 1918.

Prov: the artist, Hastings on Hudson, New York, to Marlborough Fine Art, New York and London
after 1960; to the gallery in 1982
Tate Gallery, London

In 1915-16, Lipchitz produced a small group
of tall, vertical sculptures representing figures
seated or standing. These are composed of
wholly abstract forms, some of them cylin-
drical, which represent the basic form and
volume of the body. They are abstract com-
positions which are not meant to be 'read'
literally; instead they suggest the human
figure through analogy. But no matter how
abstract Lipchitz's forms became, his concep-
tion of sculpture was nonetheless fundamen-
tally traditional. His was an art of mass and
volume. Unlike Laurens, he never explored the
potentials of Cubist constructions and assem-
blages in order to open up sculpture and turn
internal space and voids into an active com-
positional element.

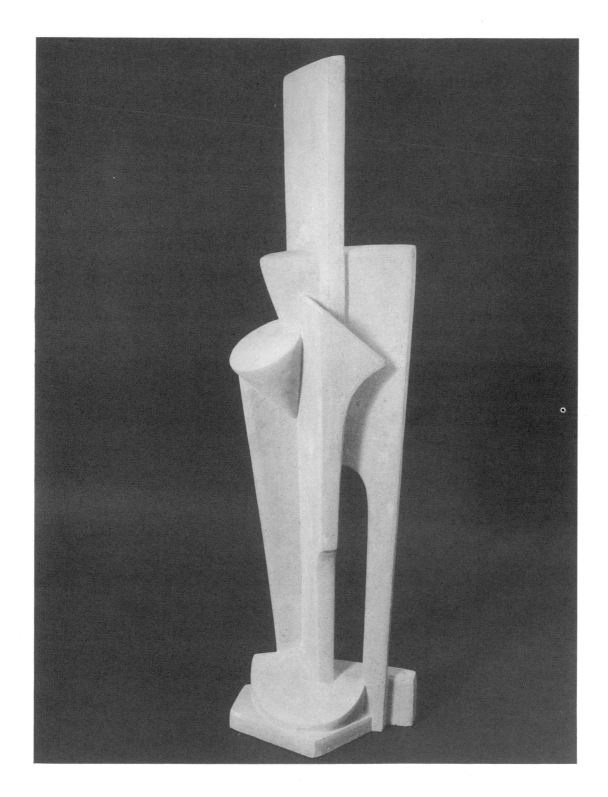

212 Man with a Mandolin

Executed in 1917
Limestone, 29¾ (75.5) high
Neither signed nor dated

Edn: one cast in bronze (made in America after 1960) is known; the original version in plaster (1917) is in the Musée National d'Art Moderne, Paris. This version in stone was carved by a specialist in Paris between 1917 and 1918.

Lit: Société Anonyme, p. 133; MNAM *Catalogue Lipchitz*, no. 9, pp. 32-3; Museum inv. no. 1941.547

Prov: the artist, Paris, until 1924; to The Société Anonyme (Katherine Dreier and Marcel Duchamp), New York, 1924-41; to the museum in 1941
Yale University Art Gallery, New Haven, Conn. Gift of Collection Société Anonyme

Despite its basically abstract formal structure, this massive stone carving represents a move back towards legible figuration, though the representational elements are stylised. The influence of Juan Gris's stylistic conception is apparent. The body of the figure is represented by a tapering mass of stone, on top of which is a small stylised form representing the neck and head. A sense of volume and spatial relationships is established by an intricate structure of interlocking planes, by the large cut void at the base, which evokes the two legs, and by the sound-hole of the mandolin on the left, which parallels the single eye at the top. The figure holds the mandolin close to its right side.

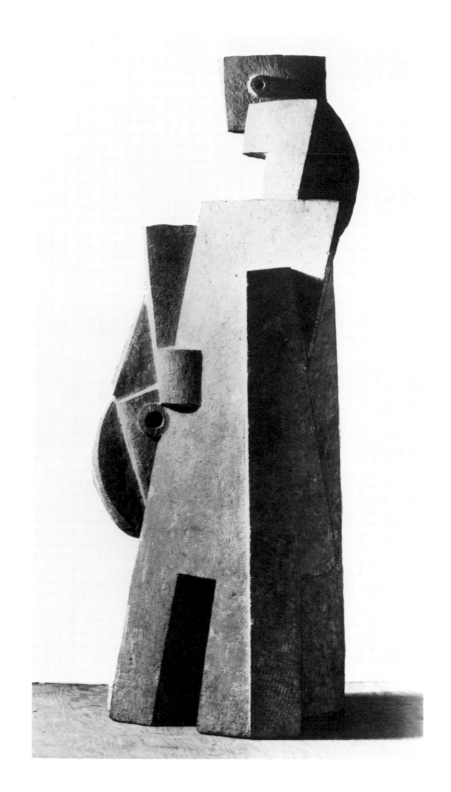

213 Still-life with Musical Instruments

Executed in 1918
Stone relief, $22\frac{7}{8} \times 27\frac{5}{8}$ (58 × 70.2)
Neither signed nor dated

Edn: the plaster of 1918 exists; one bronze cast (*Rudier fondeur*) was made in Paris during the 1920s, but further casts have been made in America since 1960. This stone version is unique

Prov: the artist, Hastings on Hudson, New York; to Marlborough Fine Art (New York), after 1960; to the museum in 1980
Kunstmuseum, Hannovermit Sammlung Sprengel

Lipchitz had not hitherto tried his hand at executing relief sculpture, because his natural instinct was to see and represent the free-standing figure in the round. But in 1918, when from April until September he was staying with Juan Gris at Beaulieu near Loches, Lipchitz was not equipped to make stone carvings and had to content himself instead with modelling reliefs in plaster. The resulting works were all still-lifes, some as here with musical instruments, and their conception was fundamentally of a pictorial nature. The influence of paintings by both Picasso and Juan Gris is evident.

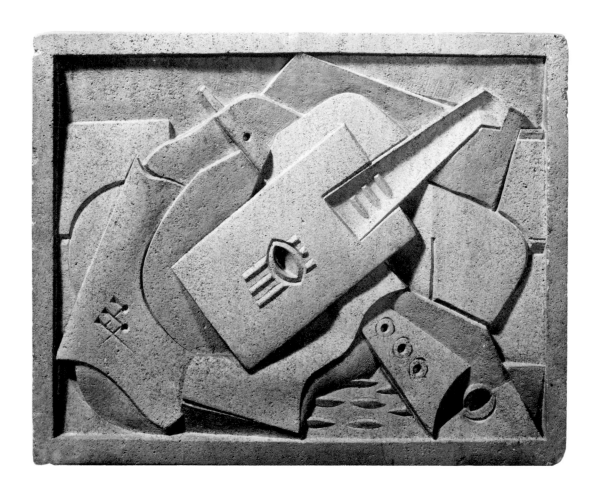

214 The Waitress

Executed in 1914
Sanguine and charcoal on paper, $16\frac{3}{4} \times 10\frac{1}{2}$ (42.5 × 26.5)
Signed and dated on right in centre: 'J. Lipchitz / '14'

Prov: the artist, Hastings on Hudson, New York; to the present owner *c.* 1964
Marlborough Fine Art (London) Ltd

Most of Lipchitz's early Cubist drawings seem to have been executed with a sculpture in view. This figure, which shows unmistakably the influence of African negro sculpture, represents, in the stylisation and generalisation of its forms, a move away from the rather decor- ative *art nouveau* conception underlying his earliest sculptures towards a Cubist-influenced analytical approach. Here one sees the artist working out a structure of interlocking planes to give volume to the figure. The waitress is holding a tray in her right hand.

215 Study of a Head

Executed in 1915
Graphite, crayon and gouache on paper, $19\frac{1}{4} \times 12\frac{1}{2}$ (48.9 × 31.8)
Signed top right: 'Lipchitz'; not dated

Prov: the artist, Hastings on Hudson, New York; to the present owner *c.* 1964
Marlborough Fine Art (London) Ltd

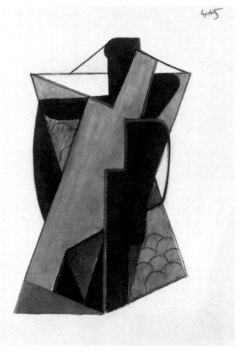

216 Mother and Child

Executed in 1915
Graphite and coloured crayons on paper, 15 × 10(38.1 × 25.4)
Signed and dated top left: 'J. Lipchitz / 1915'

Prov: the artist, Hastings on Hudson, New York; to the present owner *c.* 1964
Marlborough Fine Art (London) Ltd

The child is shown in silhouette standing in the mother's lap. There is an unusual confrontation here between the figure of the mother, a construction of several non-representational forms – except for the more legible, elongated face and the undulant hair – and the single generalised form of the child, clearly represented in silhouette.

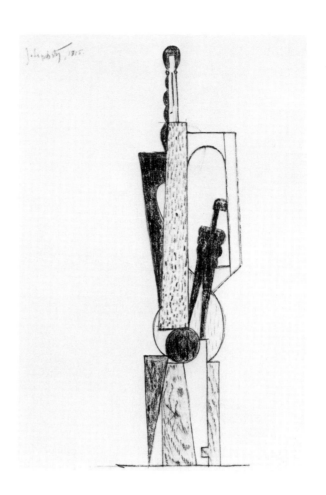

JACQUES LIPCHITZ

217 **Study for a Head**

Executed in 1915-16
Crayon and gouache on paper, $18\frac{1}{2} \times 13\frac{1}{4} (47 \times 33.5)$
Signed top left: 'J. Lipchitz'; not dated

Prov: the artist, Hastings on Hudson, New York; to the present owner *c.* 1964
Marlborough Fine Art (London) Ltd

The conception here is both two-dimensional and pictorial. The most recognisable feature of the head is the open mouth with four teeth showing. Colour is used decoratively to animate the flat surfaces.

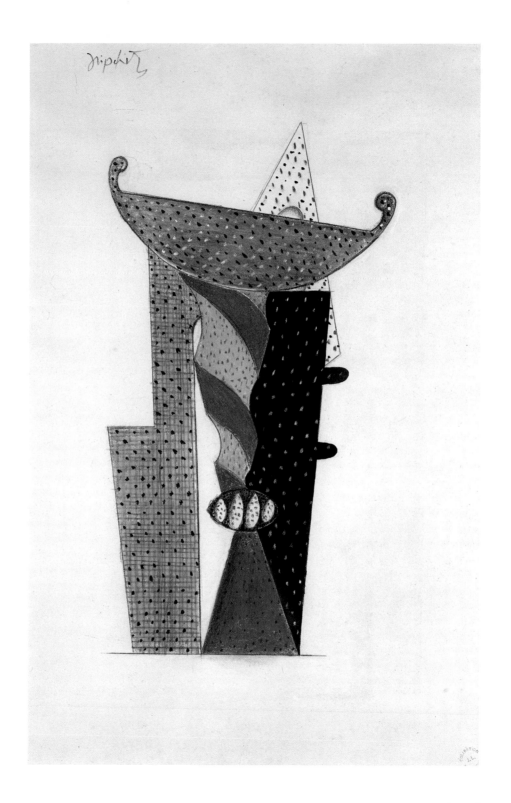

218 **Fruit-dish with Grapes**

Executed in 1918
Oil, paint and sand on paper, $11\frac{3}{4} \times 10\frac{1}{2}$ (29.9 × 26.7)
Signed top right: 'J. Lipchitz'; not dated

Prov: the artist, Hastings on Hudson, New York; to the present owner *c.* 1964
Marlborough Fine Art (London) Ltd

The conception of this brightly coloured com-
position is essentially two-dimensional and
pictorial. In fact Lipchitz made use of it to
create in 1919, after his return to Paris from
Touraine, a low relief (14 × 18 [35.1 × 45.2])
carved in stone, and painted, which is now in
the collection of the Musée National d'Art
Moderne (Centre Georges Pompidou) in Paris.
One bronze cast was made from the original
stone relief.

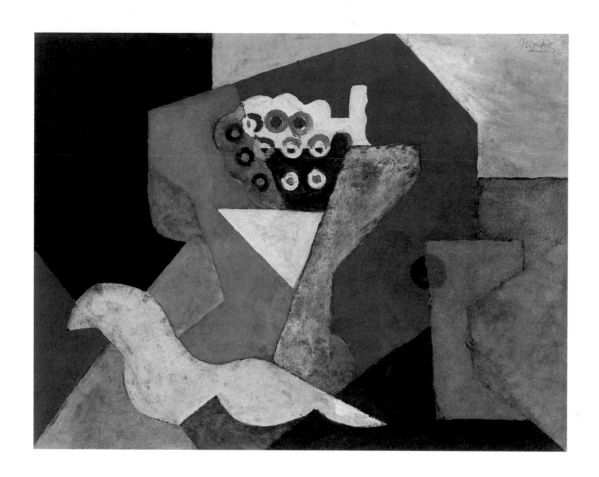

219 **Clarinet, Guitar and Sheet-music**

Executed in 1918
Charcoal on paper, $13\frac{3}{4} \times 17\frac{1}{4}(35 \times 43.8)$
Signed bottom left: 'Lipchitz'; not dated

Prov: the artist, Hastings on Hudson, New York; to the present owner *c.*1964
Marlborough Fine Art (London) Ltd

This is clearly a project for a composition in relief. A second, larger ($18\frac{3}{4} \times 11\frac{7}{8}[47 \times 29.8]$), simpler and more definitive drawing of the same subject is known (repr. in *Lipchitz Exhibition Catalogue*, Marlborough Gallery, London, 1973, no. 48). The sharply contrasted areas of light and shade in this drawing, as well as the use of heavy black lines, gives this drawing an unexpected expressionistic character. It has elements in common with a musical still-life composition executed in terracotta by Lipchitz in 1923 for Dr Barnes of Philadelphia. Beginning in 1925, Lipchitz abandoned the formal discipline of his earlier Cubist-inspired sculptures in favour of a freer, more rhythmic and expressionistic idiom.

Robert Delaunay 1885-1941

Paintings page 422

Albert Gleizes 1881-1953

Paintings and works on paper page 426

Louis Marcoussis 1878-1941

Print page 434

Jean Metzinger 1883-1956

Paintings page 436

Jacques Villon 1875-1963

Paintings and prints page 440

220 The Eiffel Tower Framed between Curtains

Painted in 1910-11
Oil on canvas, $45\frac{5}{8} \times 38\frac{1}{4}$ (116 × 97)
Signed bottom right: 'R. Delaunay'; a former inscription with the date '191[?]', in the centre at the bottom, has been painted over

Lit: Düsseldorf 1968, no. 20; Museum inv. no. 1018

Prov: Jean Coutrot, Paris: to the museum in 1965
Kunstsammlung Nordrhein-Westfalen, Düsseldorf

Delaunay, who had no formal training, adopted from the start of his career the purely colourist as opposed to the linear stylistic approach to painting. The first influences which determined his style were those of late Impressionism, Neo-Impressionism and probably also Fauvism. His main concern was with light, evoked by colour contrasts, and with sensations of space: Delaunay was not concerned with solid tangible reality, nor with the formal analysis of objects. Cézanne's use of colour was another source of his inspiration and he was, therefore, consciously and temperamentally opposed to the method and achievements of Cubist painting. Yet he profited by what he saw of the fragmentation of forms in the paintings both of Cézanne, as well as of Braque and Picasso, to create in his own works a new type of non-perspectival space and a sense of movement. He achieved this through the interplay of blocks of colour, as opposed to line and modelling, which evoke objects and a spatial experience. Delaunay was therefore shocked by and rejected the neutral tonalities and sparse linear structure of Cubist paintings by Braque and Picasso. To him, these appeared to be 'painted with cobwebs'.

In this view of the Eiffel Tower and some surrounding buildings, Delaunay has used Cubist fragmentation to express a dynamic vision of a modern city. He has flattened the pictorial space, yet he invokes a spatial experience by splaying out the sides of the tower and by representing sections of it, as the structure rises into the sky, from a series of different viewpoints.

221 Windows Open Simultaneously (First Part, Third Motif)

Painted in 1912
Oil on canvas, $18 \times 14\frac{3}{4}$ (46 × 37.5)
Inscribed bottom right: 'Les Fenêtres 1912 / à Alex Tairoff amicalement ce souvenir de Paris, 1923'; also inscribed on back: 'lère partie 3me motif / Fenêtres ouvertes simultanément / Paris 1912 / Delaunay'

Lit: Tate 1981, pp. 160-2; Museum inv. no. T 920

Prov: the artist, Paris, to Alexander Tairov, Moscow, 1923-62; Georgi Costakis, Moscow, 1962-67; Costakis sale, Sotheby's, London, 26 April 1967, lot 51; sold to the gallery
Tate Gallery, London

Delaunay was here re-creating the visual experience of looking out of an open window in his studio across the city of Paris. The focal point of this objectless colouristic composition is a triangular form, with a long tapering neck, broken into two facets at its base and painted green, which represents the Eiffel Tower. This style of painting was christened 'Orphism' by Guillaume Apollinaire and treated by him as a major branch of Cubism. It is, in fact, a style which, at first, took advantage of Cubist discoveries but which, in its later development after 1911, was transformed into the opposite of Cubism, particularly because it stood for the dematerialisation of reality. Apollinaire, whose pictorial judgment was confused and who therefore arrived at misguided conclusions, included Kupka and Léger among the Orphists. But there is nothing in common between these artists, Delaunay and Léger, except a concern with the basic nature of colour. Kupka, on the other hand, influenced Delaunay after 1912 towards abstract conceptions involving coloured forms and the orchestration of colour.

222 Portrait of Jacques Nayral

Painted in 1910-11
Oil on canvas, $63\frac{3}{4} \times 44\frac{7}{8}$ (162 × 114)
Signed and dated bottom right: 'Albert Gleizes / 1911'

Lit: Museum inv. no. T 2410

Prov: the artist to Joseph Houot, Paris (Jacques Nayral was a pseudonym); Mme Joseph Houot, Paris; her son Commandant Georges Houot, La Flèche, until 1979; Sotheby's, London, 5 December 1979, lot 79; sold to the gallery
Tate Gallery, London

Jacques Nayral (1879-1914), a young author and dramatist, was chief editor at the publishing house of Figuière. He was himself responsible for accepting and publishing Apollinaire's *Les Peintres Cubistes* (1912), as well as Gleizes and Metzinger's *Du Cubisme* (1912). Nayral was associated with the sociological aims of the group known as L'Abbaye de Créteil. In 1912, Nayral married Gleizes' sister Mireille. The background of this portrait is derived from the garden of the artist's house in Courbevoie, a Parisian suburb.

Nayral was killed in action near Arras in December 1914, and a sketch for a later commemorative portrait is shown here as no. 226. The early sketches for the present portrait are dated 1910.

Gleizes, like his friend Metzinger, was, at least until 1911, one of a group of Parisian painters who looked on themselves as followers of Cézanne and worked in a colourist idiom. But Gleizes and Metzinger looked back at Cézanne with a knowledge of facetting in the 1909-10 works of Braque and Picasso, which they had seen. Pursuing formal dislocations, a timid degree of facetting and formal stylisations, they and their friends saw themselves, by 1911, as a Cubist group, and because they exhibited together at the Indépendants and the Salon d'Automne they represented the new style for the Parisian public, which did not see the truly creative work of Braque and Picasso.

This is not a true Cubist picture. It is a conventional portrait painted in a post-Cézannian idiom, which involves elementary facetting and cubification derived from Braque and Picasso.

ALBERT GLEIZES

223 **Bridges in Paris (Passy)**

Painted in 1912
Oil on canvas, $22\frac{7}{8} \times 28\frac{3}{4}(58 \times 73)$
Signed bottom left: 'Albert Gleizes'; not dated

Lit: Museum inv.no.65/B

Prov: the artist, Paris; Sidney Janis Gallery, New York; to the museum in 1961
Museum Moderner Kunst, Vienna

The conception underlying this cityscape with the buildings of Paris, the Seine and three bridges built across it (in the foreground), is Cubist in intent but lacking in the consistency of contemporary Cubist paintings by Braque and Picasso. There is a conflict here between fragmentation and a realistic representation of various other elements. The dominant in-fluence seems to be that of Léger's paintings of the rooftops of Paris executed in 1911. Since 1910, the *Section d'Or* group, formed around the brothers Villon, used to meet on Mondays at Gleizes' studio in Courbevoie. The group included Léger and Gris (see commentary on no.229).

224 **Landscape**

Painted in 1912
Oil on board, $14\frac{3}{4} \times 17\frac{1}{8}(37.5 \times 43.3)$
Signed and dated bottom left: 'Alb. Gleizes / 12'

Lit: Guggenheim 1976, no.46, p.139; Museum inv.no.38.474

Prov: the artist, Paris, 1912-38; to the museum in 1938
Solomon R. Guggenheim Museum, New York

Here Gleizes has sacrificed, by contrast with no.223, the appearance of the landscape to a combination of abstract forms within a linear structure. Thus only a few elements are easily identifiable, such as the river in the foreground flowing under a bridge on the extreme left.

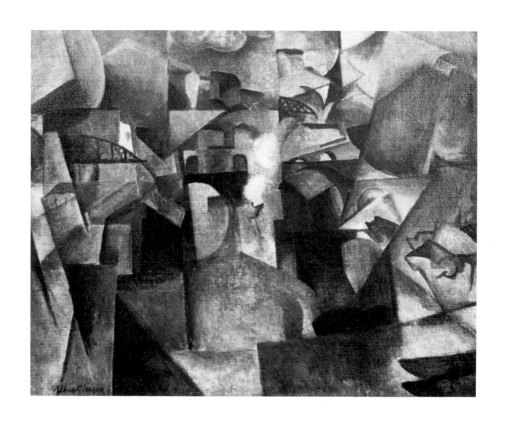

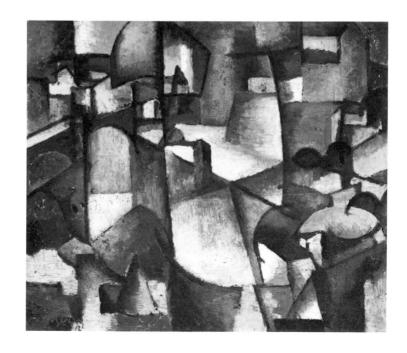

225 Landscape

Painted in 1913
Oil on canvas, $36\frac{3}{8} \times 25\frac{5}{8}$ (92.4 × 52.4)
Signed and dated bottom left: 'Alb. Gleizes 13'; and on back: 'Paysage / A. Gleizes'

Lit: Quinn 1978, no. 28; Museum inv. no. 31.59

Prov: the artist, Paris, to Walter Pach, New York; sold for $200 to John Quinn, New York, 1916-24;
Quinn estate 1924-7; Quinn sale, American Art Association, New York, 9 February 1927,
lot 512; sold for $110 to Ferdinand Howald, Columbus, 1927-31; to the museum in 1931
Columbus Museum of Art, Ohio. Gift of Ferdinand Howald

A country village is represented: in the foreground is a low bridge and in the background a high viaduct or railway bridge. The spatial structure with long, thin, vertical planes, the formal simplifications and contrasts, the clear and bright colours derive from such paintings of Léger as 'The Level Crossing' of 1912. A similar, though mathematically calculated, structure of strip-like upright planes was used to great effect by Juan Gris in paintings of the summer of 1913, such as 'Landscape at Céret' (no. 63).

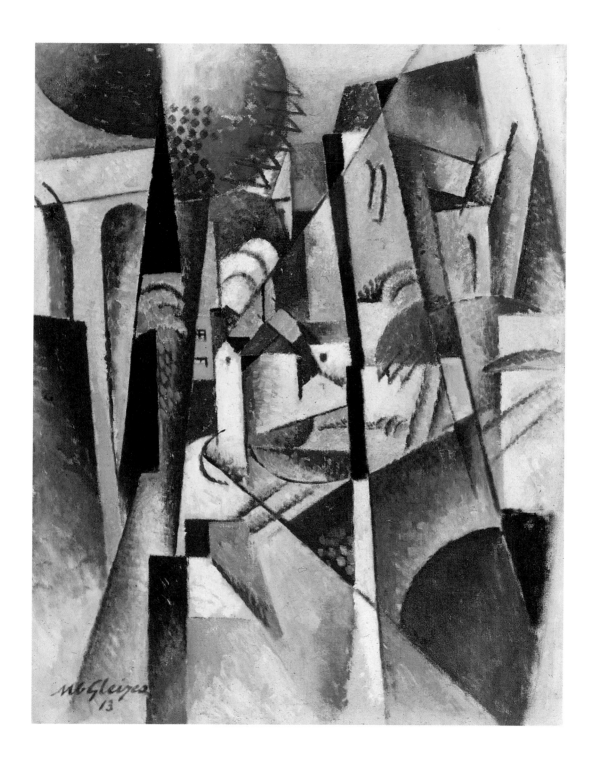

226 Sketch for Portrait of Jacques Nayral

Executed in 1914
Gouache on paper, 16 × 12 (40.5 × 30)
Signed and dated bottom left: 'Alb. Gleizes / 14'; inscribed: 'Jacques Nayral tué à la Bossie 1914'

Prov: the artist, Paris, to Mme Juliette Roche Gleizes, Paris, by 1953; to the present owner in 1956
Marlborough Fine Art (London) Ltd

This posthumous sketch of Nayral's head and shoulders may have been designed by Gleizes with a second portrait of his brother-in-law in view (compare no. 222 of 1910-11). The spatial flattening, like the structure of the composition, is Cubist in conception and reveals the influence of Juan Gris.

227 Study for the Portrait of an Army Doctor, No. 1

Executed in 1915
Ink on paper, $7\frac{3}{4}$ × 6 (19.7 × 15.2)
Signed and dated bottom right: 'Alb. Gleizes / Toul 1915'; inscribed below: 'Pour le Portrait du Prof. Lambert'

Lit: Guggenheim 1976, no. 49, fig. a, pp. 145-9; Museum inv. no. 38.760

Prov: the artist, Paris, 1915-38; sold to the museum in 1937
Solomon R. Guggenheim Museum, New York. Gift of Solomon R. Guggenheim, 1937

Gleizes has here adopted methods of composition which approach the 'synthetic' Cubist idiom created by Braque and Picasso.

LOUIS MARCOUSSIS

228 Portrait of Guillaume Apollinaire (1st Version)

Executed in 1912
Drypoint, $19\frac{1}{4} \times 10\frac{5}{8}(49 \times 27)$
Neither signed nor dated

Edn: ten on Arches paper

Lit: Lafranchis 1961, G.31, p.325; Museum inv.no.50-134-A1-128

Prov: Louise and Walter C. Arensberg, New York and later Hollywood, until 1950; to the museum in 1950, but not installed until 1954
Philadelphia Museum of Art, Philadelphia. Louise and Walter C. Arensberg Collection

This is the first of two such engraved portraits of this date, the second (Lafranchis G.32) being dated '1912-1920' in the plate. The composition here is longer than in the second version and includes in the foreground a table with a pen and inkwell on it, as well as a sheet of paper, on which the poet's left hand is placed. Written on it is a poem. The poet's head is clearly rendered here and facetting has been left to a minimum. In the second print, the word 'Kostrowicki' does not appear at the top. A third much smaller portrait of Apollinaire (etching; Lafranchis G.113) is a greatly simplified variant of this first version and was executed in 1934 as an illustration for a new edition of Apollinaire's volume of poems *Alcools*.

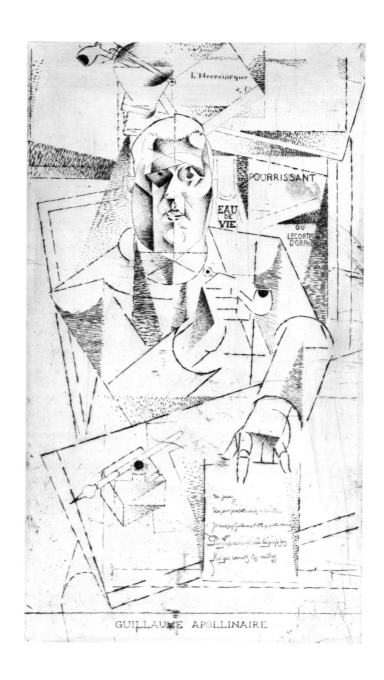

JEAN METZINGER

229 Portrait of Albert Gleizes

Painted in 1912
Oil on canvas, $25\frac{1}{2} \times 21\frac{1}{4}$ (65 × 54)
Signed bottom right: 'Metzinger'; not dated

Lit: Museum inv. no. 66.162

Prov: early whereabouts unknown; Mlle Henry, Paris; Leonard Hutton Galleries, New York; to the museum in 1966
Museum of Art, Rhode Island School of Design, Providence. Auction and Museum Works of Art Funds

The three brothers Duchamp-Villon, who lived at Puteaux on the outskirts of Paris, were active members of a group of self-styled Cubist artists. They encouraged a theoretical approach to the representational problems of Cubism, and relied on geometrical calculations. Their theories of harmonious relationships were based on an analysis of the structural principles practised by masters of earlier centuries. Metzinger joined the group, although his pictorial vision was basically naturalistic. He did his best to follow the example of his friends and would impose on his subject a system of planes, angles and proportional relationships which were intellectually determined. Metzinger's painting, therefore, appears artificial and schematic. The group of modern-minded artists around the Duchamp-Villon brothers was called La Section d'Or (The Golden Section): Gris was an occasional visitor. The influence of Gris on Metzinger was considerable, as is evident here in the vertical planar structure. Compare paintings by Gris of 1912-13. Note that the artist's palette, which appears behind his head, is apparently unattached, an illogicality which one does not find in Cubist paintings by Braque and Picasso.

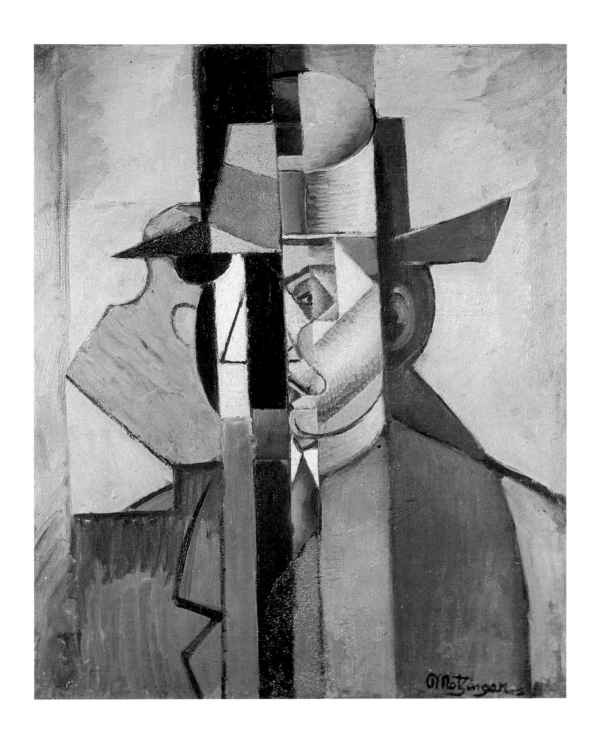

JEAN METZINGER

230 The Yellow Feather

Painted in 1912
Oil on canvas, $28\frac{3}{4} \times 21\frac{1}{4} (73 \times 54)$
Signed and dated bottom left: 'Metzinger / 12'

Prov: the artist to Caroll Galleries, New York ($100) as agent for John Quinn, New York, 1916-24; Quinn estate, 1924-26; Dr Ing. Oscar Stern, Stockholm, by 1954; Philippe Reichenbach, Paris; to the present owners by 1964
Mr and Mrs R. Stanley Johnson

In the structure of this figure piece, Metzinger – a painter of little imagination and no originality – has clearly sought guidance from the Cubist paintings of Braque and Picasso of 1910. But he has not properly understood the pictorial logic of their compositions, with the result that an inner stylistic conflict exists here between naturalistic forms, angular stylisations, illustrative drawing and an arrangement of Cubist planes. Metzinger has taken a superficially Cubist figure, dressed it up and placed it in a wholly conventional, bourgeois setting. This provides the excuse to incorporate several decorative passages: the lace curtain, the woman's *jabot*, the fan, for example.

Note that the woman's left eye is missing, while the right eye is suggested by a freestanding linear curlicue. The painting of the feather in a contradictory Impressionist manner crowns the picture with a touch of humour.

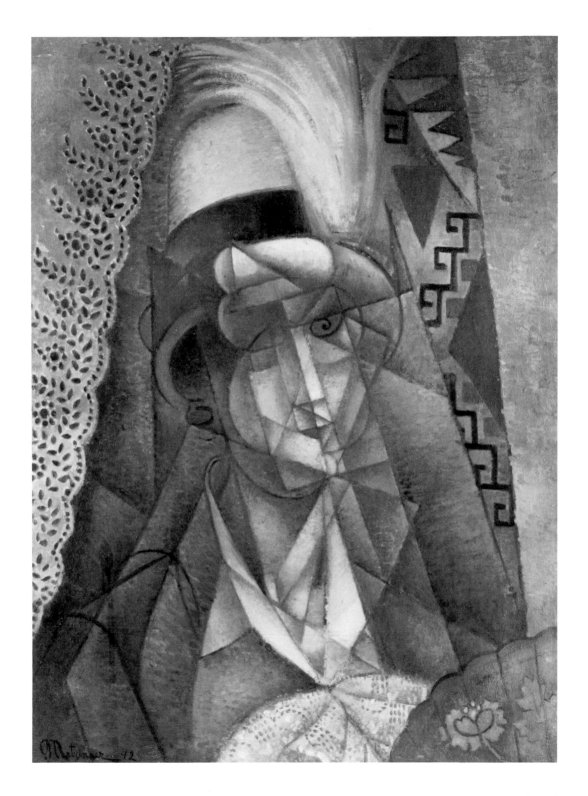

231 **Portrait of Mlle Y. D.**

Painted in 1913
Oil on canvas, $50\frac{3}{4} \times 35 (129 \times 89)$
Signed lower right: 'Jacques Villon'; not dated

Lit: Museum inv.no. 53.28.1

Prov: the artist, Paris, to John Quinn, New York ($525) 1915-24; Quinn estate, 1924-7;
Leo Bing, Los Angeles; Anna Bing Arnold, Los Angeles; to the museum in 1953
Los Angeles County Museum of Art. Gift of Anna Bing Arnold

Towards the end of his life, Villon referred to himself as 'the Impressionist Cubist' and this description is apposite because, as here, a play of light and luminous tonalities were characteristic features of his work. In the first phase of his career, Villon established himself as an engraver and commercial illustrator. He only began to paint seriously in 1910, at the age of thirty-five. It was at this time that he became aware of the Cubist paintings of Braque and Picasso through his brothers and their friends.

But Villon did not attempt to imitate them. He made a limited use of the technique of facetting and progressively evolved, under the combined influences of Gleizes and Delaunay, a style based on fragmented forms and a succession of overlapping planes of colour used to evoke volume and a sense of space. The representational element is here largely suppressed. This is a portrait of the artist's sister Yvonne seated in an armchair.

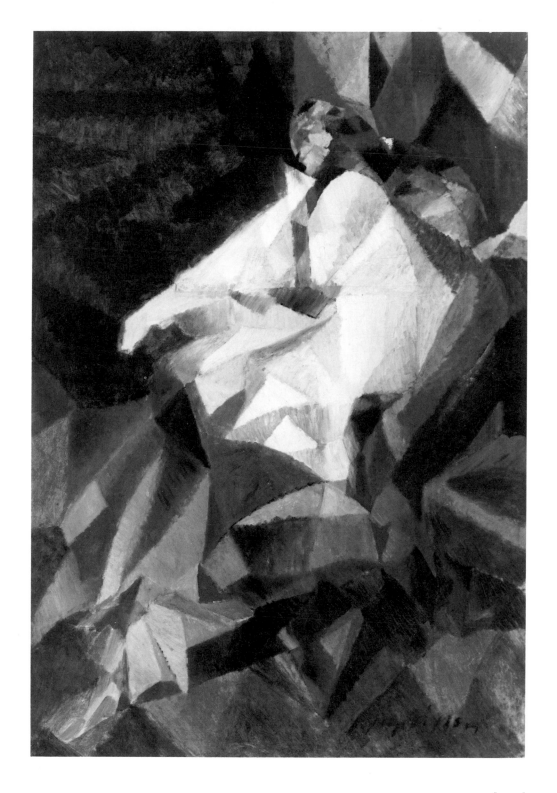

232 M. D. Reading

Executed in 1913
Drypoint on paper, $15\frac{3}{8} \times 11\frac{9}{16}$ (39 × 29.5)
Signed bottom right: 'J. Villon 6/30'; and bottom left in the plate: 'J.V.'

Edn: thirty copies

Lit: Auberty and Pérusseaux 1950, no. 198
Samuel and Dorothy Glaser

The subject is M. Justin-Isidore Duchamp, the artist's father. This is not strictly a Cubist work, though in his planar structure and in the break-up of the volume of the head Villon has had recourse to Cubist methods. The intense confrontations of dark and light areas here suggest a play of light and a fundamentally colourist pictorial conception.

233 Portrait of the Actor Felix Barré

Executed in 1913
Drypoint on wove paper, $15\frac{3}{4} \times 12\frac{3}{8}$ (40 × 31.5)
Signed lower right in the plate: 'Jacques Villon'; signed and numbered in pencil below: 'Jacques Villon 32/32'

Edn: thirty-two copies

Lit: Auberty and Pérusseaux 1950, no. 199; Museum inv. no. M 12876
Fogg Art Museum, Harvard University, Cambridge, Mass. Special Purchase Fund

Villon made two other engraved portraits of Barré in 1913 (Auberty and Pérusseaux 1950, nos. 189 and 190). A drawing relating to the second of these is in the Metropolitan Museum, New York. Barré was an actor at the Grand Guignol in Paris.

Select Bibliography

Over the last twenty-five years, an extensive literature has developed on the artists represented in the present exhibition and on the subject of Cubism generally, its place in twentieth-century art, and its relation to contemporary developments in architecture, poetry, philosophy and music. Indeed, so vast is the number of publications that we have chosen to limit the following bibliography to a few essential reference works in which the reader will find the rest of the literature listed. Good chronologies, and further information regarding the exhibitions and books in which individual work included in the present exhibition have appeared, can be found in the standard *catalogues raisonnés* identified below. The full references for other publications cited in abbreviated form in our catalogue are listed after the Select Bibliography.

CUBISM

Alfred H. Barr, Jr, *Cubism and Abstract Art*. New York, 1936.

Douglas Cooper, *The Cubist Epoch*. London and New York, 1970.

Edward F. Fry, *Cubism*. London and New York, 1966.

Gleizes and Metzinger 1912 — Albert Gleizes and Jean Metzinger, *Du Cubisme*. Paris, 1912. Eng. trans. London, 1913.

John Golding, *Cubism: A History and an Analysis 1907-1914*. rev. ed. London, 1968.

Daniel-Henry Kahnweiler, *Der weg zum Kubismus*. Munich, 1920. Eng. trans. New York, 1949.

Robert Rosenblum, *Cubism and Twentieth Century Art*. rev. ed. New York, 1976.

FOUR MASTERS

Georges Braque (1882-1963)

Douglas Cooper, ed. *G. Braque*. London, 1956.

M.(1907-14) — Nicole Worms de Romilly and Jean Laude, *Braque: Cubism, 1907-14*. (Maeght Catalogue) Paris, 1982.

M.(1916-23) — Nicole S. Mangin, *Catalogue de l'oeuvre de Georges Braque, peintures, 1916-23*. (Maeght Catalogue) Paris, 1973.

MNAM *Papiers Collés* 1982 — Isabelle Monod-Fontaine, ed. *Georges Braque, les papiers-collés*. Paris, 1982. Eng. trans. Washington, D.C., 1982.

Vallier — Dora Vallier, *Braque, L'Oeuvre gravé*. Paris, 1982.

Juan Gris (1887-1927)

Cooper — Douglas Cooper and Margaret Potter, *Juan Gris, Catalogue raisonné de l'oeuvre peint*. Paris, 1977.

Letters — Douglas Cooper, ed. *Letters of Juan Gris*. London, 1956.

Daniel-Henry Kahnweiler, *Juan Gris, sa vie son oeuvre, ses écrits*. Paris, 1946. Eng. trans. rev. ed. London, 1969.

Fernand Léger (1881-1955)

Cassou 1972 — Jean Cassou, Jean Leymarie and Michèle Richet, *Fernand Léger, dessins et gouaches*. Paris, 1972.

Cooper 1949 — Douglas Cooper, *Fernand Léger et le nouvel espace*. Geneva, 1949. Eng. trans. London, 1949.

Edward F. Fry, ed. *Functions of Painting, by Fernand Léger*. London, 1973.

Green 1976 — Christopher Green, *Léger and the Avant-garde*. New Haven and London, 1976.

Virginia Spate, *Orphism: The Evolution of non-figurative Painting in Paris 1910-1914*. Oxford, 1979.

Pablo Picasso (1881-1973)

	Pierre Daix, *La Vie de peintre de Pablo Picasso*. Paris, 1977.
D	Pierre Daix, and Joan Rosselet, *Picasso: The Cubist Years, 1907-1916*. London and Boston, 1979.
Geiser	Bernhard Geiser, *Picasso: Peintre-graveur*. Bern, 1933.
	Ray Anne Kibbey, *Picasso: A Comprehensive Bibliography*. New York, 1977.
S	Werner Spies, *Sculpture by Picasso, with a Catalogue of the Works*. New York and London, 1972.
Tinterow 1981	Gary Tinterow, *Master Drawings by Picasso*. New York and Cambridge, 1981.
Z	Christian Zervos, *Pablo Picasso, Oeuvres*. 33 vols to date. Paris, 1932-present.

TWO CUBIST SCULPTORS

Henri Laurens (1885-1954)

| | Werner Hofmann, *The Sculpture of Henri Laurens*. New York, 1970. |
| | Marthe Laurens, *Henri Laurens, Sculteur*. Paris, 1955. |

Jacques Lipchitz (1891-1973)

| MNAM Catalogue Lipchitz 1978 | Nicole Barbier, ed. *Lipchitz, Oeuvres de Jacques Lipchitz. Collection du Musée National d'Art Moderne*. Paris, 1978. |

ASSOCIATED FRENCH ARTISTS

Robert Delaunay (1885-1941)

| | Virginia Spate, *Orphism: The Evolution of non-figurative Painting in Paris 1910-1914*. Oxford, 1979. |

Albert Gleizes (1881-1953)

| | Daniel Robbins, *Albert Gleizes*. New York, 1964. |

Louis Marcoussis (1883-1941)

| Lafranchis 1961 | J. Lafranchis, *Marcoussis, sa vie son oeuvre*. Paris, 1961. |

Jean Metzinger (1883-1957)

| | Waldemar George, 'Jean Metzinger' in *L'Esprit Nouveau*. Paris, March 1927. |

Jacques Villon (1875-1963)

| Auberty and Pérusseaux 1950 | J. Auberty and C. Pérusseaux, *Catalogue de l'Oeuvre gravé de Jacques Villon*. Paris, 1950. |
| | Daniel Robbins, *Jacques Villon*. Cambridge, Massachusetts, 1972. |

ADDITIONAL WORKS CITED IN ABBREVIATED FORM

Cooper 1956	Douglas Cooper, *Fernand Léger, dessins de guerre*. Paris, 1956.
Cooper 1982	Douglas Cooper, 'Braque as Innovator: The First Papier-Collé,' in *Georges Braque, The Papiers-Collés*. Washington, D.C., 1982. Trans. from MNAM *Papiers Collés 1982*.
Düsseldorf 1968	Kunstsammlung Nordrhein-Westfalen, *Catalogue of 20th Century Paintings*. Düsseldorf, 1968.
Guggenheim 1976	Angelica Zander Rudenstein, *The Guggenheim Museum Collection: Paintings 1880-1945*. New York, 1976.
I.	Georges Isarlov, *Georges Braque*. Paris, 1932.
Kröller-Müller 1968	Rijksmuseum Kröller-Müller, *Drawings of the 19th and 20th Centuries, Catalogue*. Otterlo, 1968.
Kröller-Müller 1969	Rijksmuseum Kröller-Müller, *Catalogue of the Paintings*. Otterlo, 1969.

McCully 1981 — Marilyn McCully, *A Picasso Anthology: Documents, Criticism, Reminiscences.* London, 1981.

MNAM *Catalogue Braque* 1982 — Nadine Pouillon and Isabelle Monod-Fontaine, *Braque, Oeuvres de Georges Braque. Collections du Musée National d'Art Moderne.* Paris, 1982.

MOMA *Janis* 1972 — Alfred H. Barr and William Rubin, *Three Generations of Twentieth Century Art: The Sidney and Harriet Janis Collection of the Museum of Modern Art.* New York, 1972.

MOMA 1977 — Alfred H. Barr, Jr., *Painting and Sculpture in the Museum of Modern Art, 1929-1967.* New York, 1977.

Quinn 1978 — Judith Zilczer, *John Quinn: The Noble Buyer.* Washington, D.C., 1978.

Rubin 1977 — William Rubin, 'Cézannism and the Beginnings of Cubism,' in *Cézanne: The Late Works.* New York, 1977.

Seligman 1979 — John Richardson, ed. *The Collection of Germain Seligman: Paintings, Drawings and Works of Art.* New York and London, 1979.

Société Anonyme — G.H. Hamilton, *Collection of the Société Anonyme.* New Haven, 1950.

Tate 1981 — Ronald Alley, *Catalogue of the Tate Gallery's Collection of Modern Art, other than works by British Artists.* London, 1981.

List of Lenders

PRIVATE COLLECTIONS

Acquavella Galleries Inc. 66
Galerie Beyeler 101, 120, 129

Ida Chagall 198
Mr & Mrs George S. Coumantaros 71

Mrs Harold Diamond 67

Mr & Mrs Ahmet M. Ertegun 84

Mr & Mrs Jacques Gelman 18, 125
Samuel and Dorothy Glaser 232
Galerie Gmurzynska 144
Georges Gonzalez-Gris 92

Alex Hillman Family Foundation 75
Sir Antony and Lady Hornby 11

Sidney Janis Gallery 24
Mr & Mrs R. Stanley Johnson 230
Riccardo and Magda Jucker 112, 115

EWK 186, 189

Madame Denise Laurens 204
Galerie Louise Leiris 44, 90, 181-4, 187

Fondation Maeght 49-56
Alex Maguy 2
Marlborough Fine Art (London) Ltd 214-19, 226
Sara and Moshe Mayer 99

Galerie Nathan 95
Morton Neumann Family Collection 77

Lionel Prejger 171
Private Collections 3, 4, 6, 10, 17, 20, 21, 22, 25,
 26, 28, 30, 32, 33, 34, 35, 36, 42, 46, 47, 48,
 58, 59, 61, 64, 65, 68, 72, 78, 79, 81, 83, 85,
 86, 87, 94, 98, 100, 105, 106, 108, 110, 113,
 116, 117, 118, 121, 131, 133, 139, 141, 145,
 147, 149, 150, 158, 159, 161, 167, 169, 185,
 190, 193, 200, 201, 202, 203, 205, 206, 207,
 208, 209

Alex Reid & Lefevre Ltd 175
Rosengart Collection 109

Stanley J. Seeger Collection 153

Thyssen-Bornemisza Collection 13, 143

Vieira da Silva-Arpad Szenes 199

PUBLIC COLLECTIONS

Basel, Kunstmuseum 27, 40, 43, 45, 73, 76, 80,
 97, 102, 179, 180
Bern, Kunstmuseum 142
Boston Museum of Fine Arts 124
Buffalo, Albright Knox Art Gallery 123

Cambridge, Mass., Fogg Art Museum 165, 233
Chicago, Art Institute of 7, 37, 88
Cleveland Museum of Art 119
Columbus Museum of Art 41, 146, 225

Detroit Institute of Arts 148
Düsseldorf, Kunstsammlung Nordrhein-
 Westfalen 103, 220

Edinburgh, Scottish National Gallery of Modern
 Art 15
Eindhoven, Van Abbemuseum 8
Essen, Museum Folkwang 136

Fort Worth, Kimbell Art Museum 127

Hannover, Kunstmuseum mit Sammlung
 Sprengel 213

Indiana University Art Museum 82

London, British Museum 188
London, Tate Gallery 14, 19, 69, 122, 140, 194,
 210, 211, 221, 222
Los Angeles, County Museum of Art 231

Madrid, Museo del Prado 74
Mainz, Mittelrheinisches Landesmuseum 157
Minneapolis Institute of Art 1

New Haven, Yale University Art Gallery 212
New York, Solomon R. Guggenheim Museum 9,
 96, 128, 224, 227
New York, Metropolitan Museum of Art 156, 160
New York, Museum of Modern Art 16, 31, 60, 93

Otterlo, Rijksmuseum Kröller-Müller 57, 91

Paris, Musée National d'Art Moderne 12, 29, 38,
 151, 152
Paris, Musée d'Art Moderne de la Ville de
 Paris 197
Paris, Musée Picasso 130, 134, 137, 154, 155,
 162, 163, 164, 166, 168, 170, 172, 173, 174,
 176, 177, 191, 192, 195, 196
Philadelphia Museum of Art 70, 104, 132, 228
Prague, Národní Galerie 23, 111, 114, 126

The Friends of the Tate Gallery

The Friends of the Tate Gallery is a society which aims to help buy works of art that will enrich the collections of the Tate Gallery. It also aims to stimulate interest in all aspects of art.

Although the Tate has an annual purchase grant from the Treasury, this is far short of what is required, so subscriptions and donations from Friends of the Tate are urgently needed to enable the Gallery to improve the National Collection of British painting to 1900 and keep the Modern Collection of painting and sculpture up to date. Since 1958 the Society has raised well over £500,000 towards the purchase of an impressive list of works of art, and has also received a number of important works from individual donors for presentation to the Gallery.

The Friends are governed by a council – an independent body – although the Director of the Gallery is automatically a member. The Society is incorporated as a company limited by guarantee and recognised as a charity.

Advantages of membership include:

Special entry to the Gallery at times the public are not admitted. Free entry to, and invitations to private views of, paying exhibitions at the Gallery. Opportunities to attend lectures, private views at other galleries, films, parties, and of making visits in the United Kingdom and abroad organised by the Society. Use of the Reference Library in special circumstances. Tate Gallery publications, including greetings cards, etc. and art magazines at reduced prices. Use of the Members' Room in the Gallery.

A single membership includes husband and wife in all subscription categories*

Benefactor £1,500. Life membership.

Patron £150 or over annually. Five fully transferable guest cards.

Corporate £75 or over annually. Subscription for corporate bodies and companies. Two fully transferable guest cards.

Associate £40 or over annually. Two fully transferable guest cards.

Member £10.00 annually or £9.00 if a Deed of Covenant is signed.

Educational & Museum £8.00 annually or £7.00 if a Deed of Covenant is signed. For the staff of museums, public galleries and recognised educational bodies.

Young Friends £7.00 annually. For persons under 26.

*The rates quoted above were correct at time of going to press.

For further information apply to:

The Organising Secretary,
The Friends of the Tate Gallery,
Tate Gallery, Millbank, London SW1P 4RG.
Telephone: 01-834 2742 or 01-821 1313